**Vrasidas Karalis** is Sir Nicholas Laurantus Professor in Modern Greek and Byzantine Studies at the University of Sydney, Australia. He has published extensively on Greek political life, Greek cinema, European cinema, Byzantine historiography and contemporary political philosophy. Most recently, he has authored *A History of Greek Cinema* (2012) and co-edited collections on Martin Heidegger, Hannah Arendt and Cornelius Castoriadis. He has also published articles on Theo Angelopoulos, Alfred Hitchcock and Sergei Eisenstein.

'This remarkable study is the only book on Greek cinema that goes beyond mere film analysis, providing fresh insight on the diversity of Greek cinematic production from post-World War II to the present, and including contemporary filmmakers such as Lanthimos and Tsangari.'

– Andrew Horton, University of Oklahoma;
author of The Films of Theo Angelopoulos

'Karalis here focuses on what makes realism culturally significant and effective in Greek cinema. It is a bold and clever move, a brilliant follow-up to his History of Greek Cinema. Wide-ranging, comprehensive, insightful and original, this book is an impressive attempt to explain why (and how) Greek cinema matters.'

– Dimitris Papanikolaou, University of Oxford

Tauris World Cinema Series
Series Editors:

Lúcia Nagib, *Professor of Film at the University of Reading*
Julian Ross, *Research Fellow at the University of Westminster*

Advisory Board: Laura Mulvey (UK), Robert Stam (USA), Ismail Xavier (Brazil), Dudley Andrew (USA)

The *Tauris World Cinema Series* aims to reveal and celebrate the richness and complexity of film art across the globe, exploring a wide variety of cinemas set within their own cultures and as they interconnect in a global context. The books in the series will represent innovative scholarship, in tune with the multicultural character of contemporary audiences. Drawing upon an international authorship, they will challenge outdated conceptions of world cinema, and provide new ways of understanding a field at the centre of film studies in an era of transnational networks.

Published and forthcoming in the World Cinema series:

*Animation in the Middle East: Practice and Aesthetics from Baghdad to Casablanca*
By Stefanie Van de Peer

*Basque Cinema: A Cultural and Political History*
By Rob Stone and Maria Pilar Rodriguez

*Brazil on Screen: Cinema Novo, New Cinema, Utopia*
By Lúcia Nagib

*The Cinema of Sri Lanka: South Asian Film in Texts and Contexts*
By Ian Conrich and Vilasnee Tampoe-Hautin

*Contemporary New Zealand Cinema*
Edited by Ian Conrich and Stuart Murray

*Cosmopolitan Cinema: Cross-cultural Encounters in East Asian Film*
By Felicia Chan

*Documentary Cinema: Contemporary Non-fiction Film and Video Worldwide*
By Keith Beattie

*East Asian Cinemas: Exploring Transnational Connections on Film*
Edited by Leon Hunt and Leung Wing-Fai

*East Asian Film Noir: Transnational Encounters and Intercultural Dialogue*
Edited by Chi-Yun Shin and Mark Gallagher

*Film Genres and African Cinema: Postcolonial Encounters*
By Rachael Langford

*Impure Cinema: Intermedial and Intercultural Approaches to Film*
Edited by Lúcia Nagib and Anne Jerslev

*Lebanese Cinema: Imagining the Civil War and Beyond*
By Lina Khatib

*New Argentine Cinema*
By Jens Andermann

*New Directions in German Cinema*
Edited by Paul Cooke and Chris Homewood

*New Turkish Cinema: Belonging, Identity and Memory*
By Asuman Suner

*On Cinema*
By Glauber Rocha
Edited by Ismail Xavier

*Palestinian Filmmaking in Israel: Narratives of Memory and Identity in the Middle East*
By Yael Freidman

*Paulo Emílio Salles Gomes: On Brazil and Global Cinema*
Edited by Maite Conde and Stephanie Dennison

*Performing Authorship: Self-inscription and Corporeality in the Cinema*
By Cecilia Sayad

*Queer Masculinities in Latin American Cinema: Male Bodies and Narrative Representations*
By Gustavo Subero

*Realism in Greek Cinema: From the Postwar Period to the Present*
By Vrasidas Karalis

*Realism of the Senses in Contemporary World Cinema: The Experience of Physical Reality*
By Tiago de Luca

*The Spanish Fantastic: Contemporary Filmmaking in Horror, Fantasy and Sci-fi*
By Shelagh-Rowan Legg

*Stars in World Cinema: Screen Icons and Star Systems Across Cultures*
Edited by Andrea Bandhauer and Michelle Royer

*Theorizing World Cinema*
Edited by Lúcia Nagib, Chris Perriam and Rajinder Dudrah

*Viewing Film*
By Donald Richie

Queries, ideas and submissions to:

Series Editor: Professor Lúcia Nagib – l.nagib@reading.ac.uk

Series Editor: Dr. Julian Ross – J.Ross1@westminster.ac.uk

Cinema Editor at I.B.Tauris, Maddy Hamey-Thomas – mhamey-thomas@ibtauris.com

# Realism in Greek Cinema

## From the Post-War

## Period to the Present

**VRASIDAS KARALIS**

BLOOMSBURY ACADEMIC
LONDON • NEW YORK • OXFORD • NEW DELHI • SYDNEY

BLOOMSBURY ACADEMIC
Bloomsbury Publishing Plc
50 Bedford Square, London, WC1B 3DP, UK
1385 Broadway, New York, NY 10018, USA
29 Earlsfort Terrace, Dublin 2, Ireland

BLOOMSBURY, BLOOMSBURY ACADEMIC and the Diana logo
are trademarks of Bloomsbury Publishing Plc

First published by I. B. Tauris
This paperback edition published in 2021

Copyright © Vrasidas Karalis, 2017

Vrasidas Karalis has asserted their right under the Copyright,
Designs and Patents Act, 1988, to be identified as Author of this work.

For legal purposes the Acknowledgements on p. xi constitute
an extension of this copyright page.

All rights reserved. No part of this publication may be reproduced or
transmitted in any form or by any means, electronic or mechanical,
including photocopying, recording, or any information storage or retrieval
system, without prior permission in writing from the publishers.

Bloomsbury Publishing Plc does not have any control over, or responsibility for,
any third-party websites referred to or in this book. All internet addresses given
in this book were correct at the time of going to press. The author and publisher
regret any inconvenience caused if addresses have changed or sites have
ceased to exist, but can accept no responsibility for any such changes.

A catalogue record for this book is available from the British Library.

A catalog record for this book is available from the Library of Congress.

ISBN: HB: 978 1 78076 729 1
PB: 978 1 3502 4284 5
ePDF: 978 1 78673 077 0
eBook: 978 1 78672 077 1

To find out more about our authors and books visit
www.bloomsbury.com and sign up for our newsletters.

# Contents

| | | |
|---|---|---|
| **List of Figures** | | ix |
| **Acknowledgements** | | xi |
| | Introduction | 1 |
| 1. | Realisms and the Question of Form in Greek Cinema | 5 |
| 2. | The Construction and Deconstruction of Cinematic Realism in Michael Cacoyannis' Films | 60 |
| 3. | Nikos Koundouros and the Cinema of Cruel Realism | 98 |
| 4. | Yannis Dalianidis and the Cryptonymies of Visuality | 129 |
| 5. | An Essay on the Ocular Poetics of Theo Angelopoulos | 157 |
| 6. | The Feminine Gaze in Antoinetta Angelidi's Cinema of Imaginative Cathedrals | 191 |
| 7. | Greek Cinema in the Age of the Spectacle | 215 |
| | Optimistic Epilogue | 240 |
| **Notes** | | 246 |
| **Bibliography** | | 263 |
| **Index** | | 273 |

# List of Figures

| | | |
|---|---|---|
| 1.1 | Yorgos Tzanellas, *Agnes of the Harbour* (1952). The allure of classical prosopography | 32 |
| 1.2 | Gregg Tallas, *The Barefoot Battalion* (1954). The gaze of innocence | 34 |
| 1.3 | Maria Plyta, *Eve* (1953). Objectifying the male body | 35 |
| 1.4 | Maria Plyta, *Eve* (1953). Reversing the gaze: female libidinal aggression | 36 |
| 2.1 | Michael Cacoyannis, *Windfall in Athens* (1954). The face as cultural geography | 73 |
| 2.2 | Michael Cacoyannis, *Eroica* (1960). The face of hidden desires | 84 |
| 2.3 | Michael Cacoyannis, *Electra* (1962). The fear of living under the maternal gaze | 89 |
| 2.4 | Michael Cacoyanis, *Zorba the Greek* (1964). The simple gestures of consideration | 94 |
| 3.1 | Nikos Koundouros, *The Ogre of Athens* (1955). Death without redemption: the violence of history | 102 |
| 3.2 | Nikos Koundouros, *Young Aphrodites* (1963). The loss of innocence and the fear of growing up | 109 |
| 3.3 | Nikos Koundouros, *1922* (1978). The nightmare of history and the destruction of human communication | 112 |
| 3.4 | Nikos Koundouros, *A Ship for Palestine* (2012). The incomprehensibility of symbols: history as an alien territory | 116 |
| 4.1 | Yannis Dalianidis, *Story of a Life* (1965). The secret life of objects | 145 |
| 4.2 | Yannis Dalianidis, *Tears for Electra* (1966). Manipulating male desire | 148 |
| 4.3 | Yannis Dalianidis, *The Sinners* (1971). The usable masculinity through the key-hole | 150 |
| 4.4 | Yannis Dalianidis, *Under the Sign of Virgo* (1973). The male femininity devouring the feminine male | 151 |
| 5.1 | Theo Angelopoulos, *Days of 36* (1972). The geometry of political tyranny | 174 |
| 5.2 | Theo Angelopoulos, *The Hunters* (1977). Breaking the monochromy of history | 178 |
| 5.3 | Theo Angelopoulos, *Alexander the Great* (1980). The birth and death of legendary utopias | 180 |

## List of Figures

| | | |
|---|---|---|
| 5.4 | Theo Angelopoulos, *Landscape in the Mist* (1987). The dissolution of forms and the lost imaginary | 183 |
| 5.5 | Theo Angelopoulos, *The Weeping Meadow* (2004). The blurred images of oblivion | 187 |
| 5.6 | Theo Angelopoulos, *The Dust of Time* (2009). The whiteness of un-knowing | 189 |
| 6.1 | Antouanetta Angelidi, *Idées Fixes/Dies Irae* (1977). The female Mara and her death | 201 |
| 6.2 | Antouanetta Angelidi, *Thief or Reality* (2001). The female Holy Trinity | 203 |
| 6.3 | Antouanetta Angelidi, *Thief or Reality* (2001). The dust and darkness of being | 207 |
| 6.4 | Antouanetta Angelidi, *Topos* (1985). The other forms within the forms | 210 |
| 7.1 | Yorgos Lanthimos, *Kineta* (2005). The lost geometry of grand narratives | 228 |
| 7.2 | Costas Zappas, *Uncut Family* (2004). The triangulation of lost connections | 236 |

# Acknowledgements

I would like to thank many people and institutions that contributed in various ways to the writing of this book: first, the Michael Cacoyannis Foundation in Athens for sending me without delay the Cacoyannis film I couldn't find anywhere; the filmmaker Antoinetta Angelidi, who provided me with her films and the existing critical literature on her work; Professor Anthony Stephens, a colleague and friend, for his edifying comments and suggestions; Dr Angelos Koutsourakis for providing me with some hard to find recent films; and finally, my colleagues and students at the University of Sydney for their support, encouragement and the endless discussions about the relevance of Greek cinema.

My special gratitude goes to Philippa Brewster, who initially accepted the publication of this volume for I.B.Tauris. To Professor Lúcia Nagib as the editor of the series for her support of the project. To Anna Coatman for her comments and patience. Finally, to Maddy Hamey-Thomas for her enthusiasm after taking on the position of editor.

In its initial stages, the text was copyedited by Ms Eleni Eleftheria-Kostakidis. My special thanks to Pat FitzGerald for her meticulous editing; my deepest gratitude to Sarah Shrubb for her perceptive final editing, pointing out many problematic aspects of the text.

# Introduction

The present book follows my published history of Greek cinema in an attempt at a closer look at certain filmmakers whose work I briefly analysed there. Each chapter delineates their persistent concern for a cinematic visuality of the lived experience, accented by the social imaginary of Greek culture through the transcultural narrative codes and transnational modes of representation provided by the global medium of cinema. What we are interested in here is not only *what* made the cinematic 'product' possible but *how* it achieved its accepted form so that its industry could become viable.

My approach is varied and eclectic, combining film and cultural studies, psychoanalytic interpretation and formal analysis as well as political and social contextualisation. Some biographical information is also included in order to account for critical moments and reorientations in each filmmaker's life and work. The truth is that each of these filmmakers needs and deserves a separate book-length study. Their work is so multifaceted that a variety of approaches by diverse hands is necessary in order to present it fairly to an international audience that knows nothing about its local impact and significance.

Greek cinema is the most remarkable achievement of a small market, an underdeveloped industry and a local culture tormented by partisan feuding, personal bias, fierce territorial imperatives and entrenched institutional favouritism. Nevertheless, many Greek films transcend their own structural strictures and develop a semantic surplus that can be reinscribed and reinterpreted through different social experiences and cultural conceptualisations. A Cacoyannis film is not simply a film by Cacoyannis, although it is still a film made by Michael Cacoyannis: discursive structures do not overdetermine or efface the empirical self of the filmmaker. Yet films are collective artefacts resulting from various encounters and they often become autonomous symbolic markers, separated from their contextual origins.

I hope that this book contributes to the consolidation of Greek film studies as a distinct field of research and inquiry, in a way that makes it accessible to global cinephiles. Certain recent books on Greek film studies seem to address themselves to a Greek audience despite the fact that they are written in English. I have tried to avoid such an inward-looking approach by constantly comparing the work of these filmmakers to international movements or to the work of directors from various traditions, so that global audiences can locate them on the imaginary maps of transcultural film production. A number of monographs – based on postgraduate degrees – which have been published recently substantially contribute to the study and promotion of the field; however, most of them are expository and descriptive and do not offer an interpretive argument about the qualities of the cinematic production, its continuing significance or its possible relevance to world cinema.

In order to take the field of Greek film studies out of its infancy, we must connect works, ideas and films with analogous and homologous works, ideas and films from various cinematic traditions. Furthermore, we must resist the temptation, so dominant in Greek studies, to deal with all cultural creations as commentaries on the disastrous and melancholic political history of the Greek state. If there is a purpose in this book, it is to show the diversity and heterogeneity of cinematic production in Greece. As such, the present book cannot exhaust the whole variety of formal experimentations or indeed the distinct character of many works. I've tried to include not only well-known *auteurs* such as Theo Angelopoulos but also directors from the studio system, such as Yannis Dalianidis, whose work is looked upon with derision by the few historians of Greek cinema. I've also included a chapter on experimental, avant-garde cinema which is not known at all; the work of Antoinetta Angelidi belongs to European cinema as much as it is part of Greek cinema. The exploration culminates with the work of Yorgos Lanthimos and Athina Rachel Tsangari, as the most tangible representatives of globalised local cinemas and the end of a perception that Greek cinema was only either *Zorba the Greek* (1964) or *The Travelling Players* (1975): that is, either naive folklore or perplexing politics.

Chapter 1 explores the establishment of the cinematic as a specific field of visuality in the cultural imaginary of Greek society. It problematises the concept of realism as discussed by certain theorists and examines the particularities of Greek cinema within its Balkan, European and global contexts. The following chapters explore specific filmmakers and their quest for form, realistic or symbolic, presentional or representational. Chapter 2 is dedicated to Michael Cacoyannis. Cacoyannis is widely known for *Stella* (1955) and *Zorba the Greek*. There is little

else known about him internationally despite regional interest in his other films. The work of Nikos Koundouros is not known at all in the English-speaking world and Chapter 3, explores his oeuvre; he is one of the most idiosyncratic and versatile filmmakers in postwar European cinema. In Chapter 4, the work of Yannis Dalianidis is also presented for the first time to an international audience, as expressing, under the codes of the studio system, the submerged sexual identities that were silenced by the strict forms of self-censorship imposed by the producer. In Chapter 5, I explore the work of Theo Angelopoulos, which is well known, especially through the work of Andrew Horton; however, after Angelopoulos' death, fresh approaches are needed to explore various overlooked aspects of his movies. Chapter 6 is dedicated to the experimental films of Antoinetta Angelidi, which provides an opportunity to discuss the overlooked tradition of anti-realism, as well as women's cinema, in Greece. Chapter 7 is dedicated to the younger generation which came to the fore after the millennium and whose work is becoming increasingly part of global cinema. Finally, the Epilogue tries to make sense of the cultural consequences of the current crisis, which is the result of both financial collapse and cultural implosion.

There are two main thematic threads that link all the chapters: first is the quest for form, both visual and narrative. Second is the idea that the form itself, in its intent and structure, has its own content 'prior to any given actualisation of it in speech or in writing,[1] as Hayden White suggested. The first thematic thread revolves mostly around the constant problematisation of realism and the second focuses on the multifarious attempts to deal with successive traumas of history. The book is structured around the transformations of realism over a period of sixty years through the efforts of various filmmakers to institute a form commensurate with the silenced traumas of the recent past. Realism remained an elusive project reinvented by different filmmakers, and some of them either abandoned it as visual language altogether or repudiated it as legitimate cinematic form. The constant undercurrent in most films was the silent and corrosive presence of the hidden and censored traumas of history. The traumas of history were present but not represented: this study contributes to the unconcealment of such eloquent dissimulation.

Finally, the subversion of the traditional ways of seeing became possible through the masterful use, initially by Cacoyannis, of montage, a disruptive stratagem that liberated cinematic representation from all notions of romanticised 'national' authenticity or dehistoricised photographic verisimilitude and opened it to the ambiguities and the multivocalities of modernity. Montage created the flexible formal matrix out of which all other experiments with form became possible, and offered to all cinematographers a formal schema, a

comprehensive *gestalt*, which empowered them to embark on further polymorphous experimentations.

My reading is a 'situated' interpretation of Greek cinema from the point of view of a diasporic scholar, who writes from outside the country and who does not participate in the local debates about which is the best canon of Greek film. The purpose of this book is to present a number of Greek filmmakers, predominantly as creators of cinematic culture and contributors to global filmic languages. The relentless and ongoing process of globalisation, which also results in aesthetic and stylistic syncretism, will define the 'value' of each one of the directors and ultimately the significance of Greek cinematic languages in the future.

Despite the paucity of studies in other languages on Greek cinema, I would like to point out the intriguing exploration of Cacoyannis' films by Professor Alejandro Valverde García in Spanish and the brief but incisive study by Beniamino Biondi on the work of Nikos Koundouros in Italian.

My hope is that more scholars from various backgrounds will be interested in Greek cinema and new studies will be written on the surprising journeys of many imaginative and adventurous Greek filmmakers.

# 1

## Realisms and the Question of Form in Greek Cinema

## Some preliminary questions

> Cinema is a vast subject, and there are more ways than one to enter it.
>
> Christian Metz[1]

> Everything in cinema is an enormous deception, an impeccably organised deception which indiscriminately serves either realism or imagination. By its nature, cinema is anti-realistic and what we call 'cinematic realism' is nothing more than the illusory employment of tricks, simple or complex.
>
> Vassilis Rafailides[2]

The latter quote is how Vasilis Rafailides (1934–2000), the most influential Greek film critic, addressed the question of realism as a project and an autonomous language of cinematic representation. According to him, the filmic text itself becomes the space where visual inventiveness can restore the fractured continuity between experience and imagination and thus establish the ground for an experiential convergence between filmmakers and their audiences. 'Modern cinema,' he added, 'is closer to reality than any other form of expression. Realism finally gained its true meaning, as filmmakers learned to respect the value of facts *in themselves*.'[3] (Emphasis added.)

Rafailides' attempt to articulate a theoretical conceptualisation of cinematic realism raises many questions without providing any concrete answers. According to him, the paradox in cinema is that through imagination 'modern cinema indicates a method which can incite us to acquire a total awareness of our historicity'.[4] Thus he links the historical self-awareness of the spectator to the representation of facts in themselves, and simultaneously emphasises the illusory character of all cinematic representations. In his approach this paradoxical, self-contradictory

character of images, which depicts the real by perceiving it through imaginative processes, is the dominant constitutive element of the cinematic as an experience distinct from other arts. Rafailides, like many other critics and theorists, tried repeatedly to address the question of cinematic realism, only to conclude that it has always been a profoundly elusive, contested and unstable category. An optimistic formulation, expressed by André Bazin as 'a re-creation of the world in its image, an image unburdened by the freedom of interpretation of the artist or the irreversibility of time',[5] can be considered restrictive, or indeed partial, in capturing the multiplicity of ideas and practices designated by the term 'realism'. All attempts to define realism in cinema have only intensified its conceptual vagueness, while at the same time foregrounding the ideological function of the term.

In this book, I use the term 'realism' to indicate specific sets of visual devices framing formal arrangements in open space, linked through specific narrative codes. Narrative links the subjective world to its objective contexts through images; ultimately, filmic composition is more than the total sum of its parts, as it is more than a rapid succession of photographs. For the realist, what happens on-screen and off-screen are inextricably connected; this link makes realism an unstable and self-questioning mode of conceptualising and visualising, of indeed imagining, social experience. Filmmakers have understood realism in different and incongruous ways; experimental filmmakers, for example, strongly suggested that what they were doing was 'pure realism', whereas others stressed that 'realism' was a fallacy fragmenting the unity and the autonomy of the cinematic experience. Consequently realism is more a project in continuous reinvention and less a clearly recognisable genre defined by its historical development or the declarations of various theorists.

For this reason, I talk about realisms and explore their various formations and transformations in the work of different cinematographers. Self-proclaimed realists always foreground empathic union between image and viewer, not simply because they want to bridge the gap between the real and the imaginary, but also because they believe that such union can abolish all distance between them, though only for the duration of the film. Fredric Jameson, exploring 'the antinomies of realism', provided a complex yet apt definition:

> What we call realism will thus come into being in the symbiosis of this pure form of storytelling with impulses of scenic elaboration, description and above all affective investment, which allow it to develop towards a scenic present which in reality, but secretly, abhors the other temporalities which constitute the force of the tale or the récit in the first place.[6]

Storytelling and scenic setting are thus crucial in appreciating the 'affective invest-ment' that makes realism, in all its varieties, the dominant mode of representation in cinema. It is true, of course, that most European directors have used realism differently from American filmmakers, despite their constant interactions. As Shohini Chaudhuri observed, 'in European cinema, realism is often conceived as an appeal to national or cultural "authenticity," offering an alternative to Hollywood by addressing cultural specificities unavailable in Hollywood'.[7] Yet the perception of such cultural authenticity has changed over time, and so the meanings of 'real-ism' have changed as well. Realism, according to Edward Lucie-Smith, is 'not ... an absolute but ... an elaborate and ever-shifting interplay between content, means of expression and context'.[8]

Obviously, the term has nothing to do with a presumed correspondence between reality and image or with the quest for verisimilitude. Furthermore, despite its generality as a concept, it can be seen only through the specificity of its use by distinct individuals – which perhaps constitutes its very paradoxical nature. The unfolding of cinematic space is also connected with specific forms of narrative. In classical cinema, space becomes the actual focus of the narrative itself: where something happens is as important as what happens. Filmic space also defines not only the specific genres that are possible but also the limits of rep-resentation for each filmmaker. As Eleftheria Thanouli stated: 'The classical spatial system offers the filmmakers an unsparing range of options for manipulating the space "in" and "out" of frame and for generating the illusion of reality in the clas-sical realist sense.'[9]

In this exploration of postwar Greek cinema the concept of realism and its various modes – or options, according to Thanouli – will be investigated through the work of a number of significant filmmakers as it evolved in differ-ent socio-political circumstances, industry pressures and aesthetic pursuits. Its manifestations indicate its problematic character: it circumscribes the instability of 'morphoplastic visuality' in the Greek cultural imaginary as it evolved out of the actual instability of its historical experience. The instability of 'morphop-lastic visuality' refers to the distinct local visual culture and its confrontation with the new modes of representation framed through the camera after the rise of modernity in the early twentieth century. It took at least thirty years (from 1914 until 1945) to learn how to use the camera cinematically rather than to capture one-dimensional photographic stills. The first director in our explora-tion, Michael Cacoyannis, was the first to use the camera to incorporate kinetic human presence. Only after this did the experimentation with the potentialities of cinematic representation begin.

Furthermore, historical experience itself was extremely volatile and traumatic over a long period of time. Most directors I examine struggled to imagine the pictorial schemata that could visually depict the rapidly changing character of lived experience; at the same time they were in a constant dialogue with forms of exploration occurring worldwide – German expressionism, poetic realism, Hollywood and Bollywood, Italian neorealism, the French New Wave, independent American cinema and Dogma 95. The flow of such cinematic dialogues, and the interplay between industry, tourism, transnational fantasy and globalised economies, led to hybrid forms of representation that synthesised and blended sometimes incongruous genres, thus creating the puzzling multiplicity of realisms I want to explore here.

In brief, Greek filmmakers, like all others, appropriated global technology and ideas to represent the codes of local epistemic regimes and the horizons they defined. The investigation of such plurality of realisms is connected directly to David Bordwell's suggestion that 'realism as a standard of value ... raises several problems. Notions of realism vary across cultures, over time and even among individuals ... It is best then to examine the functions of *mise-en-scène*'.[10] Indeed, realistic representation is about composition in space and the constructivist principles that define what and how things can be framed in the cinematic visual field. As Brendan Prendeville pointed out about painting, 'all twentieth century realisms were partial and hybrid'.[11] Different camera angles do not simply indicate different perspectives, they indicate different experiences and ultimately different meanings. Without the mediation of form we cannot understand the actual meaning and effect of films on their audiences synchronically or their relevance diachronically. As John Gibbs aptly concluded, 'an understanding of *mise-en-scène* is a prerequisite for making other kinds of claims about film'.[12] A film is political if it is made *politically*, and not as another form of political pamphlet, as Theo Angelopoulos has observed.[13]

In Greek cinema, after cinematic visuality was formed, the specific character of its narrativity was also crystallised – only then can we talk about 'Greek national cinema' proper. Noël Burch, who has explored persistently, through the Japanese and French cinemas, what he called 'the problem of the film subject', aptly observed:

> When film-makers finally become fully conscious of the cinematic means at their disposal, when the possibility of creating organically coherent films in which every element works with every other is within sight, surely the subject matter of a film, the element that

is almost always the starting point of the process of making a film, must be conceived in terms of its ultimate form and texture.[14]

Together with Burch, Donald Richie has explored the narrative patterns in Japanese cinema and suggested a useful distinction between a 'presentational' and a 'representational' ethos:

> The representational intends to do just that, represent: It is realist and assumes that 'reality' itself is being shown. The presentational, on the other hand, presents. This it does through various stylisations, with no assumption that raw reality is being displayed. The West is familiar with some of these stylisations (impressionism/ expressionism), and the Japanese cinema will introduce us to more. Film 'realism' is itself, to be sure, just another stylisation but its position is in the West privileged. It is not traditionally privileged in the East.[15]

The distinction is also pertinent for Greek cinema. Theo Angelopoulos, one of the central figures in this exploration, pointed out that modern Greeks and their culture find themselves between such divides: 'We do not belong to the West,' he stated, '[and] we are not part of Eastern Europe – we live at the crossroads of modern civilization.'[16] Indeed the dichotomy between representanialism and presentationalism was one of the central structural and cultural parameters in the development of Greek cinema, and in fact of all dominant Greek visual regimes. When the legacy of the Byzantine visual tradition with its 'reverse perspective' was abandoned, traditional Greek visual practices entered the continuum of modern visuality, just at the time of its fragmentation by radical modernism. Greek cinema gained its distinct self-awareness only after it solved such questions of form during the 1950s, when this exploration begins. At the moment when Greek artists confronted mainly the question of perspective, or adopted the radical re-forming of seeing through montage, Greek cinematic production gained its specificity.

As Pavel Florensky had observed, 'realism in art has as its necessary prerequisite the realism of an entire world-understanding.'[17] During the Russian Revolution, Florensky was one of the first theorists of visual perception who pointed out this 'question' and ultimately the 'impossibility' of realism in all pictorial imaginary. Realism, according to him, presupposed:

> a kind of tendency that affirms some kind of *realia* or realities ... If one accepts that such realities do exist, then all human endeavour and consequently art can be a cognitive schema for the

understanding and the representation of the real. However, when formal schematisation takes place then cognition may be expressed by means of art; works of art unite us with realities that are inaccessible to our senses – such are the formal prerequisites for any artistic realism, and a tendency that rejects even one of them thereby forfeits its right to be called realism.[18]

This means that there are many relationships between the cinematic image and the world it stands for. This multiplicity of relationships determines the multiplicity of formal schemata and in many cases the changes in cinematic form we detect in the life of a filmmaker or over a period of time.

The answer to the question of cinematic form is crucial, because as David Bordwell and Kristin Thompson suggested, 'subject matter and abstract ideas all enter in the total system of the artwork … subject matter is shaped by the films' formal context and our perceptions of it'.[19] By dialectically connecting form and subject, we can clearly follow the emergence of specific yet diverse cinematic imaginaries in various historical situations. By analysing them we can see how specific films become meaningful cultural activities, through which ideological formations, aesthetic structures and political practices are legitimised, or delegitimised. It is true that they are not the only ones and that a completely different interpretation and articulation is possible. As in all cases, this historical contextualisation belongs to the contested field of situated readings and elicits a distinct discourse around dominant cultural assumptions.

Furthermore, drawing from Jean-Luc Godard's *Histoire(s) du Cinèma*, I assert that cinematic visuality prevailed at the moment that new techniques were introduced, allowing new ways of seeing. The use of montage was probably the most significant turning point in this process: it first appeared with Gregoris Gregoriou in the early 1950s but it achieved its artistic completeness with Michael Cacoyannis. Montage not only destabilised the narrative linearity of a story but de-structured the world that made it possible, by reassembling its constituent forms and reconfiguring its perceptual regimes. Christopher Phillips pointed out that 'montage served not only as an innovative artistic technique but functioned, too, as a kind of symbolic form, providing a shared visual idiom that more than any other expressed the tumultuous arrival of a fully urbanised, industrialised culture'.[20] Cacoyannis, in the last scenes of *Stella*, created the 'designative specificity' of cinema by juxtaposing images in collision and therefore representing the interacting multiplicities and contradictory ambiguities of modernity. As Godard observed, it was at that 'particular moment [that] the visual took over' and cinema as collective experience became

'popular ... because people saw and there was montage and the association of ideas. There was no need to say "I've seen that"; one understood through seeing.'[21]

At the moment this was achieved a distinct schematisation of cinematic images was crystallised and general styles with their individual variations began to develop. This is exactly what Mark Cousins meant when he talked about 'schema plus variation' and observed that all innovations happen when filmmakers 'vary the schema and create a whole new set of possibilities'.[22] At the moment when an innovative form reconfigured experience, a new visual language was established and therefore new individual idioms became possible. Until Theo Angelopoulos reinvented montage, essentially by discarding it, Greek cinematic poetics worked on the possibilities of montage as established by Cacoyannis in his second movie, which coincided with a series of political, social and cultural changes in the country – and indeed epitomised them.

## In search of historicity

> We believe that Greek films will stand next to the best foreign films if we understand and use appropriately the advantage offered by cinema itself, the advantage to start, using the acquired experience of others, *from where the others have arrived today.* [Emphasis added]
> Yannis Tombros[23]

The publication of my book on the history of Greek cinema,[24] although it covered a serious vacuum in the field, simultaneously created fresh demands for specialised approaches to the study of Greek cinema. It was deeply unfortunate that until recently there was no continuous and, following Roland Barthes, 'intelligible narrative'[25] about the historical development of Greek cinematic production. In Greek, there existed only a number of impressionistic and untheorised explorations of its development, articulated predominantly along chronological lines, following the Thessaloniki Film Festival[26] or around the elusive School of Athens.[27] However, some of the most significant films were never screened at the Thessaloniki Film Festival, and others were never released for public viewing. At the same time, the idea of an 'Athenian School' presupposed or implied other schools and styles, or other centres of cultural production competing for hegemony and funding – and that was never the case in the small market that is Greece.

The writing of a coherent and intelligible narrative necessitated a synthesis of historical information, socio-political contextualisation, formal analysis and cultural interpretation. In the end, I opted for the exploration of the 'minor dialogues' developed over time between specific films, individual filmmakers and collective

movements, when they occurred. Such dialogues led to certain significant conversations about cinematic representation and its relationship with reality, as well as about the nature of the cinematic experience itself and its links with society, politics and culture. Unfortunately the central characteristic of all such dialogues and conversations was that they were frequently interrupted, because of state intervention or because they ran out of intellectual and aesthetic relevance. Such disruption mirrored the general instability that marked Greek society and political life as well as the fluid funding models of film production. On other occasions, however, a distinct and admirable creative explosion led to a remarkable cinematic renaissance that produced significant individual films and novel perceptions of cinematic representation whose relevance and importance transcended the borders of Greek national cinema and the limitations of a specific understanding of filmmaking.

However, a number of serious methodological and theoretical issues need to be addressed in order to construct an appropriate exegetical model of the overall development of Greek cinema as a historical, cultural and artistic phenomenon. Lydia Papadimitriou observed that 'Greek cinema is undoubtedly the result of multiple formal and cultural influences; it has been used to express multiple ideologies and, at times, to serve particular interests.'[28] Such multiplicity and multidimensionality is one of the most bewildering characteristics of its history. Furthermore, beyond the specificities of its development, the scholar must examine cinematic production within the totality of cultural productivity in the country in order to situate it historically and account for its social impact. Maria Stassinopoulou, debating all exclusivist approaches to Greek cinema, aptly stated: 'A thorough knowledge of local and regional aspects and particularities is indispensable … for almost everything that might appear exceptional at first glance there are parallels to be found.'[29]

Furthermore, a more accurate contextualisation is needed. Dina Iordanova took the drastic step of incorporating Greek cinema within the overall evolution of Balkan filmmaking. Although the state, because of the Iron Curtain after 1945 and the ongoing frictions with Turkey, promoted the image of an un-Balkan Greece, the parallels between those states and Greece in social experience and political structures, as post-Ottoman and semi-secular societies, are really striking, and too obvious to be ignored. As Iordanova observed:

> The failure to acknowledge shared traits and the lack of interaction results in unproductive isolation from each other. It is a specific characteristic of the Balkan situation that each one of the countries in the region prefers to look at some West European country for cultural identification rather than to any of its Balkan neighbours.[30]

The poetics of the Balkan cinematic imaginary are based on patterns of representation primarily from Byzantine iconography, with its frontal linearity and two-dimensionality. They are also based on the blended folk traditions formed within the cultural continuum created during the Ottoman Empire; constant interactions with Italy and the Orient created quite unique hybrid cultural forms and social discourses in certain areas. Finally, with the rise of nationalism and the establishment of nation states, the arts of visual representation were deeply impacted by an accelerated Westernisation imposed by the continuous attempts of local bourgeois elites to introduce pictorial perspective, through painting, photography and ultimately cinema. The development of the new art was based on the existing dominant visual culture, which was focused on strong, basic and bright colours, avoided black and white contrasts and – most significantly – ignored perspective. These technical problems hindered the development of cinema both technically and aesthetically. In Italy, for example, cinema came as a result of 'a long tradition of visual narrative, beginning with the Medieval, Renaissance, and Baroque fresco style in churches, palaces, and public buildings and continuing through the Enlightenment with magic-lantern peep shows'.[31] That was not the case in the Balkans and the Near East, where the central form of public entertainment was the shadow-theatre, which added movement to the traditional two-dimensional perception of space but maintained a linear and continuous perception of time, as seen also in religious icons and folk paintings.

These parallel and sometimes concurrent conflicts can be seen in cinematic traditions in the Balkans – Turkey, Bulgaria, Romania, Albania and Serbia, amongst others. For example, Nikos Koundouros' *The Outlaws* (1959) and Vulo Radev's *The Peach Thief* (1964) have obvious parallel visual structures, as do Yilmaz Guney's *Hope* (1970) and Theo Angelopoulos' *Reconstruction* (1970), and the first film of the Iranian New Wave, Dariush Mehrujui's, *The Cow* (1969). The comparisons could be extended, and one conclusion can be drawn: that all visual cultures of the region confronted many homologous problems in the construction of their filmic poetics as they attempted to explore spatial depth, temporal asynchronicities and narrative fragmentation through the central art of modernity, the cinema.

Also, as the most prolific of the local traditions, Greek and Turkish cinemas show many striking parallels. During this transition, both traditions struggled with the ambiguities, contradictions and dark aspects of modernity as they confronted their inherited cultural memory, revisited its morphoplastic potential and reimagined its iconographic forms. Furthermore, compensating for its deeply rooted sense of historical belatedness and psychological inferiority, the region

was receptive to influences from diverse sources and open to multiple 'visual dialogues' with many established traditions. The influence of Soviet cinema, for example, must be pointed to, as refracted through the lens of Sergei Eisenstein, Vsevolod Pudvokin and Alexander Dvozhenko. That influence was reinvigorated by the popularity of Mikhail Kalatozov, mostly through his seminal work *The Cranes Are Flying* (1957), and after the 1970s by the almost religious admiration for Andrey Tarkovsky; in a telling way, Theo Angelopoulos and Nuri Bilge Ceylan must be considered Andrey Tarkovsky's as well as Antonioni's principal successors. Furthermore, though Hollywood was not obviously present in the cinema of the Communist countries of the Balkans, the cinemas of Greece and Turkey were complex melting pots, spaces of intense transcultural translation, as they transformed the dominant visual regimes of seeing through certain subversive innovations emanating from that centre of cinematic hegemony.

Indeed the directors of the Old Greek and of the Yeşilçam cinemas struggled to reconfigure visual ethnography in terms of modernist aesthetics and present their audience with new images relating to political identity, and social and cultural identification. This made them extremely dangerous to their respective power elites; their work demythologised all ethnographic invariables and deconstructed the dominant narratives about society and history. Melodrama as a genre debunked official fantasies about the homogeneity of the nation by offering viewers a gendered picture of reality, full of the unpredictable psychodynamics of sexual encounters and the conflicts between social classes that could not be reduced to any idealised perception of 'national psyche' (primarily understood in masculinist terms).

Using a historical context offered a frame for a universal drama to be enacted and recognised. Stanley Cavell explained the melodramatic mode of representation as 'the hyperbolic effort to recuperate or to call back a hyperbolic reliance on the familiarity or banality of the world'.[32] The emotional and aesthetic hyperbole itself was at the heart of the success of melodrama as a genre in both Greece and Turkey. Michael Cacoyannis, with whom I start this investigation of Greek cine-poetics, struggled to tame this hyperbole through a neoclassical use of form and an Aristotelian unfolding of storyline, and indeed his precarious success set the pace for the filmmakers to follow. His visual language created the elemental vocabulary that paved the way for all other cinematographers in Greece.

This book focuses more on codes of representation, as constructed by a number of Greek filmmakers and less on the organisation of the film industry, the legal framework of its operation or the relationship between audiences and

films. I insist on what might be called *the poetics of seeing* in Greek cinema, as embodied by specific works in different genres at particular historical moments. I also focus on the distinct configurations of realism formed after the end of the Greek Civil War (1949/50) in order to frame landscapes of cultural memory, patterns of social tension, strategies of ideological coercion and visualisations of individual experience. Such configurations have distinct formal aspects, as well as historical references, and must be approached in terms of both their semiotic structures and their cultural underpinnings. However, it is important not to consider such representations as reflections of what was happening 'out there' in a restrictive, mimetic understanding of realism. On the contrary, it is vital to stress both the consonance and the dissonance between codes of representation and their pragmatic or semiotic references. The minor dialogues between films essentially mean continuous conversations between images: we must never forget that images are possible because of other images and not because of the events they supposedly document. The exploration in this book is about the legitimacy of realism as the dominant mode of the cinematic in Greek culture, as well as the many forms that realism has taken over the last sixty years. As Susan Hayward stressed, 'multiplicity of realisms means that a film cannot be fixed to mean what it shows'.[33] Consequently the central exploration in this book is about the experiments with realist forms of a number of Greek directors whose work is taken to encapsulate wider yet historically specific social agendas, political projects and formal quests.

At a theoretical level, one has to rethink Lucien Goldmann's thesis that the freedom of the artist, the filmmaker in this case, and the collective character of the film itself derive:

> from the fact that the structures of the world of the work are homologous with the mental structures of certain social groups or [are] in intelligible relation with them, whereas on the level of content, that is to say, of the creation of the imaginary worlds governed by these structures, the writer has total freedom.[34]

By talking about realism I am pointing out the homologies between events and representations, although the one is not reducible to the other and without assuming any ontological link between them. As Lúcia Nagib aptly observed, talking about a number of filmmakers from global cinema:

> Theirs is an eminently physical, therefore expositional and exhibitionist cinema, which rejects *a priori* truths in order to make room

for risk, chance, the historical contingent and the unpredictable real, regardless of whether they are popular or art, fiction or documentary, narrative or avant-garde.[35]

Nagib explores the 'ethics of realism' as shared by various filmmakers from both art-house and minor cinemas in their effort to achieve 'a fidelity to the contingent character of the "event of truth", that is to say, to realism'.[36] Realistic representation in Greek cinema was the framing device through which the contradictions and ruptures, the continuities and antinomies, the dominant structures and hegemonic ideologies of the social polity were articulated, contested and visualised. The transformations of realism, as modes of visually structuring, or restructuring, an unstable social formation and a collective memory disrupted by historical trauma and existential loss, are probably the most enduring formal achievements in Greek filmmaking. Cacoyannis, for example, struggled to piece together his own mythopoeic representationalism, as later Yannis Dalianidis did and today Constantine Giannaris does. However, Nikos Koundouros and Theo Angelopoulos, Antoinetta Angelidi, Yorgos Lanthimos and Athina Tsangari work with the paradigm of presentationalism, as they test the limits and the possibilities of representation itself, and in doing so they explore further potentialities of visual poetics, and so produce different perceptions of reality.

Andre Bazin's spatio-temporal objectivist perception of realism did not exclude the subjective intervention, as he noted: 'By the power of photography, the natural image of a world that we neither know nor can know, nature at least does more than imitate art: she imitates the artist.'[37] Through the transmutations of realistic representation, we can clearly see changes in self-perception, self-understanding and self-representation, in both individual and collective experiences. For this reason, my methodology draws on what David Bordwell called 'middle-level research'. Instead of working from within the confines of a grand theory and using particular films of filmmakers to instantiate its doctrines, I focus on the study of specific work, enriching it with 'gay/lesbian, feminists, minority and postcolonialist perspectives' so that we can construct theories for the tradition through the study of 'particular phenomena'.[38] Such a research approach stresses the generalities within the cinematic medium while simultaneously pointing out the specificity of each film. This approach is close to Kristin Thompson's neoformalist analysis, which insists:

> that the film can never be taken as an abstract object outside the context of history. Every viewing occurs in a specific situation, and the spectator cannot engage with the film except by using viewing skills learned in encounters with other artworks and in everyday

experience. Neoformalism therefore grounds analysis of individual films in historical context based upon a concept of norms and deviations. Our most frequent and typical experiences form our perceptual norms, and idiosyncratic, defamiliarising experiences stand out in contrast.[39]

Consequently, I situate the filmmakers and some of their films within the context of their historical realities but at the same time I investigate the constitutive elements of their poetics. This is the only way to ensure that the individual or the specific film will not be subsumed under the general and that the general won't be reduced to special cases and disconnected symptoms.

I must also stress that, despite its specificity, as the product of a peripheral European society with a small market and limited technological potential, Greek cinema has been, since its very foundation, a transcultural field of production, open to external influences, constantly inviting the contribution of outsiders while whenever possible attracting foreign funding. On many occasions, a special movement or an unusual 'gaze' emerging in Greek cinema had its origins elsewhere, and its implied contexts and subtexts cannot be found in Greek society. (As argued in an earlier publication, Greek cinema was established by a Hungarian, Joseph Hepp, and consolidated its visual specificity through the cameras of an Italian, Giovanni Variano, and an Englishman, Walter Lassaly.)[40] The internationalism of Greek cinema was both a cultural necessity and a political choice. As the Greek state was for decades ruthlessly hostile to the industry, or imposed its ideological obsessions through strict censorship, connections with other international productions were the only channels for technological innovation, for the liberation of the cultural imaginary from provincialism and for the synchronisation of a peripheral society with the postwar aesthetic and philosophical concerns of the emerging global cinema.

Local filmmakers were influenced by Italian neorealism, the French New Wave, American action films, film noir, Brazilian Cinema Novo and (retrospectively) by Soviet cinematographers and German expressionists. They engaged in a systematic visual appropriation of all these aesthetic forms within their own optical schemata: such a continuous project of cinematic acculturation was inaugurated, in a conscious and systematic way, by Michael Cacoyannis in his early films, and led to the consolidation of a distinct visual style, representing not a singular identity but a multiplicity of pictorial identifications of class and gender. Because of Cacoyannis' achievement, the official ideology of the Greek state and the master narrative of its national mythology never found a legitimate cinematic

expression, except during the Dictatorship between 1967 and 1974. As a consequence, even conservative directors contributed to the establishment of what we call 'oppositional aesthetics', as most filmmakers, intentionally or subconsciously, depicted the incongruities and discrepancies within the structures of Greek society and produced images about implied social conflicts and looming political crises.

Cinematographers and the audience had to fight the coercive mechanisms of the state in order to watch a film that would show their everyday experience, with its contradictions and irregularities. Even films by Yannis Dalianidis, the presumed epitome of bourgeois decency and middle-class respectability, were rated as inappropriate for adolescents because of their 'immoral content'. Consequently, filmmakers and the industry had to develop codified forms of representation in which an implicit critique of and resistance to the official ideology was formulated and visualised. In their own distinct way, Nikos Koundouros and Theo Angelopoulos were the masters of such oppositional language, which undermined dominant perceptions about history, memory and politics. From another point of view even commercial directors such as Yannis Dalianidis, but also the grand trio of mainstream cinema, Gregoris Gregoriou, Dinos Dimopoulos and Vassilis Georgiadis, adopted an analogous anti-language by infusing the dominant formulas of melodrama with unsettling subtexts and disturbing micro-narratives about gender, class and history. Because of such codified narratives, themselves due to the ubiquitous presence of censorship, even an unfairly understudied filmmaker such as Costas Andritsos could not make obvious his Marxist aesthetics: his film *Dirty City/Vromiki Polis* (1965) – and his other mature work – still remains one of the most provocative and troubling representations of the industrialisation and urbanisation processes during the 'Greek economic miracle' of the early 1960s and of the victims at the margins of such 'progress'.

## Debating the canon

> I never denied melodrama. I believe in 'communicative' cinema which negotiates and affects the wide audience with good taste. That's my basic principle. I never intended to insult the aesthetics of the viewer.
>
> Gregoris Gregoriou[41]

Greek films were spaces where contradictory and frequently incongruous 'discursive formations' functioned as cultural markers of abrupt social change or

imminent social conflict. The screen framed an uncanny, disturbing and subversive view of what could not be represented but everyone could discern. As Michel Foucault indicated about parallel cultural discourses, the screen became the most obvious public space in which cultural dispersion and de-identification were taking place, as in it 'one cannot discern a regularity: an order in their successive appearance, correlations in their simultaneity, assignable positions in a common space, a reciprocal functioning, linked and hierarchised transformations'.[42] For example, a film such as Alekos Sakellarios' *The Germans Strike Back/Oi Germanoi Xanarhontai* (1948) said nothing about the raging Civil War, yet it was *precisely* about the Civil War. The film noir made in the early 1960s also addressed the lingering traumas of the German Occupation, especially concerning the collaborators who were never punished but who were, instead, raised to power, without ever presenting the issue. Also, films made during the Dictatorship of 1967–74 about the democracy of ancient Athens never mentioned anything about the absence of democracy in contemporary Athens, although they were all about this.

For all these reasons, films were intentional palimpsests made of various – and on many occasions conflicting – layers of cultural, social and political scripts. Furthermore, despite the dominance of left-wing ideology amongst the central filmmakers, very strong tension, oppression and ideological suffocation dominated this most prolific period in film production, between 1950 and 1970. As in other European countries, the Left in its official institutional expression (the Greek Communist Party) was staunchly negative about many of the works studied here. Their official 'anti-formalist campaign', introduced by Andrei Zhdanov – about 'positive work heroes', 'socialist realism' and 'ideological purity' – could not be accommodated within the ambiguities, the ironies and the contradictions of rapid modernisation. Even directors such as Nikos Koundouros and Theo Angelopoulos, who declared themselves members of the Left, repeatedly felt the brunt of negative left-wing criticism, to their great annoyance and frustration. In the debates of the period, one can detect the disillusion of most of them with the official Left ideologues' inability to understand their work, follow their experiments with form and content, accept sexuality and gender as parts of human identity and discard schematic perceptions of class struggle.

For these reasons, the history of Greek cine-poetics has remained a rather obscure area in European filmmaking. The obscurity was imposed by both internal and external factors. For example, there was always a question about the canon of Greek national cinema within the country. Critics never agreed about the best Greek films. In 2006, the Pan-Hellenic Association of Film Critics released its

verdict on the ten best films in the country, after a secret ballot of its members. The ten films (11 in reality) were:

1. *The Ogre of Athens/O Drakos* (1955) by Nikos Koundouros
2. *Eudokia* (1970) by Alexis Damianos
3. *The Travelling Players/O Thiasos* (1975) by Theo Angelopoulos
4. *Stella* (1955) by Michael Cacoyannis
5. *The Counterfeit Pound/I Kalpiki Lira* (1955) by Yorgos Tzavellas
6. *Reconstruction/Anaparastasi* (1970) by Theo Angelopoulos
7. *Rembetiko* (1984) by Costas Ferris
8. *The Photograph/I Fotografia* (1986) by Nikos Papatakis
9. *Karkalou* (1984) by Stavros Tornes
10. *Sweet Bunch/Glikia Simmoria* (1983) by Nikos Nikolaides and
11. *The Four Seasons of the Law/I Earine Sinaxis ton Agrafilakon* (1999) by Dimos Avdeliodis.[43]

Given the substantial number of films produced in the country (about 5,000 in total), the list was always going to be unfair. Most professional critics privileged art-house films at the expense of 'commercial cinema'. Every commercially successful film was, according to the dominant perception, by definition bad. (In American terms, the difference would have been more obvious if Andrew Sarris and Pauline Kael had compiled their own separate top ten film lists.) There are no comedies on the list, no films made before 1950 and no films made by women directors. For example, Dimitris Gaziadis' *Astero* (1929) and Orestis Laskos' *Daphnis and Chloe* (1931) should have been included because they paved the way for all art-house films – indeed for all Greek films; their impact transcends their shortcomings, which were due to the technology of the period. Also, Alekos Sakellarios' *The Germans Strike Back* (1948) deserves a place on the list because of its impact: it shaped audience expectations and cultural agendas. Gregoris Gregoriou's *Bitter Bread* (1951), the first genuine experiment with realistic representation, paved the way for genre films and also should have been included, as should Gregg C. Tallas' *The Barefoot Battalion* (1953), one of the most innovative films about the visual reconstruction of collective memory.

A commercial blockbuster like Dalianidis' *Stephanie/Stephania* (1966) also deserves at least an honourable mention for its effectiveness in defining public taste and determining dominant imagery about feminine sexuality. Costas Manousakis' *Fear/Fovos* (1966) is the single most forgotten masterpiece in the history of Greek cinema, a film that deserves to be revisited and reassessed. Dinos

Katsuridis' *What Did You Do in the War, Thanassis/Ti Ekanes ston Polemo Thanassi* (1971) also deserves a place, not simply for 'its arresting simplicity',[44] but also because it is one of the very few films about psychological realism, and one of the even fewer films that succeed in constructing a recognisable comic character. Tonia Marketaki's *The Price of Love/I Timi tis Agapis* (1984) represents the consummation of quality cinema in the tradition of Jean Renoir and Max Ophüls. The fact that it appeared many decades after their works adds to its significance: it resurrected and re-established a lost tradition of translating literary stories to cinematic images. Finally, it would be unimaginable to compile a list of the best Greek films without Cacoyannis' *Electra* (1962) – probably the most accomplished film of formalist aesthetics ever made in the country, Cacoyannis' response to Sergei Eisenstein's aesthetics and Ingmar Bergman's existentialism.

Despite its glaring gaps, the list was and still is indicative of the kinds of films that were valued by critics following mostly *la politique des auteurs* – a mode of film criticism inaugurated in the pages of *Cahiers du Cinéma*. But the list does not reflect what the public liked: if it were to be compiled on the basis of ticket admissions, none of these films would have made it onto the list. This indicates the fluidity of perceptions about what makes a film 'good', or indeed 'culturally significant', and what criteria we use to assess film production. It also expresses a view about which films could be considered 'representative' of the collective experience or public taste. Because of such fluidity and ambivalence, no major monographs have been written so far on Greek cinema: it was quite unclear which was the official canon and which the unofficial counter-canon of its dissidents.

Moreover, despite the fact that many works have been published about the development of cinema in other European countries, Greek cinema has remained something of an oddity, domestically and internationally. For example, in the recent history of cinema written by Mark Cousins there is only one brief mention of Theo Angelopoulos' political modernism and his 'grand tracking shots in the spirit of Mizoguchi, their complexity capturing the country's complicated history'.[45] David Parkinson has also suggested that Angelopoulos 'was inspired by the imposition of military rule to amalgamate history and myth in the Jancsò-like meditations *The Travelling Players* (1975) and *Alexander the Great* (1980)'.[46] Like many things Greek, individual films or filmmakers were known predominantly as commentators on 'the country's complicated history' but there was no general narrative to link them, to indicate the social contexts that made their production possible, to examine the cultural debates underpinning their cinematic philosophy or to delineate the common structural patterns in their visual poetics. Most external appreciations of Greek cinema emphasised the picturesque and the exotic

but not the pictorial formation or the kinetic visuality. Michael Cacoyannis' *Zorba the Greek* (1964), as well as Theo Angelopoulos' *The Travelling Players* (1975) were hanging in the air, decontextualised and deterritorialised: they were somehow unexpected and therefore inconsequential monoliths that appeared and disappeared into the amorphous mass of mediocre or simply indifferent films produced by the dozens in an exotic and somehow hyperactive Balkan country during the last sixty years.

At the same time, not many films succeeded in transcending the cultural or linguistic barriers imposed by the hegemonic centres of cultural production upon all peripheral European countries. The Greek state preferred to subsidise the importing of films from Hollywood than to support the local industry, which was dominated by dangerous Communists, or sexual perverts, according to its official ideologues and the censorship committees. Furthermore, as a bookish culture founded on the veneration of ancient texts and monuments, the official cultural system exhibited a spectacular ocularophobia; despite the fact that its ancient culture was predominantly visual and its Byzantine heritage privileged the visual circumscription of the body, having both determined what Martin Jay called western European ocularocentrism, modern Greek official culture showed reluctance and hostility towards embracing the central representational medium of modernity, which Vachel Lindsay characterised as 'the photoplay of action'.[47]

Officially, images were privileged only as religious icons or museum exhibits, foregrounding stillness and atemporality against their perception as actualised motion and as photographs in rapid kinetic succession. This prevented the development of new scopic regimes, new perspectival theories and novel visions of reality which could undermine the political conformism of the official view; as Martin Jay stated, the new ontology of moving images invites us 'to see the virtues of differentiated ocular experiences'.[48] Such differentiation in seeing, and the regimes of seeing became possible only through the creative dialogue between filmmakers who struggled to liberate the image from the photographic immobility of antiquated historicism.

As the ontology of the moving image implies questions about its semiotic references and their relation to the realities around it, the Greek state was very negative towards this central art of modernity. As André Bazin so succinctly observed, 'the cinema is objectivity in time' and 'the image of things is the image of their duration'.[49] Against an official perception of time as a suspension of history, the cinema presented fluid realities through the frame of an individual story or the perspective of an individual. It confronted the immobility of the past with the simultaneity of contradictory emotions caused by moving images and their context. Because

of this, it created a sense of unsettling insecurity that exacerbated the intensity of the actual traumas of history (the Asia Minor Catastrophe, the Metaxas dictatorship, the German Occupation and the Civil War, together with poverty, emigration, imprisonment and displacement). While the official state narrative was that the nation, the eternal pure ethnos, had conquered time and history, cinema presented images of traumatised individuals, forgotten by history, broken in their self-perception and lost in the cracks between social classes.

As the country suffered for long periods from political volatility and social unrest, what was allowed to be seen and to become objectified in the social sphere as public spectacle was severely regulated, controlled – and, of course, censored. Most filmmakers had to confront primarily not the restrictions of an undeveloped industry and technology, but the hostile or patronising surveillance of the state apparatuses, which were suspicious of even the most conventional cinematic representation as a potentially subversive act against their authority. Certainly there were good reasons for this. At the moment the camera recorded human bodies in motion in their everyday life, unexpected associations emerged: the picturesque Greek islands were places of exile and death, the pristine beauty of rural countryside was the *topos* of executions and conflict, the villages, which were where the presumed 'authentic' Greekness had existed since time immemorial, were scenes of primal crimes against women in particular, dissidents, forgotten minorities and other social or ethnic groups. The associative function of images framed the picturesque landscapes of the country as terrifying trauma-scapes, as spaces of negative sublimation and deep psychical disturbance.

In short, through the simple act of representing space, cinema revealed the suppressed memories of reality, the silenced histories of human presence and the permeating anxieties of a political structure in search of legitimacy. Every frame of the camera confronted its audience with what could not be represented: they all felt its presence but its representation was suspended and de-visualised. The visual occlusion imposed upon the real by the Greek state was challenged by the simple showing of cunning acts of un-concealment: empty buildings, roofless houses, roads with huge holes dominate Cacoyannis' and Koundouros' films of the 1950s. For the viewers, these were reminders of the recent Civil War, which had sent a considerable part of the population to exile, or to the firing squad, and of the bombs that destroyed the cities. The living memory of the recent war was presented unmediated but in an unconscious manner, as if the traumas of the past had nothing to do with the actual experience of contemporary history. Even in the most naive comedies, such as Cacoyannis' *Windfall in Athens/Kiriakatiko Xipnima*

(1954), viewers were exposed to the spectacle of a city trying to laugh over its own ruins; they did laugh, but without ever daring to look around them.

Later, during the 1960s, in one of Yannis Dalianidis' jejune musicals, *Something Sizzling/Kati na Kaiei* (1964), a young musician leaves Thessalonika to find work in Athens, which indirectly indicated the huge wave of internal migration to the capital without any preparation and indeed, psychologically, without ever leaving the village – such internal migration became one of the most persistent narrative features for a whole generation of filmmakers. The camera was never allowed to show the sadness and desolation of the abandoned villages and empty country towns. At the moment, in 1969/70, when Angelopoulos set his camera in front of an 'authentic' village, outside the glamorising colours of the studio system, what was revealed was not simply astonishing but politically dangerous: empty spaces, deserted houses, abandoned lands, total monochromatic silence, loss and absence. The mirage of urban modernity was in its essence a cruel and dehumanising experience of exile, displacement and uprootedness.

At the same time, many charming comedies of the same period recorded the transition to new modes of habitation, social interaction and interpersonal relations in a comic way that was not always funny; in many ways it recorded a very painful grimace, misconstrued as an attempt to smile. Dinos Dimopoulos' sweet tragic-comedy *Madalena* (1960), with the superstar of the studio system, Aliki Vouyiouklaki, was the most accomplished visual monument to the transition from an old way of life to the mechanised organisation of society and the economy. In addition, the clash between urban and rural mentalities, expressed through the comic conflict of local dialects, indicated the violent homogenisation of all domestic cultural diversity: in Athens, villagers had to conform and learn to speak and behave as decent petit bourgeois if they wanted to succeed. These films showed, more than anything else, the infancy of the petit-bourgeois class (*mikroastoi*) that was going to become the dominant power elite of the country, especially after the 1970s.

## The epistemological potential of trauma

> Cinema has nothing to do with images; it only has to do with reality.
> Christos Vakalopoulos[50]

In a masked way, the cinematic screen showed the forbidden experiences of the past and implicitly re-enacted the 'forgotten' traumas of viewers without verbally articulating them. Despite the optimism of Cacoyannis' cinema (as a newcomer

from Cyprus, via England, Cacoyannis was the all-seeing innocent outsider), recent history – as epitomised by specific urban spaces – was a series of disasters the memory of which destabilised the structures and the institutions of the post-war state and the shaky foundations of its politics.

There are two conditions that were felt in synchronic and diachronic terms simultaneously: the experience of defeat and the experience of trauma. Reinhart Koselleck pointed out the anthropological significance of being defeated. 'The condition of being vanquished,' he writes, 'apparently contains an inexhaustible epistemological potential. Historical change feeds upon the vanquished.'[51] Following the experience of being vanquished, another experience emerged, as the defeat itself could not be expressed in the public sphere: the sense of loss was projected onto a paternal figure or a radical belief. On the other hand, all space on the screen monumentalised the feeling of trauma created by these disasters and by the inability to mourn them. Greek audiences after the war had to deal with vivid memories of the German Occupation, the famine of 1942/3, the two Civil Wars and, finally, years of poverty, forced immigration and political persecution. It was not allowed to address these accumulated traumas in public. They had been experienced by the same traumatised refugees of the Asia Minor Catastrophe back in 1922 – and their children, who also experienced the turbulent political unrest of the 1930s. We use the word 'trauma' here as Maria Tumarkin defined it: 'to describe not a medical condition or a pathological state but an individual and collective response to loss and suffering – an ongoing response that affects people to their very core.'[52]

The problem was that the trauma could not be addressed publicly as a collective and social event, through ritual acts that would sublimate the anxiety of identity confusion and the fear of imminent threat. The inability of the power elites of the country to deal with such repeated traumas and create rites of collective purification simply exacerbated the sense of loss and incomprehensibility, which became the permeating mental atmosphere of postwar cultural imaginary until the 1990s. Such confusing interplay between presence and absence, lack and abundance, resulted in an inability of the social body to deal with the accumulated traumas and losses of history. As Jeffrey C. Alexander defined the field of trauma theory:

> Cultural trauma occurs when members of a collectivity feel they have been subjected to a horrendous event that leaves indelible marks upon their group consciousness, marking their memories forever and changing their future identity in fundamental and irrevocable ways.[53]

The complication in this case was not that the trauma was too horrendous, but that the official state apparatuses never allowed any space, or created any sites of memory, where the trauma could be relived and healed. Thomas Elsaesser, who explored how trauma had informed postwar German cinema, indicated that memory and trauma are:

> the chief markers of identity, individually as well as collectively. Once upon a time, nations and communities tried to unite around a common project, directed towards the future (changing the world, fighting for a better life) that ensured a sense of personal identity and collective belonging. Now it is shared memories, or the retrospective construction of a group (manifest in the use of 'generation' as a period marker) that defines self-worth and creates the (fraying) ties that bind.[54]

The Greek state and its power elites imposed this: 'the trauma of history was present but never represented'[55] Indeed, one could claim that traumas are extremely important for the process of change and transformation in culture and society, but they have to be mourned through, objectified and verbalised as public discourse. If this doesn't happen, the trauma is internalised and forms the very identity of the individual and the group. In that respect Vamik D. Volkan and Norman Itzkowitz are right in their exploration of Greece's 'chosen traumas'; however, the trauma did not go back, as they claim, to the battle of Mantzikert in 1073 or the fall of Constantinople in 1453, although the last one seems to have established the template for collective mourning in the cultural imaginary. In reality, the 'chosen traumas' refer more to a series of recent events – the Asia Minor Catastrophe, the German Occupation, the famine of 1942/3, the grand disillusionment during the December events of 1944 and the Civil War – which all remained unmourned and unverbalised. This has nothing to do with the fear of the other and everything to do with the violent collusion of the Greek state in the suppression of memory and the disappearance of all objectified representations from the public sphere until 1978, when Koundouros released the controversial film *1922* (1978), his elegy on the Catastrophe.

Volkan and Itzkowitz state that:

> Large-group mourning of past losses is usually not experienced as a shared sadness and grief. In fact, the average citizen is often not aware that a large-group mourning is in process. It takes its course in societal actions, where its derivatives appear in the review of past affiliations such as emotional attachment to religious institutions of the Ottoman Empire and contemplation of how to integrate them in the modern identity.[56]

If we replace the 'Ottoman Empire' with 'the Greek state', we immediately real-
ise the truth of Volkan and Itzkowitz's observation about the analogous psycho-
dynamic background of Greeks and Turks:

> Neither Turks nor Greeks have successfully mourned all their
> past losses or resolved all their past traumas, nor have they modi-
> fied their negative images of the other group. The Greeks have
> made *Tourkokratia*, their shared conditions of Greek life under the
> Ottomans, a marker of present-day identity. This augments both a
> sense of victimisation and a sense of entitlement.[57]

The truth, however, is that although *Tourkokratia* has remained an official state
ideology, the most widely felt emotion, in popular culture, is that the events of
1922, the expulsion from their ancestral homes, the mistreatment of the refu-
gees by the Greek state and their inability to mourn that immense loss, created
the most dominant emotional substrate of all our cultural imaginary, especially
during the formative years of Greek cinema. In a way, the very few references
to these events, such as Adonis Kyrou's *The Round-Up/To Mploko* (1964), about
the German Occupation and the Greek collaboration, Gregoris Gregoriou's
*Expulsion/Diogmos* (1965), about the lost generation of 1922, or even Yannis
Dalianidis' *Story of a Life/Istoria mias Zois* (1965), about the Communist
rebels in exile, transformed the screen into what Pierre Nora has called *lieux
de mémoire*, a realm of memory: only the experience of watching such movies
could mobilise the audience to work through grief and mourning. The cin-
ematic *lieu de mémoire* was a substitute for the sites of remembrance, shared
grief and commemoration rites; the collective character of the cinematic expe-
rience summoned the viewer to relive history and therefore create 'an uncon-
scious organisation of collective memory that was up to them [the viewers] to
bring to consciousness'.[58]

These films objectified the profound conflict between memory and history –
history being the ideological mechanism for control and subjugation, and memory
the psychological need for the cathartic transcendence of past traumas. Sigmund
Freud pointed out that 'normal mourning overcomes the loss of the object and it,
too, while it lasts, absorbs the energies of the ego'. But 'after it runs its course' it cre-
ates the 'economic condition for a phase of triumph'.[59] The moment of triumph, the
overcoming of mourning, occurred only during the cinematic experience: only
at the cinema could the nation feel that the war was over and they could now put
their home in order; this was indeed a very dangerous idea for the power elite
controlling the state and its institutions.

The epistemological potential of the defeat and the ongoing unresolved traumas offer unique points of entry to the poetics of Greek cinema. The style of representation was modified according to the changing realities the filmmakers themselves experienced within their society and, of course, through their own internalisation processes. Unfortunately, we do not have a history of Greek society from an anthropological point of view. Writing the history of any cultural production means, primarily, detecting the forces that make such production possible, since the writing of history is not simply an arbitrary collection of 'facts' but an attempt to establish connections between events, we must revisit Roland Barthes' idea that the historian is not the one 'who collects facts as signifiers and relates them'.[60]

However, Greek filmmaking was more than a recording of post-traumatic eventualities. Its enormous potential was liberated after the Civil War. It is true that the very few Greek films that became internationally known were noticed only because they emphasised what was already publicised about the country itself. Other concerns – for example, the intensely debated problems of national identity, of so-called Greekness, of belonging and of political orientation – were infrequently noticed by international critics. It is true that this notorious 'identity question' became dominant only in the late 1970s and during the wasted decade of the 1980s, when certain directors, especially Lakis Papastathis and Yannis Smaragdis, went through a prolonged and well-funded 'identity crisis' – a product of self-indulgence rather than self-questioning. The socialist government in the 1980s did its best to manipulate the issue of belonging, privileging a parochial fusion of populism and nationalism that later became known as ethnopopulism, the dominant political and cultural discourse until today. On most occasions, such an approach gave the impression, even to Greek filmmakers themselves, that the cultural imaginary was perpetually frozen around questions of belonging, identity and nationality. No questions about gender, class, sexuality, politics or poetics were raised in discussions of the significance of the films: as already seen in Cousins' and Parkinson's accounts, even films as complex as Theo Angelopoulos' *The Travelling Players* (1975) were discussed more in terms of their political references and less in terms of their presentation of historical experience or indeed in terms for example of the disgust shown towards sexuality.

These are the main topics of the present book on Greek cinema: realism, trauma and predominantly visual poetics. My previous book attempted to construct a 'narrative of the long duration' about the specificities and regularities of cinematic production in Greece by interweaving the minor dialogues that developed between films or between filmmakers into an 'intelligible'[61] narrative, as parts of the wider cultural conversations articulated in the country throughout

the twentieth century. Here we take a closer look at the history of cinema as an exploration of mental representations in specific formal arrangements and individual psychological projections: the purpose of exploring the history of a visual medium is to investigate the codes and the form of such representations as well as the psychological experiences imparted in them and through them. It is essentially an attempt to analyse the individual ability to think visually and, more specifically, cinematically. As Rudolf Arnheim stated, 'Visual thinking calls for the ability to see visual shapes as images of the patterns of forces that underlie our existence – the functioning of minds, of bodies, or machines, the structure of societies or ideas.'[62] Therein lies the anthropological meaning of cinematic visuality.

Here also one can also locate the central element in Greek cinema that accounts for the absence of films with a genuine religious worldview (in the manner of Robert Bresson, Roberto Rossellini or Andrey Tarkovsky); its anthropocentric and pragmatocentric character is seen in the continuous process of self-invention and individuation within societal structures that struggled to abort such possibilities. Greek cinema explored the horizontal dimension of being; it constructed its iconography, recorded its luminosity and illustrated its morphological complexity. It did not depict the metaphysical questions of existence, or the conditions of the 'absurd' that dominated Europe after the war and the Holocaust. As I argued elsewhere, there is no religious cinema in Greece.[63] It focused on the material, the small, the quotidian. Its focus on these elements may justify Siegfried Kracauer's suggestion that realism in films is the way to allow spectators the 'experience of things in their concreteness'.[64] Yet within such mundane elements, it privileged a pluralistic vision of reality, in which the poor and the rich, the powerful and the powerless, the creative and the sterile coexisted, and indeed existed because of each other, in a dialectical co-dependence.

At its best, Greek filmmaking tried to empower the individual and the small groups around it to confront the mythologies of the tribe and individuate their meaning. If there was something fixed in front of the camera it was the confusing, disorienting and unpredictable conflict between state and society. The disconnection between individuals and the structures around them was the most persistent invariable. Most significantly, the language of images was where the reconciliation between memory and contemporary reality, past traumas and future projects could take place, although on most occasions the tension within these social discourses remained unmasterable. Greek cinema did not produce grand myths of collective absolution or individual catharsis: it depicted the asymmetric relationship between social and personal conscience without ever trying to resolve it. Despite its 'specular' character, it exposed the fantasies

of the official state; its screen created an open event, where meaning emerged unexpectedly, from within a culture of trauma and a society of self-imposed oblivion.

## History and the formation of visuality

> The image – its plastic composition and the way it is set in time, because it is founded on a much higher degree of realism – has at its disposal more means of manipulating reality and of modifying it from within.
>
> <div align="right">André Bazin[65]</div>

Greek cinema of the 1950s and 1960s stands out as a unique achievement within the strictures and the confines of an unstable political system, and as a vocal testimony to the power of the cinematic experience itself. Many Greek filmmakers understood the screen as the *topos* on which an alternative version of reality could be depicted, and as the space where the liberating potential of cinematic images could materialise. Others constructed a reversed order of images, hiding a disturbing picture of social reality behind conventions and common truths. In the mid-1960s, conformism became the official ideology of the studio system. This eventually led to its demise and its replacement by television sitcoms. Other directors, in reaction to mechanisms of studio and state control, erected – through independent productions – mythical superstructures as the ultimate articulations of social and individual experience in a time of depersonalisation and alienation.

The thread that permeates the work of the directors I will discuss here is their elaboration of a fluid and highly transmutable realism beyond the innocent verisimilitude and photographic reproduction of the visible that dominated cinematic representation before 1950. The changing nature of realistic representation over such a short period of time makes these directors unique case studies. As Peter Wollen observed:

> Reality is, so to speak, filtered and abstracted in the mind, conceptualised, and then this conceptualisation of reality is mapped on to signals which reflect the original reality itself in a way which words, for instance, can never hope to match. Thus the cinema is seen to give world-views in the literal sense of the term, world-conceptions which are literally world-pictures.[66]

The 'world-pictures' constructed by each of the directors will be the central topic of exploration here. Their realism took on different codifications over the postwar decades in their attempts to show the instability and the disequilibrium dominating the social experience while simultaneously mapping out the psychodynamic energies permeating it. As noted, the traumas of history and the inability to mourn made the cinematic experience itself a cathartic ritual of self-purification and communitarian solidarity. Greek cinema was based on the dual heritage of Michael Cacoyannis' neoclassical realism and Nikos Koundouros' symbolic realism. They were the first to realise that the cinematic image was not a mere reproduction of visible realities but also an unsettling restructuring of the dominant social order through alternative 'world-pictures'. They were the first to produce fields of visuality: that is, to elucidate the cultural codes operating within each work of art and forming its visual language. Both of them built on existing visual practices but reimagined their signifying potential, creating a difference, 'a difference within the visual ... a difference, many differences, among how we see, how we are able, allowed, or made to see, and how we see this seeing or the unseen therein'.[67] Their antinomic realism has its own genealogy both within and outside the country.

Since the 1930s, many directors had struggled to construct a distinct form of realism. The most significant of all, Yorgos Tzavellas (1916–76), was a unique cinematographer with a deep knowledge of *mise-en-scène* and the versatility to move easily between comedy and drama. His work can stand comfortably next to that of Jean Renoir, William Wyler and Michael Curtiz. He constructed a kind of stylised representationalism of transparent neoclassical lucidity and sharpness, with the camera framing individual or family portraits and replicating nineteenth-century bourgeois paintings: he was the Edgar Degas and the Guy de Maupassant of Greek cinema. Being predominantly theatrical and literary in his approach to *mise-en-scène* and acting, Tzavellas was afraid of fast movement, deep contrast and strong expressiveness. He let his camera expose everything that could be seen and could be said through the singular perspective of the director. His gaze domesticated everything: having being born in an era of communitarian organicity, and having being formed under the shared ideal of liberation from the Germans, Tzavellas' films present a world of fallen angels, true believers and committed idealists. Modern capitalism, possessive individualism and conspicuous wealth deviated humans from the true purpose of life, which is love. Tzavellas' nineteenth-century moral and liberal humanism wanted to restore through cinema the lost authenticity in personal relations, revive the traditional values of empathy and compassion and establish a new sociability for humans, based on their ability to empathise with each other.

Figure 1.1: Yorgos Tzanellas, *Agnes of the Harbour* (1952). The allure of classical prosopography.

Because his ethical vision of cinema was as the new medium for the liberating and sublimating function of art, he avoided any ambiguity of meaning and representation: indeed he couldn't really understand modernity. His gaze – and it was a gaze like Degas', structured around 'momentary glimpses' – revealed the truth of thinking and feeling as a specific and unique subjective expression objectified through the singularity of its visual form. Films like *Marinos Kontaras* (1948), *Agnes of the Harbour/I Agni tou Limaniou* (1952) and *The Counterfeit Pound/I Kalpiki Lira* (1955) succeeded in piecing together an effective grammar for a new visual language that addressed contemporary concerns in form, script and spectatorship; they were nevertheless wanting in their script, continuity and (to a degree) in effective *mise-en-scène*. Their stories were based on episodes loosely linked through diegetic interventions or an invisible omniscient narrator. In a series of articles on cinema published in 1946, Tzavellas was the first to declare that: 'Cinema is neither poetic, nor fictional or theatrical. It's a uniquely new form of expression.'[68]

Especially in his movies after 1955, Tzavellas incorporated the narrator's voice as a distinct character (as, for example, in his best work, *The Counterfeit Pound*). However, until his final film in 1965, the comedy *The Woman Should be Afraid of the Man/I Gini na Foveite ton Andra*, he struggled to deal with the destabilised gender images and the fluidity of social norms (which is precisely what the story in the film is about). He avoided heavy editing and montage, and insisted on the affective force of the story and its visual completeness, as a nineteenth-century family portrait, although his gentle use of dissolves indicates a distinct dialogue with D. W. Griffith and Jean Renoir. Most of his films explored the potential of immobility, by having the actors standing still in front of the camera. (See Figure 1.1.) Dialogue and acting gave a loose frame to a story that could never find ultimate resolution without the *deus ex machina*, the voice of the omniscient narrator. His works are visual commentaries on nineteenth-century narrative and pictorial practices, yet his iconography marked the transition from photographic realism to the realism of the subject matter. In a strange way, he employed modernity's medium in order to show the dehumanising and exploitative character of modernity itself.

Gregoris Gregoriou's *Bitter Bread/Pikro Psomi* (1951) was also a film that asked many questions about the possibility of representing contemporary experience: its depiction of depthless urban space under noisy reconstruction after the war, the ambiguity in its characterisation, its ambivalent representation of societal identities as alarmingly indeterminate, constructed an open-ended frame for the new conditions for self-determination. The film was structured around fast editing and radical montage: it was the most successful appropriation of the Soviet montage tradition in the country to that point, with a moderate infusion of Italian neorealism. Gregoriou was primarily interested in constructing a visual language to articulate the complex and unpredictable situations in which ordinary people found themselves after the war's destruction of traditional patterns of self-definition. The struggle against the Germans became the symbol of a moral and political reconciliation, but after the Civil War, the wave of immigration and the rise of unfettered capitalism, everything that reminded of prewar realities and identifications, like the survivor from the Nazi concentration camps, became silent and meaningless. Gregoriou stressed that his films were closer to Jean Renoir and Marcel Carné than to Italian neorealism.[69] It was probably the idealism of this film, its idealisation of the common people, that was fatal to its success: its affective realism, expressed through fast montage, an operatic music score and fatalistic resignation, defined the end of such a form of representation. He never tried to repeat the style of this film.

Figure 1.2: Gregg Tallas, *The Barefoot Battalion* (1954). The gaze of innocence.

The same applies to another important film of the period: Greg Tallas' magisterial *The Barefoot Battalion/To Xipolito Tagma* (1953), with its oneiric nostalgia for a lost world of purity and innocence, articulated an unexpected variety of realism, as a fusion between symbolism and romanticism. The blurry and slightly unfocused camera, the flashbacks and the heavy editing are linked by the explosive and operatic music by Mikis Theodorakis, which transforms all urban space into a spatial symbol of a suspended temporality – the wonderful world of children's subconscious. The camera work by the prewar veteran Mihalis Gaziadis linked the urge to document the hostile open spaces of the devastated city with the mind's nostalgic illusionism; it was an early form of magic realism, as even the dark world of the German Occupation was transformed into an enchanting landscape of adventure and awe. (See Figure 1.2.) Both Gregoriou and Tallas stopped short of moving towards naturalism, although Tallas, an expatriate from the United States, tried to do so in his sexually explicit film *Ayoupa/Bed of Grass* (1957) paying homage to Howard Hawkes' *The Outlaw* (1943). The transition from realism to naturalism, possible thanks to advances in camera technology, proved fatal to many directors, even to the accomplished visual language of Cacoyannis in the late 1960s.

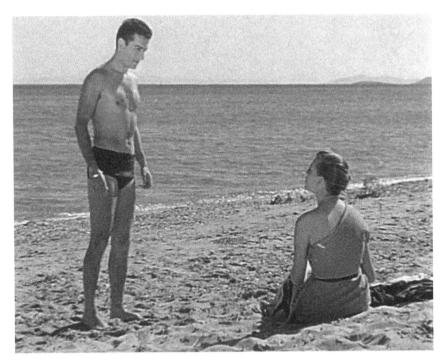

Figure 1.3: Maria Plyta, *Eve* (1953). Objectifying the male body.

Finally, the dramatic cinema of the first woman director, Maria Plyta, deserves much consideration as the background for many directors and films of the period. Plyta started with certain provocative and somehow subversive films about the feminine presence in history, in which reality is seen from the point of view of women, as the constant experiencing of violence, coercion and submission. However, mainstream producers did not trust her because of her gender. She then produced some of the most successful conventional melodramas in the 1960s, until she completely lost her ability to think cinematically. Her *Eve/Eva* (1953), however, must be considered the first consciously feminist confrontation with the patriarchal institutions of marriage and monogamy in a visual narrative in which the feminine presence is dominant and the male body is transformed into a sexual fetish for the female gaze. (See Figures 1.3 and 1.4.) Unfortunately, her last films were television series, shorter than her previous films, full of music, gender stereotypes and rhetorical dialogue devoid of meaning – this despite the fact that they were all focused around the suffering of women and thus appealed to male audiences who enjoyed watching female masochism. Her form of realism was both poetic and symbolic, working with pictorial nuances, gender subversions and

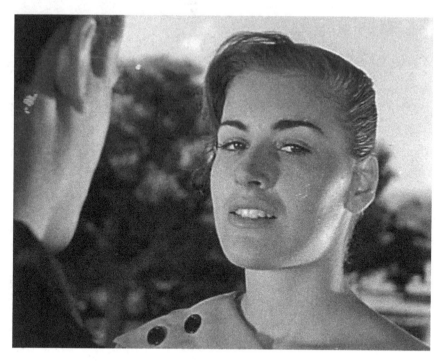

Figure 1.4: Maria Plyta, *Eve* (1953). Reversing the gaze: female libidinal aggression.

shades of emotion, hiding more secrets than they revealed, in somehow puzzling forms of centreless narrative.

The same applies to the second female director of Greek cinema, Lila Kourkoulakou. Her first feature film, *The Island of Silence/To Nisi tis Siopis* (1959), was an ingenious fusion of documentary and fictional recreation of actual events that took place in a leper colony on a Greek island. However, she soon discovered that very few producers trusted a woman to direct a film, despite the success of her first work. Her few works afterwards were fictionalised biographies of Greek politicians, laden with melodramatic rhetoric and nationalistic fervour – from a liberal point of view – which somehow confronted the state. This was certainly the case with her film on the most significant Greek politician *Eleftherios Venizelos* (1965).

Cacoyannis and Koundouros built on the traditions created by these cinematographers. However, they also had to deal with immense and relentless change on an unprecedented scale, and they struggled to articulate it in visual terms and to construct a complete cinematic story, in terms of Aristotelian poetics. As they confronted the unpredictable and volatile upheavals in everyday life, both directors adjusted their 'ways of seeing' in order to construct coherent and at the same

time confronting representations of multiple existential adventures and obscure micro-histories within the hidden experiences of Greek society. They did so intentionally but also unconsciously, because, as John Berger indicated, 'If the new language of images were used differently, it would, through its use, confer a new kind of power.'[70] Indeed, they both – intentionally in the case of Koundouros and probably unconsciously in the case of Cacoyannis – tried to empower the viewer by presenting and representing the silences of history in terms of what could *not* be seen: past traumas, social exclusion, gender inequality, political persecution. They did so by constructing complex codes of representation, in both 'closed' and 'open' forms, through which they attempted to address the question of how filmic language could respond to an unstable social reality and, more importantly, expose the 'higher immorality' of the social and power elites in control of the state.

Their own development within realism as a form of representation is equally instructive: Cacoyannis started with sculptural realism in his four films of the 1950s and consummated his work with the hyper-realism, indeed high formalism, of the ritualistic *Electra* (1962), but deconstructed his achievement with the monochromatic sculptural extravaganza of *Zorba* (1964). When he later tried to move from realism to naturalism, the crisp transparency of his forms simply dissolved in the polychromy of the surrounding space; his later films are made up of visual fragments that cannot be fused together in a coherent and communicable way. In *The Trojan Women* (1973) and *Iphigenia* (1977), human forms look like hyperactive and verbose ghosts moving around a landscape that overpowers them. His further attempts at naturalism fail to deal even with the simplest form of verisimilitude: they always veer off to the over-theatrical and the non-cinematic. In full circle, with his last film, *The Cherry Orchard* (1999), Cacoyannis made cinema a sub-genre of the theatre, immobilising the moving image and annihilating the ability of human form to express ambiguities and *aporias*. There is always a privileged position of knowing at the centre of all his works: his cinema is deontological, foregrounding the centrality of a bourgeois liberal ideology about class, subjectivity and reality.

On the opposite side of the spectrum, Nikos Koundouros' early films operated within the parameters of 'poetic or symbolic realism'. In the 1960s experimental non-linear narrative prevailed, but this ended with the stark and nostalgic realism of *1922* (1978). Films such as *Magic City* (1954), *The Ogre of Athens* (1956) and *Young Aphrodites* (1964) indicated his desire to confront society with what was being chosen to be ignored, to remain unseen and overlooked. His later films have been dedicated in elaborating a form of 'symbolic meta-realism',

as seen in *Bordelo* (1984), *The Photographers* (1998) and his latest film, *Voyage to Palestine* (2012). Even his underrated *Byron, or Ballad for a Demon* (1991), with its spectral realism and illusory sense of history, has to be seen as a hallucination, indeed as 'the nightmare of history', from which, to his horror, nobody could awake.

Koundouros was the first director who dared to deal with the traumas of history and to present them on the screen. As mentioned already, his film *1922* (1978) did more to objectify the trauma of the Catastrophe than any official ritual of the state. He did so indirectly because of the strict censorship and the omnipresent social panic in remembering the Catastrophe. Indeed, oppression is a constitutive element of his visual language. His cinema embodied the continuous narrative of trauma expressed in all levels of human existence: social, political, personal. His gradual adoption of an increasingly symbolic, almost allegorical, style, through the visual language of ideotypes, was the inevitable outcome of mainstream persecution and rejection. Koundouros was the master iconographer of the concealed trauma of history – and he remained that until his latest films.

Around the efforts of Cacoyannis and Koundouros to represent a reality of visibilities and invisibilities, most other directors constructed their individual forms of representation with 'soft realism' (Yannis Dalianidis), 'metahistorical realism' (Theo Angelopoulos), 'semiotic anti-realism' (Antoinetta Angelidi), 'episodic hard-realism' (Constantinos Giannaris) and 'meta-cultural realism' (Yorgos Lanthimos). Such varieties of realism, which can be easily divided into perceptual realism or conceptual realism,[71] have to be seen within the context of Greek cinema; since the first feature film in 1914, cinematic representations had focused on conflict, struggle and breakdown. There were very few fantasy films, even fewer historical epics, only a handful of truly religious movies, and even fewer films of pure imagination until quite recently. What always mattered – or almost always mattered, as we shall see – was the episode and the incident within a given social context, which was fluid, unstable and somehow hostile to all efforts to be articulated into images. Probably for this reason, Greek filmmakers have been unable to construct a character or form a grand narrative about history, imagination and identity. There are some notable exceptions, such as Theo Angelopoulos, but in his work form overpowers individual characterisation, and his experiments with depictions of temporality create, in effect, discontinuous, non-linear, circular counter-narratives.

Most Greek films, both before and after 1970, when the New Greek Cinema movement broke out, were forced to avoid a direct confrontation with the dilemmas and the puzzles of history; they even avoided the predicaments and the

contingencies of current social experiences. The central thesis of the present book is that this happened not only because of censorship and politics, but predominantly because most of the filmmakers of the period tried to create a visual language of symbols, signs and references which could depict the experiential (and political) indeterminacy in the country. Indeed, the persistent concern of the filmmakers included in this study has been about form: they have constantly attempted to create types, emblems and symbolic dialects that sublimate individual and collective experience within a social context of fluidity and instability. On some occasions, the audience was asked to enter a universe of visual correspondences that at most times were oblique and too complex. This anxiety about form was also about the forms of anxiety: how do we represent anxiety in a way that would indicate the anxiety for its own representation?

As a consequence, very few Greek films showed us a world without dark shadows. Even the conformist anti-realist comedies of the 1950s and 1960s recorded an implicit network of threatening political institutions and precarious social order. These countless comedies offered a temporary compromise, a fragile accommodation of opposing forces, within the framework of petit-bourgeois compromises. Yet, all comedies lambasted the rise of the petit bourgeoisie and the uncomfortable trade-offs they had had to make in order to become accepted by the hegemonic political order. However, the construction of specific social characters – the rascal, the simpleton and the con-man, for example – indicated a deep ambivalence towards dominant patterns of behaviour and accepted social typology. Yet comedies do need special discussion: they had to express what was forbidden, either by censorship or by ideology, in a way that could be accepted by the petit-bourgeois audiences, be unnoticed by the censors and make money for the producers, while at same time satisfying the aesthetics and the ethics of their director and, occasionally, of their protagonists. Their double-speak, a language based on evasions and displacements, needs a more elaborate and detailed discussion, as the characters they employed were symbols of social defeat and cultural melancholia. The triumphant wedding that usually ended these films was less the hope of a new beginning than the death of all projects of modernity.

Nevertheless, the carnivalisation of a traumatised self-perception through anarchic humour and transgressive language makes these films unique. Their comic language needs more discussion, as it is based on what might be called vernacular orality, through which the ungrammatical and non-syntactical 'speech acts' indicated subversive acts against uniformity and standardisation. The totally insane language of comedians such as Georgia Vasileiadou in films such as *The Beauty of Athens/I Oraia ton Athinon* (1954), *The Coffee-Reader/I*

*Kafetzou* (1955) and *The Auntie from Chicago/I Theia apo to Sikago* (1957) is probably one of the most surreal acts of rebellion against a linguistic homogenisation from above: the tension, fluidity and complexity of everyday life was expressed through the mask of illiteracy, as it was the only way that the illiterate masses of industrial workers or marginalised outcasts could vent their rage and resistance. At the same time it shows their destructive elements, which made them suspect to the authorities and resulted in their strict censorship. As Gerald Mast observed:

> The greatest comedies throw a custard pie (sometimes literally) in the face of social forms and assumptions. The greatest film comedians are antisocial, but in this antagonism they reveal a higher morality. Ironically, these iconoclastic comedies are products of a commercial system that depended on the support of mass audiences composed of anything but iconoclasts. Perhaps the enjoyable silliness of a comedy muted the underlying attack; perhaps comic iconoclasm provided the audience with a useful emotional release, an opportunity to indulge their own antisocial urges without damaging the social fabric; perhaps the iconoclast was free to speak against social and moral values because he used the entertaining comic form – a traditional privilege of comedians since Aristophanes.[72]

Until their disappearance in the 1980s, comedies were full of disguised rebellion against the social order that propelled society to capitalist modernisation while depriving the people of all defences against the relentless march of material and class changes. They were political statements against an exploitative system that while promising modernity imposed class barriers and social exclusion. Yannis Dalianidis, as we shall see, was the commercial director who, underneath his innocuous comic characters, played the system off against its own proclamations: propagating wealth yet imposing poverty, promising freedom yet enforcing subjection, permitting democracy yet implementing autocratic rule. As the most significant comedian of Greek cinema, Thanassis Vengos, stated:

> In all my efforts one can discern the moral effort I commit myself to … I am not a true artist. I am not, that is, a professional actor. Let me say it. Clearly and unambiguously. I am an amateur. An amateur passionate about his work. I am totally committed to what I am doing. With passion. Passion for perfection which occasionally is totally unnecessary …[73]

When comedies resurfaced in the late 1990s, they became the visual spaces in which cultural amnesia and social implosion could be pleasantly consumed and enjoyed; the society of the spectacle had imposed its own rules of engagement with the audience through the domination of mass media, with its mostly televisual codes and advertising strategies of subjectification. Their producers were the big television channels and cinema multiplexes, which used them as handy instruments for seducing audiences into watching formulaic soap operas or simply deflecting the audience's attention from their derivative 'trashy' aesthetics. The fact that they made so many successful comedies with many jokes, but without any sense of humour, is something that has to be addressed anthropologically and psychoanalytically in another study.

## Contested fields of visuality

> Hide the ideas, but so that people find them. The most important will be the most hidden.
>
> Robert Bresson[74]

This book is dedicated to the study of specific filmmakers and their individual contributions to the Greek visual idiom. They are the central figures who established the polyphony in the cinematic language of what might be called 'national Greek cinema' – although the term itself is highly contested. After them, a number of filmmakers, such as Antoinetta Angelidi, Constantine Giannaris, Yorgos Lanthimos, Athina Tsangari and Costas Zapas, articulated a multi-ocularity in representation by exploring the potential of cinema from different perspectives and for different audiences. They also defined innovative approaches to the medium, although the overall dearth of theoretical conceptualisation of the cinematic experience remains to this day rather glaring.

All of them problematised patterns of cinematic production in the digital – or indeed post-cinematic – era, as the cinematic medium itself goes, since the 1990s, through a prolonged transmutation, morphing into something much more indeterminate in form but more documentary in character. From the younger generation, Angelos Frantzis' *Polaroid* (2000) and especially *In the Woods/Mesa sto dasos* (2010) explores what Bruce Isaacs has called 'new cinematic imaginaries' by giving, through the aid of new digital technologies, 'more reality to the image' and 'greater capacity for aesthetic virtuosity in celluloid production'.[75] With him, as with the accomplished master of cinematic innovation Vassilis Mazomenos, the post-cinematic enters dynamically into the visual and verbal discourses around

cinema's role in redefining the realistic projects of the last sixty years. With them forms of 'impure cinema'[76] relocate the configurations of realism in recent cinematic history. Intermediality and hybridisation create new visual languages, genres and possibilities for the cultural imaginary in the early twenty-first century.

Michael Cacoyannis was the first director to consciously approach film as an autonomous constructivist formation. His narrative films frame conversations with other films: he consciously interweaves texts and subtexts from the history of cinema in his movies, which are like visual pastiches of various cinematic idioms. Here I call it *interfilmic transcription*. His works inaugurated a dialogue between Greek cinema and Hollywood. Indeed one could claim that his films became the sites of confluence between incongruous visual languages. In the end he became unable to control the tension of their conflict or the undesired consequences of their colliding signifiers.

In his early films the coexistence of such incongruous idioms was created through a realism based on linear narrative, pictorial photography and sharp contrast. The contrasts were visual and aural: he was the first who successfully incorporated landscape and music into the actual narrative of the film while, through the camera of Walter Lassally, managing to detach his images from their non-filmic references. However, that detachment became precarious as his films became more ambitious and more complex: *Electra* (1962) consummated and at the same time destroyed the achievement with its hyper-realism and stylised ritualism. As Cacoyannis was evolving, his dense synthesis of story, landscape and music became more self-referential and opaque: *Zorba* (1964) is a film in fragments and episodes, unified only through the visual plasticity of Lassally's camera. The same can be said of all his other films until the end of his career. His last film, *The Cherry Orchard* (1999), was a strange return to pre-Cacoyannis representational codes. In its theatricality, it abolished the dynamism and the fluidity of the images he had achieved in his films of the 1950s. The camera was following action; it was not part of the action. His later films were the most anti-Cacoyannis films produced in the country; it was a strange privilege to start a revolution of images and end up with the image of a revolution lost.

Nikos Koundouros is another unique case in formal innovation. Nothing has been written on him in English, although Greek critics rank his magisterial *The Ogre of Athens* (1955) as the best film ever made in the country. His film *Young Aphrodites* (1964) also gained considerable international recognition as an emblem of the liberated sexual energy of the 1960s, while his experimental *Vortex* (1967) still awaits recognition as one of the most radical reimaginings of the libidinal tension between masculinity and femininity, or 'the polymorphous perversity

of desire'. His *Songs of Fire/Ta Tragoudia tis Fotias* (1974), a documentary that recorded the restoration of the Republic as a continuous public festival of celebration and euphoria in the public sphere, still captures the explosive optimism of the period, when the city streets became spaces of uninhibited expression, cultural creativity and social activism. His monumental *1922* (1978) is probably a turning point in his work, as it ended his experiments with the cinematic gaze and privileged the energy transmitted by the story itself. After 1978, Koundouros plunged without any reservations into the madhouse of history. The versatility of his visual style remained remarkable: from neorealism to expressionism and then from symbolic realism to hyper-realism, culminating in totally allegorical and symbolic narratives about violence, murder and destruction. With his last films he seems to have explored the visual language of post-history, as his stories became symbolic essays on the mental states involved in totally imaginary situations.

In each one of his films, Koundouros has been a different director. He constantly renewed his visual grammar, the movement of camera, the framing of action, the performance style of his actors. Indeed, one can attribute the confusion and the bewilderment of critics to this most significant aspect of his *mise-en-scène*. With each new film Koundouros negated the stylistic or the rhetorical achievement of his previous work. His films as a whole form a dialectical cinema of antinomic representations, and are probably the single most important cinematic oeuvre in terms of never relinquishing their oppositional rage. Shaped during the gloomy persecution of all dissent in the 1950s, Koundouros addressed the relationship between power and the individual and the mechanisms of oppression that restrict freedom. His is the cruel cinema of an enraged humanist, and it lashes out against the oppressive presence of state power without comic relief or irony. His films after 1980 show the despair and ravages of war, in the manner of Francisco Goya and Edvard Munch, as they portray the fragmented body of contemporary societies and the brutal violence of the state against the powerless and the dispossessed. His worship of the underdog led him to explore history from below, from the point of view of those who suffer history and whose existence is expendable and inconsequential within the grand schemes of ideology. With time, his films became more inward-looking, self-referential and somehow claustrophobic, although they are all set in open spaces and populous border stations.

Koundouros' last films conflate space into a microcosm where everything has lost its transparency. His trajectory, however, was extremely strange: he is the only director who took risks with the medium and totally reversed the cinematic gaze, from an Aristotelian thematic unity to an almost Kafkaesque episodic circularity, without protagonists and without catharsis. His storylines flow like endless streams

in a huge river of relentless change. The director simply isolates a micro-episode, a little detail, an insignificant formation, which his camera magnifies and intensifies, in order to indicate what passes unnoticed and is lost under the rapid revolution of things beyond the control of the individual.

Any study of Greek cinema would be misleading and incomplete if it did not address the great paradox of Yannis Dalianidis, the most commercially successful director in the country. Despite the undeniable fact that his films (he made a total of 65 dramas, comedies and musicals) shaped the emotional landscape of two, or even three, generations of filmgoers in the country, they are treated with derision and contempt by film historians and reviewers to this day. Commentary on his work is mostly an assessment of the studio era in Greece and its production mechanisms at the peak of its commercial success. Dalianidis is an uneven director: his films are as repetitive as pop art paintings. They repeat a formula and exhaust their very intense emotional power almost immediately. Like pop art artefacts, however, they also contain slight and imperceptible modifications, variations and shadings, which make them interesting and significant, as they discreetly depict for the middle-class family audience certain annoying and disturbing truths about their life. Indeed, it is important to see his films as a work in progress, as a constant struggle with the potentialities of the medium, as visual investigations of what could not be represented or should not be explicitly depicted on the screen.

Dalianidis was an empirical director; he learned how to direct by making films, by working with the nitty-gritty of production and by focusing his skills not on the *mise-en-scène* or even the script, which he almost invariably wrote, but on the performances. He was a director who worked with actors and for actors: the storyline, the settings, the camera movement, the structure of representation were all secondary elements in his work. The centrepiece of his cinematic look was the actual bodies of his actors, male and female, their clothes, movements, expressions and gestures. The rhetoric of his choreographed images was intensified by the corporeality of his actors. His camera was a cunning deflector of attention: he appealed to the widest possible audience, and he knew that the experience of the bodies crammed close to each other at the movie theatre in the dark would generate a powerful sexual energy that he wanted to express in an indirect way on the screen in front of them. Dalianidis was and remains the most Freudian and Marxist director in Greek cinema: without making it explicit, he knew how to manipulate the repressed desires of the growing middle class and portray them in an innocuous and non-threatening style. He knew also to situate such repressed

desires within the context of a class society, stressing emphatically the political element in their birth.

Dalianidis always worked with stereotypes; he never looked at the marginal, the irregular or the anomaly, although in his later successful films these types take a more prominent position. His audience was the emerging middle class of the 1960s, who wanted to forget the ravages of the Civil War, the German Occupation and, most importantly, their rustic or proletarian origins. They imagined a well-ordered world that secured their position and accepted them as they were without any questioning about their past. Furthermore, they wanted to see themselves as human beings with depth and sentimentality – which, of course, they were – but they had chosen to disregard all this because of the compromises they had had to make in order to make money and be successful.

Dalianidis' films are legitimising fantasies for this emerging class and their characters are modelled on the repressed desires of his audience, which they were unable to sublimate; his cinema expressed the excess of negativity that was looming in the rise of the urban middle class and its unexpected eruption in moments of self-destruction and collective violence. His camera focused on those moments when negative emotions were beyond control and rational thinking: cleverly enough – indeed over the shoulders of his closeted revolutionary producer Filopoimin Finos who, on the other hand, was very well aware of Dalianidis' hidden 'dark nature' – he depicted one-dimensional characters in search of their own salvation as they collided with dominant patriarchal practices and patterns of respectability.

In the final analysis, Dalianidis himself was one of them, and felt immense empathy for the inner turmoil of all those young people, men in particular, who could not express their sexuality. Indeed, his whole work could be seen today as the first complete gay mythologisation of the social experience in Greece. One by one his films created a continuous coded symbolisation of the sexual pathology of everyday life, articulating well-structured cryptonymies about the secret libidinal names that the young were struggling to invent for their sexuality while they were still controlled by the hostile world of fathers and the sweet tyranny of mothers. In constructing this model of cryptonymic realism, Dalianidis also projected his own desires and closeted homosexuality onto the story itself, through his identification with the 'phallic eye' of the voluptuous actress Zoe Lascari, his intense admiration for masculine torsos, tight trousers, disappearing penises and the overall voyeuristic neuroses of a terrified masculinity. His provocative film *The Sinners/ Oi Amartoloi* (1971) was a game of hide-and-seek of erotic substitutions: his main

theme was the nudity of the male protagonist and his phallic aura, the ubiquitous but invisible penis and the name that could not be named: homoeroticism.

However, the repressed middle class abandoned him simultaneously with the collapse of the studio system. The majority of the petit-bourgeois audience found refuge in the soft porn films of the period; a tiny minority opted for the art-house cinema of the early 1970s and the rise of the New Greek Cinema. By 1975, Dalianidis was an anachronism, a forgettable chapter in the history of Greek cinema, whose work was constantly criticised and rejected under the rubric of the 'old commercial cinema'. The work that stands staunchly opposed to the finan- cial success and stylistic uniformity of the 'old commercial cinema' is that of Theo Angelopoulos and the New Greek Cinema. Without doubt, Angelopoulos is one of the great transnational cinematographers of the twentieth century. His films stand out as unique in their attempt to create a distinct cinematic language of visual perception irreducible yet conscious of its constitutive elements. Angelopoulos' images retain the psychological power to evoke other images of which the specta- tor becomes aware only after the prismatic analysis of each one of them. They are visual palimpsests, made out of many layers of references and connotations, not only historical but also cinematic. The act of seeing in his ocular poetics confirmed James Elkins' statement: 'Seeing is metamorphosis, not mechanism.'[77] His first films had the aesthetics of documentaries, like the ones produced in the 1960s, leaning closer to *cinema verité* and with strong references to the French Nouvelle Vogue and the Czech New Wave.

Although the black and white *Reconstruction* (1970) presents a rather com- plex structure in storytelling and camera movement, it is configured with the sim- plicity and the plain geometry of a silent film. The references to earlier films are constantly in front of the spectator; at the same time, however, viewers have the uneasy feeling that something peculiarly novel that challenges habits and patterns of behaviour is happening in front of them. Angelopoulos cunningly and surrep- titiously structured his first film as a series of photographs of old and forgotten crimes, but with the immediacy and the directness of a personal story, indeed of a tragic story of a friend in the neighbourhood. It was also a peculiar kind of film noir, without the implicit sexual energy of the genre or the narrative dislocation of its storyline. With minimal music and amateur actors, Angelopoulos relocated the centre of psychological gravity from the individual to their actions. The camera (that is to say, us, the community around the criminal) was the guilty bystander whose presence transformed the personal story into a collective tragedy: thus we are all participants in a system that disempowers people in order to brutalise and neutralise their civic and moral consciousness.

After *Reconstruction*, Angelopoulos made some of the most political films in world cinema, paralleled only by the works by Glauber Rocha and the Brazilian Cinema Novo. Between 1973 and 1980 he released a series of polychromatic visual essays on the conflict between institutional power and the individual, while exploring new cinematic possibilities. In films such as *Days of 36* (1972), *The Travelling Players* (1976), *The Hunters* (1977) and finally *Megalexandros* (1980), the collective adventure is the focus of the camera; no protagonist, character or individual psychology stands out. During the 1980s, however, the individual, overwhelmed by disenchantment, loneliness and helplessness, becomes the centre of his exploration. The disillusion with all political projects that swept Europe in the late 1970s, common to directors as diverse as Robert Bresson, Michelangelo Antonioni, Bernardo Bertolucci and Rainer Werner Fassbinder, was represented by new existential questions that were woven into the structure of his emblematic long takes. Most of all, Angelopoulos almost reinvented colour and lighting for Greek cinema: in his epic *Megalexandros* the bright, warm and archetypal colours of earth and nature created an iconographic hyper-realism that dazzled the eye like a late Byzantine mosaic.

After that film, he toned down the vibrancy and energy of natural colours by experimenting with muted shades of grey, green and yellow over sombre and dusky surfaces. Clouded skies, dark expanses and ashen, wooden interiors frame the movements of characterless individuals in their attempt to come to terms with the ominous historical changes around them; a smooth and melancholic impressionism permeates all his films during the 1980s, a decade of lost illusions and ideological disappointments. During the same period Angelopoulos also privileged another elemental force within the structure of his films. After 1984, the real force energising his images was less visual and more acoustic: music. The soundtracks, most of which were composed by Eleni Karaindrou, became actual participants, sometimes the driving forces, in the storyline of his films.

Although Angelopoulos worked with many screenwriters, the main themes and ideas were his and he had a special approach to dialogue. His films were never really successful commercially, and the critics remained divided about them. He decided to make his political films by systematically refuting the political significance of Eisenstein's montage, and by instead infusing his stories with the theatrical techniques of Bertolt Brecht. He also rejected Georg Lukacs' 'critical realism', with its novelistic and, in essence, Aristotelian construction of storytelling, although one can easily discern the fierce battle between Aristotle and Brecht in his films until the late 1990s. Furthermore, until his last two works,

there was no room for psychological empathy and emotional identification in his films. Actors were almost redundant in them, especially in the films before 1984, while in the later ones they dominate the screen: *Eternity and a Day* (1997) is made around the existential awkwardness of Bruno Ganz; the vertical image of a suffering human body punctures the large horizontal canvasses of Angelopoulos' epic style of representation. The lyrical mood around the actor and the epic mode of the action create a strange collision of styles, idioms and iconographies that needs further analysis.

Moreover, powerful archetypal myths underpin his stories, which are frequently taken from newspaper reports. Individual cases are fragments of lost macro-narratives and vanished universal identifications which the director effectively conceals in the poetic language of his dialogue, whenever dialogue exists, or in the long shots of depthless grandiose landscapes. Indeed, the whole of his work is defined by the conflict of two opposite and irreconcilable aesthetic paradigms: Aristotle's need for catharsis and Brecht's admonition that art should never function as a substitute for life. Angelopoulos' aesthetics embody the ambiguous orientation of all modernist aesthetics: they remain open-ended and leave everything somehow in abeyance. His films frame what is absent from the shot and invite the viewer to look outside the screen in order to understand the meaning of its images.

More than any other contemporary Greek – or indeed European – director, with the exception of Derek Jarman and Terence Davies, Angelopoulos understood that the colours of his shots were extremely effective non-verbal signs and messages to his audience. Later in his work, especially after the collapse of socialism, Angelopoulos' films moved from his early expressionistic techniques to blurred visual splashes of muted colours fusing into each other. His films after 1995 stand out as relentless experiments with colours and sounds more than as films that frame political views or ideologies. At the beginning of his career he was a craftsman of stark contrasts and neoclassical symmetries; later he became the most sophisticated *colourateur* of contemporary cinema.

His achievement is even more significant in that it is not based on technical innovations or digital effects. The powerful expressionism of his latest films bring him closer to Wassily Kandinsky and El Greco, as the mixing of colours creates an otherworldly atmosphere of sensory impressions and mental inversions. Angelopoulos is an intellectual director, indeed a director's director, whose dense and compressed visual idiom has to be dismembered in order to be remembered. His work needs more discussion and analysis. He attempted something Promethean: to reinvent all cinematic codes of representation. He was both

successful and unsuccessful, and his intense struggle with the medium produced both greatness and failure.

The work of Angelopoulos eclipsed other innovative contributions by less popular filmmakers. Women filmmakers were always at the forefront of radical approaches, but have been discussed only briefly in the overall literature about Greek cinema. With the exception of Tonia Marketaki and Frida Liapa, who won moderate international attention, very little is known about female filmmakers and their achievements. Tonia Marketaki's political film noir *John the Violent/ Ioannis o Viaios* (1973) paved the way for a completely novel field of visual exploration that culminated in the experimental camera of Antoinetta Angelidi.

Angelidi is the patricidal daughter who singlehandedly dismembered patriarchal and androcentric codes of representation with a series of films that reshaped what constitutes cinematic language. She calls herself primarily a 'visual artist', indicating that her cinematic gaze explores the limits of visuality and visualisation. Her camera does not subvert or appropriate the dominant male-centred visual regimes. Angelidi's cinema reconfigures the visibility of symbols. She discards that which is ideologically tainted, cinematically worn out and thus politically spurious. Her thematic lines are not Aristotelian myths: they are Sapphic lyric odes, in which time and space have converged and human experience is framed within the timelessness of the subconscious – a gendered subconscious by all means, refuting Sigmund Freud's fear of the oceanic unknowability of the feminine. The feminine gaze is not an anti-masculine gaze; it is an enhanced perception of the real, a heightened understanding of experience. It is the gaze that looks into origins and beginnings as well as ends and finalities: the gaze of the mother as the beginning of life and as the last word in life.

Her films are about Genesis and Thanatos – they frame liminality as the most crucial existential parameter for self-definition. This can be seen in the development of her visual language, starting with the monochrome variations on themes from Carl Dreyer and Jean-Luc Godard in *Parallages sto Idio Thema/Idées Fixes/ Dies Irae* (1977), to the expressionistic Byzantine-Baroque synthesis in her trilogy *Topos* (1985), *The Hours – A Rectangular Film/Oi Ores – Mia Tetragoni Tainia* (1995) and *Thief or Reality/Kleftis i Pragmatikotita* (2001). Angelidi avoids the illusionism of technological cinema and the easy sensationalism of contemporary digital effects: she records mystery-dramas in a front of a static camera that becomes the archetypal *axis mundi*. I call her cinema eschatological because it deals with the ultimate sources of creativity through a gendered vision of history.

Finally, any account of the poetics of postwar Greek cinema would be incomplete if nothing were said about its current situation. After 2009, the

country and its economic infrastructure entered a period of violent and apparently uncontrolled contraction, which led to heavy financial losses and affected the movie industry and all other cultural creativity deeply. Consequently, not only did the Greek state stop funding films; all production shrank dramatically in this time of social and political deterioration. The few films that have been made (ten to twelve per year) have portrayed a reality completely different from the one set in front of the camera until then. It was not Kracauer's 'nature caught in the act', although it had the openness of its fragmented indeterminacy.[78] The new depicted reality was incoherent and somehow negative: all accepted codes of seeing had collapsed, to be replaced by nihilistic emptiness. 'How do you film disaster?' is the central question in the poetics and the politics of these new filmmakers. The current cinema, as represented by P. H. Koutras, Costas Zapas, Yorgos Lanthimos, Athina Tsangari and recently Alexandros Avranas, amongst others, explores a profound and almost foundational asymmetry between the images that had symbolised Greek experience until now and the present-day demise of meaning. The images have become idols, and obscure vision. These films attempt the impossible task of bringing back the light to a mind addicted to the unreality of specular absences.

With the current crisis as the background of all cultural creation, past traumas are also revisited and the old defence mechanisms – reverting to infantile narcissistic certainties – are expressed through a return to the illusions of omnipotence and grandeur offered by fascist ideologies. The trauma of sudden and unexpected humiliation simply exacerbated these tendencies, adding a promise of returning to the safety of the minimal self, in which the world out there and the fantasy world in the mind could no longer be separated. The current humiliation is because the world seems to have lost its reality, and this gives rise to delusions about power and control that become dominant, destroying all meaningful conversations. The inability to become affluent, which until then was a symbol of status, self-assurance and success, has created an enormous failure in psychical organisation. A society without projects of renewal becomes a breeding ground for a regression to the fascist mentality of unrelatedness, exclusivism and narcissistic self-victimisation. It also indicates a failure of the moral imagination to take on the pretensions and the delusions of the political order and to confront the apathy, amnesia and inertia of the petit bourgeoisie. Contemporary Greek cinema targets this self-centredness and exposes its language and symbols; it avoids grand narratives and yet seriously questions the right of the filmmaker to be the moral conscience of society.

## Beyond the heresy of realism

> You are making absolute cinema, which means that I work predominantly on the image, to achieve the self-sufficiency of the image.[79]
>
> Costas Sfikas

This asymmetry could be detected even in the late 1990s, when the social demography changed after the collapse of Communism and the influx of millions of refugees. The cinema of Constantinos Giannaris expressed the gradual fragmentation of the symbolic *Lebenswelt* in the society through violent, rapid and aggressive snapshots. The refugees acted as catalysts, and all the pretensions, fears and anxieties of Greek society were exposed and became, for the first time, part of the public discourse. Giannaris unleashed a revolution that was to bring the hidden horrifying undercurrents of Greek society under the magnifying lens of cinematic representation. His visual style drew from a range of cinematic styles – American, English and French, amongst others – but also from traditional Greek films and television shows. The scripts of his films were spasmodic and look somehow stretched to fit the time span of 100 minutes that is expected of a film for the big screen, being therefore formal reinventions of two distinctive modes of representation, the cinematic and the televisual. The conflict of modalities in representation becomes even more pertinent as more people watch films on their television, computer, cell phone or tablet screens today.

His early short films, exploring mostly the queer experience through the eyes of existential loners, were emblematic of his later works. His black and white film *North of Vortex* (1991) is a road movie through the United States. It is in fact a homosexual response to the heterosexist fantasy of Koundouros' *Vortex* (1967). His seminal *From the Edge of the City/Ap'tin Akri tis Polis* (1997) achieved something that his subsequent films failed to do: it had a continuously accelerating pace and a gripping dramatic structure through using a mix of genres, polychromatic frenzy, sonic delirium and multiple filmic references. His later movies left more things unvisualised and hidden, as if the director was more cautious about provoking the sensitivities of his middle-class urban audience, which had reacted negatively to his early films. The secret desires of such urban audiences found their ambivalent relief with the early films of Panos H. Koutras, whose films *The Attack of the Giant Mousaka/I Epithesi tou Gigantiou Mousaka* (1999) and *Strella* (2009) mix provocative gender-bending with a heavy overdose of twisted melodrama, in the tradition of Pedro Almodóvar. His more recent *Xenia* (2014) is a mesmeric melange of magic realism and transcultural visualities that shows his eclectic fusion of stylistic elements from popular and high culture

through a sustained vision of social liberation built around the psychodynamics of homoeroticism.

However, during this period a new form of representation began, discarding of all forms of 'Bazinian realism', with the 'weird wave',[80] as inaugurated in Yorgos Lanthimos' *Kineta* (2005). Historically, it is interesting to remember that this film was made and released during the 'reckless years' of the conservative government (2003–9), with its conspicuous consumption of borrowed affluence. The 'weird wave' did not emerge until after the financial collapse of 2009 but its gestation occurred in the years after the 2004 Olympics, as the most radical opposition to the abuse of language and power by the political order of the country. Its main target was – and still is – the domination of Greek society through its central, conservative, and most consecrated institution, the family. Its second target was the main instrument of Greek nation-building, the Greek language itself, as employed by the political order to manipulate the understanding of reality. Finally, living in the era of mass media, the last target was the abuse of images by the spin doctors of politics in order to obscure the absence of future-oriented social projects. Other subtexts were the anxious world of masculine power, the sweet tyranny of maternal love and the asphyxiating reality of universal surveillance. Films made in private spaces and about private lives depict no sense of privacy or individuality: everything and everyone is a prefabricated automaton, a mechanised instrument in the service of invisible social forces, lost in the maelstrom of existential nothingness.

Yorgos Lanthimos, Athina Rachel Tsangari and Alexandros Avranas struggle to de-ideologise filmic images by exposing the structural patterns of horror underneath the self-aggrandising fantasies of the urban bourgeoisie. Their strange films confront the hallucinatory world of illusion and delusion constructed by the political order in order to avoid the 'terror of the real'. They represent a radical debunking of the fictions invented by the Greek state and of the ideological structures that support them. Cinematically, the anti-realism of their films, with its post-logical lack of referentiality, transforms them into rare social documents embodying, probably better than any historical account, the atmosphere of falseness, cynicism and demoralisation that permeated the public sphere during the years of reckless irresponsibility. They are representations that consciously misrepresent: by subverting what is inverted they unveil the mechanisms of falsification and deception, the ideological coercion of people through the manipulation of their images, words and memories.

Together with Lanthimos, Tsangari and Avranas, a provocative outsider, Costas Zapas, confronts Greek society with its actual nightmarish actions – the actions that nobody dares to talk about, the violence and annihilation that encapsulate the

Hegelian dialectic of master/slave as imposed by the patriarchal elites. Zapas finds the master/slave relationship a permanent metaphysical reality of self-definition in Greek society. It is institutionalised on such an immense scale through the family, the school, the church and politics that the only way a subject can gain self-awareness is by becoming either the master or the slave. The audience feels deeply uncomfortable with the images about themselves that appear in Zapas' *The Rebellion of the Red Maria* (2010), and with the extremely negative representation of everyday reality in the 'Family Trilogy' (2004–8). With Zapas' iconoclastic films, Greek cinema entered its deconstructive period, its second modernism, and it is not afraid to destroy all the evocative, affectionate and intimate symbols that led the nation to its current devastation.

## Re-reading visual regimes

> I don't think that film has a grammar. I don't think film has but one form. If a good film results, then that film has created its own grammar.
>
> <div align="right">Yasujiro Ozu[81]</div>

The reading of these filmmakers suggested here will be based on what might be called their processes of morphogenetic visualisation, essentially their visual poetics. I will analyse specific films, not always the most well-known or commercially successful, but films with particular significance within the overall development of their makers' visual idiom. I take a cautious formalist approach, or more precisely a neoformalist approach, while at the same time exploring the political statements and the ideological structures that determine and delineate each cinematic work per se. Formal analysis always focuses on the specific 'architectural structures' that shape images and formal representations. Vasilis Rafailides suggests the fairest critical approach to evaluating films: a film, he wrote, is good not because we 'like it' but because its form clearly manifests the discernible constructivist intentionality of its creator. The 'architectonic plan' on the basis of which the film was made is integrated within the film itself, and our duty is to find it.[82]

The complexity of the structural process in such representations is the central theme of this analysis, and there is a specific focus on the filmmakers themselves, as individuals – and therefore, on some occasions, their psychological formation, social status and ideological position must be taken into consideration. The closeted homosexuality of some of them, for example, must be discussed, as must also the aggressive heterosexuality of others: you cannot understand Dalianidis without the former and Koundouros without the latter. We do not try to sexualise their poetics – but

sexuality is a salient constituent of their semiotics. What is on the screen bears the conscious or unconscious vestiges of a self that, like Alfred Hitchcock's cameo appearances, function as personal signatures and border markers of signification. It is time to de-exoticise Greek filmmakers and see them as image-makers, as creators of cinematic visuality, and therefore as creators who reshape visual perception and visual hermeneutics. At the same time we must see them as agents of cultural intervention, and examine the ways that their realities impacted on their work.

These constitutive elements, questions of belonging, identity, politics, class, gender and race, exist within the 'ocular poetics' constructed by each of them in order to communicate a vision of reality – or, more precisely, a series of visions as reinvented at different times. Only if we see them as image-makers in continuous reinvention of their medium can we connect their work with general questions about cinematic representation, and understand their responses to the ethics of visual constructiveness. As Jean-Luc Godard so incisively stated: 'Art is not the reflection of reality, it is the reality of that reflection.'[83] Ultimately, the constructive imagination of each of these directors forms a vision of the reality around them and around their viewers.

Finally, we must see them in their constant evolution and change, as most of them renegotiated the limits of visual representation over time. The early poetics of Cacoyannis are quite different from those of his middle and later periods. Each one of these filmmakers must be seen within specific semantic fields, pictorial practices and visual regimes. Cacoyannis' language belongs to the era defined by André Bazin's understanding of realism, through the perspective of John Grierson's approach to film as having predominantly 'documentary value' about a reality out there that is both comprehensible and representable. Indeed, viewers can clearly see, especially in the works of Cacoyannis' most creative period, 1954–63, a very serious attempt to depict the changing realities of Greek society through the eye-camera of a social commentator. Between 1954 and 1964, Cacoyannis explored the aesthetics and the ethics of open spaces. They were 'contested spaces', either ravaged by war, and therefore spaces of mourning, or newly opened territories, and thus spaces of promise. In other films, he investigated what Bela Balazs called 'the psychological effect of facial expression'.[84] Until then he managed to keep the development of the story and the invisible scripts of the plot together. Aided heavily by Walter Lassally's penetrating camera, he constructed a functional correspondence between what is depicted and what is not. His realism framed the camera in order to give his viewers Bazin's 'objectivity in time'[85] at the same time as his cinematic script gave them 'the image of things' as 'the image of their duration'.[86]

54

This was his great temptation, to which he succumbed in the end. As long as his camera foregrounded the sculptural qualities of things, each shot and frame constructed a dynamic depiction of contingent forms, fully at home in their corporeality and temporality. In his nostalgic recreation of the past in *Eroica* (1959), he blurred the acuity of the vision; with his magnificent *Electra* (1962) he reverted to hyper-realism through enhanced shots and static frames – with this achievement he abandoned the poetics of his early work. By moving away from the objective sculptural realism of his first period, he deconstructed the complexity and the verisimilitude of his own images. The process was completed with *The Trojan Women* (1971). It was like looking at ancient Greek statues covered in glorious colours under bright light: the passage from realism to naturalism changed the focus of his camera from the mystery of the human face to the externalities around the body to which the body was not inextricably connected, while dialogue sounded like an awkward addition. Clothes, indeterminate no-spaces, libidinised nudity decentred his camera – which was no longer in the hands of Walter Lassally.

His films after 1964 explore other features in form and genre, without the immediacy and the directness of the black and white photography of his early works, the crispness of their visual specificity or the illuminating presence of subplots. He moved from realism to naturalism and then to verism – which essentially created an unexpected mismatch between form and presentation: the bright colours of naturalism dissolved all formal distinctness and specificity. Hyperbole took over both drama and comedy and established a deep asymmetry between the story and the plot which undermined the structural cohesion of his later films.

On the other hand, even Nikos Koundouros' images belong to a hybrid genre between Italian neorealism and German expressionism. His works dwell in spaces between genres, representations and visions. His camera is always where it shouldn't be: it observes, like an uninvited and unwelcome guest, horrible crimes and unrepresentable atrocities. Siegfried Kracauer's theory of redemptive realism is the most appropriate entrance to Koundouros' work. He was the first director who understood that the camera constructs a dangerous way of reimagining reality. As Kracauer notes, at the moment he sets his camera for shooting he becomes:

> the man who sets out to tell a story but, in shooting it, is so overwhelmed by his innate desire to cover all physical reality – and also by feeling that he must cover it in order to tell the story, any story, in cinematic terms – that he ventures ever deeper into the jungle of material phenomena in which he risks becoming irretrievably lost if he does not, by virtue of great efforts, head back to the highways he left.[87]

Koundouros correlated changes in angle and colouration with transgressions in the political imaginary through his strong desire to unveil all silenced traumas. Unlike Cacoyannis, Koundouros uses Hollywood's version of realism against its own ideological and aesthetic implications. The semantics of his visual language were adversarial: they deny the hegemonic primacy of representations that affirm the existing order of things and confirm dominant centres of power and meaning. In a sense, his images are negatives of reality, as they negate all representations that are accepted as valid and 'true'.

This visual polemic against such invisible structures of power can be detected in all his films until 1978. His seminal breakthrough with form took place with *Vortex or Medusa's Face* (1967), an experiment in minimalism in storyline, plot and visual symmetries. From then on Koundouros gained enough confidence to delve into the 'dark night of the soul' and the 'jungle of material phenomena' with rage and pathos. The theme of violence against innocent people became dominant. His *1922* (1978) explored the condition of victimhood through its drab colours and muffled sounds. It is his masterpiece in composition and *mise-en-scène*: it situates the individual within the dark background of historical upheavals with the clinical detachment of a puzzled bystander. The visual complexity of his late films is structured around the contemporaneity of memories in the human unconscious, in continuous battle against each other and against the mind that dreamt them. Koundouros' strong tendency towards symbolic deterritorialisation places his characters in the vortex of multiple temporalities simultaneously. Formally, this makes Koundouros, as a filmmaker, the hero of the cutting room, using heavy editing and deep fast montage, and at the same time the Don Quixote of cinematic imagination.

If Laura Mulvey knew of the work of Yannis Dalianidis when she wrote her famous essay, 'Visual Pleasure and Narrative Cinema',[88] she would have had to modify her perception about the scopophilia of the male gaze and explore the scopophobia of the male look, of the 'female man'. We cannot understand the hugely successful films made by Dalianidis in the 1960s without taking a psychoanalytical approach to them. As the main representative of popular cinema and the filmmaker who shaped the aesthetic tastes of two generations, Dalianidis is a peculiar case. He depicted the confused gender perceptions of his society as they related to his own self-perception by substituting identities and representations: the male is female and the female male, in an exchange of gazes, self-perceptions and, most importantly, desires. Dalianidis seemed to have seduced the gaze of a whole country by deflecting its attention from the true objects of his desire. The male gaze stared through a female body at the body of half-naked men, exposing them

to objectification and fetishisation. My approach to his work is to explore the disguises of his homosexuality, and of his militant Marxism, and try to explain why his viewers and reviewers could not perceive the subversive character of his imagery.

At the opposite side of cinematic production is Angelopoulos' work. It is too complex to be seen or appreciated though a singular prism or a specific perspective. One could claim that in an era of diminished expectations Angelopoulos tried the impossible – to restore the centrality of the cinematic experience by recalibrating visual perception. The ultimate *auteur* himself, he expressed a comprehensive vision of history, form and visuality. He wanted to instruct viewers in new ways of seeing, not simply to make them conscious of how we are conditioned to see, drawing from John Berger's pithy argument that 'every image embodies a way of seeing'.[89] He is the consummate phenomenologist of visual aesthetics; his films are simultaneously embodiments of a special perception of light and its iconographic manifestations. They can be understood within the Bergsonian tradition, as expressed by Gilles Deleuze.[90] What we witness in Angelopoulos is an exploration of Merleau-Ponty's mysterious character of vision, which is never 'done with: it is shifted from the "thought of seeing" to vision in act'.[91]

These directors made their films, and in return the films made them. Angelopoulos, Koundouros and Cacoyannis became cultural and national icons while they were still alive. Most recently, and using different styles of representation, Angelidi, Giannaris, Koutras, Zapas, Lanthimos and Tsangari stand on the boundary between the known territory of visual deconstruction and the unknown landscapes over the borders of Greek territory. From such a privileged yet precarious position they challenge normative perceptions about national cinema and its language as well as dominant perceptions of form and identity. In a way, they are all characters in interstitial exile; they are left on the borders between countries, languages and traditions, constantly redefining the concept of national cinema. With them, Greek cinema is distinctly Greek when it is not Greek at all. It gains self-awareness and identity only when it turns its gaze to madness, illogicality and alterity, exploring universal forms of being and codes of communication while reframing them in surprising ways.

Antoinetta Angelidi, as part of the experimental and poetic approach to cinematic images, must be seen as the poet of spatial constructivism. Everything else – colour, story and dialogue – is part of an Eisensteinian understanding of filmmaking via the discontinuous images of Jean-Luc Godard. Like Eisenstein, she insists that 'the sphere of the film is the most inexorable *objectivity* that it can ever be';[92] her cinema is focused around Maya Deren's idea that cinema is about 'the objective, impartial rendition of an otherwise obscure or remote reality'.[93] With

her the question of realism and what it stands for takes probably its most 'drama-turgically' accomplished non-narrative form. After her, experimental-poetic cinema followed other paths and probably lost its political edge; her work remains an unexpected monument of the post-1974 cinematic 'lost spring'.

Following her, the directors I present here are the local manifestations of a global movement to transcend the photographic stillness of the nineteenth century and plunge into the frantic fluidity of the post-cinematic twenty-first century. In them, Lars Von Trier, Michael Haneke, Wong Kar-Wai and the Dardenne brothers fuse with Gus van Sant, Mathieu Kassovitz, Baz Lurhmann and Pedro Almodóvar in a melange of personal styles full of idiosyncratic emotions and peculiarities. New and distinct styles emerge: Athina Rachel Tsangari's *Attenberg* (2010) takes cinematic representation to unexplored territories through its geometric realism and post-Heideggerian thanatophilia. Lanthimos' reversal of cinematic expectations reinvents dialogue and script. Their form innately bears the danger of becoming formulaic and repetitive. To some degree Yorgos Lanthimos' *Alps* (2012) does that. However, the unfolding of its visual potentialities is still underway and it will be interesting to follow what new directions it will take – as we see in his recent *The Lobster* (2015).

The new directors are more enraged than melancholic, and search for their language in places that no one has dared to go so far. As they evolve, they try to deterritorialise themselves, as existential homelessness is their main personal story as well. They are still left with their body, and this embodied presence frames their vision of reality and liberates its radical potential. The realism of corporeal presence is the central style, and the main thematic exploration, of contemporary Greek cinema. In a strange way, the mystery of human presence is the ultimate focus of their camera. It frames a distinct anti-Aristotelian and anti-classical defamiliarised representation of form and storytelling. Yet through parody and irony they relativise iconic figures or model patterns of being and expose the insecurities and the fears of the dominant petit-bourgeois sense of reality, while stressing the material gravity of the world of objects that their class lived for (and ended up being prisoners of).

They live in an era characterised by Cornelius Castoriadis as 'generalised conformism',[94] in which coherence has been mutated into violent normalisation, linearity into depersonalisation and cathartic solution into nihilistic meaninglessness. Greek filmmakers dare to dismantle the best and most enduring achievements of their culture, and this gives them a significance beyond the recognition of their immediate environment. Social instability and ideological confusion have become the main targets of their representations: in a strange way, through the

imaginative restructuring of quotidian realities they manage to produce enduring images about madness, chaos and tragedy as conditions for the redefinition of contemporary Greek subjectivity.

Their transgressive realism is the product of heightened imaginative revisioning of actual existence, a process attributed to the paradox of their anti-realistic realism. They do not produce healing fictions for a culture in deep implosion, or escapist utopias for its ideological legitimation: they carnivalise its symbols by ambiguating and problematising their style, authority and semiotics. Thus they transform the cinematic screen into 'the third space' where the radical potential of each filmic reality is emphasised. They decolonise audiences from ideological obsessions, gender fixities and class conformism. New representations emerge through the constant hybridisation of techniques, styles and stories that characterises their work – and they depict naked experiences of reality without aestheticised temporalities or escapist fantasies.

Their images are not cathartic but apotropaic: they objectify the trauma of history, and mobilise visual thinking to deal with the questions of a new cultural imaginary in a challenging and radical manner, which the official ideological apparatuses of the nation state never managed to do, or were never willing to allow. If their images are confronting and unpalatable, without the exoticism of the habitual Hellenic euphoria for tourists, that is because the face of the beast is itself confronting and unpalatable. The paradox of this spectacle being simultaneously their angel and their demon lies at the heart of their creative *unimagining* of all dominant codes of representation. With them the trajectory inaugurated by Cacoyannis is completed, brought to its end and reoriented: their anti-realism becomes the only mode of representation that can foreground the unreality of fantasies. It remains to be seen what happens next. During this age of anxiety, confusion and collapse, there is a strong feeling that something interesting will be achieved – and as the Australian writer Patrick White said, 'only those with imagination are able to see reality'.

# 2

# The Construction and Deconstruction of Cinematic Realism in Michael Cacoyannis' Films

## The return of the stranger

> Probably, there is a dark side in me.
>
> Michael Cacoyannis[1]

When Michael Cacoyannis (1922–2011) moved to Athens from England in 1952, he immediately recognised the soft and luminous landscape of the city and its environs as his personal cinematic language. He hadn't been in Athens or in Greece before, as he had been born in Cyprus, into a genteel family of colonial officials; his father was the first Cypriot to be knighted by the King of England. The Attic landscape was scarred by the ravages of a decade of successive wars but not yet deformed by intense industrial development or inordinate urban sprawl. The wide openness of space, concentrated around small neighbourhoods with small houses looking towards each other around a shared courtyard was one of the characteristics of its urban architecture that fascinated him. The successful translation of such a communitarian urbanscape into a visual idiom representing the existential adventure of its inhabitants became one of the most emblematic achievements of Cacoyannis' filmmaking.

In Athens, the young cinematographer also discovered the Greek film industry in a state of fervent reconstruction following the near destruction it had suffered during the 1940s. His immediate contribution can be seen in the context of both 'film culture' and the 'cinema industry' of the country. His arrival coincided with the gradual proliferation of studios around the capital and the competition between them for new stars, catchy storylines and fresh ideas. The pro-British and pro-American political orientation of the country secured his position, as he was to become one of the central figures of liberal conservatism in the cultural politics of the country. Together with his support of the political establishment, Cacoyannis had some very personal ideas, and these motivated him to change

established visual practices or patterns in film production by giving a distinct transnational character to his films, a practice which would be completed by using Walter Lassally as his principal cinematographer. He was not simply making movies; he was recreating the history of cinema, strenuously attempting to construct a functional visual language for the local experience. Gregoris Gregoriou, one of the central figures of postwar Greek cinema, emphasised that even with his first film 'Cacoyannis captured the pulse of the Greek audience with the least possible compromises. It was an enviable achievement, as his subsequent cinematography confirmed.'[2] The achievement was not, however, without a deep psychological anxiety. In a confessional statement to Christos Sfiakos shortly before his death he revealed his attempt to reinvent himself as 'Greek':

> I frequently reflect on what I am and I finally decide that I am a *Philhellene* [emphasis added]. I consider this term quite significant, as it proves that I worship something that was not given to me by definition, but, on the contrary, it was a virtue that I consciously acquired.[3]

This statement indicates his deep identity dilemmas, which can be seen both as visual project and cultural concern throughout his work; at the same time, they express the underestimated autobiographical impulse that informs his films. Cacoyannis was an outsider who became an insider, but never ceased feeling an outsider.

With his first feature film, *Windfall in Athens* (1954), Cacoyannis attempted something innovative: while most directors, especially of the pre-war generation, struggled to domesticate their camera within the possibilities and the confines of the studio and so enable themselves to be in command of its effects, he dared to take it out in the open and explore the bustling realities of a society which was still struggling to cope with the challenges of the present and the grim memories of the recent past. Such a risky exodus from the safety of the studio to the uncontrolled ambiguities of the open reality established a particular form of ever-expansive realism that was his distinct contribution to the development of cinematic realism in the country. His first film frames what André Bazin described as: 'not certainly the realism of subject matter or realism of expression but that realism of space without which moving pictures do not constitute cinema.'[4] From his very first film, Cacoyannis' camera focused persistently on the urban skyline, the streets, the houses and the movement of people through them in a continuous spatial unfolding without horizons. By moving it amongst them at an almost frantic pace, Cacoyannis was the first director to liberate the camera

frame from the revered immobility of prestigious family portraits and the allure of photographic stillness.

The successful formal achievement of his first film entailed a 'psychologisation of space' that allowed him, as a director, to proceed with the investigation of emotional complexities and conflicts – not simply as social facts but, more importantly, as internalised psychological events. Cacoyannis' second film, the demotic musical *Stella* (1955), not only consolidated the art of narrative cinema in Greece but also established a tradition of cinematic exploration of what constitutes the specificity of 'Greek national cinema'. If there could be a social and cultural institution that might be called Greek 'national' cinema, then it was undoubtedly established by Cacoyannis with this second film; in this he fused many elements of cinematic grammar that had been developed by earlier local directors, thereby creating a continuous narrative, sequence unity and expressive *mise-en-scène*. By synthesising all these elements he developed a functional form of representational realism which was to reach its full potential in his next films and would make him the founder of a new cinematic culture in the country.

His third film, *A Girl in Black/Koritsi me ta Mavra* (1956), depicted the Greek countryside, the presumed centre of all national authenticity, as the *topos* of an ongoing conflict between modernity and tradition. Until then, in the few instances in which the issue was addressed, films depicted the conflict in a naive and distinctly anti-modernist way: accepting the privileges of modernity, in the form of technology, but simultaneously rejecting its morally dangerous pluralism and subversive social criticism. Cacoyannis insisted on depicting the impact that such a conflict had on individual psychology, social mobility and interpersonal relations, especially on the position of women in Greek society. He was the first director to present modernity not as a conspiracy or a sinister destruction of traditional values but as a promise of social justice, gender equality and individual empowerment. From that starting point, he expressed a strong liberal humanism, a humanism that was cautious about radical changes but that strongly foregrounded the values of libertarian bourgeois culture. *A Girl in Black* constructed the first complete character in Greek cinema, a recognisable individual, denuded of romantic idealisation or superfluous sentimentalism, and without the expressive hyper-illusionism and sonic sensationalism of his second film.

At the same time it established a new form of narrative realism, without the emotional and rhetorical excesses of *Stella*, by foregrounding collective mentalities and depicting implied mental structures about gender, class and sexuality. With this film Cacoyannis completed his project of narrative realism by visually framing the 'experience of something observed'.[5] With both films, he revisited the

The Construction and Deconstruction of Cinematic Realism

traditions of John Grierson's British documentary school and collaborated with the German-British cinematographer Walter Lassally, who became his personal visual lens as he moved from the formal realism of his early films to the symbolic and poetic realism of his work in the 1960s. Together with Grierson's ideas and to some degree those of Humphrey Jennings, Cacoyannis' visual practices relate to the observations of the theorist of classical realism, Siegfried Kracauer, who stated that:

> When you have watched for long enough the surface of a river or a lake, you will detect certain patterns in the water which may have been produced by a breeze or an eddy. Found stories are in the nature of such patterns. Being discovered rather than contrived they are inseparable from films animated by documentary intentions.[6]

Indeed the 'found moments' that seem to have fallen almost accidentally into the frame of his camera constitute the central aesthetic contribution of his early films, as they were transformed within the context of the film, foregrounding what he called 'the emotional cohesion of real life'.[7] Cacoyannis was the first director to realise that the prime focus of a camera was to capture fluidity and speed; as he stated: 'some of the best shots in my films were realised when this mechanism was so active as to capture one single unpredicted moment'.[8]

His last film of the 1950s, *A Matter of Dignity/To Teleftaio Psema* (1958), brought his camera back to the changing urban environment as it explored the collapsing traditional Athenian aristocracy in its humiliating compromise with the ascending *nouveaux riches* and the gradual domination of the petit bourgeoisie. The film depicted the inability of the traditional elite to maintain its status and authority within the rapid capitalist commodification of values, practices and relations. The bourgeois collapse was illustrated in diverse spaces, almost in the manner of Gustave Flaubert and Guy de Maupassant, as the aristocracy transformed itself into a spectacle, an object of nostalgic elegance and grace, in order to be sold at the highest possible price. The central actor, Elli Lambeti, played her role of the living commodity – as the daughter who was to be married to a wealthy upstart – with sublime detachment: yet what looks so 'beautiful' is in reality her personal tragedy. Manos Hatzidakis' music, with its disparate sonic references to jazz, foxtrot, popular Greek tunes and classical music, underscored the confusion and internal anxiety of the characters as they struggled to maintain their obsolete social distinctions and hollow personal dignity. Lassally's photography 'dived' into the depths of each frame while circling with affection and tenderness the bodies of the actors in their most intimate moments of humiliation and emotional

defeat – and the reality of defeat and trauma is what comes through most of his films thereafter. It was a drama about the deep changes that the traditional bourgeoisie was going through as Greek society was entering its rapid industrialisation, and was the first to depict the rise of the new ruling class of the petit bourgeoisie. Cacoyannis later said he felt that some scenes in the film were amongst 'the most successful things'[9] he ever did.

Cacoyannis' development as a director during the 1950s indicates that from the very outset of his career he had begun to articulate what was to be the first complete narrative storyline in Greek cinema, situating it within its historical context and finally extracting from it the aesthetics of 'sculptural realism', his central cinematic language and medium in this period. The main aspects of such realism are the tendency towards symmetrical shots, the deep space between forms, and the dominant position of objects. He also reinvented the proxemic patterns of his camera, from the intense close-ups and frantic jump cuts of his second film to the medium or long shots of his later films, recalibrating territorial depth and spatial continuity in his attempt to create a detached and critical view of the reality depicted. (Later, in *Electra* (1962), he would achieve a functional harmonisation of both.) Furthermore, drawing from ancient Greek vase representations, Cacoyannis demanded 'an austerity in composition and framing' because 'in the tremendous sharpness of the Greek light, even the convention of make-up becomes unacceptable: faces must retain the earthy texture of stone in order to become alive'.[10]

With his first four films, Cacoyannis' cinematic language drew from Italian neorealism and French poetic realism infused with techniques, styles and devices borrowed from the Soviet montage tradition, the British documentary film movement and Hollywood patterns of storytelling. His sculptural realism synthesised all these visual styles and languages in a way that had never been done before in the local industry. However, realism was the original habitus of his camera, not its ultimate destination: starting with the immediate, the palpable and what he called 'the linear simplicity of the Greek landscape together with the imaginary proximity to nature',[11] Cacoyannis moved to the sphere of the symbolic, the transhistorical and the mythic in the second decade of his development. His transition can be discerned in his exploration of the formal possibilities offered to him by the cinematic medium itself; the creative fusion he achieved between the Hollywood tradition and the postwar European cinema of Vittorio de Sica, Ingmar Bergman and (especially) Roberto Rossellini allowed him to experiment with the camera and its possibilities to depict what could *not* be seen within its frame. The film that encapsulated the transition was *Eroica/Our Last Spring* (1959/60), in which

poetic realism, expressed through the eyes of nostalgia, framed the ubiquitous trauma of the 1922 Asia Minor Catastrophe in an archetypal and allegorical manner, as if the fate of a generation had in reality predetermined the future of a whole society.

After the failed production in the badly dubbed Italian *The Wastrel* (1961), Cacoyannis' visual idiom embarked on the exploration of complex symbolic narratives from the ancient Greek tradition, in his grand cinematic trilogy based on the tragedies of Euripides – *Electra* (1962), *The Trojan Women* (1971) and *Iphigenia* (1977) – which brought Greek cinema to the attention of a global art-house audience. The transition from the early sculptural realism to the symbolic hyperrealism of his subsequent films transformed his work into an exploration of the limits of realism itself and its potential to represent abstract pictorial patterns and liminal conditions of being. His understanding of the limitations of realistic representation can be clearly seen in his struggle to transform the camera into an active participant in the exploration of human form based on neoclassical aesthetics while at the same time maintaining the grand scale of the tragic universe. At the heart of such transition we can find a strange accident, the film *Zorba the Greek* (1964), with its 'episodic' narrative, which shows simultaneously the expressive potential and the impasses of his visual script. A film critic usually sympathetic to Cacoyannis, Pauline Kael, wrote about *Zorba* that 'the script is unconvincing and Cacoyannis' worst fault is choreographed grand sequences – set pieces – which the camera exposes as too neatly grouped, too obviously planned'.[12] The film is indeed too artificial, and, despite its length, it lacks narrative cohesion, which is given only at the end through the extra-diegetic element of music.

Unfortunately, most of the films he directed after 1964 seem like imitations of his own style, unable to construct a successful plot through a convincing script or to articulate a cinematic language with formal and stylistic cohesion. The subtexts, both compositional and social, with which he infused his films after the 1960s eroded the structure of his realism and undermined the self-sufficiency of its form. Theatricality took over and one could claim that after the 1980s Cacoyannis was a theatrical director even when he made movies. I suggest that after *Zorba* an epistemological rupture took place within his visual idiom which redefined his relation with space, movement and acting, closing down the openness of form of his first film. His ambitious comedy *The Day the Fish Came Out* (1967) lacked narrative cohesion, and its sense of humour was rather dated: the bright colours, the characteristic costumes, the electrifying music by Mikis Theodorakis and the hyper-inflated performances indicated that theatricality was taking over his

cinematic imagination. The open space of his earlier films had shrunk into the theatrical stage which gradually dominated his subsequent works.

## Industry and creativity

> There is no singular script in my work.
>
> Michael Cacoyannis[13]

The context for the production of his films is crucial in order to understand how his remarkable achievement in the 1950s lost its relevance in the next decade when Greek and European cinema went through a crisis of representation that was to dismantle the conventions and the styles that had formed their visual language after World War II. As mentioned before, when Cacoyannis moved to Greece in 1952 the urban landscape of Athens was still scarred by the traumas of the German Occupation and the Civil War (1947–9); at the same time, strict and intrusive censorship did not allow the indiscreet eye of the camera to explore the Athenian landscape as lived experience and cultural memory. The films that were made about the city until the mid-1950s were idealised war dramas, slapstick comedies or bourgeois melodramas – all of them made mostly in the confined space of a studio and providing idealised stories about the recent past without any context. The camera neither was allowed, nor allowed itself, to look around in order to record or unearth the hidden stories of the ordinary citizens who had endured ten years of immense suffering and persecution.

Precisely because of his 'otherness', Cacoyannis was able to see the rhythm of lived temporality and the pattern of its spatial manifestation in an urban reality that was rapidly changing. The German Occupation and the Civil War had left the country in a state of deep trauma, which censorship and the oppressive mechanisms of the state precluded from representation and, consequently, cathartic objectification. The state of collective psychological trauma was not represented; the defeat of the Communists in the Civil War erased the memory of their resistance against the Germans. The silenced trauma of the Asia Minor Catastrophe was also re-enacted, with the freedom fighters in exile or in prison and the anti-Communist collaborators in government. The trauma could be seen everywhere in the cityscape, in the behaviour of the people and in the relations between the state's apparatuses and its citizens. It was not allowed, however, to be conceptualised or even articulated on any level of public communication without fear of persecution and exile; it remained codified and cryptic. Most movies of the period are indeed films *à clef*, sometimes extremely obvious in what they referred

to but on other occasions totally opaque and impenetrable. The ubiquitous censorship frustrated every attempt to tell the story of the collapsed buildings, the missing roofs and the destroyed roads. Consequently, every depiction of what was out there constituted dangerous conduct, entailing self-exclusion and marginalisation, and therefore led to self-censorship and consequent psychological displacement.

Most directors after 1949 had to tread very carefully in order to make their films without incurring exile or banning. In the aftermath of the Civil War many actors, directors, screenwriters and cinematographers were sent to remote and barren islands for 're-education'. What in the 1960s were to become landscapes of authentic 'Greekness' and 'Mediterranean allure' were in reality places of punishment and dread, landscapes of horror and violence, of experiences that could be expressed only indirectly. During this period of intense social turmoil, cinema became the central medium through which Greek society reflected on its own structure, cultural memory and traumas; it was a period of high realism for the arts, which replicated the Greek world with the faithfulness of a photograph. Cacoyannis was the first cinematographer to deal with these lingering questions by compiling a visual language that articulated a complete narrative about individuals and their society in their organic interconnectedness. In a sense, Cacoyannis was the organic intellectual, in the Gramscian understanding of the term, for the conservative ideology because he embodied – or at least tried to embody – the regime's liberal conservative values, divided as they were between the progressive agendas of the postwar reconstruction and the fear of a socialist revolution. His cinematic realism, as a political statement, was dichotomised by competing values: the intellectual necessity to depict the contradictions of reality and the ideological fear of giving these contradictions a political expression.

From another point of view, Cacoyannis was the type of intellectual Michel Foucault characterised as the 'specific intellectual' whose:

> essential political problem is not to criticise the ideological contents supposedly linked to science or to ensure that his own scientific practice is accompanied by the correct ideology but that of ascertaining the possibility of constituting a new politics of truth. The problem is not changing people's consciousness – or what's in their heads – but the political, economic, institutional regime of the production of truth.[14]

Following Antonio Gramsci's suggestion about 'organic intellectuals', Cacoyannis never distanced himself from any political involvement; he stood for the principles

of liberal humanism and his work has to be seen within the context of the internal contradictions of conservative liberalism. Here we can also detect the structural dichotomy that undermined the cohesion and continuity of his work; 'the tinge of neorealism'[15] that we find in his early films came into a deep conflict, after the 1960s, with ideological 'representationalism', in which historical experience was absent. The internal conflict became obvious after his disillusionment with Greek political democracy, especially after the 1967 Dictatorship, when he had to leave the country and live in Europe and the United States.

Indeed the hyperrealism of his films in the 1960s collided with a social reality that was becoming increasingly unstable, dangerous and incomprehensible. Cacoyannis' response was a return to myths, to the classics and to the universe of sublime conflicts and ritual purifications. Like every modernist before him, he found in classical myths the missing and desired equilibrium, the 'mythical method' that had inspired James Joyce and, amongst his compatriots, the writer of *Zorba*, Nikos Kazantzakis. His personal development as a filmmaker was the story of many modernist artists before him – with George Seferis[16] being the intellectual exemplar of such an approach – and, in a strange way, also later of his cinematic antithesis, Theo Angelopoulos. For reasons that had to do with their disillusionment with certain collective projects of modernity (liberalism in the case of Cacoyannis and socialism in that of Angelopoulos), they retreated from contemporary history and found refuge in the archetypal structure of ancient myths, in which the turmoil, fluidity and the instability of reality were eliminated. Although Cacoyannis himself avoided all classical references (*Stella*, for example, takes place on the slopes of the Acropolis hill but the Parthenon is only seen once, fleetingly), his tragedies look more like exercises in symbolic dehistoricisation. Yet both history and autobiography can be found firmly encoded within these film: if we go beyond the obvious neoclassical fantasies and idealised projections, his *Electra* (1962) is closer to Lawrence Olivier's *Hamlet* (1948), with the emphasis on the oedipal fixation on the absent father and the sexual antagonism with the mother. Indeed we could claim that *Electra* is a prime Freudian text, exploring the destiny of the postwar generation and its relation to the myths, institutions and emotions of the recent past as epitomised by the dominant and sexually active mother-figure after the assassination of a dangerous and amoral father – a theme also explored by commercial directors of Greek cinema, constituting the *cinema de papa* in the local context.

*Electra* is more about primal narcissism and less about politics or classicism, as it depicts the frustrated struggle of the young to enter the world of adulthood by passing through, or escaping, the networks of power and the machinations

The Construction and Deconstruction of Cinematic Realism

of control the adults have created in order to maintain their power and authority. The drama caused by external conflicts is internalised; it is not simply about the new generation taking over but about the old generation fighting back and destroying the ability of the young to question, react and believe. Ultimately, it becomes a drama about personal identity as the children find in their own psyche the presence of pernicious parents who dominate the external horizon of history and the internal landscapes of their being. In a sense, *Electra* is a very personal film: it is both about the destiny of his generation and an autobiographical comment on the director's personal formation. Cacoyannis also indicates that it is 'about the burning confrontation of individual guilt',[17] which accounts for the disturbing psychodynamics latent in family life that seem to dominate the film.

When in 1965 he collaborated with Jean-Paul Sartre in the stage production of *The Trojan Women*, Sartre observed that Euripides' tragedy was at the time of its creation 'a sort of allusive commentary on the conventional stereotypes' and that he used the 'conventional stereotype in such a way as to destroy it from within'.[18] Cacoyannis infused the tragic form with tense psychosexual energy, so that his realism evolved into archetypal symbolism aimed at destroying the authority of venerable symbols, or symbolic forms, from within. This is the strong subversive element in *Electra* which he persistently avoided in his other two filmed tragedies. The electricity, for example, between Orestes and Electra at the moment they killed their mother (so suggestively depicted by the sudden touch of their hands, which terrifies them) indicates the latent sexuality that permeates the story. The matricide, however, instead of liberating them, makes them homeless – Cacoyannis' reference to the dominant atmosphere of postwar existentialism.

## Interfilmic transcriptions

> *Windfall in Athens* was a comedy inspired by the frenzy of Athenian streets.
>
> <div align="right">Michael Cacoyannis[19]</div>

Cacoyannis' first film was a hilarious, yet provocative, comedy. It was Greece's entry at the 1954 Cannes Film Festival. *Windfall in Athens/Kiriakatiko Xipnima* (1954) was a comedy of errors, similar to French, Italian and British comedies of the period, full of vivid dialogue, sparkling humour and genuine cinematic innocence. The film is about a young girl called Mina whose lottery ticket was stolen as she was swimming. Two children took her bag and sold its contents, including

the ticket, the number of which is her birthday. It is subsequently purchased by Alexis, an aspiring songwriter and musician, who lives a life of idleness punctuated by dreams of success. When Alexis wins millions, Mina launches a public campaign through the media and, finally, the court system to retrieve the money. She is assisted by a famous lawyer who, partly moved by her innocence and partly enchanted by her nascent sexuality, stands by her, being subconsciously sexually attracted, despite the negative reaction of his jealous wife. The court decides in favour of Alexis. However, Alexis likes Mina and offers her one-third of the money. She declines, but a mutual attraction is born between them, and in the end, now in love and inspired by the prospect of marrying, they kiss each other and share the money.

The story itself is neither exceptional nor original. It is the whole *mise-en-scène* by Cacoyannis and his approach to the visual material that really makes the difference. (He also wrote the script.) One can even see this film as an experiment with timing in filmic narration and as a precursor to his next film. The film's story unfolds within a strange and paradoxical context; it has to be situated in this context in order to be understood and for its impact to be realised. Upon its release, the film was an immediate success, second in ticket sales only to another musical comedy. Twenty-two films were produced that year, most of them at the Egyptian Studios in Cairo and Alexandria. The camera of Cacoyannis' film belongs to the Italian cinematographer Alvise Orfanelli, resident in Alexandria, who even in the studios of Cairo, was able to capture an authentic Greek atmosphere through spontaneous movements, genuine facial expressions and hilarious vernacular dialogue, probably because of his contact with the then thriving and prosperous Greek community of Egypt.

The main theme of Cacoyannis' comedy is a presumed deception and unfair loss – the notion that an invisible network of operators does things beyond the control of ordinary people. Seen under the light of its structural morphology, the story in the film has a pattern: innocence – deception – loss – recognition – reconciliation. The whole story is about transgression and redemption through the catalytic influence of emotional reconciliation. The main sequence of events is triggered by the mischief and deception of the two little thieves who stole Mina's belongings in the first place. It is also interrupted by the trickery and the deception of the venerable lawyer, whose sexual advances delay the story, creating confusion in the main female character and testing her ability to choose correctly, as well as provoking moral expectations in the audience. The appearance of the lawyer's wife also tests the limits of Mina's actions and transfers her struggle to the level of unconscious intentions and displaced desires.

## The Construction and Deconstruction of Cinematic Realism

Both main characters have no father – and the lawyer is more of a father figure than a sexual presence. The representation of parentless children in this film is interesting, as in Cacoyannis' subsequent films, parents, especially sexually active mothers, become negative catalysts and undermine the psychological stability of their children. This can be seen in *The Girl in Black* (1956) in particular, and later on in Cacoyannis' depiction of the matricide of a sexually active mother in *Electra* (1962). The same obstacles are introduced for the male character, Alexis, who has to overcome his childish flirtatious behaviour, especially towards his flippant landlady, and his opportunistic use of his sex appeal, in order to recognise the ultimate purpose of his good luck: self-realisation through the acceptance of another person. His victory over external and internal obstacles manifests itself in his denunciation of his good fortune and his offer to become the guide and the hero of Mina's life: at this point he has become his real self – a cultural hero who composes music and songs and possesses unexpected wealth, the dream of the rising bourgeoisie. Furthermore, around the adventures of the two protagonists Cacoyannis weaves the minor stories and adventures of many other characters, some of them without any relationship to the main story, except as catalysts for the narrative to unfold.

Vladimir Propp called such components 'narrattemes', as they complete the sequence of the fairytale;[20] they can be found here within an urban landscape, in a modern fairytale of trial and success, tribulation, recognition and reconciliation. Cacoyannis is the first director to intervene in the script in order to give structural cohesion to such urban fairytales. His close associate and cameraman Walter Lassaly observed:

> Michael Cacoyannis and I saw very much eye-to-eye in visual matters, and his script for the film [*Girl in Black*] was one of those rare ones where the scenes were already broken down into actual shots, making it into a shooting script which was both meaningful and practical. As he was the writer/director, the script was really a notebook for himself, reminding him how he had visualised the action.[21]

Lassaly emphasised Cacoyannis' visual sensibility, which focused on solving formal aspects of the cinematic language in order to address questions of representation and acting. By breaking down action into 'actual shots' he could use the camera to construct a visual narrative as well, linking the episodes of action through conventional filmic strategies of representation. Cacoyannis established a meaningful correspondence between script and image, in an organic way, privileging the visual over the verbal and discarding altogether all language that could

not be transformed into visual motion. In a way, he departed completely from the tradition of the French inspired *cinéma de qualité*, which still used image as a by-product of novelistic narratives. On the other hand, it was a period when the need for good scripts was intensely discussed in Greece: Vion Papamichalis, one of the most important critics of the time, stressed that 'the greatest danger which threatened all Greek film production was the absence of good scripts'.[22] Throughout his life Cacoyannis himself remained extremely sensitive to the question of scriptwriting:

> In order to make a movie, we must first write the script, by all means. Words pre-exist so that we can be certain that the necessary form can exist also, necessary not only for the dramatic construction of a scene but also so that certain rules can be respected relating to the economy of the script itself. However, I am not primarily a scriptwriter and not a director; I was forced to write my own scripts, since it was the only way for the doors to open: it later became the rule. My scripts do not need psychological instructions; they were produced by the roles themselves and the situations. In the theatre I was restricted, [but] … in cinema I was liberated from the geography of the stage and its restrictions, so my mind could expand towards everything.[23]

*Windfall in Athens* was the first film to have a well-paced script and effective timing in the transition from one scene to another, and probably the only film until that time with no serious gaps in continuity. With his first film Cacoyannis made possible the transition from a script based on a book to a script written specifically for cinema, with the translation of recognised stories into the visual language of images with compositional unity. In order to achieve this, he avoided distinct episodes and flashbacks, which could have disrupted the emotional climax of the story. The film introduces both protagonists concurrently and the viewer immediately understands their role in the story, which is ultimately a *Bildungsroman*, the fictional rite of passage into adult life as prescribed by modern capitalist society, from poverty to wealth. The symbol of lottery money foregrounds the unpredictable character of modern social mobility, especially after the 1950s, when new social forces began to prevail against the lost supremacies of pre-war aristocracies. Money won in the lottery offers the opportunity to break through traditional structures and enables the individual to fulfil their dreams and aspirations. (See Figure 2.1.) Mina belongs to another 'order of things', as her sister says: 'Take the money and do with it … what they call … I don't know, something like clothes … vestments …' 'Investments,' Mina replies. 'Yes, that,' her sister agrees. It is interesting to point out the different way another humanist cinematographer, Yorgos

# The Construction and Deconstruction of Cinematic Realism

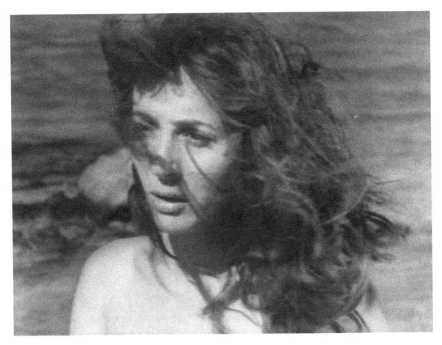

Figure 2.1: Michael Cacoyannis, *Windfall in Athens* (1954). The face as cultural geography

Tzavellas, depicted the commodification of emotions in his great film of the same year, *The Counterfeit Pound/I Kalpiki Lira*: 'Love is not fake – only money is fake,'[24] the narrator concludes in that story.

The camera always frames couples, two figures together. Also, although the camera produces many close-ups as a discreet bystander, it generally remains at a distance, framing medium shots that are reminiscent of newspaper photographs and impromptu snapshots while alternating states of frenzied movement and moments indicating the inner discipline of character – a mode of depiction that would also dominate Cacoyannis' *A Matter of Dignity* (1958). Yet the body is at the same time released from its middle-class reserved respectability and gains an enchanting and graceful fast movement, something that Cacoyannis explored in his subsequent films with subtlety and sensitivity.

Peter Cowie observes that Cacoyannis was one of the first European directors in the postwar period to have 'already shot scenes on location in city streets for his first film *Windfall in Athens*, while the French and British, for example, were still very much confined to the studio environment';[25] Greek film critic Nikos Fennec-Michelidis has also pointed out the direct references by Cacoyannis to Luciano Emmer's *Domenica d'Agosto* (1951), with its neorealist settings and the

documentary style that would make Emmer one of the best directors of the genre in Italy.[26] René Clair's *The Million* (1931) probably provided the original theme of the lost lottery ticket and must also have inspired the film's 'musical' style of acting; Cowie notes that 'Clair's actors seem to express with their movements the same zest as a singer does in his songs.'[27] Elli Lambeti's acting was distinctive for its ebullience and enthusiasm; Dimitris Horn also gave an amazing performance, oscillating between the unconventional artist he wanted to be and the respectable bourgeois he was by birth. As in Clair's film, acting was an enhancement of vivid sound and music, through a vivacious choreography of gestures and emotions, exploiting at the same time the famous love affair between his protagonists in real life. Cacoyannis was one of the first directors to use the filmic persona of his actors as a comment on their actual personality, something which in *Stella* (1955) would indeed invent the persona and the personality of Melina Mercouri.

In terms of form, Cacoyannis' references to other films, a practice that the director would repeat in most of his mature work, indicates his deep awareness of cinema as a medium with its own history, grammar and patterns of articulation. By adopting frames and scenes from Emmer and Clair, as well as from popular Hollywood films, Cacoyannis became the pioneer in Greek cinema of what might be called *inter-filmic transcriptions*, extracting a specific scene from its original filmscape and placing it in a completely different context in an act of cinematic and visual acculturation. Interfilmic transcriptions give his work, especially of this period, a deep aesthetic and narrative complexity: he rewrites a shot by inscribing it into a context of different references and different cultural connotations. This would become the hallmark of the cinematic language he consolidated, especially with *Stella*, in his attempt to construct a visual idiom based not on literary inventions but on purely cinematic devices, such as expressive acting, functional montage and effective narrative timing.

Gerasimos Stavrou also pointed out the special skills of the director in his first film:

> Despite the simplicity of the story, cinematic narrative unfolds with ease, diversity, rhythm and very sophisticated taste. The director's imagination is extremely rich because it knows what to use, knows what to see and how to see it.[28]

Finally, as the famous journalist and film critic Eleni Vlahou stressed:

> This is not simply 'a noble effort', or a 'step of progress'; this is simply *a film* … which can freely travel, go to Cannes, be screened

The Construction and Deconstruction of Cinematic Realism

in festivals, where it might receive no awards or distinctions, but it won't shame its miserable country, which in itself is a major landmark.[29]

Consequently, Cacoyannis had a role in the consolidation of the conservative liberal ideology in Greece, as his work was the site of convergence between conflicting social texts, codes of representation and visual potentialities. Within this site one can also detect subtexts on gender, especially masculinity, and the rise of new perceptions of feminine social roles. With his early films the narrative was mostly focused around family melodramas and domestic spaces, establishing the template for all the later films that explored the hidden life of families. The other implied subtext, sexuality, is also a strong element firmly incorporated in his early films: unfortunately, Cacoyannis never allowed himself to address openly this aspect of his creative language. However, in order to understand this strange, and somehow distracting, evasion we must revisit his first films and look more closely at how he pieced together their visual grammar.

*Windfall in Athens* imported a considerable part of European cinematic history into Greek film production; with his next film, Cacoyannis would take on the great fear of Hollywood. References to films such as *Stella Dallas* (1937) and *From Here to Eternity* (1953), and to American musicals and westerns, abound in the film. His interfilmic transcriptions need to be studied carefully, because they have contributed significantly to a distinctly cinematic grammar of visual perception, something that had, until then, been used only infrequently and spasmodically, by directors such as Yorgos Tzavellas. The visual regimes that have since dominated Greek film production were founded by these early works. In *Windfall in Athens*, his first unproblematic film, Cacoyannis managed to explore certain themes that were extremely risqué for the period, avoiding all forms of melodrama with the comic relief offered as closure at the end. Indeed, the distraction scenes depicting the sexual advances of the married lawyer insinuate into the main story a theme that would be foregrounded in Cacoyannis' next film, *Stella* (1955), a film that sees Cacoyannis turn his camera towards the question of what happens when institutions, social roles and expectations overdetermine human choices. Beyond its gender exploration, *Stella* is a film about women's capacity for moral agency within a patriarchal society.

Although *Stella* is his most popular – and over-studied – film, Pauline Kael found it 'crude, vigorous' and an 'overcharged melodrama', and concluded that 'the movie doesn't have the grace of Cacoyannis' later, more subdued *A Girl in Black*, but it's a triumph of temperament'.[30] One can make the same observation about

his first film, in contrast to *Stella*: it is a film without the emotional and rhetorical manipulation of the latter. It makes its audience feel at home at the movies by seamlessly extending the domesticity of a communitarian life to an urban reality and way of living. *Windfall in Athens* transforms the landscape of Athens into a friendly, positive and life-affirming presence, by insisting on the specificity of its mundane components and on the idealistic notion that pre-capitalist modes of being can coexist with capitalist forms of social organisation. What dominates its temporality is the sense of the present moment, of a vivifying simultaneity that transforms the mundane existence of the modern middle class into an exciting and promising wonder.

*Windfall in Athens* is also a parable about the illusion of innocence, the discovery of the complexities of the world and the disruptive function of modern institutions. And as noted elsewhere, Cacoyannis is:

> interested in representing complete human characters, with their internal life, dilemmas and follies. The representation of individuals as 'psychological beings' living in an internal reality of their own soul and making failed or successful attempts to communicate became the dominant theme in his films.[31]

With his first film, Cacoyannis explored the ways in which the young generation was socialised and conditioned to accept predetermined gender and social roles. Yet one could say that, formally, Cacoyannis was still trying to find his 'voice'. He had directed a farce, an intelligent satire of the rising petit bourgeoisie, during its ascent to power in a period of reconstruction. Despite its comic sense, characterised by witty dialogue, fast editing and funny situational misunderstandings, the film overall is a rather serious depiction of a society in a state of intense social mobility. Many social references, such as the role of the press and the judiciary, indicate the tensions that give this film its latent political edge. What is absent from its story is also important. Cacoyannis was cognisant of the fact that certain themes needed to be depicted without actually being articulated. In other words, they needed to be part of the plot but not of the story, and to be presented in a way that allowed them to escape being noticed by the censors – or indeed the audience.

Comedies, especially during the postwar period, typically ridiculed authority and its servants. The invisible authorities – the government, the army officer and the secret police – were the central targets of Greek cinema in this period, and one could certainly claim that the invisibility of power in the film was a response to its ubiquitous intrusion into daily life. However, in the spirit of his early humanistic

As I have argued elsewhere, *Stella* has a precursor: Maria Plyta's *Eve/Eva* (1953), a film made by the first woman director presenting women as sexual and moral agents. Cacoyannis seems to have been influenced by Plyta's unique and disturbing film, which needs further study in the way that it constructed a feminine image for the cinema.[36] Yet his is still a masculinist fable about femininity with continuity problems in both script and composition. Lindsay Anderson, in his report from the 1955 Cannes Festival, seems to have noticed the formal and ideological discontinuities of the film when he wrote: '[Coco]yannis' style is less mature ... and there are times when he is apt to overplay his hand; but the full blooded gusto of his film is extremely engaging.'[37] Indeed Manos Xatzidakis' music holds the story together with its effective fusion of diverse sonic auralities. In the final scene of dancing with two different styles, in two different rhythms and out of two different worlds, Cacoyannis brings everything together with an ingenious use of montage which gave him the opportunity to juxtapose the symbiotic yet competitive existence of opposing temporalities in Greek society.

Because of the competing social and aesthetic agendas in its structure, *Stella* can be inscribed within diverse interpretive paradigms: the fact that the feminist cause has been taken over by men, who constructed a fantasy about feminine presence and indeed kill her at the end, must suggest that the metaphor is more about the imminent loss of masculine power than about women's liberation. Furthermore, I would suggest that the film is about 'castration anxiety', the fear of 'a penis without a phallus'[38] and the moral panic of patriarchal authority when confronted by the liberation of women – and not about the liberation of women as a political issue. More than that, it is about the control – and ultimate destruction – of feminine desire and its expression within a given social order. In the end, Stella accedes to her own death, as she has already surrendered her free will to the patriarchal system. She is the voluntary sacrifice to the omnipotent masculine authority, which simply confirms, through her death, the inability of women to live unmarried and uncommitted. The romantic association of desire with death is another unsettling aspect of the film: women who desire must be assassinated, a symbolic theme in many conservative societies. The internalisation of women's inferior position is another stunning feature of this film; this would find its most poignant depiction in the assassination of the nameless widow in *Zorba* (1964).

Beyond this, the realism of the film is not to be found in the characters but in its exploration of urban space. Cacoyannis stated that 'the popular entertainment venue *Paradise* existed in Athens. I was always of the opinion that it was better to use existing spaces instead of constructed artificial ones.'[39] The camera of Costas Theodoridis explored the streets, back alleys, playgrounds, backyards,

open areas and confined spaces in an almost Hitchcockian manner: the scene at the church, when Stella fails to appear for her wedding ceremony, is probably one of the most claustrophobic and suspenseful 'entrapment' scenes ever depicted in cinema. Also, the final scenes, when the camera uses a documentary mode to show the student parade for the national celebration, are equally telling: there has been no more effective depiction of urban alienation and estrangement. The camera roams over the faces and clothes of the bystanders while looking at them though windows, shops and kiosks or via their reflections on the wet streets. This slightly unfocused camera *verité* approach transforms the national day celebration into a place of anonymity that might save Stella. But as she surrenders to her own death, the drama has been decided, primarily within her; and Cacoyannis shows us the psychic impossibility of a woman existing without a male partner within a masculine order that ruthlessly punishes those who question the centrality of the phallus. Despite its popularity amongst feminist theorists, *Stella* is a film about what is lacking in masculinity, especially about the fear of mutilation and castration. It shows maleness experiencing a deep anxiety about its power and therefore being full of rage against those who question its domination. As Judith Butler observed:

> The law requires conformity to its own notion of 'nature'. It gains its legitimacy through the binary and asymmetrical naturalisation of bodies in which the phallus, though clearly not identical to the penis, deploys the penis as its naturalised instrument and sign.[40]

A woman who uses the penis, but does not submit to the power of the phallus, must become the blood sacrifice to the symbolic domination of both. Stella depicts the negative side of Cacoyannis' conservativism as it dramatises the internalised coercive mechanisms used to perpetuate a dominant order.

The positive side of his conservativism can be seen in his masterpiece of this period, the mesmeric *A Girl in Black* (1956). Pauline Kael wrote about the film:

> It's a strongly individual work – the camera moves fluidly over the dark expressive faces and the narrow streets; the Greek sunlight hits the white houses and the whole island seems exposed. Cacoyannis' script is much smoother than in his earlier *Stella*, but there is no adequate preparation for the startling last sequence, which may give you the uncomfortable feeling that a group of children are drowned in order to strengthen the character of the hero – a weak Athenian writer (intelligently played by Dimitris Horn). The film has a vibrant simplicity, though, and its defects are, at least, Cacoyannis' – they're not the results of compromises and studio edicts.[41]

The film was screened at the 1956 Cannes Festival together with Satyajit Ray's *Pather Panchali* (1955), Alfred Hitchcock's *The Man Who Knew Too Much* (1955) and Alain Resnais' *Nuit et Brulliard* (1955), amongst others. (The film won the Golden Globe Award for the Best Foreign Film that year.) In a sense the best scenes of the film stand for what Hitchcock himself claimed for his own film, as astonishing expressions of 'pure cinema'.[42] Indeed, no other Greek film between Gaziadis' *Astero* (1929) and Angelopoulos' *Reconstruction* (1970) achieves such effective morphoplastic equivalence between form and story. Dialogue, storyline and codes of representation work together so that the film frames a uniquely un-romantic tragedy, which despite its happy ending, exposes the micro-histories hidden under the idealised admiration of the 'authentic' Greek landscape: 'I know that you don't like this dry land,' says the main character. 'But you have the impression that everything is exposed to the light. Nothing remains hidden.' 'Not even the sins of men?' his friends asks – and the film is precisely about the hidden sinfulness of traditional societies.

The trauma of war has defined the life of the characters even before they become active in society. The children, and this is a film about the life and death of children, exist under the invisible net of past suffering, under the sins of their parents. The American critic Bosley Crowther foregrounded the most harrowing scene of the film:

> There is a hideous episode in the Greek film *A Girl in Black* ... that sends shivers down the spine and rather vividly indicates the climate of this modern Hellenic tragedy. It is when a young man of Hydra, sun-baked island in the Sea of Crete (sic), sets upon his own widowed mother in the open streets of the town and beats her for being a loose woman while the jeering townsfolk gather round. Passionately and wildly, the youth lashes at his mother's face, punches her with brutal fury and tears at her unloosed hair. And drawn to the street by the commotion, his poor, frightened sister pitches in and tries to pull him away from their weeping mother. It is a shocking, humiliating scene.[43]

The film starts as an escape from the ethnography of authenticity but culminates with the total shattering of all pretensions about the purity and the integrity of such ideological constructions. The final dénouement comes with the drowning of innocent children as death transforms the villagers from bystanders to the tragic chorus of a collective drama. The script avoids the excessive emotionalism of *Stella* and understates its theme: Elli Lambetti performs her role with austerity, motion-less, and almost emotionless. Cacoyannis used both professional actors and local inhabitants in an attempt to foreground the documentary value of cinematic

images – something strongly emphasised by Walter Lassaly's rich and deeply nuanced black-and-white camera work. The island landscape becomes itself the main protagonist in the film. It is the landscape that occludes all memory, which in turn impedes the individuation of the characters: they all live as parts of a natural timelessness. Their humanity, which emerges through memory and emotions, destroys them.

Before the emergence of mass tourism, the island of Hydra was the first place after the Acropolis to be transformed into an imaginary *topos*, through the work of the cubist painter Nikos Hadjikyriakos-Ghika (1906–94). If Cacoyannis' previous films were about time and duration, moving images in time, this one is about pure form, and about the solidity and the materiality of figural architectonics. Stylistically the film is a strange amalgam of Jean Renoir, Michael Powell, Carol Reed, Robert Bresson, Ingmar Bergman and Carl Dreyer; only in *Electra* (1962) would Cacoyannis try something similar, ritualising the natural landscape. Human forms 'pop out' of the interlocking planes of the closed and impenetrable landscape. Indeed they punctuate the massive spatial continuity, emerging as black vertical lines out of the colourless and historyless background. This is his most effective experiment in visual constructivism, a modernist problematisation of the 'nature of reality' as space generates continuous formal configurations unfolding a storyline like reliefs on a frieze.

With his next film *A Matter of Dignity* (1958), Cacoyannis enhanced his sculptural, neoclassical realism, achieving a continuous development of time and space, linking open form and effective characterisation. The script presents the compactness of an Aristotelian narrative: unity of time, space and action. What also keeps the narrative together is the nuanced performance of Elli Lambetti, as the young girl Chloe, suffering under her reckless mother and becoming the symbolic sacrifice to the new capitalist order. The dominant mother squanders everything on cards and lavish parties: she embodies a form of maternal domination, emotional blackmail, which disempowers and ultimately annihilates her own offspring. The film is a sad elegy to the suicide of the old patrician and the obsolete bourgeoisie; the unifying camera records its demise with an overwhelming detachment, or occasionally with remarkable ambivalence, contempt and empathy simultaneously. It also captures the hollow elegance and the inflated rhetoric of the old class system as it struggles desperately to retain its privileges and authority – but history is merciless. The new capitalist class appropriates their sentimentalist verbosity and uses it against them. Gestures, language, behaviour all lose their significance and are transformed into stratagems of marginalisation and expulsion from the new arrangement of power. Only at the end, as the miracle happens and the mute

child speaks, does the camera remain silent. The loud bells tolling overpower the human voice: only 'sonic vibrations' can be seen, as human forms against the bright white colour of the Aegean island, while the camera turns towards the sky as if in a leap of faith out of history. Lassally's sharp visual contours transform the screen into an open horizon: miracles happen and reality can embrace them. Despite its ruptures, reality is meaningful and there is a place for everything within the frame. This is similar to what Bazin pointed out about Jean Renoir:

> [he] uncovered the secret of a film form that would permit every-thing to be said without chopping the world up into little fragments that would reveal the hidden meanings in people and things, with-out disturbing the unity natural to them.[44]

The achievement of these films is indeed remarkable and didn't pass unnoticed. Lindsay Anderson saw the early Cacoyannis films:

> [this is] the young Greek director whose three films to date have shown such liveliness and versatility. From next Monday the Everyman are running an enterprising, three-week season of them – *Windfall in Athens, Stella*, and *The Girl in Black*. This is the kind of thing we need at home.[45]

So there may be some Cacoyannis influence in the later development of the Free Cinema movement in England and the emergence of the British New Wave in the 1960s.

Yet despite the certainty of his visual rationalism, what was standing in front of Cacoyannis' camera was unstable and elusive. It was becoming obvious that, after almost ten years in the country, this cosmopolitan dandy, who loved to exoticise the working class and proletarianise the aristocracy, had developed a firmer understanding of the traumas lingering beneath the surface of reconstruc-tion – and some of them were his own personal hidden traumas. The optimism of the first films – and indeed the certainty that humans can be in control of their destiny – began to be shattered by the anti-colonial war on his native island of Cyprus and the brutal reaction of the colonial British authorities. There was so much Britain in him, enhanced by the presence of Lassally that his whole visual perception began to be modified. What was standing in front of him as a pain-ful vestige of the past was silently recorded by the camera, almost like a dance of ghosts that could not be ignored any more. Some hasty shots over the destroyed roofs of houses in Athens, bullet marks on the walls of the city and the complete

silence about the past were the real indicators of some troubling realities that were fragmenting his neoclassical cohesiveness.

After *A Matter of Dignity*, his next film was *Eroica/Our Last Spring* (1959/60), a paradoxical work, appearing in 1960, the year his homeland, Cyprus, became an independent state and the division on the island between the Greek majority and the Turkish minority started to become obvious. The special significance of the film can be inferred from the fact that Cacoyannis had been working on its script since the early 1950s, but it didn't make it to film for almost ten years. The closed universe of Athens, the urban landscape where dramas unfold every day, withdrew; the sharp contours of bodies, the open geographies of the human face, the community of shared experiences and memories were all shaken. *Eroica* is about the last spring before the Asia Minor Catastrophe and shows that, finally, history had caught up with Cacoyannis. It takes place in a dreamlike past, the world of childhood, full of awe and wonder, before the gradual awakening of sexuality and the painful awareness of the imminent collective tragedy. Despite the great camera work by Lassally and the ethereal music by Argyris Kounadis, it fell short of capturing the atmosphere of enchantment that was so brutally lost in Smyrna. Most critics rejected the film. Walter Lassally wrote about it: 'It was a very romantic subject, full of symbolism and echoes of Greek tragedy, and gave me splendid opportunities for atmospheric photography.'[46] Indeed the film is a lyric tone poem, framed by visual softness, shallow focus and fluid imagery which indicated a new orientation of Cacoyannis' work, inspired by the French New Wave, especially the early cinema of François Truffaut, as well as the early British New Wave films by Tony Richardson and Karel Reisz, especially their film *Momma Don't Allow* (1955), which was, indicatively enough, filmed by Walter Lassaly shortly before he started his collaboration with Cacoyannis. It also indicates a very interesting latent dialogue with Hollywood again, especially with D. W. Griffith's soft focus camera in *Broken Blossoms* and *Orphans of the Storm*, working more on mood and less on realism.

The story is about a company of adolescents going through their rite of passage to adulthood; it is based on one of the most significant novels of Modern Greek literature, by Kosmas Politis.[47] During their last year in Smyrna, they experience love, desire, rejection and death, as a rehearsal for what was to follow the year after. The world of the adults is alien and remote; their realities never converge. The parents and their concerns are incomprehensible shadows, opening and closing doors at night or in the morning, playing their own games, ignoring the wonder of childhood and adolescence. (See Figure 2.2.)

Figure 2.2: Michael Cacoyannis, *Eroica* (1960). The face of hidden desires.

Cacoyannis' tangible realism was here diffused, muted and transformed into a dematerialised reverie. The lost city of Smyrna became the symbol of lost childhood, or perhaps of the sense of wonderment in the face of the secret desires of the human body, and of the tense cryptoeroticism energising the adolescent bodies.

Unfortunately, the film is miscast and the young actors were too young to understand the tragic generation they incarnated. The sense of trauma, loss and absence is aestheticised, and each frame in the end is transformed into a lifeless photograph. Stylistically, the film problematised the transparent realism of his previous works. Sharp figures were here diffused into each other, the landscape 'thinned' out as if it had no solidity in an oneiric simultaneity of conscious behaviour and subconscious desire: indeed the first signs of latent homoeroticism can be found in this drama about love and death. The liberal humanism of Cacoyannis sought to find closure and resolution through an act of cathartic *anagnoresis*, as an oscillation between the collective and the personal. But the story needed a heroic death for the adolescent who is killed by accident, his death being the omen for what was going to follow, after the end of that 'last

# The Construction and Deconstruction of Cinematic Realism

spring'. In a sense, Cacoyannis' realism was based on Aristotle's definition of tragedy:

> Tragedy, then, is mimesis of an action that is elevated, complete, and of a certain magnitude; in language embellished by distinct forms in its sections; employing the mode of enactment, not narrative; through pity and fear, accomplishing its catharsis of such emotions.[48]

This definition introduces us to the central problems of Cacoyannis' visual poetics when he turns his attention to the filming of tragedy, as the medium for expressing the upsetting libidinal undercurrents which confront the mainstream audience of the period.

The Aristotelian model was used, with some modifications, by the Hollywood studio system to produce its most successful narrative genres, such as melodrama, westerns and detective films. The Hollywood genre formula emphasised the individual instead of the collective, time over space and character over situation. Thomas Schatz classified the plot structure as follows: 'establishment, animation, intensification and resolution'. According to Schatz, this familiar narrative 'strokes the collective sensibilities of the mass audience'.[49] In this sense genre film becomes a cultural and social space where emotions can be shared in a sublimated, decontextualised and deterritorialised manner. Schatz elegantly concludes: 'as social ritual, genre films function to stop time, to portray our culture in a stable and invariable position ... the genre film celebrates certain inviolate cultural attributes'.[50] David Bordwell characterises the main narrative employed by Hollywood as 'intensified continuity', which 'in its mildest, most common registers obeys classical precepts. In its wildest reaches, it presents a boisterousness in tune with the edgier examples of innovative narrative.'[51] It is precisely the oscillation between classical self-sufficiency and innovative open-endedness that defined the strengths and the weaknesses of Cacoyannis' achievement – and the gradual deconstruction of his style.

With *Eroica* and his next film, *The Wastrel* (1961), Cacoyannis' attempts to harmonise Hollywood practices with the British documentary tradition started to falter: the emotional over-intensification produced by fast action and the extensive montage used in the latter film could not be accommodated within Grierson's idea of filmmaking as a tool for promoting critical dialogue between social classes. Grierson had stressed that cinematic realism, as expressed by the documentary film, would be at war with false perceptions of time because of 'its insistence on authenticity and the drama that resides in the living fact'.[52] After 1961, Cacoyannis'

synthesising attempt started imploding: the lived experience itself had become too intense and simultaneously too remote to be depicted through the forms of Hollywood – forms that tamed and sanitised the emotional impact of events. Cacoyannis' codes of representing reality became too self-conscious, somehow artificial and too complete in themselves to represent the extreme instability that defined the transformation occurring in postwar European societies. (*The Wastrel* was an international production.)

At that moment, he discovered Euripides and the world beyond the realm of history, whose representation was a matter of abstraction and ellipsis more than a variety of actual details, richness of texture and compositional gravity. Greek myths offered him a universe that spoke his language and at the same time addressed questions that he thought pertinent to his generation without politicising them. As a humanist belonging to the generation of Grierson, Renoir and Rossellini, Cacoyannis wanted to transcend the semantic nihilism of the existentialists, the dark universe of Ingmar Bergman's terrifying Protestant God in *The Seventh Seal* (1957) and the anti-tragic infusion of classical myths with melodramatic motifs in films such as Dudley Nichols' *Mourning Becomes Electra* (1947). His classical realism, indeed his classicism, was an attempt to find a new balance between idealism and reality through the adaptation of archetypal myths. His discovery of tragedy offered a way out of his creative entanglements and, to a certain degree, a political, philosophical and aesthetic alternative. *Electra* (1962) is probably the finest and most intricate film ever produced in Greece, because of its formal geometry, tragic atmosphere and cinematic timing, a superb example of total cinema, combining acting, music and performance in an almost operatic completeness. It is primarily cinematic, not theatrical or staged; Cacoyannis stated that his experience as director and screenwriter convinced him that 'cinema could redeem the terrible force of tragedy through the immediacy of reality without diminishing its essential grandeur'.[53] Walter Lassally's camera, with its warm chiaroscuro, charcoal blackness and sharp transitions from closed to open spaces, together with an ingenious alternation between close-ups and long shots, created a cinematic mythical landscape full of evocative presences. As Anastasia Bakogianni points out, *Electra* 'is a mixture of conventional filmic techniques adopted from Hollywood and art-house elements'.[54]

Cacoyannis incorporated natural space into action: the sky, the mountains, the trees and the roads are co-protagonists in this play about family revenge. The key to the film, as well as to the story, is the ultimate subtext of all Cacoyannis' films: the child's anxiety in front of a sexually active mother. Probably this was the main reason for the over-theatricality of each frame, which is enhanced by the ritual

The Construction and Deconstruction of Cinematic Realism

solemnity and hieratic stillness of action. Kael again is very perceptive; she talks about the 'authentic solemn grandeur' and states that 'still, trying to show how vividly modern this classic is, he [Cacoyannis] produces discomfort: we're neither here nor quite back there'.[55]

I have briefly analysed elsewhere the philosophical meaning of the film, which is so obvious that it passes almost unnoticed.[56] The iconic status of Cacoyannis never allowed a hermeneutical reading of his work in order to decipher the coded messages of psychological character inscribed there. In the very few notes that he wrote about the film Cacoyannis stated:

> My purpose was to transform tragedy into cinema, and not to direct a performance of tragedy in front of the camera; to achieve, through purely cinematic means, the same emotional force which tragedy achieves, the same pity, the same fear, the same catharsis.[57]

Later in his life he saw the purely Hellenic element in the film. In 2008 he said:

> With *Electra*, I wanted to present the ultimate glory of Greekness. Actors are not the only characters in the film. Ancient twisted olive trees, rocks and dry land act together with them; they existed then as now and will exist forever as components of our land.[58]

However, a close reading of the film shows a multiplicity of scripts woven together: Anastasia Bakogianni, after a thorough analysis of the film, concluded:

> Cacoyannis' film is in the 'realistic mode'. His political message is 'masked' behind a more realistic representation of the story. Cacoyannis was trying to convey a political message in his films. Bad rulers should be punished. In responding to the turbulent politics of Greece in the twentieth century, Cacoyannis used his reception of Euripidean tragedy to condemn war and bad government.[59]

However, the film's psychological and autobiographical references have been under-studied. As mentioned earlier, the film can be also read in the way that Laurence Olivier interpreted Shakespeare's *Hamlet*: it shows an ambivalent attitude towards a sexually active mother, guilt for an absent father, the attraction for the usurper of the maternal body and, finally, the latent incestuous connection between sister and brother. Without reverting to cross biographism, it was a metaphor for his family life, as well as his closeted sexuality. In his revealing interviews with Christos Siafkos, late in his life, Cacoyannis meticulously avoided all references to his mother, stressed the 'tyrannical' character of his father and lavished adoration on his sisters, especially Yiannoula. The mother is a shadowy figure 'a true socialite,

she liked going out a lot, which was good for us children, as in the house were always two maids'.[60]

His early memories indeed give the feeling that there was something irregular in his family life that is never elaborated. The following strange statement gives a key to the understanding of what was silenced:

> I lived a good life, although I never had a family. I loved human beings who did love me also with greater passion. I frequently broke erotic conventions which the current morality imposed upon me. But more than anybody else, I loved my work.[61]

In the final pages of the same revealing interviews, Cacoyannis also mentions the inability of his father 'to look at him face to face' and the strange association between his mother and unmentionable words like 'erection' and 'wet dreams'. 'Once,' he says, 'I heard my parents making love and I was profoundly shocked. I didn't want to be the witness of their sexual life.'[62]

The film is full of Oedipal overtones as the children prepare the assassination of their mother, which will cause them suffering and persecution. The subtle erotic undercurrents between brother and sister, the fear of the phallic mother dominating their mind, the allure of the sexual usurper Aegisthus, the feminisation of Orestes, the masculinisation of Electra all show that the story as rendered by Cacoyannis is:

> the tragedy of a self which, for reasons we are meant to feel as valid and powerful, cannot give up the illusion of its own centrality and uniqueness, cannot invest itself in a symbolic order based on filial succession and the substitution of objects, and for whom, there-fore, death is not the destruction only of the physical self, but of the world of significances that self has sustained.[63]

In the end, it is the tragedy of a character in 'narcissistic self-enclosure'.[64] However, Electra is both female and male, both the active and the passive individual who incites hatred and action while fighting to retain the memory of the lost father – that is, of a unifying myth. By shaving her hair, an act of profound anthropological desocialisation in Mediterranean cultures, she androgynises herself, in order to combat the fear of the phallic mother and restore the 'naturalness' of the social order. In this case, her mother, Clytemnestra, does not suffer penis envy, as a facile Freudian reading would have suggested. In an era of unstable identifications the phallus does not belong to a specific gender; it is the attribute of those in power, ascribed to them by internalised inferiority and submissiveness. Clytemnestra herself, probably the most interesting and complex character in the film, stands

# The Construction and Deconstruction of Cinematic Realism

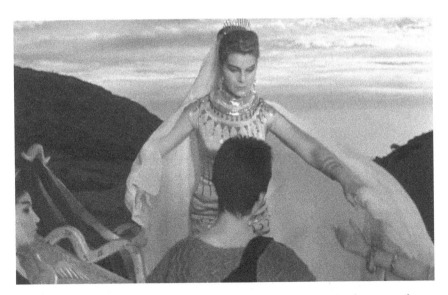

Figure 2.3: Michael Cacoyannis, *Electra* (1962). The fear of living under the maternal gaze.

for the omnipresent anxiety of knowing both physical and social exclusion, as the symbol of unwanted maternity and the desperate effort to empower her individual self. (See Figure 2.3.) The film is about the frightening majesty and the terrifying attraction of a powerful woman who becomes the master of her own destiny – something for which her own children cannot forgive her. She is a unique character in his work, very different from the mothers in *Stella, A Girl in Black* and *A Matter of Dignity*. She is aggressive, unrepentant and uncompromising. Her costume, which references the Minoan snake goddess, frames another demonic irregularity: the maternal body is the terrible abode of a hostile beginning. It is a malevolent mother who determines the destiny of her castrated and neutralised children. Paraphrasing T. S. Eliot, in their beginning was already their end; their tragedy was complete and had no redemption.

The Aristotelian structure, which in his earlier films dominated the plot, now becomes the most important aspect of Cacoyannis' visual poetics. He achieved this by intensifying the visual transparency of Lassally's camera, moving it in and out of the action, and establishing an effective timing for the unfolding of the story. The film has an accomplished rhythm as it moves from one scene to another, from open to closed space, from frames dominated by dark ominous colours to others permeated by white surfaces, indicating catharsis. The camera angle is always upwards, bringing the vast sky into the frame, and also, therefore, the silence of god observing dispassionately the tragic circumstances of being. The rhythmic

timing is effectively underlined by Mikis Theodorakis' minimalist music, through mostly wind, tympani and string instruments, with distinct sounds and long silences. Theodorakis here avoids the emotional rhetoric of his other music scores and emphasises the chthonic elementarity of forms and feelings.

When, later, Cacoyannis made *The Trojan Women* (1971) and *Iphigenia* (1977), he abandoned the hyper-realism of that intensified rhythmic temporality and opted instead for a polychromatic naturalism, almost for ultra-verism. Despite the better technical equipment, the colours themselves betrayed the subject matter: the story lost its evocative doubleness, being at the same time remote and close to the viewers. It became a genuine televisual spectacle, full of obvious ideological allusions and having a strong political elements: in the case of *The Trojan Women*, the allusion was to the feminist wave of the period. Pauline Kael, in one of her best reviews, 'Helen of Troy, sexual warrior', indicated that indirectly – and beyond the filmmaker's own intentions – Helen becomes the most important character in the film, offering, she writes, 'a demonic illumination of the text'.[65] Roger Ebert observed that Cacoyannis 'photographs [the actors] as icons. They are historical statues ... The performances all seem too objectified, too generalised ...'[66]

On the other hand, the most important Greek film critic, Vassilis Rafailides, in an extremely scathing review of *Iphigenia*, wrote:

> From Euripides has remained only the skeleton of the myth. Its flesh was devoured, obviously by the directors of the Greek Film Centre, whilst the poetry and philosophy of the tragedy was completely gobbled up by Cacoyannis himself. And this happened because he wanted to modernise the tragedy and make it totally unrecognisable.[67]

Indeed, both films were used more to make a point and less to re-create an atmosphere, a temperament, a mood. Rafailides was also referring to the newly established Greek Film Centre and the politics of film production in the country after 1974: funding came for conservative filmmakers, and created a new regime of 'national' (in the sense of 'anti-left') personalities, one of the first being Cacoyannis himself. In the same year, while *Iphigenia* was fully funded by the Film Centre and was given thousands of army personnel, equipment and access to archaeological spaces, Angelopoulos received not a single drachma for his most interesting experiment with colour, mood and ideological paranoia, *The Hunters/I Kinigoi*. The difference between Cacoyannis' conventional realism and the disquieting expressionism of Angelopoulos' film is indeed a significant element in terms of

The Construction and Deconstruction of Cinematic Realism

understanding the development of the two directors' visual poetics and their 'political destiny' post-1974.

Rafailides hit the mark when he wrote:

> The great Yorgos Arvanitis, while a world-class photography direc-
> tor in the films of Angelopoulos, failed here to balance the colours
> and to focus the close-ups; how he constantly manages to lose his
> key of luminosity is something that only Cacoyannis could explain.[68]

The central problem with these two Cacoyannis films is precisely the use of colour: it enhanced the contemporaneity of the films, replicating existing visual regimes and confirming dominant forms of visual perception. (David Thomson called *Iphigenia* 'an inducement to high-culture tourists'.[69]) The ambiguous and ambivalent atmosphere in *Electra* was lost here in terms of its semantic polyvalence and psychological intensity: the understatements of that first film become overstatements in the next two – with Irene Papas totally squandering her austere acting style. The plethora of colours, the emotional rhetoric and the conscious visual extravaganza transformed them into paradigms for the conventionalisation of the exceptional. As the screen fuses with the politics around it, the film becomes the archive of its own production and of the ideological structures that made it possible; it consciously discards its own open-endedness and singularises its ambiguities. The old liberal humanist of the 1950s was transformed into a state intellectual who constructed patterns of representation that confirmed dominant stereotypes in power structure, cultural memory and gender dynamics – although in an uneasy and rather fragile visual iconography.

After *Iphigenia*, Cacoyannis made two puzzling films, *Sweet Country* (1986) and *Up, Down and Sideways/Pano, Kato kai Plagios* (1992), in which the growing weaknesses of his style became painfully obvious: loud performances, stories without narrative unity, camera work full of clumsy movement and awkward angles. In the last film, for example, which could have been his mature response to the narrative ingenuity of his first comedy, Cacoyannis seemed lost within the very Athenian landscape that formed him – he had become so familiar with it that he could no longer admire it or detect its quirky aspects. While the film tries to use a portable camera, in the end it becomes only the eye of an irrelevant yet cunning journalist whose open vision of the past has shrunk into an introverted and closed neighbourhood. In short, Cacoyannis was afraid to clearly state his intentions, which have nothing to do with the film itself but with his own disempowerment in the new conditions dominating the cultural imaginary of the country. This was a film for television (or even for the videotape market), and the

cinematic character was totally dispelled by its strong theatricality, half-revealed subtexts and static camera.

However, behind the artificial plainness of the plot and the presumed naivety of the story, Cacoyannis does make a discreet statement, at last, about his own sexuality. The virile, robust and hyper-phallic body of Panos Mihalopoulos, who had previously seduced Yannis Dalianidis, becomes now the focus of yet another story about a sexually active mother and her gay son, played by the equally seductive Stratos Tzortzoglou. This is probably the key film for unlocking the unsettling subtexts and disturbing references that we find in Cacoyannis' previous films: fatherless children in rebellion, with powerful and sexually demanding mothers, struggling to assert their presence and protect their subjectivity. Indeed this is a consciously 'queer' film with lovable gay characters rewriting the classic Freudian family saga and revisiting his main theme, the predicament of children in a society created by dominant parents. Mina, Stella, Marina, Chloe and Electra all represent the same child, in search of an absent father figure. As their lives are dominated by relentless mothers, the absent figure becomes the desire that motivates them to act, but they always end up lost, confused and homeless, as the only way to the father comes through the maternal body, which desires another man.

The great mothers – inconsiderate, indifferent, remorseless – look at their own children with apathy, if not contempt. The child feels guilty because she must have done something that she is not aware of: the guilt of being your own self becomes one of the most significant psychological under-scripts in his films. In the end the child decides to identify with the aggressor: she joins the ranks of the dominant group because that is the only way to experience acceptance and recognition. Yet there remains the suffering of gender dysphoria and confusion. Symbolically, the child castrates itself and experiences its presence in terms of masochistic suffering and corporeal loss: it develops another unseen and unverbalised identity, as the dysphoria cannot be surpassed and the anxiety undermines self-understanding. In this psychological entanglement we can also locate the aesthetic and formal impasses of Cacoyannis' creativity.

Cacoyannis was too afraid to repeat Gustave Flaubert's famous dictum: 'Madame Bovary, c'est moi!' His male characters are mostly negative, aggressive and possessive. The soft and gentle male characters are tormented and rejected: Alekos in *Stella*, Marina's brother in *A Girl in Black*, Orestes in *Electra*. Yet the animalistic sexuality of Miltos, Christos and Aegisthos creates the most memorable characters in terms of male chauvinism and its predatory sexuality. At the same time his most cohesive and convincing characters are always

women, but they are female characters constructed by a man. We must see them more as projections of tendencies considered feminine and less as authentic markers, or symbols, of femininity. In her essence, Stella was a man in disguise, a man who could not reveal the truth about his feelings. Cacoyannis makes a game of inflections and refractions with the expectations of his audience – but the game became too complex and in the end incapacitated him.

Cacoyannis started out with the liberal project of realistic presentation, moved towards the hyper-realistic mythopoeics of dehistoricisation and consummated his work through his endorsement of a totally artificial naturalism that dissolved the ability of the cinema to explore potentialities in the social realm and on the psychic level. In a sense, Cacoyannis was very close to the trajectory followed by Roberto Rossellini, from his early neorealism to the introspective cinema of his last films. Rossellini, however, saw realism as a spiritual project, with strong religious underpinnings and very obvious educational function. In *Rome, Open City* (1945), realism becomes the platform on which the competing systems of the Italian cultural experience found their most significant formal coexistence: the social agendas of Marxism and the 'grace under pressure' anthropology of Catholicism. Cacoyannis' *Matter of Dignity* reaches very close to this ideal but Cacoyannis cannot see the spiritual dimension of religion – like most Greek filmmakers, in fact. He sees the rituals around religious experience, the phenomenology of the *cultus*, but not the transfiguring presence of the mystery. Religion, where it exists – in the church in *Stella*, for example – represents the institutionalised oppression of social heteronormativity. There is no salvation outside social class. (His failed foray into religious cinema with *The Story of Jacob and Joseph* (1975) indicated a search for the miraculous but in a completely irreligious way.) The humanist in Cacoyannis could not find an opening for a space of mysterious ambiguities: his anthropology was constructed around the melancholia of existential guilt that was exacerbated by the emptiness of the skies and the psychological loneliness of social outcasts. Tragedy provided him with the only metaphysical answer to the questions of human presence, history and memory. 'Ancient tragedy,' he said, 'explores truth in depth, up to the dark roots of the naked scream'.[70]

Unlike Cacoyannis, later in his career Rossellini produced static, anti-illusionistic and unrepresentational didactic films in an attempt, as he declared:

> to present man with the guidelines of his own history, and depict drama, comedy and satire, the struggles, the experiences and the psychology of the people who have made the world what it is today, making it a criterion to fuse together entertainment, information and culture.[71]

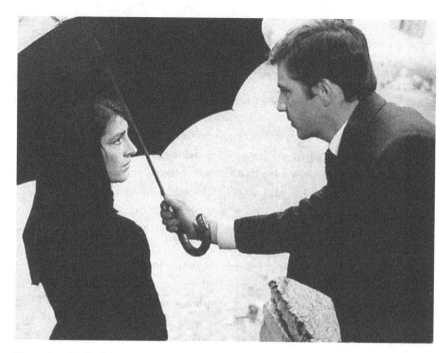

Figure 2.4: Michael Cacoyanis, *Zorba the Greek* (1964). The simple gestures of consideration.

That is probably the main element missing in the cinematography of Cacoyannis: a unifying background that could harmonise the competing agendas of his society, art and personality. His liberalism was not sufficient to account for the unpredictable subversions of history. His early cosmopolitan humanism was reconfigured into a nationalised version of identity, as he himself was transformed into the successful symbol for the country, after the blockbuster success of *Zorba* (1964). In a strange twist of fate, his most popular film arrested his aesthetic development and indicated the demise of his own visual language. (See Figure 2.4.) His national status was further enhanced when, in 1974, he produced a very interesting documentary about the Turkish invasion of Cyprus, his birthplace. In the film, which is flattering for neither side, he again used the black and white contrasts and explored the bleakness of real history, returning in a sense to Grierson's understanding of the function of the documentary as 'the creative treatment of actuality'.[72]

However, it was the discovery of colour that was the ultimate blow to the syntax of his images: it dissolved the solidity of his early formal representations into the ephemeral satisfaction of a consumable text. In 1967 he produced an ambitious, yet humourless, and politically anti-American comedy, *The Day the Fish Came Out/I Mera pou ta Psaria Vgikan stin Steria*, which he later blamed for his

neglect in the US. With its international cast, this film represents his first attempt with colour, but even Lassally's eye for detail could not save this film from its self-consciousness. The comic element belongs more to the clothes, the dances and the naked male bodies, the implied gay iconography, and less to the actual funny situations; the luminous and bright colours must have seduced Cacoyannis, who designed the most important element in the film, the costumes. The comedy, however, does not work: the incongruity between story and form creates a strange internal neutral space. His realism here became a mirror copy of his previous realism: it was so specular that no emotion of any kind could be felt by the audience. It is a film of immense jocularity and has to be understood as the dead-end of a whole way of using the camera. Unfortunately, it also marked the end of his most creative period. His separation from Walter Lassally, the man who could see through his eyes, opened a new chapter in his development – but he was a stranger in the world of colours he was exploring, and this estrangement can be seen in all his films after this.

## Back to the theatre

> This play is like life – it transcends all forms of analysis.
> Michael Cacoyannis[73]

In one of his most confessional moments Cacoyannis said:

> I believe that any good movie which has a certain purpose, a point of view, is automatically an ideological movie ... Cinematic form becomes the frame through which the intentions of the artist are channelled. Today, however, in most occasions we watch films in which we recognise the frame without detecting in them the intentions of their creator. For me this is not cinema of ideology, despite the obvious story, the dialogue and the filling of the camera with ideas. That is to say, even if they are bombarding us with spectacular images taken from exciting angles, this is not cinema of ideas according to me. Cinema of ideas can sometimes be a single expression on the face of a human being.[74]

Despite their stylistic disparity and ideological disjunctions, his films primarily form an autobiographical continuum. They started as attempts to relocate and acclimatise transnational images while at the same time establishing a distinct identity for a cosmopolitan filmmaker who could not experience a sense of belonging. In his peripheral position we can see the centrality of his vision: the construction of a cinematic realism for the fluid and indeterminate forms of the

social experience and individual identity around him and the fluid psychological tensions within himself. However, this realism was challenged by the very nature of 'the captured unexpected moment'.[75] His tragedies, and *Zorba*, expressed the second stage in his development, in which the aestheticisation of cinematic time became the most important aspect of his work. Later, he developed this tendency towards what Ian Aitken called 'representational realism'[76] further, as his films started self-consciously referring to the material of their own construction. They recorded his struggle to reconfigure his own art as the elements of his early synthesis started to lose their cohesion. Meanwhile, global cinema had entered a new stage of development which Cacoyannis was not willing to follow – or indeed interested in.

His historical awkwardness is something that he himself must have felt, and during the last thirty years of his life his best efforts were dedicated to the theatre. His productions of Shakespeare's *Antony and Cleopatra* (1979) and *Coriolanus* (2005) mark two peak moments in his exploration of the tragic as contemporary reality. His Greek tragedies deserve special attention, especially *Oedipus the King* (1973), *The Bacchae* (1980), *Electra* (1983) and *Medea* (2001). Despite the fact that they were advertised as meeting occasions for idle politicians and socialites, they explored a baroque sensitivity – a love of the abundant and the excessive – that Cacoyannis secretly nurtured, at least in the theatre. The painter Yannis Tsarouchis, in a published letter to the director, wrote: 'You went against the distancing that hides all amateurism and the abstraction that camouflages emptiness.'[77] The stage was full of movement, actors and settings; it was indeed clattered and hyperbolic. His last film, *The Cherry Orchard* (1999), based on the play of his ideal artistic mentor, Anton Chekhov, expressed precisely, in a genteel and indirect way, the perennial nostalgia mapped out in his work. Maria Katsounaki perceptively wrote:

> Cacoyannis chose an academic instead of a cinematic reading of the work; he fondly embraces the reader but bypasses the needs of the viewer. He looks enchanted by image and performance, by the atmosphere of family warmth so well described in the play, and moves rhythmically to the demands of a stage production, but the cinema, the all-devouring cinema, is soon lost, as we all wait for the surprise. But the director follows his course till the end.[78]

The film is the revealing gesture of an aged director towards the most important and under-studied aspect of his work: its strong theatricality.

Cacoyannis felt uneasy with the revelatory aspect of the cinematic image. Despite his realistic pictoriality, realism was dangerous territory for him, both

personally and politically. He is a realist only in the sense that he presented the morphoplastic materiality of the lived experience, its surface phenomenality, and foregrounded the continuity between space and time. But the consequences of realism led to another set of values, which stressed the subversive function of cinematic images and the radical potential of the real. Such a function was undesirable, and deterred him from talking about himself, and by extension about the life around him, and he reverted to the grand myths of the past or, finally, to urban fables about the past. However, even myths are about humans, and despite the classicist aestheticism of his best works, many invisible scripts can be read within his densely textured films. His conservative politics and his hidden sexuality never allowed him to develop the full potential of the visual language that he constructed in the 1950s. But as he stated, 'any filmmaker's work stands or collapses on the basis of its internal truth'.[79]

We must search carefully and discreetly in the forms and codes he devised in order to hide his own confessions, to never allow them to be visually articulated. As already mentioned, a Cacoyannis film is more than a film made by Michael Cacoyannis. Unfortunately, this is, it seems, the destiny and the predicament of all national icons. Their language loses its individuated meaning and is transformed into the impersonal semiosis of a social establishment, or of a dominant symbolic order. Such silencing of the personal is probably the most significant subscript in Cacoyannis' development as a filmmaker.

# 3

## Nikos Koundouros and the Cinema of Cruel Realism

### Realistic images for an absurd world

> I was never a man of theory, of paper, of writing. I am a man for movement and construction. I am a film constructionist, and this is how I like to be called.
>
> <div align="right">Nikos Koundouros[1]</div>

The work of Nikos Koundouros is not very well known outside Greece. Although his film *The Ogre of Athens/O Drakos* (1956) is considered by many critics the best movie produced in the country, his fame has been restricted because of his extremely versatile style, the lack of international distribution of his major films and, more significantly, his persistent exploration of obscure, almost subterranean structures of contemporary Greek social and political life. Furthermore, his intense exploration of history led to the development of a cryptic and allegorical style, which further hinders the international reception of his later films – more recently, even their understanding by domestic audiences. From his first feature film in 1954 to this day (2015), Koundouros has directed twelve films, releasing one film about every seven years, while at the same time working on theatrical productions of ancient Greek tragedies.

Koundouros' first two films, *Magic City/Mayiki Polis* (1954) and *The Ogre of Athens/O Drakos*, explored the possibilities of an expressionistic style found originally in the pre-war German cinema, intertwined with the British documentary tradition and lighting patterns from American film noir. Of the first, the doyen of Greek film criticism, Marios Plorites, wrote quite a perceptive review:

> There exists, especially in the composition of images in the *Magic City*, the distinct cinematic eye, which creates depth, makes uses of successive surfaces, utilises material mass. There also exists a sense of cinematic rhythm which supports the unfolding of the 'story', not

only through dialogue but through action and images. Finally, there exists an 'atmosphere', a successful recreation of the milieu of misery which motivates the heroes towards escaping and makes the viewer their assistant.[2]

From his first film, we can see the problem he has with realism: although the Italian neorealist aesthetic has a strong presence in the film, Koundouros employs a fluid, unstable realism, full of breaks and discontinuities, incorporating strategies of representation from German expressionism and film noir. The plot is full of strange twists and turns, creating an atmosphere of intensity and angst, while ending as a moral tale of redemption. As Siegfried Kracauer indicated, in a realistic film, everything depends on the right 'balance between the realistic tendency and formative tendency; and the two tendencies are well balanced if the latter does not try to overwhelm the former but eventually follows its lead'.[3]

Visually, Koundouros articulated a hybrid realism that borrowed heavily from the formalist tradition of Sergei Eisenstein, especially *The Battleship Potemkin* (1925), and the surrealist Luis Bunuel's *Un Chien Andalou* (1929), which he watched after his release from exile in 1952. The remarkable osmosis between two avant-garde traditions and the aesthetics of B movies from Hollywood became the emblematic stylistic hallmark of his cinematic language, as he explored its limits and tested its potential. Drawing from Eisenstein, Koundouros worked on 'the psychologication of objects, both in their positioning and their very presentation'.[4] Indeed, all objects reveal states of mind; cars, clothes, shoes, newspapers, the objective world around the individual all have a 'psycho-effect' on the viewer, by evoking the shared condition of living under oppression. Each object reveals what the surrounding reality hides; each object is about the politics of domination and subjection. The anonymity of the characters is another reminder to the viewers that they are under the same domination, even if they don't want to accept it.

Consequently, it was obvious, from the context of his first films, that any form of static visual language was impossible for Koundouros: first, he couldn't see realism as an art of mimetic reproduction. On the contrary, he understood it as an act of evaluative semiosis; cinematic images are reflections of reflections, taking their final form in the cutting room, through film editing (and the Bazinian *decoupage*). In one of his very few statements on his cinematic aesthetics he pointed out that:

> the image does not need any supporting arguments, because it is itself the argument. It doesn't need any other support because it supports itself. It defines with precision what is obvious, it provocatively ignores what cannot be seen, it records and at the same time

provokes its viewer to deal with it as a point of departure or as the end of a preceding narrative. The image is immobile only if you don't want to or cannot stir it into motion.[5]

Koundouros and his cinematographer of this early period, Costas Theodoridis, took many liberties by reimagining the urban landscape of Athens. If in Yorgos Tzavellas' and Michael Cacoyannis' films, the solid reality and formal specificity of the urban space is explored, in Koundouros' early works the city is de-realised: the viewer looks at a reflection of the city through Theodoridis' camera and through the cutting room. With his early films Koundouros accelerated the introduction of montage through fast transitions, relentless jump cuts and constant camera movement between interior and exterior spaces. There are two cities superimposed, blurred and somehow overshadowing each other. Urban modernity is both a cruel reality and a distracting mirage; the viewer moves from the illusion back to reality as if in a strange game of continuous affective collisions. Koundouros' dynamic juxtapositions evolved to a formalist aesthetic: during the 1960s it totally overpowered the mimetic content of his films, and after 1980, with the exception of the film *1922* (1978), it emptied images of any referential function, creating films of pure formal abstraction.

However, along with the oscillation of his work between mimesis and semiosis, Koundouros seems to have developed a whole new mythography for his cinematic characters. His second highly controversial film seemed to enhance the process of de-realising the urban experience; *The Ogre of Athens* (1955) is a quantum leap in quality as well as a leap of faith into the limits of cinematic representability. Marios Plorites wrote that this film 'repositions Greek cinema from infantilism into maturity'.[6] Both left- and right-wing reviewers were appalled by the 'apotheosis of the bouzouki, of the underworld, of petty cunningness and of incomprehensibility'. 'Why isn't the state to do something?'[7] one critic complained. The review was published in a left-wing newspaper that was supposedly against Stalinism, and representing the new Left of the period. In an insightful essay Antonia Voutsadaki explored the 'tragic irony' in the film and its affinity with *Oedipus Rex*, which was expressed in a scene of collective recognition, which is also a scene of self-recognition: an everyday man, because of his visual similarity to a famous gangster, becomes their leader until he is recognised and killed by them. This tale of an inevitable death becomes what Koundouros called 'a folk ballad' like the ones dedicated to the bandits of previous centuries. Voutsadaki concludes:

> It is an allegory of the post-war society, the one which came after the German Occupation and the Civil war; ... Koundouros' film is

a cry for freedom, and an intense expression of both individual and collective denial of submission.[8]

The realistic, pragmatic references in the film are obvious: but the film is about the physical exercise of power, the ubiquitous presence of oppression, and the way it distorts the experiential realities of people. The representation of the alienating nature of power was the main focus of the film: Koundouros wanted to avoid a romanticised depiction of armed rebellion, acts of individual heroism and spectacular confrontation. Consequently, he shows us the sinister presence of state power through the manipulation of space and the distortion of the concreteness of human form. To do so, he adopted the forms of cinematic expressionism used by Fritz Lang in *Dr Mabuse* (1922), Carol Reed in *The Third Man* (1949) and to a certain degree Orson Welles in *Citizen Kane* (1941). Aylaia Mitropoulou also detected formal allusions to Charlie Chaplin and oblique references to the shadow theatre heroes of the folk tradition.[9]

Cinematographer Costas Theodoridis used rich black and white photography to portray a distinct state of mind, a descent into hell, where people cannot look at each other's faces. The human face, which in traditional realism reveals the reality of an individual, in this film is a distorting mirror: the moment people look at the Ogre, they turn their eyes away in terror and pity. The claustrophobic reality, the fear of persecution, the horror of being betrayed by your own friends, all permeate the atmosphere of secrecy of the story. Theodoridis employed the distorting 'Dutch angle' with harsh, blurred lighting and diagonal close-ups which made the message quite clear: somebody is watching us every moment of every day. The tilting camera framed human forms through shadowy prison bars: there is no exit and no escape. Low-angle shots terrify with their distortion of the human face and body. The only 'honest' possession of each individual, the face, becomes a mirage, a deception, a clear declaration of a political and existential lie: it betrays the fascist oppression each one has internalised. At the end, when the deception – or the voluntary illusion and collective delusion – is recognised, there is only one way out: death by assassination, indeed a voluntary surrender to his own death. (See Figure 3.1.) As the anonymous individual dies, the only thing he can say to his assassins is revealing: 'Thank you. Leave me alone now. All my life I avoided making any noise.'

The film is the epic of Everyman, a powerful lyrical ballad dedicated to the innocence of all those who struggle to maintain their integrity against the forces of circumstance. It can also be read as the inability of the disempowered individual, of the alienated being, to resist the pressure of its context. As such, the film is an

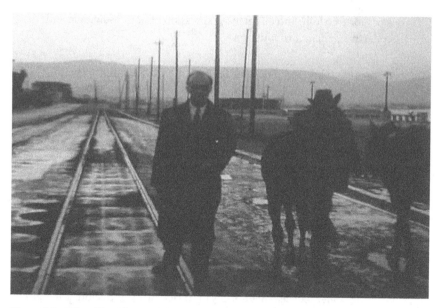

Figure 3.1: Nikos Koundouros, *The Ogre of Athens* (1955). Death without redemption: the violence of history.

essay on the birth of fascism in a society made up of irreconcilable enmities. It can also be seen as an effort of the cinematic image to depict the invisible and the unseen, the 'new economy' of power – that is, the procedures that allow the 'effects of power to circulate in a manner at once continuous, uninterrupted, adapted, and individualised throughout the entire social body',[10] as Michel Foucault expressed it. The suffocating reality of a society in which citizens define themselves under conditions of unfreedom was the existential and political reference of the film.

*The Ogre* articulated what cinema could do for culture that other arts had failed to do until then: it portrayed the closed universe of collective nightmares as an omnipotent existential reality. The chthonian Dionysianism of the subcultural outcasts was powerfully foregrounded and became the cryptogram for the invisible societies that could not be perceived by the touristic representation of the social culture. The ultimate irony in the film is the irrelevance of the organised state. At the moment when a man is stabbed to death, the camera pans over the poster of the National Tourist Organisation advertising 'Enjoy Greece'. However, the film ended with the ominous statement: 'The Ogre was never arrested, cannot be arrested, will never be arrested.' The viewers are warned about the constant danger that they will be in because of such insignificant people. Their presence is the imponderable force that could destroy or liberate, empower or annihilate.

The ambiguity of the symbol is probably one of the most significant aspects of the film's realism: under conditions of servitude and persecution, illegality and transgression can have a positive impact and become emblems of hope and liberation.

Recently, Jonathan Franzen made the film part of the narrative in his novel *Freedom* (2010), and we have seen a revival of interest in it. What fascinated the narrator of the novel is the hybrid indeterminacy of the film: 'Yes,' says the central character, 'but it wasn't a realistic movie. The picture in the newspaper didn't look like the actor, it *was him*. And if he'd just given himself up to the authorities, he could have straightened everything our eventually. The mistake he made was to start running. That's why I'm saying it was a parable. It wasn't a realistic story.'[11] Reviewing Franzen's book, Peter Bradshaw said about the film:

> *The Dragon* [*The Ogre*] is like a French New Wave picture crossed with a British Ealing comedy, with something of Fellini in its zinging energy, and Carol Reed's *Odd Man Out* and *The Third Man*. The stark, dramatic key-lighting in the 'arrest' scene gives the imagery a Weegee-type crime-scene aesthetic.[12]

He concludes, '*The Dragon* is a tremendous film, and Koundouros fully deserves the upswing of interest'; it is clear that fresh interpretations of the film are needed. However, it must be seen in the context of Koundouros' own cinematic development: it is both testimony to his early aesthetic and a documenting of the postwar atmosphere of oppression and persecution.

Koundouros' first films consolidated his fame and at the same time alienated him from the official state ideologues and the mainstream film critics. He always remained extremely intolerant of any state intervention, and his politics, as well as his aesthetics, indicate a foundational and belligerent anarchism, occasionally mixed with resentment and frustration. Between 1958 and 1960, he produced two of his most important films, *The Outlaws/Oi Paranomoi* (1958) and *The River/To Potami* (1960). Due to their misadventures with censorship and the producers, they remained effectively banned, and without distribution, until the late 1970s. Both can be characterised as the 'damned masterpieces' of Greek cinema. They form a very significant dialectical synthesis within his work, in which constructivist and compositional elements dominate the story while the episodic character of the plot looks like the forerunner of the experimental style that was to dominate his work in the late 1960s. *The Outlaws* (in a strange way, the forerunner of John Ford's 1961 film *The Misfits*), was ruthlessly censored and its story is so elliptical and discontinuous that it sometimes makes no sense. Indeed the storyline created, perhaps unintentionally, the symbolic and allegorical atmosphere that has infused

his visual language ever since. Koundouros left the censored parts untouched so that viewers could fill the gaps themselves, thus establishing a visuality of suspicion; all signs and symbols in the image become markers and reminders of what could not be shown and articulated.

It is obvious that the film was referring to the last Communist rebels of the Civil War and their desperate attempt to escape to the 'other side, where they could start a new life', as one character says. The film is like a Greek western; it deals with space and the human form in it, the way that John Ford worked to visualise his personal perception of the Wild West. Like Ford, Koundouros tried to give birth to a 'world in which the sound of the fife and the drum and the rumbling hooves of the US Cavalry inspired not dread but deliverance'.[13] With Koundouros, of course, there is no deliverance; there are only dread and horror, and a constant struggle for survival as the ubiquitous power of the state, in perfect uniforms and with lethal weapons, pursues the last remnants of the unnameable past. In the end, death is awaiting their leader, as he gives the opportunity to the young couple to escape.

In a short note on the film Koundouros said:

> I made *The Outlaws* on a story taken out of silence which was imposed after the Civil War by the darkness of a ruthless censorship. Out of stubbornness and naivety I tried to touch the unhealed traumas of the country without having realised that the fastest way to escape oppression was oblivion: for both winners and losers ... I knew that in Athens censorship was waiting for me so I searched in the silence and the horror of the Meteora Rocks the substitutes for the words that could not be said.[14]

The film expresses Koundouros' escape from the urban landscape to the open rural countryside of Greece, where he stayed for all his films until 1974. The camera of the Italian Giovanni Variano contributed considerably to the artistic unity between story and form. Antonis Moshovakis wrote a positive (in general) review of the film, but pointed out that:

> Koundouros remains an impressionist and wants to attract attention, even though the dynamism and the intensity of the image do not correspond to its content. This leads him, for example, to keep the actor stooping down in a twisted position for long in order to achieve an effective frame or even to force his actors to act weirdly with ponderous and forced movements which look artificial.[15]

In fact, enhanced artificiality is an emblematic reaction by Koundouros to the excessive soft-realism of the period. In the film industry in Greece in the late

1950s there was an increasing number of genre films (melodrama, period pieces, costume dramas), and this film seems the first auteur work appearing in Greek cinema, with the directorial point of view becoming the most significant unifying factor in the image. Artificiality of acting becomes a self-critical comment on the cinematic image itself: it gives you not a slice of life but a splash of illusion. In a sense, what John Ford did with the vibrant Technicolor style in *The Searchers* (1956), which is a commentary on the story, happens here with the hyperbolic acting, the depthless emptiness of the landscape, the sharp contrasts in lighting and, most significantly, the white dress worn by the main female character. In the dominion of phallic rocky mountains all filmed in dark ominous blackness, the immaculately white dress becomes an opening on the screen itself, an invitation to explore the hidden otherness of suppressed history.

The general, national and international, reception of the film was very positive:

> What was liked in the film was its inflexible and slow narrative, a defect which if looked at from another perspective was taken as a virtue after the demonic rhythms of the American montage had started annoying the Europeans, who were upset by the monopolisation of their cinematic markets by the seductive American recipes.[16]

This film, full of self-conscious symbolic realism, remains one of the best modernist achievements of Greek cinema. It reinvented the rules of the genre, infusing them with unsettling subtexts and, most importantly, with ambiguous referentiality. Irrespective of whether or not narrative lacunae exist (because of the censorship), they give a particular depth to the images and the story; Koundouros was to perfect this in his next film.

For many reasons relating to disagreements with the producers, his next film, *The River* (1960), was never screened in the version that its director would have liked. It is something like Orson Welles' *The Magnificent Ambersons* (1942) and *The Touch of Evil* (1958); the uniqueness of the story and the peculiarity of its visual style led the producer to stop the shoot before its completion, give the film to a rather unimaginative editor, and release it in a version which was conventional and uninteresting. *The River* – or, as the title appears on the credits, *This Side of the River/I Edo Meria tou Potamou* – represents the ultimate narrative experiment in the chronotopic representation of what Mikhail Bakhtin defined as 'the intrinsic connectedness of temporal and spatial relationships'.[17] Here we see, visually crystallised, Bakhtin's own understanding of the term:

> In the literary artistic chronotope, spatial and temporal indicators are fused into one carefully thought-out, concrete whole. Time, as it

were, thickens, takes on flesh and becomes artistically visible; like-wise, space becomes charged and responsive to the movements of time, plot and history. The intersection of axes and fusion of indica-tors characterises the artistic chronotope.[18]

Four different stories, involving four completely unrelated lives, converge on this side of the river, in a border location, between us and the others. The indeter-minate character of the others, the enemies who are ready to kill those who try to cross over, is one of the most creative elements in the film. The camera, again through the centreless field vision of Giovanni Variano, alternates between four different points of view, but always from outside to inside. So the viewer cannot empathise with any one of the characters, not even with the two cute but diabolical children, as the alarming subtext of children's sexuality disrupts the idyllic inno-cence of their dialogue. The film leaves the viewer not knowing what is happen-ing: time and space have collapsed into each other; no explanation is given and no justification can be provided.

Visually the film simply looks at the landscape as a sinister numinous pres-ence: the clothes, the bodies and the soil all form a unity of unwanted coexist-ence in a place that rejects them. The awe produced by the depthless verticality of the previous film is replaced here by the dread of endless horizontality. As Koundouros said:

> If something happens in this movie, it was again about the destiny of trapped people. Later I understood that my insistence on the image of trapped people was nothing else but my personal adventure, as well as of other Greeks, who felt trapped within the post-Civil War society, which persecuted us mercilessly. I attribute such revolv-ing around this theme to my most basic storyline: the story of the trapped individual.[19]

The film has not been studied sufficiently, although it is probably one of the most impressive works of the 1950s in Greek cinema, an exercise in pure visual style, focused on shades of white, grey and ashen colours. It is also the most serious experiment with the limits of naturalism, overstretching the potential of the sym-bolic realism we saw in his previous films. Furthermore, it seemed also to have paved the way for two great films of the early 1960s, Cacoyannis' *Electra* and Takis Kanellopoulos' *The Sky/O Ouranos* (both 1962). The themes of borders and limi-nal characters, as well as the question of how such inbetweenness can be translated into images, was to be revisited decades later by Theo Angelopoulos in his tril-ogy Borders (*Landscape in the Mist* (1988), *The Suspended Step of the Stork* (1991)

and *Ulysses' Gaze* (1995)); but Koundouros' film is a powerful visual articulation of the absurdity of divisions between human beings, who are all in a space-time continuum which eventually frustrates their expectations and ultimately destroys them. Finally, the presence of Ingmar Bergman's uneasy cinematography can be also detected in this film; although they inhabit different universes, Koundouros and Bergman share the belief that 'film as medium is well suited to destructive acts, acts of violence. It's one of the cinema's perfectly legitimate functions; to ritualise violence.'[20] Indeed, ritualised violence in all its forms was to become one of the central themes of Koundouros' cinematography, expressed through highly crafted, almost choreographed, depictions of destruction, rape and death – until his last film.

Such 'ritualised violence' and 'semiotic destruction' would be the background of Koundouros' next film. In 1963, he released probably the most internationally acclaimed film of his career, *Young Aphrodites/Mikres Afrodites*, which won many international prizes and indicated a new stage in the development of his visual poetics. Yannis Bakoyiannopoulos observed that the main characteristic of the film is its tendency towards abstract art, towards architecture:

> The director does not follow the faces of his characters as mirrors of internal changes and does not see them as prosopographical details, in the sense that they determine a personality at a certain moment, but as masks, as the component of a general predisposition. The hieratically immobile brilliant mask of the main actor is an incredible success.[21]

The film is an exercise in absolute minimalism: everything moves internally, as if human bodies are searching for their own geometry. Such abstraction is framed by a neutral, almost Adamic, narrative that explores, unhindered, the absolute transparency in the phenomenal world of visuality. As Roland Barthes asks of literary writing:

> Feeling permanently guilty of its own solitude, it [literary writing] is nonetheless an imagination eagerly desiring a felicity [*bonheur*] of words, it hastens towards a dreamed-of language whose freshness, by a kind of ideal anticipation, might portray the perfection of some Adamic world where language would no longer be alienated.[22]

It is an ascetic film recreating a world of Adamic self-sufficiency of images. Koundouros insisted that 'image in this film is a complete language of its own. It is a narrative belonging to silent cinema.'[23]

The story, loosely based on an ancient Greek novel by Longus, about a bucolic idyll between two youths, was also Koundouros' response to the appropriation of ancient Greece by the American sword-and-sandal epics and the Italian peplum films of the period. In the context of local cinema, it was his response to the presentation of classical Greece as an aristocratic culture, as in Tzavellas' *Antigone* (1960) and Cacoyannis' *Electra* (1962): for him ancient Greece was a land of anonymity and voicelessness, a kingdom of the subaltern, of the slaves who built the great masterworks of art, and about whom nobody yet knows anything. The film also frames the interconnectedness between humans and nature, in an attempt to discover the post-cultural human, the type of existence that cannot be interpreted or understood on the basis of social class, status or position. The film is also a bold exploration of early sexuality, as a provocation to the vulgar oversexualisation of the nude body that started taking place in the early 1960s: the young boy and girl struggle to understand what happens to them, re-creating the mystery of the senses without intellectualisation or sublimation. (See Figure 3.2.) The erotic attraction is framed as a natural bond, not as a way of domination or as momentary relief; consequently, despite the nudity of very young individuals, this daring film is an excellent moral tale about sexuality, intimacy and the human body (without any cheap voyeurism or scandalising paedophilia).

The Dictatorship of 1967 found Koundouros working on his most experimental and cinematically challenging work, *Vortex or Medusa's Face* (started in 1967, completed in 1971 and publicly released in 1978). The film represents his most advanced experiment with form, script and pictoriality, exploring through the minimalist linearity of a single architectural space the most complex, disconcerting and confronting enigmas of human desire. 'The landscape,' he wrote, 'will vanish, there will exist only what has a catalytic influence and an organic place in the film itself. The camera will be filled with flesh; faces and bodies will occupy the most of it.'[24] It is about four people isolated in a remote house on an Aegean island: their loneliness exacerbates the tensions between them. The archetypal woman, Astharte – Ishtar, her name in the film – inflames their passion and makes them lose control of themselves. Together with them is the first-ever complete homosexual character in a Greek film, a man desperately in love with one of the heterosexual men, experiencing the desire that could not be articulated and could not be realised. This atmosphere of intense eroticism collapses into monosyllabic dialogue and elliptical *mise-en-scène*, intensified by Yannis Markopoulos' ultra-minimalistic music, which surrounds the characters with a suffocating intensity and aggressive silence. These elements bring it close to Andy Warhol's 'underground' cinema of the same period, especially to his 1968 provocative *Fuck*

## Nikos Koundouros and the Cinema of Cruel Realism

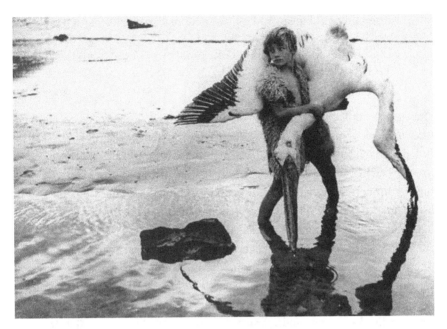

Figure 3.2: Nikos Koundouros, *Young Aphrodites* (1963). The loss of innocence and the fear of growing up.

(or as later renamed *Blue Movie*) and to a certain degree expresses homologous formal explorations as those found later in Ken Russell's haunting films of the 1970s, such as *Savage Messiah* (1972) and *Mahler* (1974).

*Vortex* is an extreme exploration of the limits of mythopoeic cinema: it ends with a film within a film, which is the film at the heart of the original film that Koundouros wanted to make. The complexity of overlaid representations makes this movie one of the most interesting explorations of the potentialities of cinematic representantionalism. It explores how reality can be represented through the liminal forms of visual geometry. There are no characters, no plot, no development; the film visualises the death of language and meaning, and the rise of the post-ideological nihilism that started overtaking Europe after the defeat of the social movements in May 1968.

In the context of the political upheaval after the 1967 Dictatorship in Greece, Koundouros stated that:

> We all wanted to make a film without voices, without wailings, without social drama. A kind of illustrated psychodrama. The heroes are tragic personalities, cut off from society, ideology, and family. They live their own closed adventure, estranged by what is happening

around them, shipwrecked on a remote rock, the dry rock of their soul, I mean, condemned to eat their own flesh ... My heroes speak English but they may as well speak Turkish or Greek. I want to say that language doesn't really matter, so that the characters have no other identity except the one betrayed by their actions.[25]

Through the crisp, static and dispassionate camera work of Karl Heinz Hummel, the film depicts humans without qualities and without mental horizons: it presents the domination of the eternal now, a self-imposed imprisonment in one's own mind by an inability to communicate with one another and an unwillingness to be united through collective projects of action. The film was a radical and unexpected departure from all the forms of representation dominant until then in Greek cinema, and remains a strange irregularity even today.

Koundouros left Greece in late 1967 and worked on many failed artistic, mostly theatrical, projects in various European countries until his return to Athens with the restoration of the Republic in July 1974. During the extremely tense and highly electrifying days after 23 July 1974, Koundouros took his camera into his own hands and roamed the streets of Athens, recording the reactions of the common people to their newly gained sense of freedom. *The Songs of Fire/Ta Trayoudia tis Fotias* (1975) is the most interesting Greek *cinema verité* documentary, exploring and interpreting the effects of such a significant political event on the life of the common people. The true protagonists of the film are the streets and buildings of Athens, the places where people came together to sing their frustration and hope – together with the handheld, unstable camera that floats through them. 'There was,' he said, 'that sublime buzzing of voices all over Athens, ascending towards the sky, sneaking in through the windows, hovering over streets and buildings.'[26] Indeed, the whole film was a collective effort, with Koundouros the coordinator, capturing the mystery of the human voice: 'Voices, rhythmic voices, singing voices, whispering voices.'[27] The scenes in which a man tortured by the secret police of the Dictatorship talks with a broken, distorted voice about his ordeal illustrate beyond any other narrative stratagem the visceral hatred Koundouros felt towards the Greek state, and to some degree highlight his distrust of the regime emerging out of the demise of the Dictatorship.

The Restoration of the Republic gave Koundouros a rare opportunity to release his banned films and screen them for the first time. Despite their limited success – most of them were screened in art-house cinemas – he became the implied father of the radical films produced in the period, sometimes in direct opposition to the dominant filmmaker of the New Greek Cinema, Theo Angelopoulos. It was to the great surprise of all that in 1978 he embarked on the production of his

monumental historical epic *1922* (1978), the only movie which addressed without any pretexts or metaphors the disastrous Asia Minor campaign and the indelible mark it left on the Greek people. Koundouros moved to the visual world of muffled, broken colours, avoiding the spectacularisation of the calamity. He stated that he made the film:

> not because [I] wanted to scratch old traumas, but to show that very few things have changed since then ... and in order to make the viewer realise that 1922 was not a final date registered in the archives of History but an open trauma for the peoples of the world.[28]

The film received many negative reviews for being 'nationalistic', and was in effect banned by the Greek state, but its impressionist colours, confronting characters and minimal dialogue need systematic study. The film, loosely based on the autobiographical novel *Number 31328* (1931) by Ilias Venezis, was the first systematic attempt by any cinematographer to directly address the *ur-trauma* of the 1922 Catastrophe. The monumentality of the event is expressed here through an alternation of moods, atmospheres and forms. It starts as a kitsch patriotic performance about the glory of Greece, expressed mostly through the detached coldness of green and yellow, then continues with the ashen and white colours of the empty inland deserts of Asia Minor, and ends with the drab and distancing uniform blue that we find the broken refugees wearing during their horrible marches of death, on the way to their 'white death' in the Salt Desert.

The film's delirium of cold colours expresses the dehumanising forms of cruelty on both sides of the conflict. Despite being filmed out in the open, it gives the impression that it is set in a mental hospital, and the camera functions as the doctor to whom each character talks about his or her sickness: melancholia, frustration, greed, disease, lust, anxiety, horror, self-reproach. All participants are equally guilty: the wealthy Greeks who had underestimated the resentment of the poor and disempowered local Turkish population in the time of peace, as well as the victorious Turks who vent their rage against their previous masters by raping and killing them in the middle of nowhere. (See Figure 3.3.) The film is certainly based on the Greek–Turkish war, but it is about the essential humanity that binds both sides. They both feel ashamed of the way they behaved towards each other. A moral conscience exists in them and the camera explores its imperceptible manifestations through their silence, their awkward movement, their evasive gaze.

After this film and its negative reception, Koundouros' cinema became completely hermetic and anti-realistic. If surrealism was always hiding in the background of his camerawork in his other films, with the film *Bordello* (1985)

Figure 3.3: Nikos Koundouros, *1922* (1978). The nightmare of history and the destruction of human communication.

Koundouros entered a visual universe permeated by the complete absence of verisimilitude or of any kind of photographic presentationalism. *Bordello* is an unclassifiable film, partly collective nightmare and partly personal fantasy; ultimately it is a film exploring the phenomenality of surfaces, the absent desire, the lack of the will to create. The most important aspect of the film is the alienating dark, fluid and muddled colours that dominate the frame. They stand for the confused state of mind and the deep disappointment that overtook the director after the failure of the Socialist Party to bring real change to the country after 1981. This is his dialogic engagement with Federico Fellini's *Satyricon* (1969) and Pasolini's *Salò, or 120 Days in Sodom* (1975). Set in the labyrinth of a bizarre brothel, the film brings together all the madness and confusion created by blind desires without object: it is about the self-consuming passion to possess someone's body even when that person hates and is repulsed by you – which is the ultimate meaning of fascism. Sex becomes an instrument of domination and humiliation: when the Minotaur appears it is a faceless big phallus, not fertilising or impregnating but destroying and making a spectacle of itself. They all applaud as the fertile semen is wasted in the rapture of nihilistic nothingness.

The disturbed and unsettling libidinal economies of the 1960s didn't lead to the liberation of desire; on the contrary, all revolutionary projects led to other forms of domination and voluntary enslavement, to an occlusion of experience by the projection onto reality of the panics and anxieties caused by the frustrated expectation of a social liberator and an existential redeemer. In this film Koundouros rejects all optimistic projects of 'progress' and revisits Walter Benjamin's cruel vision of the 'Angel of history'. In this famous proclamation, Benjamin said:

> 'Angelus Novus' shows an angel looking as though he is about to move away from something he is fixedly contemplating. His eyes are staring, his mouth is open, his wings are spread. This is how one pictures the angel of history. His face is turned toward the past. Where we perceive a chain of events, he sees one single catastrophe which keeps piling wreckage upon wreckage and hurls it in front of his feet. The Angel would like to stay, awaken the dead and make whole what has been smashed. But a storm is blowing from Paradise; it has got caught in his wings with such violence that the angel can no longer close them. The storm irresistibly propels him into the future to which his back is turned, while the pile of debris before him grows skyward. This storm is what we call progress.[29]

Koundouros explored the rise of nihilistic cynicism as the only dominant project in contemporary political imaginary. All political projects are masks hiding the will to power, the destructive tendency towards meaninglessness. As a recent study by Lefteris Xanthopoulos points out, in this film Koundouros explores the mask as a device that 'bring[s] to light the dark side of the human being, its *Other* side, the secret and forbidden. The mask constitutes an element of ritual, it introduces the magical, it denotes the complex and leads to ambiguity.'[30] Power disfigures the rationality of the human face and thus obscures its luminosity. With this film Koundouros explored history as a dark forest of labyrinthine libidinal complexities, in which the primeval Minotaur represents the monstrous presence of political authority as distortion and dismemberment. Yet again it is a political film, again about the destructive power of the state:

> I call all memories to red alarm. I add this outrageous title 'Bordello' and fill the newspapers and magazines with naked girls, because my unfaithfulness to my milieu and not only to the official state, makes me so provocative, so that I produce this films and burden it with this title – this misleading title. This film is a desperate cry over the behaviours that made Greece a land of slaves. It is about our humiliation.[31]

The cryptic symbolism is now discovered within the historical event and the lived experience of the people. His criticism of the official state ideology is also scathing, indicated by the resemblance of many characters to the emblematic heroes of the Greek tradition in politics or religion. 'There is no ideology in the brothel,'[32] he stresses. The film is about the troubled and disturbed subconscious of the people who presented themselves as liberators without ever ceasing being slaves. It is also about the anonymous populace that never appears in the film but that lives around the brothel – the anonymous crowd that is forced to work in order to keep the brothel active. Nikos Kavoukidis' camera work foregrounds the absence of the redeemer or of the redeeming experience with its claustrophobic and dark romantic colours and confined and exit-less spaces: the more they experience, the less they feel. Slaves have no emotions or memories, they are automata and mechanical copies of a lost authentic self. Nikos Mamangakis' frenetic music firmly keeps the viewer out of the frame: no empathy or compassion can be felt for such absurd caricatures of being. The acoustic spaces of the music multiply the distance between the screen and the audience.

With his next film, *Byron or Ballad for a Demon* (1992), Koundouros intensified his iconoclastic perspective. The film, which was released with English dialogue, is a demythologisation of the romantic poet Byron, who died for Greece in 1824, during its Revolution for Independence and, at the same time, a remythologisation of his personality. In a sense it is Koundouros' dialogue with Ken Russell's rather cynically romantic *Gothic* (1986), through the exploration of his final days in Messolongi as a desperado who confronts the meaningless nature of life and history. Rafailidis noted that 'here Byron is more a force of nature and less a historical personality or a great poet.'[33] Indeed, Byron is framed by nihilism and rage against an absent god who made him both deformed and creative, a philosophical reference to Albert Camus' *The Rebel* (1961). The film is about the creative illness of an individual, intertwined with a great collective project, sometimes in collusion but mostly in collision with each other. Individuals who think that they are above history become in the end puppets of the invisible forces in history, some of them located within their own bodies and others existing around them as social structures. Koundouros explored in this film the indeterminacy of human intentions: set in a besieged city surrounded by hallucinogenic fumes, reality and illusion are fused as locals and foreigners try to make sense of each other.

The film is focused on the face of the main actor, Manos Vakousis, surrounded by closed dark spaces, horizonless skies and lost languages of communication. Byron's black clothes are in direct contrast to the colourful costumes of the locals; equally, his demonic bald head is in contrast to the suspicious alert faces of the

revolutionaries. The whole film is a relentless exploration of personal identity, of how we define ourselves as creators or thinkers vis-à-vis a collective project which is probably beyond our ability to follow or our willingness to accept. It is also an angry film about the failure of a charismatic individual to understand his own self: the realism of the actual world is replaced by confused images from a fertile but self-loathing imagination. The cinematic screen does not simply frame a historical event; it describes a deranged mental universe. Yannis Markopoulos' music score fuses demotic and disparate sonic phrases in a strange, almost apocalyptic, soundscape punctuated by the sounds of canons and the screams of the dying.

His next two films bring collective nightmares to a completely new level of articulation. *The Photographers/Oi fotografoi* (1998) and *A Ship to Palestine/To Ploio yia tin Palaistini* (2011) are films about the absence of open horizons in contemporary political and social life. *The Photographers* is a version of Sophocles' *Antigone* that takes place at the borders between countries, territories and ideologies, dominated by sick green skies and clouds that look like splashes of bile over the absurd phantasmagoria of life. It is a bold experiment with form, colour and dialogue, not always successful, as the framing accomplishment of the photography by Nikos Kavoukidis looks more like a succession of stills than moving images. Each frame pulsates with energy and intensity, but all of them together remain somehow disconnected and without any points of convergence, while the acting style somehow does not fit the story.

In his last film, based on a true incident from 2010, when the Turkish ship *Marmara*, full of peace activists, tried to break the Israeli blockade of Gaza, there is no sky whatsoever: everything happens against a background of black frames that function as a subterranean cave out of which all the ghosts of the past and the phobias of today emerge, with disastrous force. (See Figure 3.4.) The film is kept together and redeemed by this monochromatic flatness used by Vangelis Katritzidakis, the director of photography; the cryptic symbolism and opaque references transform it into a hermetic parable about contemporary politics.

As in all his films after 1984, realism has been totally rejected and the director works with disruptions and discontinuities in editing. The sepia colour lacks the nostalgic warmth of old photographs, and instead has the ashen shade of a negative presence; surrealism has defined the movement of the camera and the script. 'It is my last film,' he stated. 'I wanted to make [it] in order to externalise my fury.'[34] Theodoris Koutsoyiannopoulos wrote about the film:

> A conscious attempt, I hope, by Nikos Koundouros to translate cinematically the chaos through chaos, but also with historical

# Realism in Greek Cinema

Figure 3.4: Nikos Koundouros, *A Ship for Palestine* (2012). The incomprehensibility of symbols: history as an alien territory.

> reference, contemporary references and a persistent denunciation of fascism and the violent exercise of power. *The Ship to Palestine* seems lost in the ocean, through an unfocused, experimental narrative (occasionally through a confession addressed directly to the camera, on other occasions [through] dense and incomprehensible intrigue in a film noir atmosphere), flawed direction of actors but a mostly heavy and bombastic approach which cannot accommodate so many and so unreconciled elements.[35]

With this film, a complex and adventurous journey through styles, stories and systems found its rather unfortunate end – but the journey is extremely interesting.

## Undoing the cinematic

> I love the dissolution of life and its recomposition through the camera lens and the eye of the director.
>
> Nikos Koundouros[36]

116

One can claim that Koundouros has worked, consciously or by accident, in duologies, producing two films related to each other while investigating aspects of visual presentation. His duologies explore significant dimensions of form, composition and storyline, constructing anomalous visual narratives wavering between realism and symbolism; indeed the oscillation between extreme realism and allegorical symbolism can be considered the central axis of his cinematic development. Koundouros is a great experimenter with the potential of specific forms in visual representation. After he tests the limits of each one, he abandons it and moves on to another, sometimes totally different from the previous. In a sense he explores the limits of visuality and at the same time transcends them: the realism of his first films became the starting point for the hyper- or post-realism of his late style, through an interesting problematisation of the limits of representability and of cinematic images.

From his early period, which started from Italian neorealism and American film noir, to his late works, which are closer to post-realist presentationalism, Koundouros remained one of the most resourceful of cinematographers. He cannot be classified under any specific movement or approach to filmmaking. His oeuvre is unique and isolated in the world of the commercial cinema of the 1950s and 1960s, and totally isolated within cinematic production after the 1980s. It always remained highly political, agonistic (or even antagonistic) and confrontational, qualities that on a number of occasions led to the suspension of the distribution of the films and thus to their relative obscurity. The project of a consciously constructed visual form spurred him to test new frontiers and new representations, to the extent of absolute neutralisation of all visual semiosis, as we see in his latest and, as it seems, final film, released in 2011.

Again, the unity of such disparate and contradictory experimentations can be found in the rebellious personality of the director. One could claim that Nikos Koundouros did for Greek cinema what Pier Paolo Pasolini did for Italian: he searched constantly for what Pasolini called 'heretical empiricism', which is 'a stance characteristic of his practice of holding discourse with but differentiating himself from established schools and movements'.[37] The implicit dialogue between Pasolini's *Teorema* (1968), *Porcile* (1969) and *Salò* (1975) and Koundouros' post 1980s films would show the parallels between the ideological and the aesthetical impasses of both. Although Koundouros started from within the dominant paradigm of narrative cinema, it can be seen that it soon became a prison for his creative imaginary. At the moment when Cacoyannis was crystallising his sculptural realism, focused on the primacy of form, volume and order, Koundouros was infusing his films with an intense play of shadow and

light, changing the specificity of form, exploring the disorder under the surface of social conformity and manipulating the dimensions of concrete objects. His frames presented an expressionistic world of rich blackness and angry whiteness competing with each other: when later he moved to colour, he depicted the hostile world of polychromy as a challenge to realism through the discovery of a hidden reality, lurking in the margins of history and the deep recesses of the mind. In his late films, colour became the visual indicator of the political and existential imprisonment in contemporary history: instead of being the proof of the polymorphous visual field and the euphoria of seeing, it became the cinematic proof of lack of freedom and, even worse, the absence of all conscious resistance. Colour indeed became the indicator of the absence of metaphysics from contemporary reality, while the image depicted the extreme disjunction between meaning and purpose.

Koundouros' camera framed two social forces in continuous and relentless warfare: on one side, the pernicious presence of the state – of organised power, with its mechanisms of oppression and control – and on the other, the 'common people' – the sub-proletariat, the subaltern, the voiceless and anonymous. His universe was one of almost Manichean dualism, which accounts for the strong ethicism of his work. Like Pasolini, his camera looks with rage and resentment into the world of the organised state and the social classes that support it: indeed, the film *Bordello* (1984) encapsulates his verdict on them. On the other side of reality the persecuted subaltern of Greek history – petty thieves, presumed gangsters, anonymous renegades and totally insignificant people living solely through their body – make up the pantheon of his anonymous heroes; their anonymity is the central characteristic of their visual identity. Indeed he called the most anonymous central character of his film, *The Ogre*, 'the terrible figure of Mister Nothing, embodied in the actor Dinos Iliopoulos, which haunts Greek cinema to this day'.[38]

In each of his films the camera localises a distinct point of view: at the same time it shows an oppositional and militant perspective on the social struggle. Despite the political element in Koundouros' films, they are not about Marxist class warfare or American individualism, as expressed through Hollywood films. His individuals, mostly existing in Kafkaesque anonymity, are the pre-bourgeois and pre-capitalist social underclass, a minority even within the proletariat. These are people whose only possession is their body, and who struggle to make their corporeal presence known against the predatory structures of social depersonalisation. For Koundouros, capitalism and socialism are the dual faces of the single power structure: in the visual world of his camera the central enemy is omnipotent and omnivorous state power. The infernal machine of state interferes with

the lives and the minds of the people, creating conditions of existential anomie for them: being an outsider, a heretic, an alien, is the ontological ground for the production of Koundouros' cinematic world.

The relentless negativity of his characters is indeed the most symbolic and probably the most romantic element in his visual world. They are the cinematic equivalent of John Keats' 'Negative Capability', that is, when a man is capable of being in uncertainties, mysteries, doubts, without any irritable reaching after fact and reason'.[39] The negative capability within each character leads to the decentred subject of high modernism: its search for pure freedom, dissociating itself from the structures that limit self-expression and realisation. All of Koundouros' films are about the subject who rejects the spurious gift of being part of structures that dominate the social body. Charles Baudelaire, in his famous essay on the painter of modern life, gave us essentially a prophetic description of anarchist modernists like Koundouros:

> The crowd is his domain, just as the air is the bird's and water that of the fish. His passion and his profession is to merge with the crowd ... To be away from home and yet to feel at home anywhere; to see the world, to be at the very centre of the world and yet to be unseen of the world ... to [be] a kaleidoscope endowed with consciousness, which with every one of its movements presents a pattern of life in all its multiplicity and the flowing grace of all the elements that go to compose life. It is an ego athirst for the non-ego, and reflecting it at every moment in energies more vivid than life itself, always inconstant and fleeting.[40]

His characters are thirsty for their mirror opposite and struggle to meet, imagine or even fantasise, about their own negative self – a dialectical struggle that gives them both unity and disunion, expressing in the most lucid way the creative trajectory of Koundouros' own filmmaking. Within the context of modernism, Koundouros gave a fresh impetus to the idea of impersonality in art: he is one of the few directors whose life's experiences, but not his own personality, can be detected in his films. Referring to his film *1922* (1978), he said:

> I don't make films for myself. I care for the others, the sufferings, the yearnings, the miseries, the loves and the deaths of the others. To the point that the others become me, then I sign my films, a forger maybe of things true, but content that I never harmed anyone.[41]

The absence of autobiographical elements in his films is extremely eloquent; one could claim that in his work there was a deliberate attempt to forget the self, as if

individual memory was itself the locus of alienation and inauthenticity. Hence his cinema frames the collective subject in both its historical presence and its subconscious life. Yet again, Gustave Flaubert's escape from personality does not really mean self-effacement, as Geoffrey Wall has stated; on the contrary, it is 'a dynamic form of self-multiplication'. Following Flaubert's admonition, 'Disperse yourself into everything and your characters will come alive, and instead of the eternal declamatory personality ... your work will be crowded with human faces',[42] Koundouros' characters are collective individuals; most of his films have no central protagonist and action is dispersed, or focused equally on different individuals. His films unmade the cinematic personas of actors and debunked all forms of sentimental individualism that emanated from the dominant narrative cinema. Under his expressionism, one can detect a tendency to abstraction, indeed to abstract expressionism, particularly in his late films. His representations do not correspond to a given reality: they represent semiotic systems about structures that generate and freeze emotional responses.

## The nightmares of history

> The search for a personal style is the best way of losing art. Style is not searched for. It comes by itself.
>
> Nikos Koundouros[43]

Despite the collective adventure explored throughout his films, some autobiographical information should not be ignored for the understanding of Nikos Koundouros' films. He was born on the island of Crete in 1926 into a wealthy and prominent family. He studied architecture at the University of Athens but after the Greek Civil War he was arrested and exiled – because of his left-wing views – to the notorious island of Makronisos, until 1954. During his exile, he met some remarkable artistic people, including the ingenious comedian Thanassis Vengos and the great dramatic actor Manos Katrakis, and through them he was exposed to the 'other end of the city', as he himself said in an interview.

Upon his release, he promised Vengos to deliver a letter to the mother of another political prisoner, the poet Aris Alexandrou; in order to do so he went to the most impoverished area of Athens, the slum suburb of Doulgouti, right next to the Acropolis, inhabited still by Asia Minor refugees, mostly marginalised and dispossessed proletarians, in roughly made huts and hovels. His visit to this inner-city suburb, just below the classical glory of the Parthenon, was a profound revelation to him. 'I had never seen so much poverty before,' he reminisced, 'being the son of a wealthy bourgeois family from the aristocratic suburbs.' At that very

moment he received his call as an artist, because he discovered the object of his quest. 'About these people,' he said in a radio interview in 2009, 'I wanted to talk. These people I wanted to present, the suffering and the dignity of human beings like them – and that's what I did.'

Koundouros' cinema is about the unexpected discovery of an invisible objective truth within the officially endorsed presumed 'peaceful' reality; the discovery itself was his personal trauma, and it exposed him to the collective traumas of his society. His cinema has focused ever since then on the visualisation of such collective traumas and his camera has always searched for the underlying symmetries of elemental forms and truths that are in full sight but not directly perceived. It explores, through his symbolic realism, the cruelty of historical reality, with the aim of restoring the dignity of the human person. In a sense, his cinema is a totally novel rendering of the social cruelty that was first expressed in Luis Buñuel's *Los Olivados* (1950) and *Land without Bread* (1932). As André Bazin noted:

> But the cruelty is not of Buñuel; he restricts himself to revealing it to the world. If he chose the most frightful examples, it is because the real problem is not knowing that happiness exists also, but knowing how far the human condition can go into misfortune; it is plumbing the cruelty of creation.[44]

Koundouros' 'cruelty' foregrounded all these traumas that were hidden in plain sight; the eye's direct perception of what is in front of it was mediated by pseudo-events, refracting lenses and confusing illusions. His gaze defined a didactic camera: it exposed, unveiled and revealed motives, purposes and intentions about the subconscious drives that make people exploit and torture each other. Furthermore, it demystified and debunked the ideological pretensions and falsifying strategies imposed by the dominant political order through its regimes of seeing. It remained, finally, a camera that framed history as a theatrical performance, which links his work with Antonin Artaud's 'theatre of cruelty', in which action is 'a believable reality inflicting this kind of tangible laceration, contained in all true feeling, on the heart and the senses.'[45] His cruel realism aspired to annoy, provoke and violate presumed limits and restrictions, and to expose the presumed good intentions of benevolent charismatic individuals and political orders.

Although Koundouros was Cacoyannis' exact contemporary, he avoided the neoclassical realism of Cacoyannis, with its specific singular perspective, its complete story and its sharp distinctiveness of form. Being someone who suffered himself, he avoided realism that obscured reality by its very structure, through the rhetorical manipulation of emotions or happy endings. His own form of realism,

**121**

although it avoided the intricacies of the Soviet montage, was constructed around micro-episodes without form, totally un-tragic in their essence, but full of significance. With his work, Viktor Shlovsky's idea that 'the cinema is the child of the discontinuous world'[46] finds its extreme confirmation. His camera explores the discontinuities in the world without attempting any unification or harmonisation of its ruptures.

His visit to the shanty suburb of the refugees inspired him to make his first film, *Magic City* (1954), which was his first attempt to provide a visual counter-statement to the dominant culture of relentless Americanisation and anarchic modernisation that had started in the early 1950s. His work springs from the rage of a moralist who watches the growing dissolution of a communitarian way of living under the uncontrolled and uncontested forces of urban transformation. Indeed, all his films construct different versions of the intrusion of new temporalities into the mental world of a community based on the moral principles of solidarity, trust and shame. Consequently his cinema constructs a visual language of anthropological significance – of urban anthropology, more specifically – through which the political dimension of being becomes the dominant quest.

Another important aspect is how he used his actors and the actors he chose to use: most of them were political prisoners whose adventures and mistreatment in exile could be seen on their face but could never be explicitly pronounced. Manos Katrakis, the most outstanding actor-auteur of Greek cinema, with a consistent creative vision and a self-reflexive performative style, appears repeatedly in the film without saying a word; the film was made shortly after his release from prison. His presence itself was a powerful political statement against oppression, as was the presence of Thanasis Vengos, the most important comedian in the country, whose comic talent was forged in exile and imprisonment. Such political extra-diegetic subtexts added more layers to the image: the physical presence of the actor became, paraphrasing Kracauer, 'the junction of staged and unstaged life',[47] a stratagem employed by many dissident filmmakers after Koundouros.

Formally, as an architect, Koundouros made his first film as an exercise in depicting the geometry of inhabited space. For him, human constructiveness is at the heart of visual representation: as the camera hovers over the slums of Athens, the symmetry of improvised creativity comes to the fore. His poetics are based on constructivist ideals or even cubist structural dynamics. Especially in his early films, time is not part of the presentation. In these works the camera does not take into consideration the flow of time; it shows us the condensed universe of a lyric temporality: everything happens simultaneously. Cinematically, his constructivism works through gradual mutations, as he distorts space, form

and *mise-en-scène* in order to enrich his narrative with unexpected indeterminism. Such anamorphosis has been used in famous paintings since Leonardo, with the most important example being Holbein's *The Ambassadors*. However, Koundouros uses another form of such 'forced perspective' in the way that baroque artists employed the *trompe-l'oeil* technique. The final scenes of *Magic City* are a strange amalgam of film noir and neorealist aesthetics, invoking an atmosphere of tense anxiety and fear through a completely visual reconfiguration of reality and abrupt discontinuities in editing.

In Koundouros' cinema such anamorphosis is also seen in *The Ogre* (1956) and later in *Bordello* (1985), and functions as the marker of temporality, to give dynamic qualities to the dimension of space. In that sense, his spatial arrangements are temporalised: the films of the middle period, 1958 to 1967, transform their images into rhythmic units through which indeterminate images emerge. *The River* (1960) is an astonishing kaleidoscopic construction in which unrelated storylines intersect and then vanish as if they never happened. The only connection between them is their random spatial convergence. It is space that made the characters move from their accidental position to a cinematic abode; this is itself a visual motif about their presence. In his films after 1984, Koundouros simply dissolved the achievement of his earlier work: now temporalised space is expressed through the fluidity of colours as they collide with the story itself. (Some critics would claim that the colours annul the story.) *Byron* (1992), for example, is a film about introspective temporality: the poet's despair is transformed into a cosmological principle. The Greek War of Independence, the crowd of Hellenes and Philhellenes around him, the repulsive sexuality of the human body are all subordinate to the profound nihilism of a poet whose romantic world has collapsed under the unpredictable darkness of reality. How does one depict nihilism as a cinematic event? By presenting desperadoes committing destructive acts of narcissistic self-justification? For Koundouros, despair was primarily a natural reality; it was therefore also a fundamental psychological reality and had to be expressed through atmosphere, colour and *mise-en-scène*.

If in his real work Byron was redeemed by his acerbic self-irony, in Koundouros' film his lived temporality has transformed cinematic time into a dystopic romanticism. The same can be seen in *Photographers* (1998) and *Last Ship for Palestine* (2011), where the nightmare of history overpowers the reality of individual emotions. The nihilistic mood expresses a profound problematisation of the cinematic image as the locus of order and form. His last films are about the destruction of the constructivist principles that made his earlier films both solid and fluid, formally self-sufficient and pictorially open. In a sense, after 1984 Koundouros

'romanticised' cinematic representation through an interplay of colours, incongruous symbols and unconnected storylines:

> The world must be romanticised, exclaimed Novalis in 1799, so that the original meaning may be rediscovered ... In so far as I give to the commonplace a lofty meaning, to the ordinary an occult aspect, to the well-known the dignity of the unknown, I am romanticising them.[48]

Vassilis Rafailides understood that aspect of the film when he concluded: 'He presented him [Byron] plethorically, explosively, un-historically.'[49]

Koundouros seems quite aware of the 'fragmented' character of his work and the 'discontinuous' plots of his films. In his autobiography, *I Dreamed that I Died*,[50] a strange narrative experiment in discontinuous memory, a fusion of Sergei Eisenstein's *Immoral Memoirs*[51] and Ingmar Bergman's *The Magic Lantern*,[52] he talks about 'the birth of a film, which wants to be a testimony, and an eye-witness account, full of rage, because silence is suffocating'.[53] Koundouros' poetics are based around what he calls 'the obsession of the director since the days of his exile ... to denounce the violence of power over people and humans'.[54] His films are phonocentric visualisations, exploring the tonalities in colour of the human protest and the sonic vibrations in the cries of despair. On many occasions, his films look like anarchist manifestos, indeed like visual assaults on the obvious and understandable truths of the established order. Occasionally, Koundouros becomes obsessive about the unfairness and injustice in the system of values dominating the neoliberal world, and in his cinema he distorts all accepted symbols in order to mock and ridicule their influence. His late films frame the central enemy of all human creativity as the organised state, because, as he denounces, 'it was always reactionary, stingy, intolerant, gerontocratic, retarded, hostile, incapacitated, negative'.[55]

In a positive way, he also suggests that cinema is an instrument of self-awareness and self-recognition, as it was after the war in Italy, when 'the Italian cinema, pioneer of a true epic in self-awareness, struggled to define the new face of a people tormented by fascism and the destruction of war'.[56] This culminated, according to Koundouros, in the work of Federico Fellini. Indeed the great chaos of surrealism and anti-realism that we find in Koundouros' final works is very close to Federico Fellini's baroque and surreal inventiveness, fused with the sensuality and the violence that we find in the works of Pasolini. The mixture is disconcerting, but occasionally it leaves behind images of extreme lyrical beauty and strong emotional effect.

## Discarding realism

> Realism in cinema seems to me today both boring and insufficient.
>
> Nikos Koundouros[57]

Koundouros' work is one of the most powerful denunciations of Nietzscheanism in contemporary cinema. His cinema belongs to the postwar generation the realisation that the cult of the charismatic individual that fascinated the previous generation so much was the reason behind the lingering and irredeemable traumas of the past. The charismatic individual, so pitilessly ridiculed with the image of the straw superman in *The River* (1960), represents the visual metonymy for his worldview, which stands again very close to Pasolini's '*avant la lettre*'. In a sense, being totally disappointed with the state and gradually with the working class, he was trying to find a type of individual character or a collective representation that would become able to develop its own agency under the structures of official master narrative and its usual protagonists. The bourgeois class and its values, which had so much importance for Yorgos Tzavellas and Michael Cacoyannis, is seen by Koundouros as the ultimate enemy of creativity. Koundouros, like Pasolini and Antonio Gramsci, before him:

> [praised] the working class because a specific part of this class (their beloved sub-proletariat) has retained a preindustrial, mythical and religious consciousness, a sense of mystery and awe in the face of physical reality, that Pasolini defines as a pre-historical, pre-Christian and pre-bourgeois phenomenon.[58]

For Koundouros, the persecuted minority who have been unable to find political shelter and legitimacy was the central body of agency:

> My film [*The Ogre*] was a melodrama which gave me the opportunity to develop a whole world. A world tormented by the occupation which followed the German occupation, that is to say the occupation of the right-wing government. It was a special kind of people, an idiosyncratic world in deep suffering demanding the right to live, oppressed, rudderless, unhinged, decapitated, writhing like a snake without its head, in an agonising attempt to find it.[59]

Koundouros talks about this people using the term 'Romiosini' (Romanhood), the medieval name for the Greeks who, under the control of the Byzantine and later Ottoman aristocracy, were never able to define themselves under conditions of freedom. The final Bacchic dance in the film is the revival of that hidden tradition in a modern context, as the eruption of a primordial yearning for self-awareness.

This creates a sketch for an anthropological theory of culture, analogous to the one elaborated by the Italian anthropologist Ernesto de Martino, who influenced Pasolini in his own privileging of the sub-proletariat. Ritual dancing, according to de Martino, implies the need for transcendence, the need not to be defined by the enforced invisibility of capitalist structures. By transcending the conditions that destroy your presence, you regain:

> the principle of intelligibility of human existence. It is the condition of its possibility, its ultimate purpose, and, at the same time, the cause of the limits of the being itself. The 'primordial' or 'original' transcending energy brings the being-in-the-world back to the necessity of being in it, and the duty-to-be-there to the duty-to-be-there for meanings.[60]

In the films that followed, Koundouros explored such visual primordiality as it emerged unexpectedly in the depersonalised human subjects of a political system based on oppression and thus on existential repression. He does not identify the system solely with capitalism; for him, it is organised power in general. Lefteris Xanthopoulos concluded his brief study on him by stating: 'For the *desperado* Nikos Koundouros, cinematic art is a savage belligerent art.'[61]

Koundouros persisted in presenting the negative aspects of power and of the unscrupulous elite that keeps it under its control throughout his career. The image of the sub-proletariat vanishes after 1978, and his last films are primarily about the psychopathology of power; redemption always comes in the face of a humble prophet or the cry of a lost soul. Between his clearly differentiated periods, *1922* (1978) explores with savage psychological accuracy and therefore extreme realism the impact of world historical events on the life of ordinary individuals. Starting with the emotion that we witness in the early scenes of that film, we end up with the absolute incapacity of language to denote or even locate human experience: *1922* ends with a powerful scream, unambiguous and yet beyond language. In his films after that, the semiotic realism, the idea that a sound refers or corresponds to an object or a situation, is completely rejected. Language becomes the negation of all meaning; thus historical experience cannot be meaningful because we have no means of describing the content of our encounters. In *Byron* (1992), a film about a master poet of English, language unmakes his personality: the more he struggles to talk about what is happening around him, the less he is able to talk about himself. The great romantic hero becomes an anti-hero, against his own self: the film is not about the Greeks fighting against the Turks, but Byron fighting against Byron. Unable to believe

he has to carry on, with the lost cause of himself as a liberating project. In a world without god, 'there is but one truly serious philosophical problem [left] and that is suicide,'[62] as Camus' hero would have claimed.

Politically, Koundouros' depiction of the unforgiving rise of nihilism finds its cinematic translation in fragmented narratives, discontinuous stories and indecipherable voices. Probably, a reference to the great disenchantment with the failure of European socialism during the 1980s, images, sounds and iconographic patterns have lost all direct associations with meaningful actions. The strange accents of the central actors, in *Byron* (1992) and *The Photographers* (1998) in particular, express the lack of correspondence between appearance and reality: the foreignness of the voice gives language only a performative, or an instrumental, function. The individual, the character, speaks another language which is never heard throughout the film. If in his early works a song or a monologue could frame the conditions that made images meaningful, now images are stripped naked of any reference or correspondence. Images talk to us in succession without ever taking into consideration the signifying ability of words. With the death of language (we can think here of the Greek language specifically, or of language as a general system of cognitive semiosis) a new image emerges: the time-image. According to Deleuze, this is not the image of the temporal duration of an act, 'it is movement which subordinates itself to time'.[63] So images now abandon space referentiality and temporal demarcation, and become signs of the mind confronting its limitations through 'a confrontation of an outside and an inside independent of distance, this thought outside itself and this un-thought within thought'.[64] The absurdity of the lived experience is visually replicated by the absence of any homology between images and meaningful reference.

In an interview about *The Photographers*, Koundouros pointed out:

> I choose a painful space. It is a space where people slaughter each other as we did fifty years ago. My participation, my resistance [is] to this wonderful indifference that has taken over us fatalistically when we press the button and watch the horror from our comfortable couch.[65]

The death of language is still a major political event. On such biopolitics of death Koundouros weaves what we called his relentless 'oppositional aesthetics',[66] interrogating existing borders, realities and perceptions. Some would claim that this is an artistic dead-end similar to that experienced by Orson Welles after *Touch of Evil* (1958). The geometry of empty spaces, the exploration of liminalities, the dissolution of human form, and the investigation of the monsters of conscience

led Koundouros gradually to the total discrediting of the cinematic image as a power to liberate from the distortions of existence and the corruption of consciousness. Finally, it seems that Koundouros totally extinguished all forms of characterisation, identity or specificity by privileging the extreme, the opaque and the unrepresentable. In his last films, he seems to foreground self-sufficient cinematic semiosis over narrative content, which in the end makes them extremely difficult, almost unwatchable. But one can claim that this is a new sense of realism, both dramaturgically and psychologically; the realism not of the open field and the self-sufficient form but of the Platonic cave and the house of mirrors. This is what the prisoners in the Platonic cave see every day: that's their only reality. As with Theo Angelopoulos, the profound disillusionment of the 1980s and 1990s made him turn inwards, to the labyrinth of his mind, wherein he lost the lucid geometric constructiveness of his earlier vision.

The spectre of Orson Welles is again pertinent in order to understand Koundouros' late style. André Bazin described Welles' technique:

> Contrary to what one might believe at first, 'decoupage in depth' is more charged with meaning than analytical decoupage. It is no less abstract than the other, but the additional abstraction which it integrates into the narrative comes precisely from a surplus of realism. A realism that is in a certain sense ontological, restoring to the object and the decor the existential density, the weight of their presence; a dramatic realism which refuses to separate the actor from the decor, the foreground from the background; a psychological realism which brings the spectator back to the real conditions of perception, a perception which is never completely determined a priori.[67]

Koundouros' oppositional aesthetics led him to 'a surplus of realism' that in the end he was not able to control or reconfigure. Herein one can probably find the mystery of what is called a happy failure – a failure of imagination, by all means, but at the same time the success of a fecund creative process. 'I do not terrorise anyone,' Koundouros said. 'I myself am terrorised.'[68] And this may well be the key into the unrhythmic and chaotic patterns of his late films.

# 4

# Yannis Dalianidis and the Cryptonymies of Visuality

## Cinema as empirical ascesis

> We, the people of cinema, are egocentric beings. The whole universe revolves around ourselves. If things were different, we would never revert to autobiographies.
>
> <div align="right">Yannis Dalianidis[1]</div>

Yannis Dalianidis (1923(?)–2010) was the most commercial and prolific director in Greek cinema, as a simple glance through his 74 films, 14 television serials and 16 videotapes proves. Both these qualities ensure that his work was looked upon with reservation, and even with scorn, especially after 1970, when the auteur tradition started dominating film production and – most importantly – the interpretation of films. For a long time he was the main target of – or a person of utter indifference to – the Marxist reviewers for the journal *Modern Cinema (Synchronos Kinimatografos)*, the central vehicle through which the New Greek Cinema of the 1970s articulated its principles and constructed its genealogy (despite the deep respect that its central auteur, Theo Angelopoulos, nurtured for his work). In the narrative of their invented origins, Dalianidis, the main representative of the parochial 'commercial cinema', was the pernicious vehicle for the Americanisation of the country, the imposition of Hollywood's conventional aesthetics, the reactionary star system and the glamorisation of bourgeois reactionary ideology. Even in recent and more nuanced studies, his films are criticised for using 'rhetorical demagoguery and populism, under the pretence of social denunciation.'[2]

It is conveniently forgotten, however, that a number of contributors to New Greek Cinema, such as Pantelis Voulgaris, Yorgos Arvanitis and Pavlos Tassios amongst others, worked with Dalianidis during the 1960s on the production of some of the most successful, stylistically accomplished and cinematically effective

'commercial' films of the period. As a result, very few substantial explorations of his work have been attempted. In her study of Greek musicals, Lydia Papadimitriou, referring to his early works in the genre, stated:

> These films [Dalianidis' musicals] glorify novelty and focus on a youth culture which has embraced foreign fashions. The new, more liberated values and lifestyle of the younger generations is celebrated, while the old is occasionally present in the background, sometimes providing the framework against which the young define themselves.[3]

Besides Papadimitriou, very few scholars have studied – or indeed taken seriously – his work or examined his visual poetics. In his very many interviews, Dalianidis himself focused on anecdotes and apocryphal stories about the production of his films or about his turbulent relations with his actors without ever talking about his aesthetic or ideological projects.

However, on closer examination, Dalianidis must be the quintessential demotic auteur of the mainstream cinema, as he was a director responsible for not only the *mise-en-scène* of his films but also for their script, casting and promotion, under the strict supervision of producer Philopoimin Finos. He was the archetypal filmmaker, the grand master dominating all stages of cinematic production within the restrictions – and the advantages – of the studio system in the most productive period of the consolidation of 'Greek national cinema'. However, despite their easy appropriation and success, his best films had, intentionally, multiple layers of meaning, disguised references, ambiguous representations and unexpected associations, all linked through a powerful melodramatic style, impressive music and effective acting. Such uneasy and precarious balances in the filmic text framed the very centre of his cinematic project, which focused, to the extent that he was allowed by censorship and the producer, on the exploration of the traumas of history, the psychological impact of modernisation and, most significantly, the corporeal anxiety of traumatised masculinity. A child of the Asia Minor Catastrophe of 1922, an internal immigrant to Athens for work and a closeted homosexual throughout his life, Dalianidis insidiously problematised the subscripts and master narratives that contributed to the construction of the individual and collective subjectivity at particular moments of Greek social and cultural history.

While other contemporary directors, such as Nikos Koundouros and Michael Cacoyannis, worked within strongly heterosexual imagery and hegemonic codes of representation, Dalianidis' films work subversively through such codes by adopting them and then infusing them with a confronting political, psychological

and sexual content. Dalianidis 'melodramatised' dominant forms of visual representation through powerful psychological dichotomies and social conflicts; by doing so he foregrounded hidden stories, marginal positions and oppressed subjectivities in revolt to the point of transforming the cinematic screen into the *topos* of uncomfortable and occasionally demoralising revelation. His best films visualise implied acts of mourning and anxiety, and the sexual outlaw standing at the margins of social culture while being at the centre of its material industry. His awkward and dangerous position defined a secret self-inscription in all his works, recording the tension and the anxiety of such a state of being. In a strange way, Dalianidis worked like Alfred Hitchcock, infusing his mainstream works with alarming subtexts, sexual inversions and social subversions. Tom Cohen called such subtexts 'secret agents' and defined them as follows: 'the term refers to more or less "secret" visual elements, graphic riddles, letteration, and cryptonymies that traverse all of his works, linking each to each in perpetual if active interface'.[4]

Chronologically, Dalianidis' films can be divided into two periods, although there is no firm way to impose a categorisation on the basis of genre, as he experimented with melodrama, musical, comedy, war drama and more, fusing their stylistic characteristics in a rather unstable form of 'soft realism'. The most popular part of his filmmaking started in 1959 and ended with the death of his producer, Finos, in 1977. There was a rather long transitional period when he worked for the new medium of television, between 1974 and 1981; after that year and until 1988, he produced some of his most underrated and under-studied films, which deserve closer attention and are now considered 'cult films' of a decade dominated by new forms of production and dissemination, mostly through videotape and without public release at the movie theatres.

Most of his films depict experiences of weakness and situations of disempowerment. The tendency of Dalianidis to transform ordinary characters into emotional, or even sentimental, symbols of hopeless rebellion was a very effective stratagem: as long as they expressed the fantasised super-ego of culture, they could also be accepted by those who controlled power and dictated patterns of normality to film-goers. In that respect, there was always a certain naivety on his part about his role as a director, a naivety that can be seen in most of his films through his one-dimensional characters, the stereotypical conflict patterns and the necessary happy ending (in most occasions imposed by his producer).

Dalianidis' involvement with cinema was completely empirical. He started making films without having studied anything about it, and the more he did, the better he became. From his directorial debut with the actress Aliki Vouyiouklaki, *The Little Vixen/I Mousitsa* (1959), until his last film, *Life Sentence/Isovia* (1987),

Dalianidis was a director who wanted to communicate with the audience, to flatter their virtues and chastise their vices, without directly confronting their habits and beliefs. Despite his strongly professed atheism and Leninism, his films are infused with a profound spiritual warmth, religious reverence and humanistic empathy – yet he was one of the very few Greeks who demanded a non-religious burial. As director and screenwriter, he had great ability in characterisation and storytelling: his best films are complete visual narratives, in a classical Aristotelian mythopoeic structure. They avoid montage and editing – even the settings are somehow superfluous – as his real protagonists are closed or open urban spaces, sometimes in grandly orchestrated theatrical arrangements or indeed, when successful, in genuine cinematic compositions focused on intense camera movement, effective editing and high-contrast lighting. The camera work of his main photographer in his early period, Nikos Dimopoulos, effectively contributed to the crisp and sharp contrasts between lit and dark spaces, the transition between scenes and, more importantly, in the expressionistic representation of human nudity.

Dalianidis was an actor's director, using a rather personal method to elicit complete identification between character and actor – probably the influence of Elia Kazan's method acting can be detected in his approach to performance. Like Stanislavski, he believed that 'there is an unbreakable bond between the action on the stage and the thing which precipitated it. In other words, there is a complete union between the physical and the spiritual being of a role.'[5] When this union was successful, constructing characters of intense psychological realism, as with actors such as Nikos Kourkoulos, Zoe Lascari, Manos Katrakis, Costas Voutsas and others, his films left an indelible impression. In many instances, the viewer had the impression that the acting itself brought out the complexities and the contradictions within the character; Stanislavski's idea about the union of opposites, expressed in his admonition to the actors that 'when you play a good man, try to find out where he is bad, and when you play a villain, try to find where he is good'[6] finds in his films one of its most powerful realisations. The innate contradictions in the character become part of the visual narrative itself: they frame story, style and performance the whole *mise-en-scéne* relies on the intense psychophysical dramatisation of emotions, depicting the absolute union between the physical presence of actors and their mode of acting.

Indeed such intense performances have shaped the taste and the dis-taste of two generations in the country and formed visual practices that in due time migrated to television. Unfortunately, very few of his films became successful internationally, although his visual language was that of the global popular cinema, as seen

in the Hollywood films of Douglas Sirk and the English films of Michael Powell. Although one can also detect the visual subscripts of Otto Preminger and Frank Capra or even Stanley Donen and Vincente Minelli in his various musicals, his personal style of representing social experience was through an unassuming 'soft realism', unfolding acts of conflict, defeat, anagnoresis and catharsis, in a linear and sequential seamlessness. His scripts were almost always about reconciliation, compromise and acceptance. He knew how to dramatise history in a very effective style of empathic affect – but he also knew that his rising middle-class audiences wanted a happy ending, and his producer also demanded and imposed very strict guidelines on permissible moral behaviour on the screen.

Overall, his films are structured around conflicting emotional landscapes populated by one-dimensional characters within predictable storylines; however, in a closer analysis, those storylines are full of ghosts of the past that are never named and invisible presences that are not defined. Politically, his realism predominantly focuses on urban realities in conditions of rapid industrialisation, with capitalism dismantling communal humanitarian values. His films are major cultural texts exemplifying the transition from the pre-modern bonds of family and neighbourhood (*Gemeinschaft*) to the modern state of relations defined by money, individualism and property ownership (*Gesellschaft*). If, for Cacoyannis – and, to a certain degree, for Koundouros – the human face was the ultimate map for the rational mastery of history, for Dalianidis the complete human body, its sensual movement, carnal plasticity and sexual magnetism, which expressed precisely the inability to become the master of one's own existence, was that map. The irrational fear with which society invests the naked body is at the heart of almost all of his films, as is the anxiety caused by the commodification of the very same body, its voluntary prostituting for money, possessions and status.

The boldest element in Dalianidis' scripts was the implied admission that the body itself had to consent to its own commodification, as it never had any options or any genuine choices within the class structures imposed by a greedy and terrified petit bourgeoisie. The black and white photography or the saturated colours of his later films depict landscapes of explosive desire which, despite a degree of domestication and conventionalisation for the middle-class audience of the period, are quivering with energy and intensity, unable to be contained by mainstream practices and accepted rituals of sociability. Through the almost stereotypical generic characters and the loose frameworks of action, Dalianidis' contemporary viewers were distracted from discerning the troubling and distressing subtexts that infused his images with a profound angst and disquiet, indicating an almost desperate attempt to reclaim an open space for submerged sexualities, desires and identities.

Following Julia Kristeva, one could claim that his best characters are neither subjects nor objects but 'abjects',[7] existing in the liminal spaces between convention and marginalisation, unable to become 'subjects' because of the mask of complacency they wear, which brings them into perpetual collision with themselves. Because of this, they are the negatives of themselves, mirror images, in the *camera obscura* of self-disguise and self-decentring. His work, through the visual devices of popular culture, also depicted a pervasive class consciousness of subjugation and submissiveness in collusion with capitalist modernisation – something that his Marxist critics totally missed or overlooked. Such class consciousness was expressed through the de-subjectification of the female and the male body by mechanisms of cultural and economic production as well as by state apparatuses such as the school, the church and the police. The de-subjectification of the body through its exploitation by such structures is intensely represented in his later films through the mechanisation of sex, the violent objectification of sexuality, and finally the loss of the ability to *name* the libidinal subject. One of his later films, *The Dangerous Ones (A Protest)/Oi Epikindinoi (Mia Diamartyria)* (1983), was a bold hybrid fusion of televisual strategies and cinematic framing to depict the social disjunctions of the period by pointing out the loss of rational mastery of one's own body. The implied subtext of the film was that in a period of social optimism created by the election of the first socialist government (1981), the real social problems – such as unemployment, poverty and drug addiction – remained unresolved and that a whole generation was squandered through criminality and alienation. This was a message not very well received by the leaders of the day.

In his last commercially successful film, *Maria of Silence/Maria tis Siopis* (1973), made around the filmic persona of the superstar Aliki Vouyiouklaki, the character is a mute young girl who is raped and whose illegitimate child is taken away by the rapist. She remains unable to name the rapist and the crime: the absence of language makes this film one of the most eloquent representations of male sexual aggression, female internalised submissiveness and individual powerlessness expressed in terms of class conflict. Indeed this film explores the hidden world of secrets and phobias that dominated the affluent but weak petit bourgeoisie, the masked landscape of frustrated desires and unfulfilled expectations, as they were defeated by the traditional structures of power in an era of rapid modernisation. The inability to enter the dominant symbolic order and give themselves a stable identity transforms Dalianidis' disenfranchised characters into the ambivalent *topoi* of unresolved social, psychological and sexual collisions. His abject characters struggle to fit into an accepted system of normality and are willing to submit themselves to all possible processes of normalisation: yet they always fail, and

despite the happy endings in most of his films, viewers can intuit the unsettling semantics that connect the subtexts of his films as they construct an anti-language of rupture and negativity to the very world they seem to express and glorify.

In one of his best films of the same period, the dramatic musical *Naked in the Street/Yimni sto dromo* (1969), based on a script by Iakovos Kambanellis, the city fool talks with the children: 'Tell us,' the children shout, 'how you became mad.' 'I will tell you the day after tomorrow,' he responds. 'That day is still to come,' the children insist. 'Ignorant people,' he replies, 'everything has come. Tomorrow and the day after tomorrow, even yesterday. What happens, what will happen, is already here.' And he starts a strange extra-diegetic narrative about the Asia Minor Catastrophe – looking over the camera towards a lost but ever-present past – and the life of displacement and trauma which destroyed the ability of the refugees and of their children to communicate, and to belong, for so many decades after 1922. This was a film about transgenerational trauma, and about how it was perpetuated every day through small rituals of remembrance, loss of subjectivity and a constantly deferred catharsis. Despite its eloquent music, by Stavros Xarhakos, the film is about the silence of historicity: about the silence of abject individuals living on the fringes of a symbolic order they cannot identify with unless they submit themselves to 'voluntary servitude,'[8] indeed prostitute themselves in order to gain acceptance and 'a measure of power'.[9] For the film *Those who Talked with Death / Aftoi pou Milisan me ton Thanato* (1970), a work of pure nostalgia and idealism, he used the young Yorgos Arvanitis as the director of photography. Arvanitis (who later became internationally recognised as the main cinematographer in the films of Theo Angelopoulos) ingeniously blurred the colours, infusing the frame with an eerie atmosphere of nostalgic emotionality, rather like a personal album of faded family photographs. The trauma of history was transformed into a sublimated image of unspoken suffering and abuse. Later Dalianidis recalled:

> I don't like talking about my life in the concentration camp. I came out alive while I touched upon death. Since this book is about cinema, I must mention that none, but none, of the films I saw [that] were about life in the camps succeeded in really presenting what was happening in them.[10]

This specific film was a substantial artistic and formal achievement, with fast dialogue, intriguing plot and successful editing, as it incorporated reels from the period of the Italian and German wars, through fade-out transitions; it had an operatic sense of space and was a nostalgic rewriting of history, despite being made under the censorship of the 1967 Dictatorship, which never allowed any

political references. However, the fierce denunciation of collaboration, so eloquently presented in the film, shows that Dalianidis wanted to explore aspects of historical experience that were not allowed to be screened, because of their obvious parallels with contemporary political reality. In fact this is one of the first films depicting resistance against oppression and totalitarianism framed by mature performances and powerful emotional dilemmas; the theme of moral choice that permeated his early films found here its most poignant and stylistically effective depiction.

Dalianidis attempted something similar in films such as *The Rebellious Commoner/O Epanastatis Popolaros* (1971) and *The Enemy of the People/O Ehthros tou Laou* (1972), as well as in some melodramas of the same period, in which he used historical parallels as a pretext for indicating his well-disguised Left ideology. The confined spaces explored in these films became the symbol of a society being suffocated by oppression and of individuals suffering repression. But his attempts at serious narrative cinema were never taken seriously, especially when a completely new visual temporality started dominating production, with Theo Angelopoulos's *Reconstruction* (1970). In the end, Dalianidis became the victim of his own versatility and of the very studio system that gave him the opportunity to *be* versatile. The 'cult' films he directed in the 1980s brought to the fore many troubling subtexts about sexuality that could be sensed in his earlier films. Masochism, phallic anxiety, sexual violence and gender inversion, mere innuendos in his previous films, were transformed into provocative political statements through the explicit fetishisation of the male body in both its macho (with the actor Panos Mihalopoulos) and feminised (with the actor Stamatis Gardelis) forms. Sexual aggression, impotence and orgasmic frustration received unmediated representations in these late films, which need further study as they were made in the 1980s, an era of great political delusion, puritanism and ideological indoctrination.

It is interesting that nobody ever noticed these libidinal currents in his films, or nobody ever dared to address them as coded messages in the scripts. His last film of the 1970s, which he thought of as his 'unseen masterpiece', indicatively enough entitled *Fire/Fotia*, was an explicit sexual extravaganza full of nudity, orgies and sadism, based on three male characters. 'It was a strange movie,' he said later to Jason Triantafillidi. 'It didn't look at all like any of my other movies. It was set in a primitive society and was extremely political – but it was lost.'[11] Indeed, a near-complete version disappeared after the demise of Finos Films in 1977, either for reasons of moral indignation or by accident; the story behind this film must be one of the great detective cases of Greek cinema.

A master of evasion and circumvention, Dalianidis talked about his personal adventure by presenting presumably innocent 'collective stories' that referred to the experiences of the postwar generation through a deceptively impersonal style. Nobody noticed the strong autobiographical elements that suffuse his films: they refer to his personal experiences during the war (he spent two years in a concentration camp) and the insecurity about his sexuality that he experienced after the war. In his last interview with Christos Parides he stated: 'I am a child of the war – this says it all. A war followed by another civil war in this country. When you have lived these events intensely, they influence you for good.'[12] In the same interview, he defended the absence of 'bad' characters in his films:

> Only in my last years did I make some hints about the very bad aspects of my own life. In the past I never talked about them. Something in me repressed them. I didn't want to put on any mask and I didn't want the others to suspect me as a 'hero'. I always wanted to be the next-door man, who always has pleasant things to say. This accounts for the absence of my bad aspects. Except in one case, the film-chronicle of the war, *Those who Talked with Death*. There I resurrected ugly experiences. The famine, as experienced by my family, the collapse of the front, and when all of us youngsters tried to escape to Egypt, but were stopped by the bombardment of Piraeus.[13]

Indeed his formative experiences were not simply war memories. They were also about the fact that he was adopted: his biological parents were refugees from Anatolia who arrived after the Asia Minor Catastrophe in 1922. His father died shortly after, of dysentery. His biological mother appeared in his life when he was 14; by then he had formed a very close bond with his adopted mother, who was one of the inspiring forces in his life. In a revealing interview with Manos Tsilimidis in 1993, Dalianidis talked about the great mothers who defined his life:

> All my life, women worshipped me. As if they felt a collective guilt for the fact that the one woman who gave birth to me gave me away. You cannot imagine how much they loved me and looked after me. Starting with my adopted mother ... And then with Frau Marie in Vienna. What an unusual woman! She stood like a mother to me. She was a staunch anti-Nazi. Just a slender and vulnerable creature. She took me to her place and cared for me ... We communicated with gestures and several English words. When I go to Vienna now, she is not there anymore.[14]

As in Michael Cacoyannis' work, the motif of troubling family secrets appears repeatedly in his films. The secrets of the bedroom dominate his stories without

ever being articulated: sisters who desire the same man, mother and daughter who seduce the same male predator, feminised men who are dominated by powerful female bodies. The pantheon of his characters is made up primarily of women whose sexuality wreaks havoc around them, as they react desperately to the phallocentric ethics of their everyday life. Yet the phallus remains dominant in all his films, both an object of desire and a symbol of horror. In the end of his masterful film *Story of a Life/Istoria mias Zois* (1965), two men look at each other with a guilty secret: the woman who disrupted their world was killed and they must remain silent. Such concealment indicates a bond between men formed around the the secrets of masculine power and male sadism – such libidinal geographies are implicitly framed in the film. Dalianidis also knew how to disguise male horror in front of the vaginal challenge: the mysterious female sexuality keeps them away from each other but their fear of women makes them accomplices in the crime against them. Their homosociality is easily betrayed, as the camera focuses on the male aggression with intense fascination. Dalianidis had to disguise his narratives as stories about marginalised people who suffer; yet in reality they were stories about ruthless male opportunists who would do anything in the quest for social domination; sex is a strategy for power, but at the same time their hidden Achilles' heel.

The diversity of his films has occluded the fact that a profound and constitutive existential anomie permeates all of them. They appear discreet, innocuous and idealistic, avoiding all forms of confrontation, such as that of his audience with the ghosts of the past and his own with the powers of the day (especially the censorship of the 1967 Dictatorship). Yet all his films revolve around a troubled individual, disturbed by his or her body, and present the troubled body as the central *topos* of social disruption and distress. There is always a missing father, absent or dead, exiled or forgotten; the mother figure usually acts as the ultimate super-ego who censors and castigates. In some films, the grandmother is like the stepmother of fairy-tales: sinister, omnivorous and cannibalistic. The films deploy the Freudian family romance in all its variations, framing a profound existential guilt, or the transference of guilt from generation to generation.

Dalianidis' films are about the negative side of normality, expressed through persecution, rape, humiliation, frustration and self-rejection. The interesting aspect of most of them is that their characters seem to take pleasure in their subordination and oppression. Indeed, most of his characters find enormous pleasure in mental and corporeal suffering. The films of the early 1970s are the peak moments of such mythologisation of masochistic experience; mostly, they present a profound crisis in masculine representation, as the suffering male body either

becomes objectified and reified through a carnivorous gaze or transforms itself into its opposite – becoming feminised and therefore harmless – in order to protect his mystique.

Dalianidis' female actors, Martha Karayianni and (particularly) Zoe Lascari, became the epitome of inverted and subverted masculinities, the female men, with the latent feminine egos of a male body in search of its object of desire or in search of a name for such desire. A simple reading of most of his films could easily indicate the strong but infantile narcissistic characters that dominated their plots: most of them are unable to resolve their Oedipal attachments and remain fixated at a 'mirror stage', indicating a self-consuming desire. The bodies of male actors are discreetly fetishised through their dress, and, most importantly, through the very obvious eroticisation of their movements and the sexualised wandering of the camera around them. In the early period, the virile body of Nikos Kourkoulos was the ultimate phallic totem in the structure of the patriarchal value system – covered, muscular and alluring. On the other side, the curvaceous body of Zoe Lascari was the open space for voyeuristic rape – scantily dressed, voluptuous and available.

From this point of view, Dalianidis' films, apart from being unique social documents about public taste and the studio system, are multi-layered psychoanalytic texts, depicting complex sexual identifications and framing the subtle strategies he had chosen, almost as personal defence mechanisms, in order to create images of the Other within the mind of the petit bourgeoisie in the time of its ascendancy, as it was taking over power and replacing the old families and systems of patronage with its own self-serving arrangements. In a way, the politics of his displaced desire are more subversive than the rather moralistic filmic texts produced by the famous left-wing filmmakers of the period. Even Theo Angelopoulos, with his profound debasement of the body, depicted sexual diversity and pleasure as perversion and deviation. For example, in Angelopoulos' *Days of 36/Meres tou 36* (1972), the implicit text of homosexuality was associated with the ability of state power to pervert its own people in order to control and dominate. Even in his *Landscape in the Mist/Topio stin Omihli* (1987), the homosexual bar became the *topos* for a *katabasis* to the facelessness of lost social projects. Dalianidis avoided such puritanism by ambiguating the sexuality of his characters. The petit-bourgeois audience, the producer and the censors asked for glorification of normality, class conformism and family values. In Dalianidis' best films, this happened at the end of the story, after a long and convoluted path of libidinal reversals. The character development involved in the process constituted a story within a story, inscribing a second submerged identity underneath the normality of its explicit storyline: this is what we call the 'cryptonymies of desire' in his films.

## Homeless sexuality

> There is an overwhelming desire at moments to escape personality, to revel in the action of forces that have no respect for ego, to let the tides flow, even though they flow over us.
>
> William James[15]

The primal setup in Dalianidis' films was a precarious state of being: all his major stories are about expulsion from home. For him, home was not simply a lost homeland; it was a *topos* inextricably social, classist and sexual. The expulsion from home is also an autobiographical reference. His films follow the ambivalent trajectory as he was 'growing' in the profession: they started with expulsion of the young by the older generation; they continued with class domination, as the wealthy appropriate the existential adventure of the poor and use it as an alibi for their guilt and false consciousness; and they ended with the depiction of the sexual outlaw, expressed through a queering gaze that homosexualised every aspect of social experience. The 'queering' of mainstream heterosexual behaviour was at the heart of his project, especially during the most creative period of his work: one can see his films in the same way that we interpret the 'inverted gender identities' in Marcel Proust novels and Rock Hudson's hyper-masculine film personas, bursting with homoerotic overtones.

His early social dramas, *Downhill/Katiforos* (1962), *Law 4000/Nomos 4000* (1962) and *Vertigo/Iliggos* (1963), explored the emerging youth culture of the early 1960s and its conflict with the dominant patriarchal structures, expressed through family, school, church and state. From the beginning, the main focus of the dramatic tension was the female body, its visual presence and sexual attraction; the female body disrupted the sense of reality and regularity imposed by the tyrannical and mostly impotent fathers. As he wrote later:

> In the case of *Downhill*, we are dealing with a disintegrated family, in which the father is unable to dominate. On the contrary, in *Law 4000* we have the model of the strict father who terrorises his whole family. This gave me the opportunity to insert more incidents of urban life as we experienced [them] then and maybe we still experience [them] today.[16]

The young Zoe Lascari became the alter-ego of a director who could not reveal his very private images of sexuality: her body epitomised the masochistic fantasies of a male gaze that was attracted to the masculine phallicism but was unable to express its attraction or depict the object of the desire itself. Dalianidis said about Lascari:

> My relationship with this actress was always different. I loved that girl as if she was a member of my family – that's why I was really grumpy with her. I don't know if it was a latent erotic attraction, because I understood that I was annoyed when she had affairs with other men. Later, I heard that she married Alekos Lykourezo and I felt content. Because I realised that she was in good hands and [had] secured the protection she needed.[17]

Lascari's body was sexualised by the libidinal energy of a male gaze that wanted to be desired by another man: this game of reversed reflections used the female body as its alibi, projecting its sexual drive onto the opposite gender. Dalianidis homo-sexualised the female body through its fetishistic exposure to the deflected desire for another man. This is what we call the 'submerged identities' in his work: all gender identifications are turned upside down, separating biological sex from sexuality and destabilising the connection between subjectivity and eroticism.

In almost every film, in order to resolve the implied anxiety, Dalianidis places two polar opposites of masculine characters – one strong and aggressive and another soft and submissive – next to the hyper-sexualised female: Nikos Kourkoulos and Vangelis Voulgaridis, Faidon Georgitsis and Costas Voutsas, Hristos Nomikos and Hristos Politis, Yannis Mihalopoulos and Stamatis Gardelis. In their midst there always stood a sexually domineering woman, either innocent or predatory, herself dominated by strong instincts and desires. Besides Lascari, the actors Chloe Liaskou and Katerina Helmi represent the other woman, the dangerous feminine presence, the victim of societal expulsion, who, in order to survive, dominates men through the manipulation of their sexual secrets, insecurities and phobias. The hidden and somehow distorted sexual psychodynamics of the bedroom dominate the films of this early period.

In the second part of the 1960s, Dalianidis went even further. Despite the fact that he directed some of the most successful musicals and comedies, the melodramas he released at the same time addressed some lingering and unresolved issues that encapsulated the atmosphere of the social transition taking place. A number of dramas, such as *Story of a Life* (1965), *Egotism/Eyoismos* (1964), *Without Identity/Horis Taftotita* (1965) and, more significantly, *Tears For Electra/Dakria yia tin Ilektra* (1966), *Stephanie at the Reformatory/I Stefania sto Anamorfotirio* (1966) and *A Woman's Past/To Parelthon mias Yinaikas* (1968), express a new stage in the representation of desire, sexuality and psychopathological complexity in his work. By then, the main audience of his comedies and musicals – the ageing middle class and the rising petit bourgeoisie – were mainstream, confident and wealthy; however, together with their position, the fantasies that legitimised their success

and the narratives that validated their authority had also changed. With these films Dalianidis constructed grand Freudian narratives of the suppressed and displaced identity of the petit bourgeoisie as it was becoming part of the power elite – in which, however, it still felt an intruder.

The suppressed self of the new class, the insecurity of its position, the displaced symbols of its frustrated desires and the compromises it had had to make in order to be accepted became the unnamed subtexts of these films. The privately owned apartment, the symbol of successful modernisation and integration, became the grand theatrical stage on which primordial dramas were re-enacted. *Tears for Electra* is one of the first modernist films to use an ancient Greek myth to address questions of social identity, family psychodynamics and family ethics, relocating them to the most apocryphal and sacrosanct site of contemporary bourgeoisie, the conjugal bedroom. In that regard, Dalianidis paved the way for Angelopoulos's *Reconstruction* (1970) and *The Travelling Players* (1975), in which the Atreides family saga incorporates episodes of contemporary history in a grand narrative about political power. The unsettling ghosts of the past, the looming collapse of a newly gained identity and, most importantly for Dalianidis, the amoral ruthlessness of the nouveau riche, became the central points of tension in these films – without ever being explicitly articulated and thus ideologised.

The Dictatorship of 1967 marked the rise of a new populist ideology that dominated the cultural imaginary for the next seven years, until the Dictatorship's fall in 1974. Its sentimental and demagogic populism was a mixture of fatalism, narcissistic introspection and moral panic in the face of the dilemmas, the conflicts and the ambiguities of modernisation. Dalianidis' films, like many other films made during the Dictatorship, explored the unpredictable dynamics arising from the combination of political oppression and psychological repression: the tangled web of repressed desires became the invisible catalyst bringing to the fore unwelcome emotions and uninvited shadows from the past. At a personal level, the emergence of such a strange and ominous, but somehow liberating, atmosphere also related to his mother's death in 1969:

> Only then, I felt orphaned. Every day after shooting, I went to the cemetery; I sat next to her grave and talked to her … After a while, I started being afraid of myself. Something was wrong with me. My need to have close contact every day with a grave was dangerous. I had to find humans. To make them my own, receive their love, as I had received the love of my mother, if not to the degree she gave me her love, but at least some sympathy, some warmth would have been enough.[18]

The locus of all this was the family home. A strong association between love and death followed, through the exploration of the destructive and socially disruptive function of emotions, and became the dominant themes of his later films. Such themes continued in the last period of his filmmaking, with two provocative and almost banned films: *The Sinners/Oi Amartoloi* (1971) and *Under the Sign of Virgo/O Asterismos tis Parthenou* (1973). If until then sexuality was transgressive and subversive, in these last movies it became the actual symbol of alienation, self-debasement and self-loathing. In the first film, Hristos Nomikos' hyper-masculine torso externalises the arrogance of a predatory phallus, which in the end pushes him to his own de-subjectification. In an unexpected manner which reminds of analogous works by Rainer Werner Fassbinder, Dalianidis reifies the male body, as it becomes a commodity to be sold, exchanged and abused. In the second film, the female body of a prostitute objectifies men, debases them and mocks their phallic prowess. Both films are visual essays on abjection as the 'sinners' are forced to live through self-alienated and commodified emotions, sell their bodies, and pretend to be elsewhere. Both films were released during the most militant period of New Greek Cinema, which avoided issues of sexuality and its constitutive presence in individual identity. Alexis Damianos' *Eudokia/Eudokia* (1971), Theo Angelopoulos' *Days of 36/Meres tou 36* (1972) and Pantelis Voulgaris' *Anna's Engagement/To Proxenio tis Annas* (1972) were deeply political in their message but highly puritanical in their depiction of sexuality or indeed of the naked body. Even the strangest political film noir of the period, Tonia Marketaki's *John the Violent/Ioannis o Viaios* (1973), delibidinised the suffering male body and constructed the image of a neutralised, almost genderless, subjectivity – an image that was to dominate most representations of masculinity until the late 1980s.

The disruptive character of sexual identity was not addressed by any other director of this period – probably because of the domination of soft porn films and the innate suspicion of all left-wing ideologues towards an individualistic understanding of the human body. The political films presented bodies without organs, without desires and needs, as structures without self-perception. Only Pavlos Tassios' *Yes, but No …/Nai men Alla …* (1973), the first film to explore male dephallicisation due to pornography, stands parallel to Dalianidis' bold but definitely flawed efforts. Indeed, Tassios was his assistant director for a good number of films. Despite his growing discomfort with the cinematic screen, Dalianidis constantly infused his images with displaced and dislocated sexual symbolism, to the deep annoyance and frustration of his producer.

In *Stephanie* (1966), the displaced phallic quest was expressed through a very strong lesbian subtext permeating the scenes of isolated girls in the reformatory.

The film, superbly photographed by Nikos Kavoukidis, contained confronting scenes of verbal violence, implied lesbian rape and male sexual aggression to the extent that it was released with two different endings; one a happy resolution (for the domestic audience) and the other much more sinister and horrific, with the sexual strangulation of the young girl by the detention officer (for international distribution). In the *Story of a Life* (1965) and *Tears for Electra* (1966), the powerful symbolism of displaced phallicism dominates the films through the irresponsible and predatory male characters. The first is about the missing name of the father, who dominates the desire of the daughter after his death. The second reinterprets the story of Electra in a provocative and confronting way: the young girl who decides to seduce her mother's lover in order to avenge the death of her father is one of the most disturbing depictions of libidinal aggression. The man is totally unable to resist desire; like the female character in the *Story of a Life*, who is not in control of her destiny, the man is not in control of his body.

Dalianidis confronts the audience with the moral implications of a phallocentric mentality: it can lead to insanity and violence. The absence of a brother in *Tears for Electra* also makes this film a strange take on Freud's family romance, as the psychodynamics of desire are transformed into a death wish and self-destruction; there is not any real male presence to counterbalance the unexplored ocean of feminine interiority. The *Story of a Life* is a strange and somehow subversive film: it is in four interlinked parts, as stages in the life of a woman. She starts as a young girl in a village, then moves to the big city, where she gets married to a wealthy older man, then falls in love with a young man, and finally commits suicide. The whole story unfolds around the desire generated by the always semi-naked body of Zoe Lascari. Dalianidis frames the body according to its social surrounding: 'In the Village; In the City; Amongst the Petit Bourgeois; With the High Society'. The body's value increases according to who possesses it, as each class places a different price on its consumption. It is a reified body, a thing, a commodity. It starts in a submissive state, internalising its inferiority and usability, and finally it offers its consent to being exchanged and used. The female body itself is deprived of the capacity to impart emotions: it passively accepts everything but cannot reciprocate. It is dedicated to the inner quest for the absent father, to the discovery of its lost origin. The film starts with a grand political statement made by the grandmother, acting like the stepmother who wants to devour the youth of the adolescent girl: 'Incompetent like your father. He joined the revolutionaries to save the country – he is wasting away now in exile, instead of thinking of his child. He abandoned you to fight up in the mountains.' The young girl responds: 'I wish I were like my father ... I wish I were a man like him ...'

# Yannis Dalianidis and the Cryptonymies of Visuality

Figure 4.1: Yannis Dalianidis, *Story of a Life* (1965). The secret life of objects.

The whole story is based around these words about desire, lack and failure: the moment she marries the old wealthy man, she is reunited with her father and is free to grow up and fall in love. But this is a terrible act of self-empowerment and individuation. It leads her to invent an unutterable telepathic language with which to talk with her lover: in some peculiar conversations, Dalianidis creates some of the best scenes of his films, which he repeats in *Egoism* (1964) and *The Sinners* (1971). During these suggestive elliptical dialogues, the camera revolves around an object – the phone, the clothes, the bed linen, the bed itself, the shoes or the silent naked bodies – exploring the limits of language and using the objects of everyday utility as symbols of an existential anxiety for genuine human communication. (See Figure 4.1.) This is one of the few times that Dalianidis employs an Eisensteinian tonal montage, juxtaposing 'the intensification of the static and the intensification of the dynamic'[19] and energising the stillness of the frame through imperceptible shades of gradual differentiation. Dalianidis employs mostly montage sequences that he adopted from Hollywood, juxtaposing whole images and scenes, but here the juxtaposition happens within the frame, and it foregrounds colliding temporalities and irresolvable contradictions – indeed the impossibility

of self-realisation. However, the tension was too much for a filmmaker who wanted to hide all tensions ... or indeed escape them. Only rarely would he employ montage again, and in the 1980s, he abandoned it completely, resulting in the absolute neutralisation of his visual *écriture*.

Yet these are a few singular moments, without continuity and impact. The female body increases its surplus value as it climbs the ladder of social acceptance, but starts to lose its value as it gains self-awareness. It then becomes useless and values-less, and as industrial waste, it can be discarded: self-awareness in bourgeois capitalism means self-destruction, according to the Marxist social vision of Dalianidis. This film is one of the very few of his films without a happy ending. The ending is instead a sinister gaze between men: the lover and the husband. The lover seems confused and the husband satisfied. Finally, the covered invisible body disappears into an ambulance, which takes it away. The voice of the dead woman is heard: 'My sweetheart, forgive me ... feel pity for me. I was weak ... Destiny took us always where it wanted. I was never able to control it. Never.' The wealthy husband is triumphant, the young lover incapacitated; the drama of sellable bodies goes on. The final black screen brings the audience into the story: you are next, it seems to imply, or even, you are already in this.

Despite its unsettling ending, *Tears for Electra* (1966) also did very well at the box office: his delightful musical of the same year, *Girls for Kissing/Koritsia gia Filima*, was the top film in admission numbers, this was number ten in an overall production of 120 films that year. The film illustrated incongruous but simultaneous discourses around the central social anxieties and key economic practices of that period in a surprising narrative. The contradictory style of representation is also extremely telling: close-ups, long shots, fast editing almost suggest a director who feels uncomfortable with his own story while struggling to reinvent his style. Thematically, the victimiser becomes the victim, innocence turns into manipulation and love is the ultimate weapon of self-destruction. The filmic text traces the twists and turns of such chaotic reality without being able to find anything to moralise about, as he did in his early films, or to deduce a positive message from. All these films have ambiguous and somehow confronting endings.

In one explicit scene in *Tears for Electra*, Electra seduces her mother's lover while she is still a virgin. The loss of virginity, instead of attaching her to the man, has the opposite effect: the man looks terrified by the blood, and after that the macho narcissist loses all his virility. Electra's seduction castrates him, forcing him to abandon his phallic aggression; she becomes the phallic woman absorbing his penis; she identifies with the symbolic order of the father and becomes the nemesis, bringing the gift of death to her own confused self-perception as

the final catharsis before madness. 'We are all mad in this house,' she says. 'My mother's madness is called love, your madness is called ambition, my madness is called revenge.' Dalianidis responds in a radically proletarian way to the neoclassicist extravaganza in Cacoyannis' *Electra*. The archetypal story is re-enacted in every family in the normality of their modern apartment, inhabited by fathers without consciousness and mothers without moral concerns. The film ends with an intimate scene between mother and daughter, culminating in the resolution of their negative Oedipal connection. After the passionate farewell, the daughter leaves her dead mother on the ground and falls into the hands of a very sensitive, soft and feminised young man: she has eliminated all the dangers to her empowerment. The old family is annihilated. Her sexual emancipation comes through death and destruction. The ambiguous ending of the film is equally challenging. The feminised young man is submissive to her: she is the male woman, the phallic vagina, and she will repeat the pattern of self-destruction.

Dalianidis reconfigures not only gender representation, but also gender perception. He inverts roles and expectations: these films are about the fears, anxieties and phobias of the affluent petit bourgeoisie that wanted to forget its origins. The traumas of war and defeat were simply painted over with funny faces and sublimating masks – but they were lurking everywhere in the minds of the viewers. Dalianidis used this incredible contradiction in order to invest his stories with emotional intensity and a sense of imminent danger; gently, he castigated the upcoming class of the 1960s for its lack of morals and absence of humanism. Moral issues started gaining ground in his stories; unable to challenge the strict rules of the studio system, he confronted his society with its worst fears in his dramas while he placated their anger with his comedies.

In reality, it is almost impossible to define the hermeneutical indeterminacy of such films. Can we see them as framing the immense and demoralising fear of the male gaze in front of the feminine corporeal presence or as a feminist dismantling of masculine superiority? In the case of *Tears for Electra*, by adopting the archetypal myth of filial connection, the film oscillates between the point of view of the father, the mother, the daughter and the lover: the empathic attunement of the audience moves amongst all of them; even the cunning and opportunistic maternal lover becomes sympathetic as he is transformed into a victim. (See Figure 4.2.) At that level the film is about the indeterminacy of emotions, the decentring of psychological identifications and finally the destructive rebellion of youth against a system that in the end was destined to assimilate them. In the interview with Manos Tsilimidis mentioned earlier, Dalianidis revealed:

Figure 4.2: Yannis Dalianidis, *Tears for Electra* (1966). Manipulating male desire

> You know ... I repeat: I am the child of war and I am always afraid in case something like the German Occupation happens again and I will lose everything. I went through a lot as a child ... I remember them all ...]These memories cause me horrible insecurity.[20]

Two more of his dramatic films deserve some discussion, despite the fact that Dalianidis released some very interesting comedies during the same period. First of all, *The Sinners* (1971): despite its relative success, the film was considered risqué and was effectively withdrawn from the official canon of films produced by Finos Films. Even today the film circulates only in pirate copies, censored and with many gaps in continuity. The producer, Finos, the epitome of middle-class respectability, was extremely displeased with the explicit sexuality of the film as well as with the presentation of the male body as a commodity to be sold by both wealthy women and men. Drugs, male prostitution and serious crimes are also shown in the film in an unabashed and confronting way. Even the first ever depiction of an errotic threesome in a mainstream film for the middle class must have been a most challenging experience for its audience. The presentation of a group of unemployed middle-class youths indulging in drugs and the sex trade challenged the

self-perception of a nation living under the sanitised and idealised hegemony – and presumed Christian morality – of the 1967 Dictatorship. Also, the populist fantasies of both left and right about the ethical purity and existential integrity of the working class found, in this film, their most ferocious debunking.

At the heart of the Dictatorship, when the new power elites were forged, Dalianidis, in a bold move, had displayed the emerging culture of cynicism and utilitarianism, as the power of the wealthy industrialist class was consolidated by ruthless individuals. The film enjoys something of a minor cult status amongst the fans of Dalianidis' cinema: it was his first attempt to express clearly his social preoccupations and his fear of the capitalist modernisation that was taking place under the dictators. In a revealing scene in the film, two Greek capitalists discuss whether or not they should sell their factory to German investors, who will bring more money to them. One is reluctant, saying that they will lose control; the other declares: 'As long as they make more money for us, let's lose all control. Only profit matters.'

Against the background of emerging reckless capitalism, Dalianidis reimagined the male gaze in this film. In his previous films, the female body was open to the scopophilia of the male gaze, to be violated and abused. In this film the male body becomes the passive recipient of female desire as it is exchanged for money, clothes and status. (See Figure 4.3.) The scene in which the male protagonist is effectively raped by the wealthy woman who pays him for sex must be one of the most outrageous depictions of male disempowerment: the 'proud and pure' male is humiliated and is ridiculed without dignity, as he is simply taken to the bed by a woman who only wants to satisfy her desire for sex, social exhibitionism and domination. The identification of money with desire makes this film a genuine Marxist visual essay on the surplus value of the male body as a sexual commodity to be sold, used and be exchanged: 'I did nothing more than raise a mirror in front of this society, whatever that face was. If that society was dominated by kitsch, my films wanted to depict the kitsch itself.'[21] Dalianidis' camera reshaped realism by infusing it with the symbolic order of petit-bourgeois emblems of power, possession and domination. His gay identity, so well hidden and disguised until then, became the catalytic presence that exposed the moral implosion of the ruling class and expressed the profound ideological impasse that was to take over Greek cultural imaginary in the following decade.

The most spectacular and disturbing exposé of such implosion came with a series of films made between 1973 and 1975, framed by the atmosphere of decline and occlusion that dominated the last years of the Dictatorship. *Under the Sign of Virgo* (1973) is probably the most risqué film made by Dalianidis in the 1970s,

Figure 4.3: Yannis Dalianidis, *The Sinners* (1971). The usable masculinity through the key-hole.

since we know nothing about his 'lost masterpiece' mentioned earlier. Strangely enough, the script was written by the famous director Yorgos Tzavellas: it is three interlinked stories based on the life, real or imaginary, of prostitutes. (It was originally cast for Aliki Vougiouklaki, the superstar of the studio system and the symbol of sexual propriety in the territory of cinematic images.) Constant preoccupations of the past with class, money and status are associated with desire and death; the fetishistic representation of the female body available to every gaze receives its most obvious 'Marxist' expression in this film, despite Tzavellas' conservative ideology. (See Figure 4.4.) The commodified female body has no memories; it is an empty vessel to be filled by the remembrances of others. It has no innocence, no interiority, no self-esteem. Around the feminine commodified body, the patriarchal society constructs its inauthentic codes of honour, shame and fidelity.

The second story, about virginity in a rural society, is one of the most striking satires of the virginity taboo, as the male need for penetration is gradually transformed into a castration angst in front of a *vagina dentata*. Dalianidis and Tzavellas constructed here one of the most disruptive denunciations of male fantasies about phallic supremacy. The third story is set around the confined space of apartments, where plastic furniture and material possessions illustrate the perfect and voluntary

# Yannis Dalianidis and the Cryptonymies of Visuality

Figure 4.4: Yannis Dalianidis, *Under the Sign of Virgo* (1973). The male femininity devouring the feminine male.

imprisonment of feminine presence after a wedding with an emotionally narcissistic young man, so sensitively performed by Hristos Politis. As the previous generation was destroyed by war and famine, the new one is destroyed by affluence and luxury. Money becomes the ultimate weapon for survival; it empowers everyone to regain tentative control of his or her destiny. In this last story we witness the gradual dephallicisation of the man and the aggressive phallicisation of the woman. Lascari's voluptuous body seems to pulsate frantically with penis envy, but by making money as a prostitute she becomes 'like a man' and takes control – of the life of her blind husband and of her own destiny. Prostitution empowers her to become the breadwinner of the modern house. Through the money she makes, she gives her husband back his vision, but thanks to the cruelty of petit-bourgeois morality she is abandoned and condemned. It seems that in capitalism you cannot regain control over your body once you exchange it for money. Dalianidis leaves this open to personal interpretation: how can a bad act have such good consequences?

The film could have been the Greek *Belle de Jour* (Luis Buñuel, 1967), a cult classic on male masochism, phallic insecurity and self-loathing amongst the glorification of everything plastic – chairs, tables, utensils. Unfortunately it

suffers, like his other films of the period, from an excess of naturalism: strong, bright colours link clothes, furniture and humans into a kitsch continuum of objectified relations and humanised objects. Space overflows with discarded emotions which emanate from objects, not from humans. Dalianidis and his director of photography, Nikos Yardelis, worked in a surprising style, either fusing the contours of things and humans with each other through blurry, slightly unfocused lenses, or stressing their sharp surfaces and material gravity. The camera itself is an object in the frame, as it moves like the camera in Michael Powell's *The Peeping Tom* (1960), looking through door eyeholes, into private spaces, and photographing each client's mechanical orgasm. Furthermore, Zoe Lascari deliberately acts as if she is not there: the objectification of her body does not provoke any pangs of conscience. She remains unmoved and cold, embracing men while being disgusted by them. Such instinctive distancing, which has nothing to do with Brechtian practices, presents the same detachment from the role, through theatricality and stylisation, that we find in certain melodramas by Rainer Werner Fassbinder, especially *Fox and His Friends* (1975). In his own discreet way, Dalianidis confronted the practices and the discourses of the studio system by emptying them of all meaningful signification: he presented them as strategies of alienation and domination, as enemies of the self, leading to submission and self-debasement. The moralist in him was far stronger than the opportunistic moralisation of his producer.

## Cinema for the common man

> I always wanted to be the man next door who had only pleasant things to say.
>
> Yannis Dalianidis[22]

Most of Dalianidis' films are deeply flawed, but not because he learned filmmaking empirically in the cutting room, in a solitary dialogue with his editing moviola. This could have given him the opportunity to study individual shots, construct their individual glossary and determine the precise cutting point. It could also have given him the freedom to cut and paste, to hybridise genres and forms. François Truffaut observed about Hitchcock that 'the "great flawed film" is often harmed by an excess of sincerity'.[23] This is the main problem in all films by Dalianidis: his excessive need to be sincere with himself and about himself. Indeed, he couldn't rein in that need, and so reconfigured it through inverted personas, submerged identities and transposed images. His male gaze searched for male reciprocation through the female bodies of his protagonists. This psychic triangulation created

an inwards reversed gaze, which saw both the world and the mind as chaotic constructs of sexual projections, corporeal anxieties and libidinal frustrations.

But the sexual frustrations depicted on screen were not simply his own. In his interview with Tsilimidis he made the following confession:

> My professional success gave me the love I needed from other people. Even if it was fake love – I needed it. Why? I brought my thoughts back, I tried to analyse myself and understood that I had the need for love … My adopted parents – who worshipped me – never caressed me … My adopted father thought that for anything, he had to beat me … because he wanted me to be a 'good man'. My mother, on the other hand, was by nature cold, despite the warmth she had in her heart. Despite the fact that she was a volcano of love, I remember that every time I was travelling and tried to embrace and kiss her, with her hand she kept me away and simply touched my face, wishing me a safe trip. She pushed me away … She was wrapped in a shell of coldness and no one ever managed to crack it. I never experienced love from my parents. I missed it.[24]

The confession also expresses the psychic realities of his traumatised audiences: the grandchildren of the refugee generation, the children of war and civil war parents, themselves going through political persecution, immigration and displacement. If Koundouros' films give us visual narratives of the traumatised self, Dalianidis' films construct the narrative of a collective selfhood made of lack and privation. The absence of reciprocation is one of the most significant aspects of his scripts, despite their happy endings, which were imposed by the producer and the studio. Like a master puppeteer, Dalianidis infused his characters with the feelings that permeated Greek society: the lack of creative desire and the inability to externalise emotions. Jacques Lacan observed that such absence:

> brings to light his lack of being [manqué à être] with the call to receive the complement of this lack from the Other – assuming that the Other, the locus of speech, is also the locus of this lack. What it is thus the Other's job to provide – and, indeed, it is what he does not have, since he too lacks being – is what is called love, but it is also hate and ignorance.[25]

Lack was the dominant existential reality through which the postwar subjectivities had to determine their identity. In a postwar society focused around representations of strong masculinities, this is also connected with the deep castration anxiety that dominated the period, as the accumulated traumas had undermined the

authority of the male. Films expressed this destabilisation of libidinal subjects: who desired whom? That was the question. A feminist could have seen the female as a sexual subject but the era insisted on de-eroticising women by oversexualising them. Men remained symbols of power and their dressed bodies were the loci of hidden eroticism mixed with violence and aggression. Lack, however, made them potentially dangerous and disruptive as well as desirable and seductive.

Dalianidis represented his female protagonists as castrated men, fetishising their bodies, since this was the only way he could gain acceptance in the industry. The lack in the image expressed not simply power relations between the sexes but also those between the viewer and the viewed. Dalianidis transposed sexual symbolism in his attempt to redefine sexual dominance and sexual control of the body. In his most interesting films he presented the upsetting image that in this social system neither women nor men are in control of their bodies. In the *Story of a Life* and *The Sinners* the fatalistic denunciation of a social system that overpowers and mutilates the body is one of the most salient elements: the female body is usable, the male body is rentable. They are both available to the predatory hands and eyes of wealthy amoralists who use sex – and emotions – only to possess the other's body and neutralise its sense of agency and freedom.

The bodies belong to fatherless children who live with their domineering mothers or demented grandparents. The name of the dead or absent father is always concealed and silenced. It is never revealed and it will never be discovered. The capitalist worldview has killed humans' capacity for transcendence and redemption by forcing individuals to search for lost or illusory origins. Those who manage to maintain their innocence have to escape to South Africa or the land of the dead. 'When will you get married?' asks the grandfather in *Under the Constellation of Virgo*. 'When you die,' replies his granddaughter. 'Only then can we have the house for ourselves.'

The other strong psychodynamic element in his films is insufficiency and disempowerment. Internalised lack leads to personal insufficiency – and this leads to what Judith Butler calls 'gender trouble'. Dalianidis' films problematised gender and identity in a deceptively simple way: they were the first films that presented gender as self-dramatisation in public, as a personal reinvention of the self through the gaze of the other. At the same time, they parodied all perceptions about stable and coherent identity with the constant re-elaboration of generic and stereotypical presentations of both male and female identities. Throughout his career, Dalianidis presented 'the gender effect' as, in Butler's words:

created through sustained social performances, [which] means that the very notions of an essential sex and a true or abiding masculinity or femininity are also constituted as part of the strategy that conceals gender's performative character and the performative possibilities for proliferating gender configurations outside the restricting frames of masculinist domination and compulsory heterosexuality.[26]

Consequently, his films, even his less successful works of the 1980s, reverse the gaze: we don't know who is having pleasure through the act of looking at the other's body. Is it those who look at the half-naked female body of Zoe Lascari dancing in the musical *Girls for Kissing* or those who look at her partner Andreas Douzos' fully covered body, dressed in leather and bursting with animalistic virility? To diffuse all controversy, Dalianidis overexposed the female body to the male gaze – to seduce it, distract its heterosexist super-ego and infuse the whole scene with the real visual pleasure that he wanted his male and female audience to absorb. He played a strange game by presenting the female body as desirable to women and the male body as desirable to men. As Laura Mulvey indicated:

the structure of looking in narrative fiction film contains a contradiction in its own premises: the female image as a castration threat constantly endangers the unity of the diegesis and bursts through the world of illusion as an intrusive, static, one-dimensional fetish. Thus the two looks materially present in time and space are obsessively subordinated to the neurotic needs of the male ego.[27]

The use of the female image as a disruptive puncture in the world of heterosexual normality and its political order is the most salient characteristic of his mature work. Dalianidis spectacularised the female body because, as Mulvey stated, 'the very excess of these images indicates that they conceal, or distract from, something troubling to the psyche, a mask, as it were, that, once reconfigured as a sign, reveals coded traces of repression and abjection'.[28]

The female body on screen, ostensibly desexualised and delibidinised, became the mirror in which the traumas of history and the insufficiencies of the self were reflected. Such mirroring of what was repressed and silenced transformed the cinematic scene into a 'phantasmatic space act' that framed the invisible connection between the female body and the public sphere, or the marketplace, in terms of politics and ideology. Furthermore, the female body in its self-assertive openness became the symbolic marker of the castration anxiety that permeated the traumatised masculinity of the postwar audiences. It seduced but also terrorised, because

the most suspicious men perceived the specific body as a gay fantasy: it was a screen projection by a filmmaker who desired to mythologise the collective experience of his era through the sexual frustrations, the carnal drives and the erotic entanglements of his own self as a closeted homosexual.

Dalianidis was the first director to 'queer' heterosexual images, discourses and representations. His films represent the hidden stories of Greek society, in which the homosexual subject was not able to speak on its own behalf and lived its sexuality through fantasies made possible by a series of 'permutations of roles and attributions',[29] according to Jean Laplanche and Jean-Bertrand Pontalis. In a sense, this is similar to the narrator of Marcel Proust's novel and his attempt to present his male lover in a female disguise. As Kaja Silverman observed, under the strict censorship and social control over cultural production of the times, such submerged identities contributed to the 'denormalisation of male subjectivity', which itself had an impact 'beyond the bedroom, to the far reaches of our world'.[30]

Dalianidis was a pioneer in the depiction of homosexual desire through the cryptonymic codes of submerged identities and dislocated identifications; his narrative strategies questioned the normality of gender representations and the legitimacy of their social discourses and infused them with the aberrant and deviant perceptions and practices that dared not speak their name. Maybe his work as a whole deserves closer study within the contemporary project of revisiting popular culture and extracting from its celebrated works subversive texts and radical statements their authors were unable to explicitly enunciate when they were producing them. Dalianidis, with his 'soft realism', was amongst the first to frame a visual space full of denormalised representations through an implicit iconography of negation and subversion: it invites more hermeneutical readings and further formal investigation.

# 5

## An Essay on the Ocular Poetics of Theo Angelopoulos

### Political projects and their aesthetics

> I feel that marginal distinctions are the most important distinctions
> a critic can make.
>
> Andrew Sarris[1]

The sudden death of Theo Angelopoulos (1935–2012) left the movie *The Other Sea/I Alli Thalassa* unfinished, and thus posed a question as to the ultimate crystallisation of his visual poetics. Since the early 1970s Angelopoulos had become internationally known for his emblematic cinematic style, characterised by long takes, slow camera movement, depth of field, colour variation, almost total absence of montage, minimal dialogue and elliptical *mise-en-scène*. His idiosyncratic visual language has been called 'the cinema of contemplation', because 'he calls on the audience not only to follow what is going on but to be aware of the process of the unfolding of a moment or moments as they occur in time and space'.[2] This particular invitation to the viewers by the director makes his films ambivalent spaces in which they must both be immersed in the film and at the same time feel the distance between their self and the image. It is indeed a contemplation of the limits of representation and of the limits of cinematic experience; Angelopoulos' whole work evolved as a continuous renegotiation of such limitations and their consequences.

Angelopoulos' films are extremely dense, complex and paradoxical in both their narrative and their form, and for this he became well known and controversial worldwide. His name almost became shorthand for Greek filmmaking in its totality, a situation that has caused considerable patricidal fury in the young generation of filmmakers, who seem to negate his visual language and challenge his monopolisation of fame (or indeed his funding sources.) David Thomson called

him the 'epic chronicler of Greece', recognising that 'Angelopoulos is a master, and this [*The Travelling Players*] and several of his films are almost unbearably moving if you have caught the rhythm early enough.'[3]

Probably, 'rhythm' (adopted from music) is the key to the temporalities of his films: Yvette Biro ingeniously explored the 'rhythmic contour of the film which as a whole gives an indication, gently and without resorting to any loud gestures, of the intimate connection between flow and turbulence'.[4] The oscillation between flow (as duration) and turbulence (as interruption) can be detected throughout his films, especially those made after 1984, when the loss of renewal projects suffocated the cultural imaginary of world cinema, infusing it with the hopeless turbulence of nihilism and the existential panic of alienation. There is another rhythm in his work, an ocular one between what can be seen and what is seen, with his camera alternating between these two ways of looking: his ocular poetics are constituted by an intentional interplay of presence and absence, inferred mostly through his use of colour and its fields of affective immersion.

In a series of interviews with Yorgos Archimandritis, Angelopoulos stated:

> I believe that images exist in our mind before we reproduce them. Even when we select one part to film, this part exists already in our mind. The same exactly happens with chromatic tones. There are internal colours that come up to the surface which we struggle to rediscover. And when fail to do so, we paint them. I have painted over the whole of Greece. I have painted houses, streets ...[5]

Angelopoulos is one of the few directors with a theory of visual perception that incorporates viewers themselves into what is observed. In a way, his ocular poetics are very close to J. J. Gibson's theory of ecological optics, which stresses the active role of the viewer in the perception of the image. Rich in detail, his filmic images invite the 'perceptual system of the viewer not to respond to stimuli but to extract invariants'.[6] Angelopoulos uses the realism of open space in a conceptual way, as a meta-language for history, and therefore for time and lived experience. The open space of Bazinian realism becomes in his work the enclosing frame of a particular experience: the frame and its *mise-en-scène* foreground something that is not actually seen, or indeed exists or happens off-stage. His images present without resembling: bodies and objects are arranged in geometric patterns such that the perception of the viewer focuses on what Gibson calls the 'formless invariants' on the screen: space, distance and mass. Following Gibson again, such formless invariants:

## An Essay on the Ocular Poetics of Theo Angelopoulos

> consist of features of optical structure that we do not have adequate words to describe ... things like the following: alignment or straightness, being 'in line' but not necessarily a line as such, as against bentness or curvature: perpendicularity or rectangularity: parallelity as against convergence: intersections, closures and symmetries.[7]

All his works are based on such architectural invariants in visual perception and organisation of forms, which are like skeletal *gestalten* and are animated dramatically mostly by the psychological effect of colour. Furthermore, despite the fact that he tried to reimagine his own cinematic spatiality after 1997, such visual invariants remained present in his work until his final film, and especially in his extremely evocative experiment with diffused cosmic colour, urban space and human voice, his majestic late short film *Sous Ciel (Ceu Inferior)* (2011).

My approach to his work will be primarily phenomenological; we must look at his films as visual experiences and explore the affective connotations of their visuality, bracketing out the much talked about and sought after referential meanings (mainly political or historical allusions). History, identity and ideology have been named many times as his central themes, and have led to a formulaic and stereotypical understanding of his work, as being concerned only and always with 'deep' Greekness, Marxist ideological disillusion and the silence of history. Although such concerns exist, my approach here is to examine him as an image-maker, working with form, colour and composition. Angelopoulos had a very astute morphoplastic imagination, and his films framed a continuous tension between topological pictorialities and possible chromatic configurations. In brief, there was a constant interplay in his films between the sharpness of expressionism and the suggestiveness of impressionism in pictorial terms: after 1997 impressionism seems to have won the battle, with his films focusing on saturated fluid colours, fusing with each other and gradually replacing the *plein-air* openness with intimate, dimly lit, inward-looking closed spaces. Angelopoulos' ocular poetics are defined by the tensions created by abstract/pure space and human/historical space, indeed of space versus place, instituting a new way of representing the rhythms of space-time continuum. As Maurice Merleau-Ponty indicated:

> the painter's vision is not a view upon the outside, a merely 'physical-optical' relation to the world. The world no longer stands before him through representation; rather, it is the painter to whom the things of the world give birth by a sort of concentration or coming-to-itself of the visible. Ultimately the painting relates to nothing at all among experienced things unless it is first of all

'autofigurative'. It is a spectacle of something only by being a 'spectacle of nothing', by breaking the 'skin of things' to show how the things become things, how the world becomes world.[8]

The 'autofigurative' elements of Angelopoulos' films go beyond the occasional flaws in the script and the inflated emphasis on 'dead time'. Of course we must never make the mistake of seeing him as a photographer or a painter, isolating his work as stills or unconnected snapshots. Even in the most political films of the 1970s, Angelopoulos created images as concentric circles of *internal* montage, engulfing movement within immobility, in a serpentine and somehow hypnotic manner, expressed through the slow frontal positioning of the camera, which evolved into a circular rotation around the central form within each frame. The movement of the camera is part of the story itself: the camera stands for the cultural and historical super-ego in control of a knowledge beyond the one indicated by the frame. It also acts as a 'defamiliarising' stratagem, a way to recalibrate the optical perception of the spectator, by deconstructing the dominant visual regimes established by the narrative cinema of Hollywood. Angelopoulos' phenomenological gaze moves between abstract and concrete space, projecting onto them structures of meaning. The oscillation between abstraction and specificity represents the foundational reality of his stories: the tension between what is seen and what remains unseen within the one frame, indeed by what is framed by each frame separately or what emerges through their succession. The tension is never resolved: everything remains in abeyance, as if no closure can be given by the illusory character of images. 'There is no end in my films,' Angelopoulos stated in 1988. 'I have the feeling that everything around me stands still. I am trying to break away from such immobility, to break new ground, but there is nothing very stimulating happening around me.'[9]

As the camera moves through time, the rhythm of its movement becomes an investigation into personalised temporality; the final image, as an amalgam of story, form, colour, music and angle, fuses audience and screen with what exists outside the protected space of the cinema – the political project outside the confines of art, or indeed, somewhat more tragically in his later films, the utopian project beyond the reach of the viewers. The film experience, however, is not escapism or distraction; it is a web of meaningful connections between the symbolic world and its underpinning social realities. Angelopoulos constructed a cinematic *gestalt* within the cultural imaginary. In a sense, he synthesised tropes of visual perception found in Greek directors before him, such as Nikos Koundouros, Alexis Damianos and Takis Kanellopoulos, by infusing their fragmentary styles with

## An Essay on the Ocular Poetics of Theo Angelopoulos

European, and world, practices. In a strange way, Koundouros' forgotten films, *The River* (1960) and *The Outlaws* (1958), were reinvented in Angelopoulos' first mature work, *Reconstruction* (1970). To them we must also add a number of rather disregarded films made between 1966 and 1970, in which Angelopoulos himself appeared as an actor. Namely Dimos Theos' *Kierion* (1968) and Vangelis Serdaris' *Robbery in Athens/Listeia stin Athina* (1969) two movies that were political in their aesthetics and codes of representation and which revisualised filmic temporality. With these films time becomes the most crucial signifier of action as the narrative becomes conscious of itself as a temporal indicator. If space was the great question and problem of cinema until then (exacerbated by the comforts of the studio system), now acute temporal awareness relativised the certainties of traditional realistic movement through open space. By abolishing the openness of space, *Kierion* turned the camera inwards, into an investigation of internal processes and hidden structures expressed by the confused voice-over of a narrator who doesn't know or understand much about the plot he is in or even about the actual plot of the film. By decentring the narrative Theos achieved something unexpected:

> The whole cinematic perspective of *Kierion* was totally unusual for the perceiving structures of the time. The unembellished faces, the performance style of actors, the Athenian spaces all suddenly raised the question of truth. An extremely important element for the structure of a work of art, but indeed totally forgotten![10]

*Reconstruction* builds on the visual reconsiderations introduced by Theos. With this film Angelopoulos revisited the origins of Greek cinema and reassembled its framing practices. Dimitris Gaziadis' sense of space and time, as seen in *Astero* (1929), minus its romanticism and sentimentality, were the crucial subtexts of his first feature film. The black and white photography by Yorgos Arvanitis foregrounded the elemental character of its spatial geometry: faces and bodies punctuate the stark and crisp one-dimensionality of the landscape, which is filmed in gradations of grey and black, punctuated by the minimal actions of amateur actors. The qualities of old photographs dominate each frame. *Reconstruction* was an attempt to retrieve stillness as an integral part of cinematic staging: the 'timing' of stillness became the rhythm of the camera. It is such stillness of timing that rearranges the form of action. So, as Angelopoulos said, 'the film concludes with a scene that should have been at the very beginning: the murder itself. But what exactly happens is still a mystery, because the camera remains outside, never witnessing the deed itself, only hearing the voices.'[11] The film is about traces of things past: the camera reconstructs the dead past, by presenting the process of dying.

Despite its strong political and social references, this is also a film about primordiality, about the ability of cinema to resurrect archetypal ghosts in the mind of the viewer. Stylistically, it initiated Angelopoulos' attempt to merge spatial depth and pictorial surface, discarding perspective altogether – a project that will be consolidated in his late works.

In his early films, Angelopoulos was very close to the 'ethnographic' understanding of cinema, as a result of having studied with Jean Rouch in Paris. Rouch's idea of *cinema vérité*, based on Dziga Vertov's *kinopravda*, was that instead of creating illusions of reality, the cinematographer had to 'put the camera in the street, to make the camera the principal actor, the object of the new cult of total cinema where the knicker-clad priest is the cameraman'.[12] Angelopoulos' first short film, *The Broadcast/I Ekmompi* (1968), was about the movement of the camera as the instigator of cinematic action, within open urban and closed indoor spaces. (One can easily detect Rouch's *Chronicle of a Sunday* (1960) and *Gare du Nord* (1964) camera work here, as ritualistic self-conscious performances frame and foreground individual presence.) In Angelopoulos' first film, the camera becomes the true protagonist. The actor Thodoros Katsadramis is conscious of the camera eye; and he follows it through the streets of Athens, the back alleys of industrial suburbs and the flat and barren coastline. Indoors the camera becomes like the Hitchcockian presence in the asphyxiating narrow space of *Rope* (1948); Angelopoulos used the persistent presence of the camera as the ubiquitous eye which controls movement and expression, resembling Hitchcock's practice, which was to 'vary the size of the image, in relation to its emotional importance within a given episode'.[13]

However, Angelopoulos changed the angle of the camera with surprising ingenuity and cunningness; the main focus of his first film, as well as of *Reconstruction* (1970), can be encapsulated in another Hitchcock statement: 'We must bear in mind that, fundamentally, there's no such thing as colour; in fact there's no such thing as a face, because until the light hits it, it is nonexistent.'[14] Such immanent luminosity within the cinematic frame can be detected in all Angelopoulos'films, even the most political ones. His films explore the silence and immobility of being through transparency – and silences exist not only in the script but also on the frame. The empty space between objects links them together through colour and light. Even with his first film, the appropriation of what is not visible becomes one the central aspects of his work; it remained so until his final film.

In his films until 1980 Angelopoulos frames exhibit a tantalising multifocality. Technically, they reconfigured the problem of perspective that had bedevilled Greek pictorial space since the nineteenth-century. *Megalexandros* (1980) is probably

the most monumental exploration of the rise of perspective in the visual perception of the viewer. Its iconographic model is like a Byzantine panel; Angelopoulos called it 'a Byzantine liturgy'.[15] All action is structured in circles: the movement of actor, camera and story encircle the invisible but powerful 'lost centre'. The film is based on iconographic models of naïf folk painters such as Theophilos, one of the beloved intellectual mentors of the poet George Seferis. Theophilos and the Byzantine iconography offered Angelopoulos 'autochthonous primitivism' in his framing of the central character, who represents a blood and soil movement going horribly wrong. Angelopoulos' visual poetics were based on 'inflections of light', contrasting one colour with another, thus enhancing the depth of frame, as he stresses the main practice of Byzantine iconography – 'creating space with colour'.[16] His use of colour finds in this film its subtlest manifestation. During his meeting with Akira Kurosawa they discussed, as he reported: '… not the movie at all. We started talking about the quality of black on the clothes of Megalexandros and how it was achieved – because in order to achieve such black, clothes must not be black.'[17]

During the 1970s, Angelopoulos seemed to problematise the cinematic representation of what might be called 'felt temporality' in a radical manner, as Alain Resnais did in *Last Year at Marienband* (1961) or even Jean-Luc Godard in *Breathless* (1960). His attempt to reinvent visual temporality as a reference to the actual collective realities of his society created the foundation for a new perception of historical representation. With him, the innocence of realistic depiction of history was shattered: realism in historical narratives meant imaginative reconstruction of structural formations before the act or reflections on the act. But in his films such realism was spurious, a political stratagem for manipulation and coercion. The illusion of a realistic depiction as reflecting an actual reality out there was the central focus of his re-training of spectators' vision. With Angelopoulos, Deleuze's suggestion that cinema created images that made no distinction between material reality and mental images seems to have found its ultimate and most significant expression. As Deleuze declared:

> There are Lulu, the lamp, the bread knife, Jack-the-Ripper: people who are assumed to be real with individual characters and social roles, objects and uses, real connections between these objects and these people – in short a whole actual state of things. But there are also the brightness of the light on the knife under the light, Jack's terror and resignation, Lulu's compassionate look. These are pure singularities, qualities, or potentialities – as it were pure 'possibles' … taken all together they only refer back to themselves.[18]

The 'possibles' of his images are what make Angelopoulos' work, especially of the 1970s, so distinct and so paradoxical.

Unfortunately, in the analysis of his works many scholars foregrounded the storyline, or storylines, making Angelopoulos appear predominantly a 'national' director obsessed with the identity of 'Hellenicity', or a filmmaker making films about Greek history. I suggest that we must see Angelopoulos primarily as an image-maker and focus more on the mythopoeics in his films and less on the films as a history of the Left or of the dead ends of 'political modernism'. Certainly, from his earliest films, history was the primary concern. His masterwork, *The Travelling Players* (1975), for example, remains to this day the most complex filmic narrativisation of temporality ever constructed for the screen. However, his concern with the poetics of historical experience was revisualised at different periods of his life. During the 1980s he turned his attention to the complexities and the frustrations of the mental world in his attempt to find forms for the disillusionments and the traumas of history; one can detect in all his films after 1984 a radical reorientation of his visual perception and formal schematisation – indeed, a new regime of seeing. Then he proceeded with what we might call 'the discovery of interiority' and turned his camera towards an intense dialogue with space. In his films of the 1980s, space lost its homogeneity and became the heterogeneous *topos* of an unfolding tragedy, highlighting the existential vestiges of a previously undramatised emotional conflict.

His films from this time until 1995 deal with human emotions as spatial unities, as hidden landscapes that were never allowed to be articulated, dramatised as active memories or seen as lived realities. Where in his early films time was the underlying texture upon which a monumental tapestry was woven, in his films between 1980 and 1995 space became the open-ended territory on which human adventure was retraced and thus relived. In these films, space is seen not as an aggregate of successive empty places but as the underlying script of collective defeat, individual loss and existential agony, in the form of a musical *Weltschmerz*, dramatically enhanced by the minimalistic melodies composed by Eleni Karaindrou. Karaindrou's music is indeed 'meta-Greek', as Stathis Gourgouris observed, as it works with a fusion of tonalities, both Balkan and European: 'A deeply sensuous and thoughtful music, unafraid of sentimentality but free from any nostalgia, the score to *Ulysses' Gaze* (1995) actually provides the subtle critical mindfulness (psyche) that Angelopoulos' universe demands but never directly shows.'[19] Karaindrou's music gives an atemporal, almost romantic, background to Angelopoulos' films, establishing what I have called elsewhere the 'disjunctive aesthetics' of these films,[20] foregrounding the complex network of references to filmic

An Essay on the Ocular Poetics of Theo Angelopoulos

history and historical experience that characterise that specific film as a turning point in his own trajectory.

Furthermore, it seems that from early in his career Angelopoulos had the sense that all his films formed an aesthetic continuum, like a strange mixture of *roman fleuve* and *Bildungsroman*. Each film not only took up from where the previous one ended, but contained constant references to themes, gestures and masks that had appeared in previous works. Such interconnectedness articulated the continuity of his gaze so that his works, despite differences in *mise-en-scène*, characterisation and visual elements, achieve a profound and dense unity of scope, style and perspective.

Probably the beginning of the exploration of a world without horizons can be seen in the famous burial scene of the huge broken statue of Lenin over the eternal god of Europe, the river Danube, in *Ulysses' Gaze*. Death becomes a monumental presence in the everyday reality of being; this reality is not a condition of being towards death, but a way of being defining itself within death. Martin Heidegger's suggestion that 'death reveals itself as the ownmost nonrelational possibility'[21] finds its most impressive elaboration in the final works of Angelopoulos. With *Eternity and a Day* (1998) the ephemeral nowness of existence is reflected in an intricate web of images, symbols and words that define an existential temporality *without* a sense of being. These films have a post-impressionistic use of colour, as the sharp colours and grand frescoes of the previous periods are miniaturised: they retain their scale but not their shades and tone. A new revisualisation is attempted with *The Weeping Meadow* (2004), which is structured almost as a chromatic fantasia on the fluid colours of water, whether in a river, lake, rain or the sea, while in *The Dust of Time* (2009) Angelopoulos seems fascinated by the atmospheric vibrancy of artificial light.

The choice of colours reflects another thematic thread that had become dominant by then (and here we must also include *Eternity and a Day*). All Angelopoulos' last films explore the ontological consequences of death and dying: from the wailing of Eleni over the dead body of her beloved under the eternal sound of the mother of all, the sea, to the suicide of the aged ideologue in the waters of the Berlin canal. Her death is non-relationality, disconnection, exile, and yet the film ends with a shot of the Brandenburg gate in Berlin in the dawn of the new century – offering thus the promise of a new beginning, a new crossing of the threshold between the past and the unknown future.

This is also what another intellectual of the same generation pointed out when he talked about 'late style'. According to Edward Said, the characteristic of such style is that:

it has the power to render disenchantment and pleasure without resolving the contradiction between them. What holds them in tension, as equal forces straining in opposite directions, is the artist's mature subjectivity, stripped of hubris and pomposity, unashamed either of its fallibility or of the modest assurance it has gained as a result of age and exile.[22]

This is very close to Angelopoulos' late discovery of European nihilism, as heralded in the late 1970s by the rise of post-modernism: the sparse dialogue of his previous works is now intensified, and it gains dramatic urgency and almost tragic affect. The scripts read like apologetic monologues, long and guilt-ridden confessions about the errors and the misguided hopes of the past. If in his early films actors were superfluous disruptions of the spatio-temporal continuum, in his late films they regain an almost Hollywood-like centrality. They emerge as numinous presences from the lived experience of that continuum: their corporeality addresses the great questions of the mind in which history itself was the horrible disruption.

In his last films Angelopoulos had lost the certainties of political cinema and given away the use of archetypal superstructures as 'a way of controlling, of ordering, of giving a shape and a significance to the immense panorama of futility and anarchy which is contemporary history',[23] as T. S. Eliot put it. The danger of aestheticism remains strong here, with the implicit reduction of distinct historical experiences to the repetition of old stories. One could claim that by framing the new experience through ancient myths the specificity and the novelty of each event is immediately lost or misperceived. Angelopoulos, and many other modernists, frequently succumbed to such temptation. In *Ulysses' Gase* there is only one body portraying five different female characters. Maia Morgenstein plays all five women and thus transforms the feminine presence into a dehistoricised existence. The aestheticisation of time that we see in films such as *Voyage to Cythera* (1984), *The Bee-keeper* (1986), *Ulysses' Gaze* and *Eternity and a Day* shows the serious problems that Angelopoulos experienced as a filmmaker when he abandoned the political cinema of the 1970s. Time became then psychologised; in the past the fear of individualism, which the New Greek Cinema was possessed by, never really allowed the creation of characters and complete action. It seems that only with *The Weeping Meadow* (2004) did he start delving into individuality. While maintaining the continuity of his style, the faces in his last films are pulsating with life of their own, with a strong emotional energy. This can be seen in many frames in *The Dust of Time* (2009), which constitutes an attempt to reconstruct individual memories and not collective patterns of remembering. Angelopoulos' exploration

of the confusing irreducibility of human individuality becomes more poignant in these films, his last two works.

As mentioned, a closer examination of his 14 films shows that Angelopoulos at crucial moments in time reoriented his art and reinvented, as it were, his style, adding new elements or developing new representational strategies to depict not only changes in contextual realities but also new configurations of visual perception. Consequently a careful study of his visual inventiveness from his first film to his last is of particular importance. Despite his distinctly Greek thematics, his visual language was marked by various intertextual references and ultimately by the intentional dialogue he inaugurated with other European, Asian and American directors. One must see Angelopoulos as the director who continued the rebellious legacy of 1968, still attempting the subversion of the bourgeois aesthetic that had dominated cinematic representations until then. The presence of other rebels can be sensed throughout his films – especially Michelangelo Antonioni, Robert Bresson, Yasujirō Ozu and Jean-Luc Godard. Later, a distinct dialogue with Miklós Jancsó, Oshima Nagisa and adversarially with Bernardo Bertolucci can be detected. In the 1980s Angelopoulos' language came closer to that of the late Roberto Rossellini, Andrei Tarkovsky and Ingmar Bergman. In his final films, as a transnational director, some new influences may be observed; the expressionistic chromatic frenzy of Vincente Minnelli and the emotive choreography of Stanley Donen become prominent, giving his films a complex underlying texture of psychological and existential metaphors that need further discussion and elucidation.

At the same time, the way that Angelopoulos instructed his actors is of particular significance, since their acting was a commentary on the story itself. In most of his films he avoided all forms of deceptive naturalism and emotional expressiveness. His early films were inspired by a deep suspicion of the Hollywood practice of creating an empathic union of the viewer with the characters on screen, even when something really 'complete' and 'terrible' in the Aristotelian sense was represented – as was the case with his first film, *Reconstruction*. This tradition, going back to Stanislavsky's theatrical performance as it was accentuated by Elia Kazan's Actors' Studio Method, was questioned during the 1960s as misleading and manipulative, since it moved the attention of the viewer from the story to the character – changing the focus from the big picture to the micro-history and thus creating excessive individualism. Characters in *On the Waterfront* (1954) or *East of Eden* (1955) are not models of a specific type of human psychology or behaviour. They exhibit something that was to become dominant in the counter-culture of the 1960s and 1970s, namely extreme forms of infantilising narcissism, and they

# Realism in Greek Cinema

represent, in the long run, exercises in moral self-justification and individualism. American films, especially of the studio era, with their extremely self-centred characters, went through a deep crisis in the late 1960s as the French New Wave used the same models for its own purposes through irony, subversion and self-parody; at the same time, through the central tenets of structuralism, the dominant theoretical model of the period, these films presented individuals' psychology only as 'local variations' and 'surface phenomena' manifesting general laws of impersonal cultural patterns, distancing the Hollywood iconographic models from the nihilistic individualism of their own origins.

Angelopoulos came into direct conflict with this tradition after his encounters with Carl Dreyer, Robert Bresson, Jean-Luc Godard and Nagisa Oshima. In order to frame such asymmetrical configurations of representational codes, he opted for Brechtian distancing, which became the ultimate point of reference of his visual style both in its *mise-en-scène* and in the intense stylisation of his actors. The final effect was ambiguous, puzzling and intentionally alienating, which explains the limited commercial success of his films in the United States and their neglect by Andrew Sarris, the most prominent advocate of the *auteur* theory in the country. However, beyond Brecht's theories, Angelopoulos remained closer to the tradition of Bresson in the way he used actors. As Bresson stipulated in his magisterial notes: 'An actor in cinematography might as well be in a foreign country. He does not speak its language.'[24] I could suggest here that Angelopoulos, more than any other European director of his generation, struggled systematically and persistently to challenge the visual addictions of mainstream cinematic audiences by restructuring the dominant grammar of visual representation through the infusion of non-cinematic temporalities, analogous to the experiments of Bresson in *The Trial of Joan of Arc* (1962) and *Mouchette* (1967).

His overall achievement is certainly uneven and ultimately inconclusive, but the significance of the project itself should not be underestimated. In a sense he is a director's director, offering to his colleagues the framework for a reconfiguration of cinematic representation. Together with Terrence Malick and Terence Davies, he understood that the cinematic experience did something unique: each struggled 'to give our audience the credit of being intelligent, to help them understand their existence, to give them hope in a better future, to teach them how to dream again'.[25] This romantic and didactic cinema was part of his later style. However, even in the 1970s his visual style and stories were very different from other political directors (such as Bernardo Bertolucci, or even his great teachers Dreyer and Bresson). With the last two, the main difference was his lack of religious belief. Whereas Dreyer's

168

and Bresson's films are studies of Christian anthropology, Angelopoulos' movies are studies in agnosticism: they explore the empty sky, the ruined churches, the fallen narratives, but their quest never takes the form of anything Christian.

Furthermore, where Bertolucci is fascinated by naked bodies and sex, indeed by Freudian symbolism – in *1990* (1976) and *La Luna* (1979) – Angelopoulos always treats sex as a transcendental crime, as some form of punishment that humiliates the people involved. The very few sexual scenes in his films – in *The Hunters*, *Voyage to Cythera* and *The Beekeeper* – depict the sexual act as involving only impotence, lust and despair. Indeed, *The Beekeeper* is in a sense his response to Bertolucci's *Last Tango in Paris* (1972), with the central difference between them being the depiction of sex and their structural similarity being the experience of living without projects of individual or collective renewal.

Furthermore, Angelopoulos' intellectual trajectory, and therefore aesthetic development, show that his films should not be interpreted simply as a running commentary on Greek history and society. Despite the fact that they are deeply grounded in the experience of one or two generations in the country, they encode a number of political, philosophical and existential projects that are relevant to the whole of Europe in the twentieth century. These projects involve the critique of power, the exploration of visions of utopian redemption, the traumas of historical experience, the disenchantment with all projects of secularisation, the domination of European nihilism and finally the yearning for a transformative otherness after the presumed end of history. Most of his films deal with such universal questions from within Greek experience, at the same time exploring their deep emotional structures. As David Bordwell concluded in his analysis of Angelopoulos' films: 'Often majestic, sometimes mannered, almost always melancholic, Angelopoulos demonstrates that, contrary to what the prophets of post-modernity keep telling us, cinematic modernism can still open our eyes.'[26]

In the films after *Ulysses' Gaze*, a certain return to his early concerns may be detected, and time regained its primary role as the force that moved narrative forward or indeed made the storyline cohesive and meaningful. In the last completed film, *The Dust of Time*, the narrative begins from two different points, one in the past and the other in the present, and they both move towards their eventual convergence at a certain moment in the 1970s. Temporal change follows an endless migration from country to country, from language to language, from style to style, indeed from identity to identity.

In this film, this endless displacement, forced or voluntary, frames the lives of many individuals, who experience a continuous existential homelessness without

points of reference or projects of common engagement. The only thing to which they have an inalienable right, to give them identity, is their body, their corporeal presence. This makes them unique epiphanies of a lost historical hope. In this last film, only memory gives unity to their existence. Thus, as they meet in a border café, the characters paradoxically remain as they were at the beginning of their journey: in one single frame we see the heterogeneous temporality of human emotions and the simultaneity of memory. The only certainty they have in the mist that surrounds them at the border of Canada and US is their bodies: their corporeality is their only being, and their arc of salvation. The ideologies they believed in are dead, the friends they had have disappeared and their own children are lost in the hallucinogenic world of an artificial paradise. In an interview, Angelopoulos pithily concluded: 'Today we are choking, it's impossible to breathe, it's impossible to move, [as if we are in] an ossified, a frozen situation, and, as we know from history, this is almost as if death has taken over.'[27]

*The Dust of Time* is one of the most 'experimental' films in contemporary European cinema in its representing of time as a felt experience at a complex level of narrative articulation. The problem of time has been the single most pressing and persistent *desideratum* in Angelopoulos' cinema. On most occasions, indeed until the late 1990s, he struggled to keep the Aristotelian unities of time and space at a minimum, despite the many concessions that began to emerge after *Landscape in the Mist* (1984). Together with the Aristotelian unities, he avoided the ultimate catharsis offered through emotional redemption, leaving most of his early films with ambiguous endings, offering no closure. Dan Fainaru states that Angelopoulos' 'admirers will be deeply moved by *The Dust Of Time*'s emotional impact and appreciative of the intricate work on display, but his detractors may once again find themselves irritated [by] Angelopoulos' loose treatment of reality and narrative.'[28] In a strange way, this film is like a recapitulation of the sense of time depicted in the famous television series *The Twilight Zone*, a psychological thriller exploring temporal paradoxes: characters are trapped within different 'time elements' while coexisting in the same space.

Today, most of his works are recognised not only as major 'filmic texts' but also as seminal 'cultural encodings', as they represent the aesthetic of a generation that rebelled against the established cinematic aesthetics of the past and confronted the officially imposed silences of history through the invention of new codes of representation. Angelopoulos indeed belongs to the radical movement, usually called the New Greek Cinema, which exploded during the 1970s and reconfigured all the forms, patterns and dramaturgic codes that had dominated Greek cinema until then. The fact that the movement took place under the Colonels' Dictatorship

(1967–74) explains many of the choices and the practices of the cinematographers of the period. Angelopoulos was, from the beginning, and remained until the end, the most inquisitive and the most resourceful out of all these filmmakers, renewing his visual language in crucial circumstances and critical conditions throughout his career.

Angelopoulos' late films were criticised for their episodic character, continuity disjunctions and confusingly convoluted scripts, as well as for their melodramatic, almost sentimental moods. No one had expected to see these in the work of a director whose 'de-psychologised characters' had dominated his famous films, such as *Days of 36* (1972), *The Travelling Players* (1975) and *The Hunters* (1977). Both *The Weeping Meadow* and *The Dust of Time* articulated a strange narrative rhythm; they did not simply articulate a labyrinthine temporality through the circular contemporaneity of the story, as Angelopoulos had done in his previous films. In these last films it seemed that time itself was transformed into the central signifier of the story and was the central focus of the visual narrative as the prime mover, and at the same time the ultimate *telos*, of its representation.

Despite their minimal commercial successes, most of his movies gained many prestigious awards at international festivals and elevated him into the small group of European directors who were recognised as articulating a distinct and innovative method of cinematic representation. However, with his last two films, *The Weeping Meadow* and *The Dust of Time*, it became obvious that he was working on new forms of filmic narrative and more complex forms of 'emplotment' which represented a radical departure from his style hitherto.

## The power of local knowledge

> In the first case one's father is what one would like to *be*, and in the second he is what one would like to *have*.
>
> Jacques Lacan[29]

Angelopoulos' immediate ancestors were the many distinguished directors who not only consolidated what was called Old Greek Cinema but also established what we might label Greek National Cinema, forming a distinct visual language with specific codes of representation, narrative rhythms, sonic patterns and recognisable iconographies of landscape, storytelling and implied social texts. However, the Old Greek Cinema was not in any way a monolithic cultural movement. In the 1970s, Angelopoulos and his generation dismissed the productions of the 1950s and 1960s *en masse*, in a somewhat unfair and unhistorical way. Indeed many

dissenting voices could be found within it; also, some of its most important representatives, who enjoyed commercial success, dealt with non-conventional themes and took risks with the medium. Censorship, as well as self-censorship, played an important role in defining their visual language, as they had to resist the state's attempt to control it while struggling to gain self-confidence and articulate its visual codes.

When Angelopoulos released *Reconstruction* (1970), the film industry was about to collapse following the introduction of television (1967) and the effects of the formulaic character of most films produced under the 1967 Dictatorship. Angelopoulos' first feature film was not simply a radical departure from the dominant forms of representation in Greek cinema. In it he fused Antonioni, Ozu, Osima, Bergman, Resnais, Godard and Rocha, forging a complex composite cinematic visualisation of reality. *Reconstruction* is both a film about an actual murder and the modernist rewriting of an archetypal myth: the return of the immigrant from Germany echoes the return of the ancient king from Troy. His wife had moved on – she desired a new life and had found a new lover – but she couldn't have a new life: she was a prisoner of her gender, her society, her family. From his first film Angelopoulos avoided the episodic and the anecdotal by grounding his story on the mythical substructures that are both contemporary and diachronic. The woman is an individual, but at the same time she epitomises the continuous struggle of women to regain control over their lives since the fall of maternal rule, as expressed in *Oresteia*'s Clytemnestra.

*Reconstruction* is a unique film in the corpus of Angelopoulos' work: it functions as an introduction to his later films, which are distinctive because of their grand landscapes, fresco-like pictoriality and depthless *mise-en-scène*. At the same time, the film sketches in a link that stands for a missing tangible connection between history and myth, or between contemporary individuals and the timeless masks of ancient myth. Angelopoulos' country was not the happy, euphoric and sunny Mediterranean tourist destination popularised by Cacoyannis' *Zorba* and Dalianidis' exuberant Technicolor musicals; something terrible was constantly being committed there – the perpetual murder of history. Angelopoulos' first film looked with almost anthropological impartiality upon the continuity between the human and its landscape, through a visual encoding analogous to the work of the anthropologist Jean Rouch.

Indeed, Angelopoulos' camera brought to the light of conscience the violence, brutality and injustice that had dominated Greek history to that point. The stark and gritty black and white photography not only captured but also imprisoned the liberating potential of light and the elucidating power of natural

phenomena: everything was occluded, self-eclipsed, opaque. In the land of light everything was overcast, covered by ominous clouds and overshadowed by hostile invisible presences; the landscape in *Reconstruction* was a demonic space where history, reality and experience dehumanised individuals, transforming them into predatory animals fighting for survival or self-oblivion. The film was not simply about the claustrophobic atmosphere imposed by the 1967 Dictatorship; it was also a statement about the liberating potential of human emotions – which were glaringly absent in the plot.

With his next film, Angelopoulos explored the assassination of history in Greek cultural memory, situating the story during the most brutal dictatorship in Greek history, under the fascist regime of General Metaxas (1936–41). This film, *Days of 36* (1973), is the de-dramatised exploration of institutionalised criminality, of the microphysics of power, as embodied in the oppressive mechanisms of the Greek state. Situated within the fascist dictatorship, it is an allegory of the absence of freedom and the delusional world imposed by the ruling political elite. Despite the analogies being strikingly obvious, it was filmed under the strict and pervasive censorship of the 1967 Dictatorship – and this pervasive presence of invisible institutions is also a part of the visual spaces framed by the camera.

Cinematically, Angelopoulos discovered the emotive impact of stark, charcoal colours, alternating them with shades of ochre or bright white clothes appearing like luxurious shrouds over the dead souls of the state functionaries, as the most eloquent commentary on the mummifying influence of totalitarianism. The film re-enacts the asphyxiating world of a society tormented by clandestine machinations, secretive evasions and oblique displacements. All action emanates from what happens within the confined space of a cell, which in itself becomes the locus of an intense drama that tiny capsule of space seemed to evoke the collective drama of a society under siege. (See Figure 5.1.) Narrow corridors, closed doors and, more importantly, closed mouths, conceal reality and create a network of misleading clues, deceptive statements and insidious secrets.

There is also a strong substratum of psychosexual dynamics, with the implied homosexual liaison, which was to be further elaborated in his later films. For Angelopoulos, where there is external oppression, internal repression emerges; in other words, what Marx points out enters the provenance of Freud's unconscious. As a consequence the minds of his protagonists are convoluted, twisted, confused; angst leads them to terror and fear that neutralise their thinking ability, resulting in political inertia. The political drama is primarily a drama within human conscience, as people are unable to see the sources of their oppression and cannot connect the various fragmented clues they receive from their experience into the

Figure 5.1: Theo Angelopoulos, *Days of 36* (1972). The geometry of political tyranny.

big picture of their own political emancipation. His characters live in the world of the *camera obscura*, the land of false consciousness, or 'of voluntary servitude', according to Michael Rosen,[30] unable to confront the reality of the political system that has been imposed upon them and that uses them for its own purposes. Angelopoulos leaves open the question of the willingness of people to continue living under such circumstances: his early films, restricted by censorship, satirise official power and the proverbial 'common man', although, like most thinkers of the Left in that period, he believed in the revolutionary potential of the working class.

*Days of 36* is a film of formal austerity, emotional one-dimensionality and solemn starkness, reminiscent of Oshima's *Death by Hanging* (1968). Within two years, Angelopoulos' visual language had destroyed the colourful exuberance of the Greek film industry in the 1960s and replaced it with the new experimental forms of cinematic perception. Furthermore, the *auteur* tradition from France, the crisis of narrative cinema that was taking place in Hollywood during the late 1960s and the emergence of the Japanese cinema of Yasugirō Ozu, Kenji Mizoguchi and Oshima, amongst others, influenced his style until 1975, when his next work, which was to be his formal masterwork – *The Travelling Players* – was released. Angelopoulos called it 'the yellow film', since the 'colour that permeates the whole film is that of the ochre, which is the colour that characterises the specific period,

the thirties'.[31] With these two films Angelopoulos reimagined all representations of Greek iconographies and discovered new affective topographies where the Greek collective drama was taking place; the human bodies were incongruous punctures in the emotional energy of space, while they were themselves silent, neutralised and emptied.

With *The Travelling Players*, he fundamentally restructured all established codes depicting cultural memory, self-perception and historical representation. At the core of the film are two overlaid traumas: the trauma of the refugee generation and the trauma of defeat in the Civil War. The mood of defeat characterises the almost monochromatic light dominating each scene in the film; each is red, green or blue. The pictoriality of the film is also enhanced by Angelopoulos' conscious references to the paintings of Yannis Tsarouchis (1910–89), who combined Renaissance techniques with traditional motifs from Byzantine iconography and folk paintings. In a discussion about colour, he emphasised the way that Tsarouchis used ochre to paint urban spaces, as well as his use of blue and maroon,[32] as symbols of the silent conflicts taking place every day in the anonymity of large urban centres.

The film is still of seminal importance because it offers ingenious oppositional modes for the representation of history without falling victim to the hackneyed methods of documentary depiction or the allure of realistic verisimilitude. Furthermore, in it he developed his own form of montage, which is probably the most significant axis in the construction of his ocular poetics. In an interview with Anthony Horton in 1992, he specified:

> World cinema thinks of Eisenstein when we say 'montage of attractions.' Then there is Hollywood's sense of 'parallel cutting' developed by Griffith. But what interests me is what I think of as montage *within the scene*. In my films, montage exists not through the cut, but through *movement*. I feel montage can be created through the continuous shot involving *time* and movement which involves *space*. In these shots of mine, time becomes space and space becomes time. Think how important the 'pause' is in those spaces between action and music. They are very important in creating the total effect. My scenes are complete units, but the pauses between them are really what unite all as one.[33]

The tradition of montage that Cacoyannis began, and that liberated cinematic images from photographic stillness, was dismantled by Angelopoulos' sense of 'de-montage' liberating now images from specular illusionism and emotional manipulation. Angelopoulos further developed this central feature of his

poetics in his later films. But with *The Travelling Players* he constructed a different form of representational materiality, an imaginative fusion of symbolic realism and anti-illusionistic pragmatism, with the mythopoeic substratum of the *Oresteia* taking the story beyond the confines of historical specificity and the strictures of faithfulness to factual particulars. This is his deeply political refutation of Bertolucci's avant-gardish style in *The Conformist* (1970) and Francis Ford Coppola's *The Godfather* (1972), with its narrative ellipses and stylistic discontinuities.

The film explores Greek history between 1939 and 1952 by following a troupe of travelling players as they wander around the Greek countryside performing a folk play. In reality, the storyline frames the attention of the viewer towards its main focus, which is history and politics as projects of personal and collective emancipation. Indeed, one could claim that the film is a visual essay on the ongoing drama of the incomplete European Enlightenment and its eventual dissolution by political establishments of either Right or Left, which imposed systems of oppression, control and surveillance on their citizens.

Angelopoulos' strategy of representation is based on a 'de-dramatised' understanding of historical reconstruction. Revisiting the old Wilhelm Worringer thesis, we can see this as a technique based on a fundamental oscillation between 'empathy' and 'abstraction'.[34] As the natural world becomes the immovable witness to everything that takes place, action itself becomes highly deceptive; it is an illusion performed on a stage, and ultimately becomes the stage for the presumed historical experience of the people. The basic technique employed here is both empathic and abstract, Aristotelian and Brechtian, verisimilar and illusionistic, despite the dominance of the Brechtian approach, at least during the early period. But, as Angelopoulos said in an interview: 'I started with Brecht and finished with Aristotle's definition of tragedy.'[35]

After *The Travelling Players*, Angelopoulos' next two films, *The Hunters* (1977) and *O Megalexandros* (1980), not only closed the chapter that explored recent Greek history but also brought a specific style of cinematic representation to its consummation. The first is a cryptic, hermetic and claustrophobic exploration of the delusions of the Greek political establishment and an exposing of the brutal strategies implemented in order to impose their rule on the country. The film undermines the legitimacy of all state power by presenting the ruthless political machinations used to suppress dissent and perpetuate oppression. It is Angelopoulos' response to Bertolucci's *1900* (1976), full of radical visual stratagems, slow and solemn long takes and expressionistic colours, reminiscent of Franz Marc's paintings. Political history becomes an improvised performance

An Essay on the Ocular Poetics of Theo Angelopoulos

by an elite without civil conscience or ethical considerations. Angelopoulos' film illustrates the horrible reality of a political establishment totally indifferent to the destiny of its people, created by a ruling class that is narcissistically predatory, ostentatious and guilty.

Visually, he employed the most distancing, detaching, cold colours: yellow, green and ochre, punctuated in moments of illumination by warm reds and blues as, for example, when the rebels appear from the glowing blue background with their red banners, escorted by majestic white swans. The film recapitulates the radical experiments of the German New Wave in the previous decade, from Rainer Werner Fassbinder to Alexander Kluge, in the most dynamic and expressionistic manner. *The Hunters* is a film about hallucinations – more specifically about the hallucinations of a political establishment without any *raison d'être*, in a perpetual crisis of legitimacy, unable to justify its control over society to itself or to its citizens. *The Hunters* is the most political film made by Angelopoulos. It is a visual essay in political delegitimisation, as it dismantles, in an almost Hitchockian style, the pretexts and the alibis of a power system imposed on a society. Angelopoulos believed that it was the visual complement to Hitchock's *The Trouble with Harry* (1955), and indeed there is a complex network of intertextual references in his work.

It is also the most Gramscian film made in that period, as it depicts the institutional anomie internalised by hegemonic elites who then impose their own unreality on society itself. The oppressive character of the Greek establishment finds in this film its most glacial illustration. (See Figure 5.2.) Such oppression was framed pictorially, as Angelopoulos says, 'not through the transparency of oil painting but through the blurriness of aquarelle'.[36] Time and rhythm are chromatic: this is his 'green movie'. He uses green not as the colour of vegetation but as the cold colour of mould and decay. Eirini Stathi stresses that the unfolding of colours in this film constitutes an 'extra-diegetic act',[37] a running commentary on the action as well as an intensification of the action itself.

In his next film, *Megalexandros* (1980), Angelopoulos examined the other side of the equation: living in a period of rising populism, exacerbated by the personal cult of the leader, especially in the Socialist Party, he plunged into the mystique of a blood-and-soil autochthonicity, exploring the fascist elements within this movement. The film is a grand historical epic, with cryptic symbolic references, set in the Greek countryside at the beginning of the twentieth century. It was based on a true event, the Dilesi Massacre of British tourists in 1872; Angelopoulos relocated actual historical action and reconfigured the timeline in order to produce a parable about leadership and power in the twentieth century.

# Realism in Greek Cinema

Figure 5.2: Theo Angelopoulos, *The Hunters* (1977). Breaking the monochromy of history.

The film brought Angelopoulos' exploration of Greek history to an end. It also ended the deeply political perspective of his camera, which had explored the nature of power and the existential reality of being subjected to power. In his first five films Angelopoulos set out to visualise the conflict between state and society, which left the individual without identity and collective vision. He produced two-dimensional depictions of power without authority based on coercion, exclusion and oppression. By doing so he avoided any psychologisation of his characters, who are alienated beings rather than self-conscious individuals. His exploration of human interiority was to take place after *O Megalexandros*, in a period when Greek society opted for a major shift in political life towards the Left and elected its first socialist government (in 1981).

However, the socialists did not fundamentally democratise the power structure of the state or transform the political projects of self-presentation and self-perception. On the contrary, they articulated and imposed an isolationist and exclusivist rhetoric that created its own false consciousness and its own alienating strategies. Soon – within four years – new moods began to appear in the cultural and intellectual atmosphere of the country as the result of frustration and disenchantment – those of melancholia and mourning.

An Essay on the Ocular Poetics of Theo Angelopoulos

Historical experience, for Angelopoulos, is the constant loss of innocence, dominated by violence, brutality and war. His films frame emotions as unmediated disclosures of internal realities, formed by the collapse of projects of renewal and the claustrophobic world of a polis without politics. Indeed, it seems that after *O Megalexandros* the central characteristic of his work is a certain mood, in the most Heideggerian sense of the word: finding oneself through *Befindlichkeit*, a sense of being totally abandoned in the world. (See Figure 5.3.) Such a mood needs different visual poetics, indeed a reconsideration of the basic premises of his previous poetics. David Bordwell points out that 'this is "mood cinema", like mood music. The story is amplified not simply through the threnodic score but also through the skies, the landscapes, and the bearing of the humans dotted around the frame.'[38]

In his insightful essay, Bordwell explored Angelopoulos' change of mood in cinematic representation through what he called his 'planimetric shot'.[39] Actually, such 'melancholy' was the result of both disenchantment with the failed project of modernity and a personal probing into the complexities of human relations. The period between 1980 and 1995 was the time when Angelopoulos, as an individual, became a cultural icon for Greece, the single most important mythmaker, or indeed iconophile, of the postwar period. During the same period, his work explored disillusionment with the project of political renewal; by the end of the decade, his films had articulated his absolute disappointment with the last utopian transnational project, socialism, after its collapse. During these major transitional periods, his work also grappled with the problem of human interiority and conscience, which he called 'the silence of history'.

The discovery of this 'interiority' and of the silent language of human emotions was the outcome of a complete separation of conscience from all its psychological investments and ideological aspirations. His films after 1995 use history as a situational frame in order to foreground human relations and visualise the inner conflicts of the embodied and, more specifically, ageing mind. Colours also changed in startling ways. Dimitris Theodoropoulos extensively analysed the use of colours such as grey, blue and deep green in *Eternity and A Day* (1998); these are the colours used in all his films after *Voyage to Cythera* (1984).[40]

However, before immersing himself in the universe of emotional indeterminacy, he explored the meaning of borders as imaginary divisions of human geography. His style also took a new turn; now the music by Eleni Karaindrou gave a new dimension to the image by dematerialising it and transferring it to the level of a non-verbal articulation of feelings. Karaindrou's music seems to be the most appropriate hermeneutical commentary on Angelopoulos' *mise-en-scène*. With

179

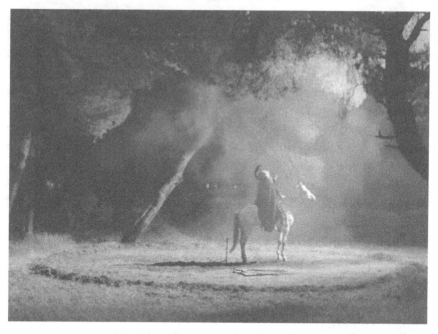

Figure 5.3: Theo Angelopoulos, *Alexander the Great* (1980). The birth and death of legendary utopias.

her music, his background landscapes were transformed into 'trauma-scapes', as they all indicate unrepresented and untold human suffering. His camera, mostly in the hands of Yorgos Arvanitis, delved into the invisible history of space through fluid, soft and always unromantic movement, re-enacting lived tragedy as a powerful emotional landscape for his viewers. Whereas before the landscape was the implicit structure or the implied master narrative of collective history, now the individual and his/her corporeal presence dominate the frame. Indeed, through the collective disillusionment of the 1980s, Angelopoulos' films foregrounded the inexplicable and unrepeatable, the singularity of the individual being seen as a testimony to the extraordinary journeys of ordinary individuals through love, language and loss.

Angelopoulos made four rather uneven films during the 1980s, a period of intense disenchantment and frustration for him. One could claim that the 'melancholy' observed by Bordwell appears only then, rooted in the profound disillusionment that his generation felt with the failure of the first socialist government. Their failure to change the societal structures and the ideological practices of the Greek state was the forerunner of the wider feeling of disappointment that was to

## An Essay on the Ocular Poetics of Theo Angelopoulos

dominate the European intellectual horizon after 1989. *Voyage to Cythera* (1984) dealt with the closure offered to displaced refugees of the Greek Civil War after they were allowed to return home; in a way it framed the disappointment with nostalgia for a disrupted continuity. The second, *The Beekeeper* (1986), explored the disenchantment of a whole generation with the dreams of their youth. Vasilis Rafailides called this uneven and somehow 'flat' film the 'most emphatically anti-realist film, with anti-realistic dialogue and equally anti-realistic diegesis of the narrator'.[41] It seems that the film challenges the visual addictions of its audience in its attempt to present the looming presence of nothingness. Angelopoulos instructed his central actor, the international star Marcello Mastroianni, to be emotionless, lifeless, almost in constant necrophany, because his psyche is really dead. The lifelessness of human existence is expressed through the muffled, over-saturated, fluid colours which fuse with each other, a technique employed effectively by Angelopoulos and his cinematographers Arvanitis and, later, Andreas Sinanos.

Colour cinematography always risks slipping towards televisual naturalism or documentary verism. As the television screen was increasingly becoming the enemy of the cinematic frame, Angelopoulos tried to salvage the cinema effect from transforming film into a spectacular object and a commodity fetish. Sean Cubitt's analysis of the process finds in Angelopoulos' film its ultimate expression. Cubitt observed that:

> Against the current of commodity cinema devoted to the promotion of the being of its audiences, its worlds, and its perceptions as objects caught in the moment of their fading, the dimensionless need not destroy dimensions: it has the option of generating them. This possibility, never removed from the history of cinema, is *the utopian in film* [emphasis added] that has always made it so fascinating.[42]

With these films Angelopoulos consciously reimagines the cinematic experience, the utopian elements of filmic visuality and the emotional effect of being exposed to the shadows of things and humans on the screen. He invites the mental and sensory participation of his viewers by articulating filmic images that vibrate with post-linguistic and post-iconographic meanings. It is interesting to observe that some crucial scenes in *The Beekeeper* take place in front of the cinema screen, still advertising its last film, Alfred Hitchcock's *I Confess* (1953). The film is also born out of another film: the filmic dimension becomes the ultimate code of signification. In the same way as the film ends in front of a curtained stage, Angelopoulos explores the theatricality of personal fantasies, for both the old man and the young

girl: they both live in a world of spectacular absences, the former about the past and the latter about the present. Also, it seems that Angelopoulos followed what Hitchcock attempted in his film: 'to build a film around a situation rather than a plot'.[43] Situation becomes more important in his films as the plot becomes more and more an internalised landscape, not about what has been lost but what is transformed into cinema. A later film, *Ulysses' Gaze* (1995), ends with an invisible screen and the sound of the projector: the film happened because of another film, the Holy Grail of all Balkan cinematography.

The third, *Landscape in the Mist* (1988), arguably one of the best European films of the decade, follows the journey of two children in search of an elusive and invisible father. It is a strange fairy-tale, a modern retelling of Hansel and Gretel, as they travel through the dense forests of indecipherable confusing and irrational signs. (See Figure 5.4.) The last film of the period, *The Suspended Step of the Stork* (1991), visualised the first crossing of national borders by a Greek director whose visual iconography had transcended by then the limits of his culture and opened up the horizons of human homelessness as a condition for self-definition.

The production of these films also showed Angelopoulos' growing international fame. Most of them are co-productions, with foreign sponsors, and in two of them the main actors are not Greek (a practice that would characterise all his late films). Also, most of his films became virtually predestined festival prize pieces. He received a string of prestigious awards from as early as 1975. After Cacoyannis, Angelopoulos was the first director to break down the cultural barrier using a language that could denote a plurality of collective experiences. The progression of his films in the 1980s, from the story of returning home in *Voyage to Cythera* to that of escaping to the great world in *The Suspended Step of the Stork*, represented a declaration of artistic consolidation and formal accomplishment that appealed to international audiences more than to Greek ones. It was in this period that Angelopoulos became a European director who struggled to make sense of what had happened with secular modernity, and of how all dreams had become nightmares and all ideologies systems of tyrannical annihilation.

After 1991, Angelopoulos' camera produced one of the most emblematic post-Communist films, which must be seen as his final farewell to the failed god of ideology. Based on the Odyssey, *Ulysses' Gaze* is a Balkan road movie, crossing borders, transgressing cultures and breaking all genre distinctions. It is also one of the best films of the 1990s, a filmic text of immense complexity, visual force and thematic intricacies. The story of a director, played with diligent awkwardness by Harvey Keitel, who tries to find the primary gaze of the cinematic reality in the

# An Essay on the Ocular Poetics of Theo Angelopoulos

Figure 5.4: Theo Angelopoulos, *Landscape in the Mist* (1987). The dissolution of forms and the lost imaginary.

Balkans, becomes an archetypal parable about the human adventure as it unfolds through hope, irrationality and destruction.

This is the first ever film to deal with the nihilism, political and religious, into which modern nations have thrown themselves, after losing all hope for projects of social renewal. The film ends with some of the most poetic lines ever written by Angelopoulos himself as we overhear the sound of the cinema projector. The film also consummated the epic mode of representation in his work, based around monumental landscapes and colossal human artefacts. The cinematography focuses on grand-scale renaissance-like frescoes, full of vibrant colours and gestures of expressionistic intensity.

At the end of the film, we understand that the main protagonist is the cinematic camera itself as the intentional and yet impartial bystander to 'the whole human adventure, to the story that never ends'. In this film, Angelopoulos rearticulated the disenchantment of a whole generation of dedicated true believers. With his 'Helen' (and it is interesting that most of Angelopoulos' female characters are called Helen) the poet George Seferis talked about a similar frustration after World War II, under the mask of the Trojan War:

> ... I moored alone with this fable,
> if it's true that it is a fable,
> if it's true that mortals will not again take up
> the old deceit of the gods;
> if it's true
> that in future years some other Teucer,
> or some Ajax or Priam or Hecuba,
> or someone unknown and nameless who nevertheless saw
> a Scamander overflow with corpses
> isn't fated to hear
> messengers coming to tell him
> that so much suffering, so much life,
> went into the abyss
> all for an empty tunic, all for a Helen.[44]

Angelopoulos' visual translation of Seferis' modernist language is another aspect of his films that needs detailed analysis. At the end of the journey, 'Helen', the purpose of embarking on the journey itself, is another 'empty tunic', an illusion, a certain nobody. With this pessimistic yet highly agonistic awareness, Angelopoulos entered the last stage of his exploration, in which his cinematic eye found itself surrounded by the neoliberal practices of voracious individualism as encapsulated by the famous Margaret Thatcher dictum: 'There is no such thing as society.' The death of the political was primarily the death of collective cultural memory. In the 1990s the whole world entered a period of social meltdown as the end of Communism led to the revival of ethnic conflicts, the rise of religious fundamentalism and the undemocratic surveillance of private life by unlimited state power. If in the 1960s Herbert Marcuse had remarked that 'we live in a society without opposition',[45] in the 1990s and afterwards the world experienced societies in a profound crisis of legitimacy. The nation state was in crisis, civil society had collapsed and the political elites were ruling unopposed, through the pseudo-events created by controlled mass media and deterritorialised cybernetic identities.

Angelopoulos was probably the first filmmaker to try to express this nihilism, not as spectacular end of days catastrophology or apocalyptically nightmarish extravaganza, but as the death of memory and emotion, as the ultimate surrender to a power system without agency and human creativity. His critics called this defeatism, but the recognition of defeat does not mean endorsement or acceptance. His last films explore the ontological and existential condition of being in time without any horizon for transcendence; nevertheless, a utopian project seems to emerge out of his late works. 'Only utopias can change the world and lead it forward,'[46] he said in 1999 to Dan Fainaru; and such a meta-historical imaginary

is what we find in his films during the last period of his life, as he dispenses altogether with all the forms of historical verisimilitude he had employed in the films of the previous decade.

## The anthropogeography of European nihilism

I saw then [1980] that history was not breathing, it was ending.

Theo Angelopoulos[47]

In a crucial scene of *The Suspended Step of the Stork* (1991) the border guard says: 'Do you know what borders are? If I take a step more, I am elsewhere – or I die!' The crossing of borders that Angelopoulos embarked on with *Ulysses' Gaze* foregrounded the liminality of human condition, the existential reality of living between spaces without belonging to any of them or being part of any while at the same time indicating the search for a new aesthetic code based on nuances and tones: interstitiality became the new aesthetic project of his cinema in his attempt to explore in-between spaces of flowing identity and indeterminate identifications. The collapse of Communism as the last utopian project of the European Enlightenment, and the revelation of the violence that dominated the twentieth century in Europe, especially during the Balkan wars, forced Angelopoulos to turn inwards and look further into the very core of existence, without distinctions, qualifications or illusions, and see the strikingly lucid elemental condition of mortality. Aptly enough, but unfairly, Geoff Dyer called *Ulysses' Gaze* 'another nail in the coffin of European art cinema … since the whole thing could be boiled down, any way to a single still photograph – a statue of Lenin gliding along the Danube on a barge'.[48] During this period borders became the emblems of artificial separation and enforced divisions between peoples and individuals.

His *Eternity and A Day* (1997), which received the Grand Prize at Cannes, encapsulates Angelopoulos' response to the prevailing European nihilism which, from Friedrich Nietzsche through to Martin Heidegger, understood human life as being-towards-death. The last day in the life of a poet becomes the focal point of a profound exploration of human relations, memories, past and present, death and transfiguration. Ultimately, it is about the greatest challenge to the despair born of the acute reality of dying, the challenge posed by the mystery of natality and the promise of each new individual life – so cruelly destroyed in the case of the dead Albanian boy. The film is a series of canvases, almost in the manner of early nineteenth-century German Romantic painters. Caspar David Friedrich's painting *Monk on the Seashore* is the hypertext that gives this film an eerie, numinous and

yet terrifying sublimity. Angelopoulos made his film a visual essay on the meaning of life or, more specifically, on the ontology of un-being. Time becomes, in this film, the most urgent code for self-articulation and self-presentation. In that final day of the poet's existence, Angelopoulos condensed the experience of a lifetime, showing the psychic simultaneity of the human unconscious, which experiences every moment as its own personal eternity.

The past of the poet is also the past of poetry; in crucial moments of the film, the Greek national poet, Dionysios Solomos, appears as the angel of death and the harbinger of a new posthumous life. In the scenes in which the poet appears, the verses recited always remain fragmented, as if the poet himself was afraid to complete his own work. Angelopoulos uses him as the ultimate example of self-sacrifice for the sake of language – probably moving towards Nietzsche's realisation that 'only as an aesthetic phenomenon are existence and the world justified'.[49] The scene within a bus is probably one of the most numinous cinematic episodes ever produced: the circular trip around different stops becomes the symbolic descent into an underworld of disembodied souls and lost ideals. It is Dante's Inferno in cinematic terms, as hell is not a place of punishment any more, but the realm of everyday meaninglessness. The end of the film frames an experience of religious sacrality as the dying poet is absorbed by the sea, the mother of all amniotic fluids, a death in the womb of the ultimate *arche* that also indicates birth and resurrection. The grey, almost colourless, monochrome of the sea is the psychological *thalassa*, as elaborated by Sandor Ferenczi, paving the way for a return to the primeval womb as a seed of regeneration. The same image is repeated in his last two films, which also end in front of the sea: the sea becomes the mirror against which the viewer sees the drama of a life without projects re-enacted. The return to the womb (*regressio ad uterum*) happens as an invitation to rebirth so that a new recognition of life can take place.

With his final film, *The Dust of Time*, Angelopoulos tried the impossible in the history of narrative cinema. Without disputing its flawed character, especially in regard to its over-plotting, one can clearly see the immense risks that he took with the representation of time, offering totally new, convoluted and definitely confusing depictions of intersecting temporalities. If in his films up to 1995, history as lived reality was the main concern of his representations, in his last films lived temporality becomes more and more prominent. He depicts history not so much as a discursive practice through images but as the psychological absorption of individual time through emotional encounters between displaced human beings with centreless temporalities. It is displacement itself that dislocates narrative and dislodges subjectivity.

# An Essay on the Ocular Poetics of Theo Angelopoulos

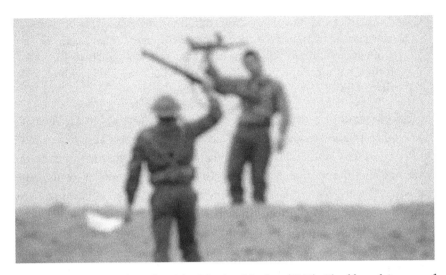

Figure 5.5: Theo Angelopoulos, *The Weeping Meadow* (2004). The blurred images of oblivion.

Dan Fainaru, in a memorable review, noted that the film:

> will undoubtedly be a hot ticket for art-house distributors and festivals, but *The Dust of Time* still falls short of settling the differences generated by Angelopoulos' films. His admirers will be deeply moved by *The Dust of Time*'s emotional impact and appreciative of the intricate work on display, but his detractors may once again find themselves irritated by Angelopoulos' loose treatment of reality and narrative.[50]

Fainaru's last remark highlights the focal point in Angelopoulos' narrative innovation. Indeed, in this film – as well as in the final part of the previous *The Weeping Meadow* – Angelopoulos broke away from all narrative conventions he had employed until then and explored new narrative possibilities based on the possible poetics of displacement and exile. His camera became the eye of the refugee, the alien and the stranger as they look back to the society that offers them temporary hospitality while treating them with fear and hostility. (See Figure 5.5.) The tense atmosphere of emotional collisions that lead to frustrated desires, muted colours and confused actions becomes the central mood in his last film. Strangers, in their paradoxical capacity to encapsulate 'the unity of nearness and remoteness'[51] are the ultimate protagonists of Angelopoulos' late style. The film was also noticed by Fredric Jameson, who pointed out that:

> *The Dust of Time* attempts (unsuccessfully, in my opinion) to break new ground by transferring the paradigm of discontinuous collective temporalities to the drama of individuals, still punctuated by history but more after the fashion of news bulletins and headlines than of qualitatively unique historical situations.[52]

Successfully or unsuccessfully, the fact remains that till his last film Angelopoulos was recalibrating and reconfiguring the radical techniques that he first introduced in the 1970s. His innovations reflected the new sense of the tragic that he saw emerging after the collapse of all modernist projects of renewal. Now his scenes were replete with memory, loss and absence: they were scenes of intense mourning and therefore of unredeemed catharsis. With this film, time also collapsed and imploded; what emerged was a post-impressionist *mise-en-scène* in the form of fused over-saturated colours, as in Georges Seurat pointillism, creating the optical effect of homogeneity of forms. Such extensive use of chromoluminarism was also expressed through the over-dramatisation of plot and storyline simultaneously: the old de-dramatised plot now gained its Aristotelian catastrophe, as everything is subverted time and again without any cathartic closure. 'I am under the impression,' he said to Fainaru in 1999, 'that only utopias can change the world and lead it forward.'[53] The statement marks indeed the end of political modernism as a project of social renewal.

Overall, in his masterwork *The Travelling Players* (1975), he had configured a totally new perception of narrative structure by bending time into space and converging temporality into spatiality. After that stunning experiment, he reverted to much more linear strategies such as we see in *Landscape in the Mist*, *The Beekeeper* and *The Suspended Step of the Stork*. In his crowning achievement, *Ulysses' Gaze*, the linear narrative structure is multiplied by references to a mythical time underpinning history and to an originary gaze before the fall into the domination of simulacra and the illusory shadows of contemporary postmodernity. Angelopoulos knew, of course, that visual narrative was different from linguistic or musical narration. In an interview with Michel Fais, Angelopoulos stressed that:

> in the written word, the reader imagines within the confines of language: spaces, faces, atmosphere, colours, voices. However in cinema you can never construct an equivalent form. Cinematic language is the language of reality. It is the language of the gaze. We cannot transfer the style and the language of a great book into film. We must go away from it, we must forget the origin of the script in order to probably construct a related music of a different order.[54]

# An Essay on the Ocular Poetics of Theo Angelopoulos

Figure 5.6: Theo Angelopoulos, *The Dust of Time* (2009). The whiteness of un-knowing.

However, in *The Weeping Meadow* the story has a well-paced unfolding while the film culminates with a primal scream in front of the endless inarticulacy of the sea. The deep emotionalism, the sentimental melodramatic tone of this film, is strange and somehow unexpected from the Brechtian director of *The Travelling Players* and *The Hunters*. After 1995, he developed an almost Wagnerian perception of the film as a *Gesamtkunstwerk*, encompassing music, script and choreography, reintegrating drama and pathos in an intricate and somehow Aristotelian tragic plot. (See Figure 5.6.) In his last films Angelopoulos recorded his own transition towards more emotionally engaging films, playing with lighting and setting – *The Dust of Time* approaches a Hollywood-style illusionism in that respect – but insisting still on the most interesting and most demanding dimension in his films, the dimension of empathic, shared, temporality.

With Angelopoulos' films, Greek cinema became one of the most ambiguous and most risk-taking locations of cinematic production in the world. His movies are amongst the very few works that have raised questions that go beyond the parochial issues of identity and history (although in some instances he did engage with similar questions and they were of deep concern for him). Angelopoulos' films constitute a unique body of interrelated works that developed over time and explored new fields of visual articulation; indeed he changed the regimes of visuality forever in a way that is both challenging and experimental. His trajectory fused individual aesthetics and collective projects. Although Angelopoulos' films started with the urgent questions of history and identity that dominated Greek society in

the 1970s, after 1980 they changed their visual grammar and their thematic references. By moving from the epic level of collective adventures to the deeper level of individual psychology, Angelopoulos' films explored the disenchantment with all projects of social renewal and the disillusion with the lack of historical agency in contemporary social imaginary.

With his Trilogy of Borders – *The Suspended Step of the Stork, Ulysses' Gaze* and *Eternity and a Day* – he employed a new style of partly personal and partly collective narratives, creating a hybrid space of colliding signifiers, by having his stories oscillate between interstitial forms of articulation fusing genres, styles of performance and semiotic networks. With his final two films, he collated a new visual language framing eschatological questions about the central ontological concerns of Western metaphysics: mortality, absence and the absolute. At the same time, he struggled to recalibrate the visual fields of his viewers through the innovations of his camera. As he stated: 'Your camera offers a different way to look at things. The film director searches for the lost innocence of the original gaze.'[55] Regrettably, his oeuvre of constructing a radically new form of ocular perception and poetics was left incomplete.

# 6

# The Feminine Gaze in Antoinetta Angelidi's Cinema of Imaginative Cathedrals

## Invitation to a beheading

The cinema is an idealistic phenomenon.

André Bazin[1]

Antoinetta Angelidi's cinematic language belongs to the hidden and unknown tradition of experimental – or, more precisely, poetic – cinema in Greece. Her films are few and short in duration: their average length is 75 minutes each. They are structured around non-linear narratives through strong images, vibrant colours and geometric arrangements. Although there is no obvious story, the filmic text unfolds in separate sections, like acts in a drama, which means there is a coherent underlining plot. Despite the impressive pictorial character of her images, her cinematic frames must be seen as kinetic totalities, not as isolated fragments of a fresco or a succession of still photographs – a concern that is addressed differently in each of her films.

Angelidi made only four films: *Parallages sto Idio Thema/Idées Fixes/Dies Irae* (1977), *Topos* (1985), *Oi Ores – Mia Tetragoni Tainia/The Hours – A Rectangular Film* (1995) and *Kleftis i Pragmatikotita/Thief or Reality* (2001). Her other short films, exhibitions and multimedia work represent an ongoing and ever-changing commentary on her cinematic explorations. (Her shorts deserve closer study as art-happenings, as do her installations in various art galleries in Athens and Paris.) Together with other experimental directors, she associates cinema with other arts, incorporating elements from painting and dance into her anti-Aristotelian and non-mythological narratives. She calls her language 'poetic cinema', which she defines as the very essence of the cinematic:

> I believe that cinema, in opposition to the illusion that Griffith created about it, has as its model not reality but dream. We never

191

perceive reality in cinema. The world is not pre-codified; there is no mise-en-scène in reality ... the oneiric and the cinematic are extremely akin. It's about images moving, the one after the other, in time. They use the same codes for the production of meaning: the two-dimensional images, their succession, movement, natural language, sounds. That's why the new art of cinema is so familiar to us. Not because it resembles reality, but because it is like dreaming. In a sense, it is the oldest art, since we have been always dreaming.[2]

Angelidi was not alone: she belonged to a generation of filmmakers from the 1970s who experienced the aftermath of May 1968 in France: having seen the deconstructive imagination in power, even for few days, was enough to reinvent the meaning of cinema as an event of political commitment and as an act of social intervention. In Greece the radicalism of the May 1968 iconoclasm became somehow obvious in the New Cinema of the early 1970s. Angelopoulos' first films, for example, have strong echoes of the radical reorientation of cinematic form as expressed by Jean-Luc Godard and the filmmakers after him. Guy Debord's early works – *On the Passage of a Few Persons Through a Rather Brief Moment in Time* (1959), *Critique of Separation* (1961) and certainly *Society of the Spectacle* (1973) – were on the horizon of all anti-filmmakers during this period. For the avant-garde, the American underground movement of Andy Warhol and Jonas Mekas, together with the great early experimentalists such as Maya Deren, Stan Brakhage, Michael Snow and Gregory Markopoulos, were the background for a movement that could not yet emerge in a Greek context – not simply because of the military Dictatorship of 1967–74, but primarily because there were no structures to support such an avant-garde movement and, more importantly, no structures to rebel against. Such poetic cinema, we could claim, has its roots in Orestis Laskos' silent masterpiece *Daphnis and Chloe* (1931) with its fragmented storyline and its luminous yet diffused black-and-white photography. However, the film which did disrupt the mythopoeic continuum of Greek cinema during the period of its very establishment was Gregory J. Markopoulos' *Serenity* (1958), a film which bears the elements of a radical reimagining of cinematic narrativity, although only in a badly mutilated form. After Markopoulos' disappointment, experimental cinema, or as he would have called it 'film as film, the creative film'[3] only occasionally emerged until the collapse of the autocratic regime and its strict censorship and ideological control. Special mention should also go to Nikos Nikolaides' *Lacrimae Rerum* (1962), a short film whose narrative unfolds through the music of Grieg, Schubert and Saint-Saens, without script or dialogue, and his grim *Eurydice BA 2037* (1975).

**192**

However, the restoration of the Republic in July 1974 created the conditions for the radical explosion of the creative imaginary for a period of time: the state seemed powerless and the institutions were shaken to their very foundations, having lost all their legitimacy. This 'creative destruction' lasted for around five years, as the political elites regrouped around a new system of sharing power while maintaining and enhancing the opacity and the inviolability of their ideological authority. Soon the parties of the Left became involved in the process of pursuing power for its own sake, and in 1981 the Socialist Party was elected to office, under the populist banner of change. The change was, of course, only in who controlled the state, not in the state apparatuses and the exercise of power itself. It was also about the hegemonic ideologies of the Left being imposed as official narratives and not as counter-narratives. By 1984, this creative era, this 'Lost Spring', was over, and the creative imaginary of Greek cinema froze in time through conformism and complacency.

During this period, however, there were a number of radical experiments with cinematic language. As we have seem, these experiments had started in the early 1970s, when Angelopoulos, Costas Ferris, Pantelis Voulgaris and Tonia Marketaki, amongst others, recalibrated the narrative rhythms and visual poetics of cinematic storytelling. It might be called the 'formalist moment'[4] in Greek cinema, because representation itself became the object of a radical reconfiguring and restructuring of the dominant visual language. The formalist moment also meant a prolonged and systematic questioning of what is or could be represented. It was the age of the *auteurs*, who relocated the centre of gravity from empathy with what was happening on the screen to an abstract presentationalism. The formalist moment had its own special codes for telling stories. They foregrounded mostly the geometry and construction of each scene, avoiding fast movements of the camera, jump cuts or montage. Most of them rewrote the rules in certain genres through projects of intense hybridisation of stylistic morphemes. For example, Tonia Marketaki's unique political film noir *John the Violent/Ioannis o Viaios* (1973) embodies a complete restructuring of the genre, infusing it with unexpected temporalities and provocative movements – similar to Béla Tarr's *The Man from London* (2005). It explores bleak world, full of rhythmic irregularity and disorienting depthless, even horizonless, spatiality.

Even Costa Ferris' more traditional narrative film *The Murderess/I Fonissa* (1975), with camera eye plunging into the mind of a deranged old woman by manipulating colour, space and motion, pushed the limits of representation in a direction even Ferris himself was never able to follow again. Finally, Angelopoulos' *Days of 36* (1972), *The Travelling Players* (1975) and *The Hunters* (1977) reconfigured

storytelling on the cinematic screen by abolishing causal connections between actions. Angelopoulos maintained the dramatic story but restructured the plot: in *Days of 36* the camera circles its way around a closed room, where all the action takes place; in *The Travelling Players* many moments of action converge on specific *topoi* of memory; and in *The Hunters* the camera stays still in front of the event of death; the hallucinations are but shadows of real events that we never see.

The generation that made films in the 1970s confronted the dominant forms of representationalism but not the codes that validated representation per se. Angelidi's first film, *Parallages sto Idio Thema/Idées Fixes/Dies Irae* (1977), represented the moment when the accepted and consecrated ways of looking at the individual experience were ruthlessly slaughtered, in exactly the way that Judith beheads Holofernes in the painting by Artemisia Gentileschi. This film was an attack on codes of representation, not on forms of storytelling: it rearranged their semiotics, by liberating signifiers from their expected performative reference. The most important aspect of this film is that it frames a way of un-telling a story, of unstructuring the seductive allure of its images and of unravelling the causality of its scenes. It all happens only because each scene, framed by a static camera, slow movement and atmospheric perspective, functions at many levels of meaning; each is full of references to Jean-Luc Godard, and, in a strange way, the other master of the Protestant Gothic, Carl Dreyer, especially his *Vampyr* (1932).

The process of destructuring the codes had started in 1974 with *Modelo*, a stunning visual achievement by Costas Sfikas. With the limited technical abilities and equipment of the period, Sfikas visualised the old dream of Sergei Eisenstein: he translated into images the abstract economic theories of Karl Marx's *Das Kapital*. This seminal film, the foundational text of cinematic experimental modernism, remains to this day the mother of all the anti-languages employed ever since to confront the prevailing form of realist representationalism. Acausal, non-linear, spasmodic and unnatural in its unfolding, it frames a universe of strange iconicities; they do not correspond to any actual events although they are about the everyday reality of work and the political system around it. They translate experience into abstract Pythagorean theorems, in geometric schematisation. The result was rather confronting and somehow contestable. Vassilis Rafailides, for one, was unimpressed:

> Sfikas' cinematography has nothing to do with what we usually call cinema. It is an incredibly bold experiment which can be accepted only by those who are tired of the more or less realistic tricks of a cinema which claims to represent reality, but which in the level of art it is impossible to be anything else but a human construct.[5]

**194**

In Sfikas' *Modelo*, the frame is divided into two parts concurrently depicting disconnected happenings without following any recognisable patterns of perspective and logic. The camera itself becomes the eye through which we look back at the presence of *homo laborans* and at the absence of its subjectivity. The work, the artefact, does not simply reflect the capitalist system that produces it; the actual object of work becomes an entrance to the inner space of being, into the creative ability of the mind, or negatively into the dormant potential of the alienated worker. Commodities form and determine the subject, so in capitalism the subject becomes itself a commodity. The process of such commodfication without the anecdotes of traditional narrative, not even as seen in Eisensetein's *Strike*, is the central focus of *Modelo*. Sfikas became the grand formalist master of experimental films and still remains, as Savvas Michail observed, 'the perennial revolution against all figurative illusions, against all affirmations of a condemned order of things'.[6]

Sfikas continued his anti-cinematic films, with *Metropoles/Metropoleis* (1974), *Allegory/Allegoria* (1985) and *The Prophetic Bird of Paul Klee's Melancholias/To Profitiko Pouli ton Thlipseon tou Paul Klee* (1995) amongst others, until his death in 2009. He paved the way for other important experimental filmmakers such as Thanasis Rentzis, Maria Gavala, Stella Theodoraki, Demos Theos and, more recently, Vassilis Mazomenos – all these warrant discussion in their own right. From 1974 to this day, the tradition of experimental filmmakers renews cinematic language by revising the ability of images to signify reality, reassembling the codes of visual perception and rethinking the role of the cinematic experience; we cannot understand contemporary Greek cinema without the silent influence of such underground movements that fight constantly, and without any compromise, against what Vassilis Mazomenos has called 'the dictatorship of realism'.[7]

This is the context for the works of Angelidi: beyond her studies with Christian Metz in post-1968 Paris, her work bears a very strong connection to cinematic life in Greece and is in a constant dialogue with global traditions and experiences. Her work is the embodiment of the openness of Greek cinema, of its polymorphous, multifocal character, absorbing elements from a range of genres, artistic regions and visual languages. Her films are about the transition from the baroque to expressionism: in their filmic time, they bridge five centuries of sensibilities and styles and establish connections with a belligerent modernism that transforms realism into a heresy of imagination.

Her films are intense visual experiences, in stylised geometric frames, full of energy (especially when they depict stillness) and of sculptural immobility (particularly when they record dynamic movement). Her films are pictorial

**195**

psychodramas, in which roles are reversed, expectations are frustrated and colours radiate with psychological associations, open to many interpretations and projections. They are all works of reversal and confrontation, made through a relocation of perspective, to the reverse gaze of feminine presence as it looks back and reclaims space and time that have been taken over and obscured.

Furthermore, her work raises the curtain on the ignored contribution of women filmmakers in Greece. They have been totally forgotten or looked upon with derision or – and this is sometimes even worse – with 'sympathy' and 'understanding'. In one of his least discerning reviews, Vasilis Rafailides aptly contextualised Angelidi's work:

> Angelidi's commitment to her distinct perception of cinematic aesthetics is rather admirable; it is however an aesthetic which belongs less to cinema and more to fine arts. With an almost pretentious contempt towards all forms of commercial success, Angelidi and Costas Sfikas are the only Greek filmmakers who stubbornly avoid any acceptance of both the classical Aristotelian rules of narration ... and the distantiation rules of the Brechtian narrative, which has defined narrative modernism ...[8]

Rafailides rightly points out Angelidi's affinity to fine arts and the unique idiom she devised in order not to succumb to mannerism: her distinct scenes could have been large panels or murals on the walls of cathedrals and prehistoric caves. They have a unique monumentality, being made by a carefully crafted arrangement of objects in confined and sometimes limited spaces. Despite the objectivity and the absence of performable storyline, the human figure plays a central role in the structure of the image. Indeed what makes her filmic texts significant is the enhanced materiality of space, form and movement: clothes, objects, words, colours, sounds all stress the material gravity of images. This also stresses a particular perception of the real: it depicts the gravitas of beings, therefore accepting the realities they create. Jacques Rancière observed that 'cinema is an art of the sensible. Not simply of the visible.'[9] Angelidi uses the visible realm in order to reconstruct frozen expressive sensibilities; her films rekindle the affective character of the image and make the viewers see what their eyes cannot perceive without the mediation of conventions. In such 'denaturalising of conventions' she detects the most significant consequence of the cinematic art as 'a general method of [the] transforming of subconscious qualities into conscious ones'.[10]

In order to enhance such effects, the illusionism of forms is replaced by Brechtian technique with a very strong theatricality. Her actors are aware of the presence of the camera; they actually talk to the viewer through the camera and

the camera is the viewer. This is the way Angelidi uses the formalist device of *ostranenie*, defamiliarisation or estrangement. Most avant-garde films, such as those by Gregory Markopoulos, for example, or even those by Stan Brakhage, do not focus on the performative function of the story. Angelidi over-theatricalises performance in order to stress a different order of experience and to 'deautomatise consciousness and counteract alienation'.[11] According to Angelidi, defamiliarisation is the dominant principle of twentieth-century art, as it 'gathers' in the structure of the image 'the method through which the ego allies itself to the death drive, wanting to overcome the libido and thus inaugurate the process of sublimation'.[12] Angelidi links the principle of formalism or neoformalism with the Freudian psychological interpretation of artistic creativity in order to renew the codes of visual imagination.

It is the breadth of her vision and the amplitude of her expressiveness that make her films transcend photographic stillness and fossilised artificiality. Angelidi animates her *tableaux vivants* through stylised movement, laconic soliloquies and poetic dialogues, in ways that not only bring them to life but also make them cinematic material *par excellence*. The central theme of her work is the process of constructing images; her cinema is the ultimate model of 'structural filmmaking', which maintains absolute minimalism in terms of what is necessary for a scene to be self-sufficient. She works like a mosaic maker, piecing together forms, colours and frames; it is the cumulative power of them all that creates an indelible impression of awe and wonder. She can do this because she is in control of the material and is not overpowered by the complexity of the materials' history. Indeed, history exists in her films as a verbal superstructure: through the words of poets such as Dante, Sophocles and the poets of the Bible and of Byzantine hymnography. Her *The Hours* (1995) and *Thief or Reality* (2001) are replete with such texts but they are always used in subversive ways. A man is Antigone, without losing his masculinity, a paedophile recites Leonardo without ever losing his dignity, a young girl is violated without ever losing her innocence. Images are mostly used in an adversarial manner: her first film, *Idees Fixes/Dies Irae* (1977), ends with a homage to Jacques-Louis David's painting *The Death of Marat* (1793), the first depiction of modernist politics in Europe, but her Marat is a woman, trying to escape or confront the coming assassins – to no avail. The film ends and we must imagine what happened to her.

Angelidi writes her own scripts, which are based on strict formalist structures and expectations: a student of Christian Metz's semiotics, she knows how to weave together psychoanalytic discourses and semiotic sequentiality, avoiding the dominant mimetic perception of narrative and representation. Following Metz,

she knows that 'the secret of film is that it is able to leave a high degree of reality in its images, which are nevertheless still perceived as images'.[13] The filmic text is constructed by self-conscious images because it is an intentional artefact: the specific configuration of signs questions the essential meaning of those signs. As Peter Wollen observed:

> a text is a material object whose significance is determined not by a code external to it, mechanically, nor organically as a symbolic whole, but through its own interrogation of its code. It is only though such an interrogation, through such an interior dialogue between signal and code, that a text can produce spaces within meaning, within the otherwise rigid straitjacket of the message, to produce a meaning of a new kind, generated within the text itself.[14]

The filmic *Topos* is precisely the space from which such semantic disruption emerges: new meaning is a disruption of old codes – most specifically the fall of existing codifications. Angelidi knows how to destroy the codes that made her own work possible. In her 'Self-presentation' she stated:

> from my dark body, as I stand framing or being diffused in the dark theatre, I see codified images in all the ways that I can see, together with a piece of nature, if I succeed in escaping the codification that has happened within that nature and which now resides in my head. With violence and the fear of aestheticism. Puncture. Architecture as *mise-en-scène*. I was pregnant when I saw *La Region Centrale* by Michael Snow. What Pleasure. All artistic problems together with temporality. Alterations and not relocation.[15]

The brief text articulates her project:

> female orgasm is enigmatic and has been dealt [with] through unsurpassable symmetries and dichotomies. So feminine script analogically to the other orgasm, which is plural and not symmetrical, does not aspire in replacing one domination with another … The corporealisation of meanings is violent, it is feminine if you want. And then. Alien myths about our own body, colonies in our collective unconscious. The task to rework everything, to alter the myths.[16]

Her project is analogous to Michael Snow's attempt to establish cosmic relations between space and time: she wants to dive into the collective unconscious and reconfigure the patterns of expression that have represented the actual reality of being a woman.

## The Feminine Gaze

In this sense, her cinema is materialist cinema because it is created out of the emotional tension that develops between what is represented, its indexical meanings and the various forms of its representation; here the filmmaker stresses its arbitrary, fluid and culturally determined meaning. Consequently, she foregrounds the gravity of each component, avoiding the temptation to use images as metaphors. It is the material fields of each scene that frame an objective reference and an almost haptic reality for the image: the vibrant colours invite the viewer to enter the visual field and be absorbed by the ecstatic sublimation of radiating forms. As Rafailides pointed out, Angelidi does belong to the fine arts – but more precisely, I must add, she is *coming out* of the fine arts. Her scenes recreate retrospectively the birth of cinema, from the early explorations of perspective by the Renaissance masters to the contemporary destruction of all perspective by Jean-Luc Godard. From the avant-garde she borrows the foregrounding of vivid imagination; from Theo Angelopoulos the self-sufficiency of colours; from the French nouvelle vogue the mixing of modernist elements with silent era techniques. Furthermore, she is in a constant dialogue with Andrei Tarkovksy's metaphysical realism and its Byzantine two-dimensionality as well as with Peter Greenaway's chromatocentric fantasies and their Baroque origins. In between them she meets Sergei Parajanov and the dazzling luminosity of his earthy colours. Her films constitute *topoi* of convergence, between similar and disparate cinematic and non-cinematic elements, all of which coexist in an uneasy way, offering her images intense energy and pulsating volume.

A simple exploration of her films shows that they are anti-illusionistic, anti-mimetic and anti-realistic visual structures. Angelidi is aware of the *gestalt* formations that make all images meaningful if they generate references to other forms and schemata. With her, the naive perception of realism as reference to something out there is ruthlessly discarded:

> I claim that, in contrast to the illusion created about it by Griffith, cinema's original is the dream and not reality. We never perceive reality as if it was cinema. The world is not pre-codified. The world is not staged. This illusion was created by mentally unwell people, and that's what I explored in my latest film *Thief or Reality*, from the point of view of an actor.[17]

Because of the unnatural codes of so-called realistic cinema, the filmmaker can only give her dreams, nightmares and visions. She is not going to deceive anyone but she wants to make a point, and a political statement. In an interview she said:

> There is a moment in my film with the representation of David's *Death of Marat*, in which I myself impersonate the Marat on the painting, in the bath. The painting itself expresses an impasse of the revolutionary individual: that impasse is the painting itself by David, the fact that David made this painting and not the fact that it shows the death of Marat. Myself, by representing a representation of a certain revolution, I believe that I subvert the logic from within which this presentation was made. By placing myself within all these, I become one of the constituent elements of the film. I undergo, like them, reversals and self-criticisms. When the person who writes occupies a place in the film, at a certain moment, this person is turned upside down and becomes self-ironic. And this is a political act.[18]

Towards this end, her images are not imitating reality, history or everyday life. She knows that imitation, the Aristotelian mimesis, means distortion and that the real can only be semiotically captured: by juxtaposing codes of representation, reality emerges in a process of intuitive reconstruction of various experiences, moments of being and split seconds of lucid human *presencing*, in the Heideggerian sense. (See Figure 6.2.) Each separate code has its own truth, but it is partial and in fragments. If the filmmaker succeeds in 'fulfilling her desire to express her own dream', then:

> the spectator can recognise her own dream or her own nightmare in the work itself. When the creation of an alien soul can disturb your own soul then it causes the *methectic* function of the work of art. It is the rarest miracle to accept from the external world your own inner images. The experience is unique. The momentary rupture of solitude.[19]

The problem of codes is crucial for an appreciation of her work. Angelidi desires to make films that come out of her life as a woman. She doesn't have a code of reference or of meaning that can guide her to make films expressing the feminine experience other than the revered and sacred codes concocted by men. She desires to construct codes for gyno-poetics that will not resemble the fetishised rules of traditional Aristotelian poetics focused around the passions of 'great men'. In an interview about her most recent installation artwork, which incorporates cinematic images, she stated:

> The projected work constantly differentiates itself. The dialogue between films – between space and spectator – constantly mutates. There is no Ariadne's thread, a singular narrative line, but constantly

Figure 6.1: Antouanetta Angelidi, *Idées Fixes/Dies Irae* (1977). The female Mara and her death.

mutating narrative lines, which are produced in a process of randomness. One could say that the form of the work reflects the complicated and constantly mutating dialogue embodied by the work itself.[20]

She thus desires a new meta-language for the cinematic language itself – a language that won't pretend to be eternal and objective but, as she stresses in the same interview, will be based on the very synthesis that every human encapsulates – 'a personal, peculiar and specific synthesis: a combination of gender, age, religion and social class'.[21] Her most recent work is called *Sewing without Threads*, a metaphor that, in the lexicon of the writer Mary Daly – a lexicon based on what women do and how women are – means 'spinning, world-making, Gyn/Ecological creation; Dis-covering the lost thread of connectedness within the cosmos'.[22]

By desiring such rich, complex and experiential language, Angelidi also attempts the Herculean task of beheading the idols of the tribe. As already mentioned, mimesis, according to her, is associated with androcentrism, with the centuries-long centrality of masculine signifiers in the creative reproduction of

form, feminine or masculine. As Savvas Michail, a 'visionary' interpreter of her work, observed, her films are focused around 'criticism and the struggle to transcend the deception of mimetic representation', as 'the functions of mimesis are confirming androcentric domination, which Angelidi's cinema rejects without any compromise through the poetic power of her cinematic iconography'.[23] Michail points out that in order to refute the established codes of thinking both verbally and cinematically from within the paradigm of androcentric mimetic codes of representation, Angelidi's films have as their central architectural principle the Freudian concept of the uncanny; he concludes his extraordinary essay on her work by stating:

> The *Unheimlich* from the return of the repressed desire and the *Unheimlich* with the return from the archaic to the modern constitute the *Grundproblem* in the daring cinematic modernism of Angelidi.[24]

Beyond anything else, and despite the lack of narrative development, characters and storyline, her films maintain a thread of thematic unity and plot continuity which give them emotional intensity and structural circularity precisely because of the presence of the uncanny in their images. Viewers feel and understand that something is happening; the happening itself, the event of visual epiphany, becomes itself the epicentre of her films. As long as the framework of reference is established, the signifiers return: language guides the mind to attune itself to the post-linguistic situations their eyes witness. Her pictorialist cinema is a confronting experience for viewers who have been habituated to some form of explicit or implicit storyline: her visual idiolect combines pictoriality with the free play of interchangeable signifiers. There is no linear unfolding, or even circular unfolding, but something is moving – and the phenomenological impact of the cinematic event itself is enough to seduce the eye and bring the viewer deeper into the movie. The cinema thus maintains its mystique, while only the cinematographer knows its secret language.

Angelidi created a cinematic style that, since its inception, has wanted to assassinate the androcentric aesthetics of presentation, storytelling and *mise-en-scène*. In a way, Angelidi is the Artemisia Gentileschi of modern cinema. Like Artemisia's paintings, her films pulsate with the density of basic colours, and construct an architectural space of structural and chromatic dynamism. Like her, Angelidi must work hard to prove the innocence of women: in an androcentric universe, all women, especially artists, are guilty for undermining the symbolic foundations of male domination, and chargeable for self-victimisation. In either case they are

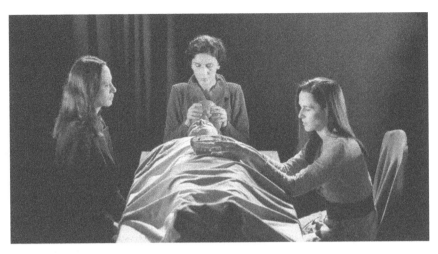

Figure 6.2: Antouanetta Angelidi, *Thief or Reality* (2001). The female Holy Trinity.

always on the wrong side of things. Like Artemisia's raped and tortured body, the great code of meaning is female corporeality from birth to death. The female body is the ultimate god of history: it gives life, it is the *urgrund* of fecundity and deathlessness. Male artists brutally sexualise the female body – naked or clothed. Angelidi simply brings out the fragility and vulnerability of its presence; she also adds, like Artemisia:

> [a] disturbing psychological content, [which] uses representation to confirm an ideology of dominance over powerlessness, in which woman's voluptuous body is affirmed as an object of exchange between men.[25]

However, the creative process itself, the act of reinventing the codes, is an act of empowerment: the artist is not the transcendental signifier we encounter in Angelopoulos' *Ulysses' Gaze*, or the archetypal male trickster Zorba, or the symbolic traumatised everyday male in Koundouros' oblique films, but a specific woman, a given subjectivity who is the synthesis of gender, class, culture and religion, and who suggests as the ultimate lexicon of meaning her corporeal presence, the body that gives birth, unearthing forms from other forms.

But it is a tortured body, mutilated and misperceived, distorted under so many centuries of inauthentic perceptions and representations. (See Figure 6.2.) In a strange way, Angelidi's visual incursions violate the sanctity of masculine historical primacy, and undermine the dominant perception of the male as the sole protagonist of history. However, they also rewrite memory, through images that emanate

from a different centre of power: they replace the phallus with the vagina, reconciling history with the beginnings of life, the physical principle of natality. If male thinkers such as Martin Heidegger are talking about mortality and finitude, female thinkers such as Hannah Arendt think of *creatio continua* and natality, exploring the interminable expansion of space and existence. Angelidi's films are about the infinity of space as a constant birth, as new forms coming into the light of being. What we see in the light is equally important: in Angelopoulos' *Reconstruction* a woman kills her husband, as also occurs in Cacoyannis' *Electra*, but Angelidi's films are about 'gynocidal re-enactments'. By using a woman to usurp Marat's position, Angelidi recognises:

> [the] multiple manifestations of the lethal *intent* of patriarchy ... This knowing requires acknowledging the interconnectedness of the ritual atrocities, refusing the compartmentalising of facts into stale and irrelevant 'bodies of knowledge' and thereby finding the focus of her anger, so that it fuels it and no longer blocks her passion and her creativity.[26]

In a sense, with the exception of her first film, her films are like medieval illustrated manuscripts: rewritten and repainted, they frame a space of hyper-visuality, punctured by voices, sounds and apparitions. They frame *l'hazard* as the first condition for the freeing of feminine imagination from her own inferiorisation; objects, words and (predominantly) colours celebrate their own contingency, the randomness of their presence. In contrast to the male need for deterministic explanations and causal serialisations of action and thought, Angelidi foregrounds the unpredictability of new forms, which also means the emergence of new mental atmospheres. In exactly the way that a mother gives birth to the unconditionality of a new being, so also does artistic freedom, which discards storyline, continuity and seriality.

As Maya Deren, the pioneer visual poet, admonished the filmmaker:

> artistic freedom means that the amateur filmmaker is never forced to sacrifice visual drama and beauty to a stream of words ... to the relentless activity and explanations of a plot ... nor is the amateur production expected to return profit on a huge investment by holding the attention of a massive and motley audience for 90 minutes ... Instead of trying to invent a plot that moves, use the movement of wind, or water, children, people, elevators, balls, etc. as a poem might celebrate these. And use your freedom to experiment with visual ideas; your mistakes will not get you fired.[27]

Angelidi's frames jump from a music pattern to a non-visual rhythmic empti-
ness, from stylised movement to verses from tragedy, from a monochrome blue
to stark juxtapositions of ecstatic polychromy. In one of her most significant
aesthetic statements, after having explored the feeling of cinematic time, she
concluded:

> There are films which, through complex tropes of temporality, cre-
> ate a fertile uncertainty, an oscillation between identification and
> defamiliarisation, between the known and the unknowable. Films
> which ask for an emancipated spectator, predisposed to think and
> feel, working through his/her own self – a spectator who can be
> either critical or enchanted. These are films of formal autonomy,
> since the potentialities of cinematic heterogeneity have been only
> partially explored. Because the complex contemporary psychical
> world deserves to be the model for all cinematic compositions.
> Because cinema can open a break so that the unsayable can be
> articulated.[28]

## Films as eschatological monuments: the omega point of being

> For me, large dimensions signify a return to childhood. I wanted to
> create a space so that adults can find themselves again in the time
> and space of their childhood.
>
> <div align="right">Antoinetta Angelidi[29]</div>

Angelidi's first film completed a process of osmosis between images and spatial-
ity: it explored the fused world of the feminine body, or the feminised male, pre-
senting a gendered view of experience and politics. *Idées Fixes/Dies Irae* framed
the unpredictable simultaneity of memory: everything coexists in the unconscious
because everything has a second life. As we saw, she calls her cinema poetic, in
the sense that it is a self-reflective cinematic act, because it thinks through its own
construction, language and semiotics. In reality, it is a cinema that reflects on the
end, the *telos*, of cinematic activity. Therefore, it could be more aptly called escha-
tological cinema, as it envisages the endpoint of experienced realities, and visual-
ises a space for the omega point of being.

Especially in the trilogy that followed her first film, Angelidi falls into the
baroque world of bright basic colours, depthless spaces and the spiral temporali-
ties that dominate the subconscious matrix of memories. The memories them-
selves spring up like religious epiphanies that disrupt the numinous blackness at

the *urgrund* of being: instead of experiencing an artificial certainty about existence, which the Aristotelian unities have imposed upon the creative imaginary of the Western world at least, Angelidi explores a more Platonic understanding of the origins of the creative impulse. As I have also noted in relation to Koundouros' later films, Angelidi's depiction of memory is analogous to Plato's wax tablet from *Theaetetus*.[30] But here the confused and superimposed imprints are not examined for their referential accuracy or political value; they become *ur-bilden*, primary images, which reveal and unveil the significance of the feminine as the demiurgic principle. Reflecting on the creative process she writes:

> I begin a film after being absorbed by a temporal scheme which condenses images around me. The beginning is always a formal trap – a matrix. A MATRIX. An idea that you can touch. It happens momentarily. Suddenly. Afterwards, throughout the long trajectory of the realisation of the film, I find again the crystallisation of the original conception. And while the immutable series of condensed temporalities, which in the end is the film, takes its definite form only with its end, the film itself opens up every full moment. It is dissolved and reconstructed continuously.[31]

After her first film, which is in reality a political manifesto, her trilogy seems to work though the originary experience which, since Otto Rank, we call 'the trauma of birth': this is another kind of traumatic experience, beyond the cultural and historical traumas of the past that had seized the creative imaginary of the previous generation. The trauma now is ontological and refers to the fallen state of having being expelled from the only paradise humans will ever know, the paradise of the maternal womb. The state of being born, the fundamental event of natality, makes history possible: we simply replicate the exit from the womb by experiencing the existential essence of colours. Angelidi's trilogy is about the dazzling spectacle of life as seen by a newly born infant. There is an interesting testimony about this by Salvador Dali, the paradoxical surrealist of colour and form. Describing his own antenatal experience, he wrote in his autobiography:

> The colours of my intra-uterine paradise were hellish – red, orange, yellow, and bluish, the colours of flames of fire; above all it was warm, motionless, soft, symmetrical, padded and sticky. I already felt that all pleasure and all enchantment lay there before my eyes ...[32]

This is what we experience as we enter Angelidi's visual universe: from the very beginning she offers a chromatic immersion that, as a profound religious epiphany, forces the viewer to start rethinking the significance of each shot; if there is

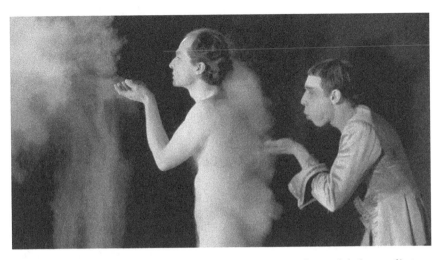

Figure 6.3: Antouanetta Angelidi, *Thief or Reality* (2001). The dust and darkness of being.

a latent plot in her films, it has to be that of the Byzantine liturgy. Furthermore, if in Angelopoulos and Koundouros we find the gradual emergence into the world of colours followed by a period of impressionistic surprise (for the former) and expressionistic frenzy (for the latter), Angelidi's images are from the very beginning steeped in their natural habitat of colours. They are conceived first as chromatic entities. Colour is not an external element on their surface; it radiates from within, it is the expression of their essential being-ness. The first shot in *Topos* is about birth and the theme of birth is expressed through the colours blue, red, green and brown, which are the colours of the earth, indicating perpetual fecundity and vital energy. Eisenstein, in his *Ivan Terrible Part II* (1958), talks about the connection between the scenes in the film and 'the polyphonic montage in colour'.[33] Angelidi uses colour antiphonally, to frame states of mind and bring the audience within the scene itself: the viewer must respond, as the film targets their own personal space. She makes use of the Byzantine inverse perspective as seen from within a Renaissance and Baroque visual expressionism, rather like Tarkovsky and Angelopoulos. Yet warm colours alternate with each other, forming the architectural and the perspectival depth in each image.

They are all framing the verticality of the human figure as they reconfigure the horizontality of the human gaze. Angelidi's frames utilise the fullness of human forms to create awe of the human presence. (See Figure 6.3.) In an extremely prescient analysis, Eleni Mahaira stressed the fact that, in a break with a traditional sense of perspective, Angelidi 'causes a confusion of perspectival axes to the point

that depth becomes height, the depth of perspective becomes ... the upper part of the cinematic image.[34] Such paradoxical fusion privileges the image itself as the *topos* where the dialectical antinomies are reconciled: the code is identical with the coded and their union establishes the strength of the visual impression. Jean-Luc Godard stated the analogous mode of presenting colour in his *Pierrot Le Fou* (1965), the paradigmatic example of a pictorial, almost pop-art employment of colours:

> when you drive in Paris at night, what do you see? Red, green, yellow lights. I wanted to show these elements but without the necessity of placing them as they are in reality. Rather as they remain in memory – splashes of red and green, flashes of yellow passing by. I wanted to recreate a sensation through the elements that constitute it.[35]

Martin Scorsese, in *Taxi Driver* (1976), also depicts the urban experience of New York through the melting colours of the city on the glass of the taxi; the film's expressionism is enhanced by the striking artificiality of its spaces.

Angelidi's chromo-poetics are based precisely on such recreation and re-enactment of the sensations experienced through direct exposure to the fluid luminosity of colours, to what Derek Jarman called 'kaleidoscopic iridescence'.[36] In Greek cinema, her work bears a resemblance to Nikos Nikolaidis' *The Wretches Are Still Singing/Ta Kourelia Tragoudane Akoma* (1978) and *Sweet Bunch/Ylikia Simoria* (1983), in both of which 'the storyline[s] [are] driven by their own vibrant and basic colours'.[37] The strong basic colours, emblematically expressed through the scarlet curtain of divine epiphany, show that Angelidi's artistic project uses the representational codes of form, composition and *mise-en-scène* formed gradually through the centuries, at the same time rewriting the language of representation itself. In dialogue, also with the experiments of the period, her *Topos* is a strong response to Angelopoulos' impressionism, as seen in *Landscape in the Mist* (1988). On the other hand, the baroque sensibility towards bright and vibrant colours seems to animate her first film: like Artemisia, 'her mastery and originality is best seen in her application of colour itself, the enormous range of saturation and intensity that she was able to manipulate'.[38]

With her next film, *The Hours/I Ores* (1995), the infant girl of the first film has grown up, or lives suspended between adulthood and childhood memories. The movie has the subtitle 'A Square Film' – action is framed through multiple narrative lines, all converging or diverging within each frame. This film does not have the architectural solidity of the previous one. However, it incorporates

images of fluidity, constant movement and fast pacing so that the unity of *Topos* is here expressed through the heterogeneity of the actual material on each frame. The stillness and stylisation of *Topos* have been replaced by emotional reactions, empathic mechanisms of identification, even little stories of shared affect. Maria Katsounakis sensitively reviewed the film:

> The primary material of *The Hours* is dreams. The secondary is silence, the 'lush, secret silence'. The third is time: in the beginning it is associative, then fluid, and finally redeeming. The film dares the descent, the 'rhythmical' immersion in places of secret desires and tormenting guilt, successfully. The development of Spendo (the name of the central female character refers to offering, the offering of her life) moves from violent dependence, during her childhood, from the traumatic memories, to the light, and in the end to the final acceptance of her own personal gaze.[39]

Each scene is also immersed in the colours of the Flemish school of painting: there are strong visual contrasts, magnified objects, empty spaces filled with elliptical forms. The film unfolds the traumatic childhood, the confused adolescence and the enraged youth of a woman, but in a way that constructs a metaphor about a feminine revisualisation of the development of history. This prismatic narrative opens up the form to multiple readings as Angelidi struggles to liberate the screen from the ideological inscriptions of the film industry. Instead of creating a melodramatic saga of individual self-assertion and emancipation, she explores the deepest ontological conditions that lead to a life of trauma and self-alienation – that is to say, the mysterious drama that we all find in the colour black. Blackness is the ultimate protagonist in this film.

The heterogeneous narrative creates a dual effect: there are both the Aristotelian empathic identification with the characters and the defamiliarising effect of the Russian formalists. The film itself becomes a contested frame of colliding signifiers. It frames an experience of the deepest possible realism, as it is now focused on objects, clothes, intimate spaces, the world of objecthood that circumscribes the individual and at the same time infuses the personal space of each life with meaning.

In a very strange way, in Angelidi's totally surreal, indeed metaphysical, art we find the question of realism solved. If naive realism was predicated on clear and total knowledge of what stands in front of the viewer, the presence of the object itself transforms it through the contact with our eyes into an unstable and unredeemed relationship. This is the abolition of solitude that Angelidi spoke about – but it can be also seen from another angle. Painter Lucien Freud observed that 'nothing ever

Figure 6.4: Antouanetta Angelidi, *Topos* (1985). The other forms within the forms.

stands in for anything ... Nobody is representing anything. Everything is autobiographical, and everything is a portrait, even if it's a chair.'[40] The heterogeneity of spatial forms frames the psychic origins of what we see on the screen: these are not the 'found moments' or the 'observed facts' we saw in Cacoyannis. On the contrary, each shot pulsates with the psychological energy of unresolved, indeed irredeemable, tension. The film ends with the naked couple at the dark night of the soul, not at the paradise of Judeo-Christian bliss. Sex is violence and aggression, the ultimate proof of the post-lapsarian reality in which women were the first victims and presumed guilty partners. The representation of sexuality in this film is indicative of what is called 'second-wave feminism', in which the act of penetration is itself a violation of the corporeal space of the woman. The self-sufficient visual language of *The Hours* overthrows the phallocentric nature of language itself: it castrates the signifying practices of the phallocracy and destroys the mental structures of a sexist universe.

The final film of the trilogy, *Thief or Reality* (2001), brings Angelidi's aesthetic and existential project to a completely new level of articulation. Now the narrative has multiplied and become more complex in its ability to reinterpret the feminine world. Angelidi indicates that the narrative has a 'fractal structure' and is a 'meta-linguistic game of self-awareness'. Stories emerge from within stories, as the film starts with a game of gambling and ends with the ritual procession of tragedy. (See Figure 6.4.) A voice repeats in crucial moments the strange ungrammatical

# The Feminine Gaze

sentence: 'Everything I spent, I had. Everything I kept, I lost. Everything I gave, I still have.' In an interview with Maria Katsounakis, Angelidi described the underlying chromatic 'emplotment':

> The first part, albeit brief, muted, de-colourised, uses everything, lighting, arrangement, as references to silent cinema, especially, Dreyer's *Vampyr*. The second is blue, since the option of contingency, entails in itself a certain coldness ... The third part, of the actor, is in full colour, natural. It begins with theatre, as the protagonist rehearses Sophocles' *Antigone*. Mortality is the element that unifies all subjects.[41]

The film rewrites Western civilisation not by being a revisionist reinterpretation of historical events, but by rewriting everything through alternative scripts: Antigone is a man, the Matthew Gospel is about a woman, the men who were the protagonists in the contests of politics and culture are replaced by women, women offer new beginnings, new openings to the closed horizons of masculine narcissistic indulgence. Together with such re-genderisations, colours underscore the filmic text with methods of inclusion and exclusion: they bring in or keep out the viewer. In this film Angelidi perfected the chromatic experimentations that we saw in Aneglopoulos' films and multiplied the signifying semiotics of the cinematic image to such a dense and revealing degree that it seems that she brought her own style to its ultimate realisation.

Angelidi's images cannibalise the visual testimonies of male violence: from Alessandro Mantegna's frantic angular forms and Goya's horrifying *Capricios* (1979/8) to Dreyer's *Vampyr* (1932) and Bergman's *The Seventh Seal* (1957). The feminine reasserts its primacy; it shows up the parasitic and necrophilic characters of patriarchy as the constant usurper of the genuine timelessness of femininity and its ability to give birth. The film rewrites the history of cinema, from the silent period to the contemporary. As Vassilis Mazomenos wrote:

> In essence the film completes the triptych of life. But you have to read it in the reverse. The '*It is Accomplished*' of the beginning raises the dramatic curtain. The desire for life sets the curtain on fire and the whole game is completed. It is related to Bergman's *Persona*, in which we can see condensed the philosophical and artistic perception of the director ... A polyphonic art-work from the future of the seventh art.[42]

The film consummates Angelidi's eschatological vision, reconfiguring patterns of representation that have shaped worldviews and images about world building.

It constructs a language that translates lived experience into musical patterns expressed through colours. Every shot is for her the omega point of creation: the continuing creation of human works not on a pre-ordained divine plan but through self-reflexivity and self-invention, constant self-fashioning. The most interesting element of her great trilogy is what also differentiates her from Angelopoulos: in her universe there are no artificial borders that divide us from them and indicate friendly from enemy territory. Borders, which so fascinated Angelopoulos and Koundouros, evoke war, violence and death. Angelidi's visual universe is made of basic colours, archetypal shapes and primary elements. As Mary Daly said, borders 'celebrate the pseudo-creative power of boundary violation' that is 'clearly an invasion of women's bodies/spirits and of all our kind: earth, air, fire, water'.[43] The borderless territories of her images illustrate the different anthropogeography of her visual space. It is not that of nihilism and death but of a beginning that is not:

> the beginning of something but of somebody, who is a beginner himself. With the creation of man, the principle of beginning came into the world itself, which, of course, is only another way of saying that the principle of freedom was created when man was created and not before.[44]

The actualised ontology of natality makes Angelidi's films central to understanding the eschatology of being: her end becomes a beginning, and the *eschaton* is transformed into an *arche*. The omega point is an *arche* – the cinema of Angelidi constructs the visual space of an *arche-graphia*, as the constant birth of unpredictable ontological promises.

## The final lexicon

> Traumas are not the only sources.
>
> Antoinetta Angelidi[45]

Angelidi's films are about the glorification of the senses – both of the body and of the cinema. They celebrate what the senses can do and what the cinema can produce. Like most avant-garde films, they explore the limits of representation and the limitations of what can be visualised; not all aspects of lived experience can enter the visual space of representation, although the structures of the mind are the organising principles of their images. Angelidi's visual essays struggle to

liberate films from the many ideological scripts that transform them into escapist exercises, and at the same time aim to dehabituate the viewer from the accepted patterns of mythopoeic imagination. Her task is what Scott McDonald has indicated is that of all global avant-garde filmmakers:

> to focus attention – an almost meditative level of attention – on subject matter normally ignored or marginalised by mass-entertainment film, and, by doing so, to reinvigorate our reverence for the visual world around us, and develop our patience for experiencing it fully.[46]

There are two distinct periods in her development. The first film is something of its own, a unique experiment with space and time, that rearranged the signs used to construct a film and the meaning which we attributed to the specific configuration of these signs. In the second period we see her major trilogy, in which the film itself becomes the integrated symbol of a novel language of visual representation, which is gendered, politically conscious and archetypally centred. The geometry of her visual spaces grapples with the underlying structures that give unity to the world of change and fluidity: under the Heracletian fire of her images the immutable shapes of the Platonic demiurge stand firm. The brilliant multicoloured surfaces of her Orphic hymns are kept together by invisible Pythagorean harmonics. Her installation works incorporate excerpts from her films and thus introduce another factor in the production of cinematic experience: filmic space becomes an actual part of the experience itself. Cinematic space, however, is always about rhythmic patterns in the movement of images, sounds, words and cuts. Angelidi works with the interplay of such cinematic 'imagemes'. The result is that 'the space out of the screen becomes space within the screen. Absence becomes presence. The film artifice can be continued. The narrative is secure and the spectator is comfortably reinscribed within the filmic discourse.'[47] Such *Gesumtkunstwerk* is made up of contrasting features harmonised through the semiotic references to their own construction.

Erwin Panofsky wrote the following memorable passage about cinema:

> It might be said that a film, called into being by a cooperative effort in which all contributions have the same degree of permanence, is the nearest modern equivalent of a medieval cathedral; the role of the producer corresponding, more or less, to that of the bishop or the archbishop; that of the director to that of the architect in chief; that of the scenario writers to that of the scholastic advisers establishing the iconographic program and that of the actors, cameramen, cutters, sound men, makeup men and the diverse technicians

> to those whose work provided the physical entity of the finished product ...[48]

There is no other accurate description of Angelidi's work but that of medieval cathedral – the fact that it is made of renaissance materials and uses post-modern design expresses the paradox of all avant-garde artistic inventiveness.

# 7

# Greek Cinema in the Age of the Spectacle

## Politics without representations

> We believe we know that in Greece history and democracy entered
> the world at the same time. We can prove that their disappearances
> have also been simultaneous.
>
> Guy Debord[1]

After the Athens 2004 Olympics, everybody in Greece was euphoric: at many
levels the country had won its gamble with the intricacies and the technicalities
of such a huge event, with its global appeal. The opening ceremony of the 2004
Olympics by the dramaturge Dimitris Papaioannou, itself a masterpiece of artistic
ingenuity and sophistication, presented a conservative historicist vision of the past
in a colourful grandiloquent style. Its sanitised rhetorical structures indicated a
strange regression towards strategies of signification that many thought obsolete.
The whole spectacle exuded an atmosphere of romantic exoticism by depicting
historical experience in a series of abstracted *tableaux-vivants* of glittering surfaces
and minimal content. It articulated a political statement expressing the anxieties
and the phobias of the ruling elite while declaring its uncontested hegemony *urbi
et orbi*. It presented a de-politicised narrative about the historical continuity of 'the
Nation' from antiquity to this day. As Dimitris Plantzos pointed out, it presented:

> the Hellenic identity overall, through a rehearsal of Greek history
> based on tangible archaeological evidence and its aesthetic appeal
> and, moreover, [was] a reaffirmation of this culture's connection –
> past, present, eternal – with the land.[2]

Such naive and self-contradictory representation created an idyllic image of the
state of affairs in the country: despite the looming social crisis, the influx of an
enormous number of refugees and the rapid rise of racist xenophobic extremism,

Greece looked like a dream world, advertised appropriately by the National Tourist Organisation with the slogan 'Live your Myth in Greece'. The triumph of popular culture was sealed in the same year, when the country won the European soccer cup, and a year later, the Eurovision Song Contest. These were indeed two or three years of jubilation and frenzy. The whole society, mobilised by the injection of external funds, felt confident and ecstatic. All these triumphs were televised, and were experienced as grand images in which the central protagonist was *The People* (*o laos*) as an abstract, classless and apolitical mass.

It was an 'integrated spectacle' in the way that Guy Debord defined it: 'the combined effect of five principal features: incessant technological renewal; integration of state and economy; generalised secrecy; unanswerable lies; an eternal present'.[3] The spectacle permeated the cultural imaginary and created a society that made its own self a spectacle to be commodified, consumed and celebrated. In other words, during these years the gradual dehistoricisation of the social and the political in Greek culture started happening, expressed through a cultural narcissism focused around symbols of power, status and wealth, which in turn were hiding rigid political hierarchies, the absence of social projects and the lack of political transparency. In a paradoxical way, as Debord had observed, such spectacular domination was creating 'limitless artificiality'[4] as the dominant discourse in public debates, and so was leading to the 'falsification of social life': the body politic was fantasising about endless affluence, political relevance and social stability. Debord aptly diagnosed this: 'the spectacle is not a collection of images but a social relation among people, mediated by images'.[5] Soon, the reaction to such extreme artificiality would become the focal story in Greek cinema.

During this period of reckless borrowed affluence, the number of films multiplied: the Greek Film Centre, under more flexible sponsorship strategies and funding models, invested considerable amounts of money in the making and promotion of films on the way to the 2004 Olympics (although effective international distribution remained a serious problem for Greek films). Almost 30 feature films were made in 2000 and that number remained steady annually until 2009. Some of them were lavish international co-productions, such as Pantelis Voulgaris' *Brides/Nifes* (2004), Tassos Boulmetis' *A Touch of Spice/Politiki Kouzina* (2004) and, through the participation of the national Broadcasting Corporation, ERT, Theo Angelopoulos' *The Weeping Meadow* (2004). More than anything else, with these films, the growing transnational and transcultural trends in recent production became obvious. In most of them, action takes place in different countries, many languages are used and actors and technical personnel from different backgrounds are recruited. Furthermore, through their distribution and the

international festival circuit, these films redefine perceptions about 'national' film culture as they become part of what Dina Iordanova called the 'dynamic process that transcends national borders, reflecting the mobility of human existence in the global age'.[6]

The Greek Film Centre was, if not the single most important, certainly one of the most important financial contributors to the majority of films during this period, having introduced a policy of co-sponsorship in the early 1990s. However, very few films were truly independent productions. That was to change only after 2006/7, when even fewer could attract funds from the European Union or other international producers. Few filmmakers – they included Theo Angelopoulos, Pantelis Voulgaris, Yannis Smaragdis and Tassos Boulmetis – succeeded in securing funds from outside the country. Also, in the late 1990s cinema multiplexes such as Village Cinemas became actively involved in the production, promotion and distribution of films, with significant success, as in the case of Boulmetis, Smaragdis and more recently Christoforos Papakaliatos' *What If/An* (2012), while Yorgos Lanthimos' films almost exclusively relied on international funds.

Domestically, the new millennium started with good omens for Greek cinema: the revival of comedies, some of them of very good quality and exceptional sense of humour, rekindled hopes that people would leave their sofas, from which they had been watching sitcoms and reality shows on television, and go back to the cinema. Indeed *Safe Sex* (2000), *The Silicon Tears/To Klama Vyike ap' ton Paradeiso* (2001), *Loafing and Camouflage: Sirens in the Aegean/Loufa kai parallagi: Sireines sto Eyaio* (2005), *Honey and Pig/Loukoumades me Meli* (2005), *The Straight Story* (2007), *First Time Godfather/Proti Fora Nonos* (2007), *Strictly Appropriate/Afstiros Katallinon* (2008), *Island/Nisos* (2009) and *I Love Karditsa* (2010), amongst others, were considerable commercial successes and did bring audiences back to cinemas. Most of the comedies were characterised by a good sense of narrative rhythm and a plausible storyline, and could effectively parody the mores of the affluent petit bourgeoisie, its rustic origins, its hidden conservativism and its disguised anti-modernism; their sense of humour, however, mostly employed parochial stereotypes and nauseating clichés about women, gays and immigrants.

The best amongst them established a novel and totally unexpected hyper-realistic mode of inducing comic relief, on some occasions by taking serious risks with the medium, its narrative potential and its narrative complexity. Formally, most of these comedies employed techniques from television, with condensed, loud and swift – almost video-clip – aesthetics. (Most of the young filmmakers were actually producers or directors of video clips or commercials for

big companies.) However, their verbal humour was usually crass and unsophisticated, although in certain cases, as in *Safe Sex* and *Strictly Appropriate*, a distinct cinematic style, reminiscent of the fragmented and messy narratives in Robert Altman's *Short Cuts* (1993), was struggling to be born. Although the experimentation with visual temporality and spatial synchronicity is worth noting, their form was not always cohesive, as they remained 15-minute episodes from a missing television serial stitched together almost at random.

Many serious art-house films were made, but they were ruthlessly – and on most occasions unfairly – reviewed by critics. Their slow pace and suggestive mood were perceived as annoying parochialisms and smug relics of the past, but they still won a large share of the funds and so imposed all those things on the younger audience – who, of course, completely ignored them. Angelopoulos, despite his personal exasperation at the commercial failure of his films, was elevated to the status of a 'national and cultural icon', beyond criticism or questioning. His high status in the later years of his life is one of the most interesting cultural improbabilities and deserves further study.

However, in the euphoria and optimism that dominated Greek social life before and after the Olympics, Angelopoulos' films could not find their place. Society was going through a major transition from the monoculture of the previous century to the polyculture of the new millennium. The fall of Communism and the influx of refugees from the Balkan and Eastern European countries created serious disequilibrium in the social and political self-perception of Greeks. The rise of ultra-nationalism and the growing visibility of many extreme right-wing social groups polarised the body politic and made the political establishment and its institutions much more conscious of the limits of their control over society. The spending spree (with borrowed money) that ensued was a clever strategy of the power elites to extend their control over society by deflecting attention from the emerging crisis to the 'eternal present' of a perpetual 'success story'. Despite its global exposure, Greece was becoming a closed and navel-gazing society, unable to situate itself in the international arena and follow the global realignments of power; the insignificance of a political culture without projects and perspectives was soon to become obvious, and to find its most unfamiliar representation.

Social dissatisfaction and unrest were still simmering long after the Olympics and exploded with disastrous consequences in December 2008 when huge riots swept the capital and paralysed all social activity. They were, at least in the beginning, a response to the unjustifiable death by shooting of a young man by an idle policeman in the centre of Athens. The government, unable to solve the crisis,

reacted in the way that all Greek governments had reacted until then: by offering more hand-outs, financial inducements or tax exemptions to everybody, and by appointing its political class as tenured public servants. The external debt of the country reached an incredible 115 per cent of the gross national product, which meant that by 2008 the country was about to default.

When the global economic meltdown erupted later that year, the government was so unprepared and society so stunned that a major social and civil implosion took place. It has not yet ended. The years after 2009 could aptly be called the Years of the Great Devastation, as the economy and the whole system of civic, political and cultural values that had legitimised the regime all collapsed. The cultural imaginary struggled to depict not only the effects of such implosion but also the processes that made it possible. In hindsight one can locate a number of films that had started mapping out the coming devastation long before the Olympics. A close study of them shows that a severe critique, albeit fragmentary and somehow dislocated, had started emerging by the end of the previous decade. The rise of what was to be called the 'Weird Wave' goes back to this period; it is not a product of the economic crisis.

Comedies were at the forefront of such critique: Panos Koutras' *The Attack of the Giant Moussaka* (1999) and *True Life/Alithini Zoi* (2004), behind their queer gaze on the psychodynamics of sexual repression, denounced and ridiculed the triptych 'fatherland-religion-family' that had dominated the political discourse for over 60 years. The central thrust of the social critique on screen was not simply the traumas of history from the Asia Minor Catastrophe onwards, but the ideological structures, legitimising discourses and normalising practices at the very foundations of the Greek state. The subversive character of these films, produced during the most affluent and conformist period in Greek history, showedt Kotras, with his sexual outlaw gaze, foregrounding unfamiliar stories, hidden episodes and undesirable adventures, all of them going to the heart of the Greek question.

In these films, music and image followed each other, creating a dense form which, under its humour, 'dragged its viewers into a paradoxically beautiful universe and revealed to them a hidden image of their own world',[7] as Koutras explained. In the era of the 'integrated spectacle', Koutras tried to subvert the images of the spectacle by inflating them, exaggerating their significance and finally presenting their hallucinogenic and illusory nature. The attack of the 'giant moussaka' was an attack on the fantasies, delusions and obsessions of a political order and a social structure that had squandered all future-oriented projects. Koutras stated:

> I believe that the Greece of 'fatherland-religion-family' has already collapsed. But there are many who out of interest, for power or money, struggle to keep it alive by all means. By not allowing people and ideas to take a strong position and change things, they create confusion and deadlocks. Greece of the previous century has no place in the new millennium and in the European West.[8]

Previous films, by Pantelis Voulgaris for example, had focused on a cautious and romanticised critique of recent history, but now many filmmakers started devisualising the political order itself, even rendering invisible the realm of the political as the space of rational and purposeful collective action. The depoliticisation of the public sphere became the most important characteristic of all production after 2008, when disillusion and frustration became the motivating forces, shaking the foundations of a social structure disintegrating towards anarchy. In a strange way the political order vanished from all artistic appropriation; together with its vanishing, the regimes that consecrated its practices were also lost. The political background of a country in crisis indeed became only a background, usually seen through television news and the spectacular reality shows offered by commercial channels. The politics of spin and spectacle that had dominated the previous decade became the nightmares, illusions and follies of a country that was about to experience its most profound crisis since the Civil War of 1947–9.

The looming crisis was also a crisis in visual representation, in the reception of such representation and in the understanding of cinematic production. Viewers watched the events on their television as they were sitting comfortably in their living rooms. They were either dreaming of a revolution that was to happen for them but without them, or they totally rejected the social upheaval as an irrational eruption of nihilistic boredom. News bulletins were interrupted every 15 minutes for commercial advertising so nobody was able to form an opinion about what was happening or to interpret it. Most directors made ample use of these sorts of TV 'snapshots' and of the cropping practices used in videocassettes or DVDs as devices to frame the 'virtual reality' of such events. The vast and depthless shots of Angelopoulos' films were replaced by self-referential episodes that, despite their specificity and crispness, seem to occlude and deflect. This new form of representation can be called episodic realism because of its constant attempt to particularise action at the expense of context: it fragments space and foregrounds individual pieces without ever constructing a landscape. Furthermore, instead of exploring modern realities or the diversity of experiences, it focuses on a detail and a side event, on a

*paraleipomenon*, and from that overlooked and disregarded incident only fleetingly and somehow reluctantly turns its gaze back to the grand narrative, or the totalising form.

This new form of visual architecture and viewing experience accounts for the disconnected and antilinear narrative construction of films such as Syllas Tzoumerkas' *Homeland/Hora Proeleusis* (2010), Sotiris Goritsas' *Raised from its Bones/Ap' Ta Kokkala Bgalmeni* (2011) and Yannis Economides' *The Knifer/Maherovgaltis* (2010). It also accounts for the techno music dominating new films as they attempt to reproduce the alertness and urgency that dominate the soundscapes of everyday experience, especially in the city of Athens during its state of implosion. The soundtrack of most films seems like a musical elaboration and amplification of the police, fire engine and ambulance sirens continuously heard during the last few years of endless protests, clashes and property destruction around the capital.

Simultaneously, the political system and its personalities became spectacularly absent from any form of political critique and social dialogue. Most films made after 2009 seem to represent a society struggling to regain its balance, stability and self-perception. The so-called Weird Wave[9] that emerged after 2005 with Yorgos Lanthimos, Athina Tsangari, Yannis Economides and, more recently, Alexandros Avranas and Ektoras Lygizos, completed the process of deconstructing all codes of representation, significance and valuing that legitimised the dominant political order. The main institutions of Greek society, as well as religion, patriarchal family and the Greek language, are the central targets of the new realism of closed spaces that has emerged. Certainly, a diversity of cinematic languages is still operating effectively in the cultural industry: together with the comedies already mentioned, successful films of classical intense realism maintain the tradition of well-made films about contemporary issues. Yorgos Gikapeppas' *The City of Children/I Poli ton Paidion* (2011) is a drama structured around four parallel stories. It visualises the quest for *communitas* in a fragmented and dissociated everyday reality. 'Soft realism' movies also became successful: Nikos Koutelidakis' *Christmas Tango/To Tango ton Hristougennon* (2011) turns back with nostalgia to a completely different mode of being, when people were in control of their emotions even when they couldn't express them. Yogros Sougias' *Burning Heads/To Gala* (2011) explores the predicament of the immigrants from Tbilisi, Georgia, in Greece with the emotional intensity of classical filmmaking. The depiction of the imploding mental world of a young man follows the pattern of the social implosion around him: meaningless words and rituals that exacerbate the descent into chaos.

The cracks in the system of self-legitimising representations had started in the early years of the decade. Yannis Economides' *Matchbox/Spirtokouto* (2002) and *Soul Kicking/Psihi sto Stoma* (2005) inaugurated an aggressive and violent attack on language itself by employing the expressive qualities of obscene vocabulary to delineate the profound existential alienation imposed on just about everybody by the structure of the family. Economides' films, including his more recent *Knifer/Mahairovgaltis* (2010) and *Stratos/To Mikro Psari* (2014), employ a nearly documentary *cinema veritè* to explore the coldness, distance and automatism imposed by the closed spaces of family homes. What in the 1950s and 1960s looked like a promise of happiness – the acquisition of an 'apartment' – has now become the slaughterhouse of human affect, the desensitising machine of all meaningful human communication, the cradle of all neuroses. In Economides' gaze the most important element in filmic representation is neither what happens nor when it happens, but where it happens: it is a new discovery of closed spaces that matters, in contrast to Cacoyannis' exploration of open space in the 1950s. Furthermore, all codes, especially linguistic codes, the triumphant glory of an ancient language, have been debased in Economides' films and have been transformed into lethal weapons for personal and interpersonal mutilation. His mastery of camera movement – dizzying jump cuts and the use of diverse angles – make his films pioneering examples of a renewed cinematic self-awareness, with a novel use of montage and a challenging rediscovery of colour as ongoing commentary on action.

The films directed by Constantine Giannaris during the same decade also deserve special mention. Starting with his 1998 film *From the Edge of the City/Ap' tin Akri tis Polis*, Giannaris offered a new gaze on the social realities, looking at them from a certain ex-centric position. With his *A Day of August/Dekapentaugoustos* (2001), *Hostage/Omiros* (2004) and *Man at Sea/Anthropos stin Thalassa* (2011) he expanded his ex-centric position in order to explore xenophobia, sexual repression and conformism. There are many undercurrents in his films, dominated by exposure of the explicit homophobia that marginalises or destroys individuals who question its control mechanisms. Another subtext explores the victimisation of women and their subservient place in the mental landscapes of patriarchal structures. His cinematic technique is also subversive: psychedelic shots succeeded by illusionist close-ups, or long takes followed by fast jump cuts. In his films the televisual and the cinematic exist in a tense and antagonistic symbiosis.

Finally, in an anthropological sense, Giannaris struggles to visually articulate the implicit rituals that give meaning to contemporary life in the cities. The alternation between open and closed spaces frames *topoi* of convergence on which the

external and internal realities are reconciled. For Giannaris, these *topoi* are better expressed by the human body, male and female, in its absolute nudity, when its fragility, vulnerability and beauty reveal the *raison d'être* for the cinematic experience itself. His cinema of transgression is focused on the powerful libidinisation of the corporeal presence and its consequences for the 'normality' of the social structure. By presenting the male body in all its nudity, eroticism and vulnerability, he subverts the dominant mystique of masculine power abiding in the hidden god of Western metaphysics, the penis. By exposing the fragility of the male body, Giannaris challenged the patriarchal morality of the omnipotent phallus by presenting instead the image of a self-destructive instrument of domination. The male body in his films, and they are all about the male body, is the *topos* of social disunity. Instead of pleasure, it offers violence; instead of strength, it exhibits weakness; instead of stability, it causes confusion.

Through such disunity, Giannaris restores the political to the heart of an officially endorsed dehistoricisation of the country. He is one of the very few filmmakers who exposes the fantasies and the pretensions of the petit bourgeoisie, who have dominated cultural production in the country, and confronts society with images of its own structure. As he observed:

> Until recently, Greece, was referred to as the little Greece, as the petit bourgeois paradise, without the class distinctions of other Balkan countries. Finally, our differences from other societies were proven rather fragile. In two years it became clear how weak were the foundations of the last forty years.[10]

Giannaris suggests the re-pristinisation of the gaze, a re-enchantment of the ordinary experience and the common space with the human body as an aesthetic antidote to the dominant regimes of occlusion, frustration and angst.

## Politics of cynicism and the cinema of visual indeterminacy

> The images of the unconscious place a great responsibility upon a man. Failure to understand them, or a shirking of ethical responsibility, deprives him of his wholeness and imposes a painful fragmentariness on his life.
>
> Carl Gustav Jung[11]

Despite his deeply political critique, Giannaris has stated: 'I don't do politics: I only *do* films.'[12] Yet behind such a highly polemical statement one can clearly detect

films that frame the profound existential disenchantment and ideational implosion the filmmaker were witnessing around them. Their cameras do not simply frame a reality: they violently break throsugh the established discourses and dominant strategies of signification that made the previous reality look stable and secure. Giannaris' contextualisation of his *Man at Sea* (2011) points out the intricate web of events, practices and principles that led to a society with a struggling cultural imaginary:

> Greek society is blindly drifting between shock and awe. I am specifically interested in the creative investigation of the pleasure of violence amongst young people, as a political or non-political response to what is happening. We are entering a seductive nihilism and reversal of everything, which may lead us to dangerous paths. Greece is drifting between shock, awe and fear. We are witnessing the immense demise of an ostensibly secure middle class; security provided by an inept and corrupt system as an exchange for such corruption.[13]

In order to depict such 'pleasure of violence amongst young people,' Giannaris fuses documentary techniques with highly aestheticised representations – something between Gus van Sant, Mathieu Kassovitz and Derek Jarman – through an ingenious hybridisation of storytelling: the effective balance between narrative and pictoriality is probably the most interesting aspect of his cinematic project as it challenges the fantasies and anxieties of a social class that was confronted by its own demise at the moment when it was celebrating its apparent triumph.

Giannaris was the first amongst many other directors who confronted the integrated spectacle of the political order and its patriarchal ideology. Yannis Diamantopoulos' *True Blue/Galazio Forema* (2005) produced the most challenging indictment of the function of family in the country: it dealt with the family as represented not by the autocratic despotism of the father but by the sweet tyranny of maternal love. What in the period of classical Greek cinema was a refuge and 'the heart of the heartless world' became now a horrible nightmare of death and annihilation. The Oedipal triangle with the missing and unnameable father culminates in death: the son who has changed his gender stabs his mother in an attempt to resolve the crisis of meaning that his/her post-gendered own body represents.

The brightness of the Aegean polychromy and the euphoria of living in a constant rebellion against your body and your class are contrasted to the profound emotional blackmail and fundamental questioning of someone's self-definition. The most pernicious destabilisation of the main character's identity does not emanate from the impersonal structures of society: it comes from within, and

permeates all senses that his body expresses. Finally, it destroys him. Indeed it is the mother who becomes the instrument of revenge that the 'system' uses in order to annul individuation and self-realisation. She is the system. As Diamantopoulos himself stated:

> Yorgos' story is purely symbolic. It is about a man who struggles to gain his balance, the acceptance of society, and hold on to anything that could help him get along. Unfortunately he fails, and consequently every right to life is taken away from him. Rejection is obvious and everywhere. His family, which is a mirror to society, rejects him too. The family acts as conduit for their society, which has uniform rules and regulations, needs and demands. This is the only way that the system won't be destabilised.[14]

Giannaris' and Diamantopoulos' films articulate the imagery of vanishing beginnings, without any sense of nostalgia. Their films explore the explosive and destructive impact of liberated sexuality and articulate a discourse about sexual interactions, exposing their commodified, exploitative and violent character. Renos Haralambides' *The Heart of the Beast/I Kardia tou Ktinous* (2005), Laya Yiuryu's *Lioube/Lioumpe* (2005), Costas Zapas' *The Last Porn Movie* (2006) and Vardis Marinakis' *Black Field/Mauro Livadi* (2009), amongst others, present sex as an act of criminal collusion against the sinister presence of history and its grand protagonists. Starting with the Nikos Nikolaides' swan song *The Zero Years* (2005) – whose title seems to set the key and encapsulate the whole period – violent, dissociative and unorgasmic sex became the symbol of a desperate attempt at self-liberation through self-destruction. The nihilism of a society without self-transcending projects turned the feeling subject inwards into a claustrophobic and suicidal anti-world; everything in there was excessive yet hollow, big but illusory, confronting and yet totally artificial. Like the nightmarish films of Koundouros, namely *Bordello* (1984) and *The Photographers* (1998), the Platonic wax-tablet memory dominates the memories and confused fantasies of a mind that was unable to recognise its specific moment in history.

In Nikolaides' last film, the cynicism that took over the public sphere is internalised and personalised. By humiliating and torturing their costumers, the four female protagonists try to regain their space by struggling to give birth to a child; but they are sterile, and instead of birth they can create only death, or *la petite mort* of deferred orgasms. The Hieronymus Bosch-like allegorical landscapes of the film are more appropriate to attune spectators to the reality of their surrounding social and political encounters. Sterility is the presupposition for all efforts

for creativity: this debilitating paradox, framed in Nikolaides' baroque nightmare, made visual the conflict between society and the state in the body polity – a conflict which has neutralised every attempt to escape the confines of a hallucinogenic irrationalism.

Despite its cryptic language, this is a highly political film presenting the gradual phasing out of democratic openness and the consolidation of a social reality without imaginary openings. Film critic Alexis Dermentzoylou observed that '*The Zero Years* is a chronology of end times, of the end of all institutions. Everything had become an illusion, a utopia, a trap.'[15] The signs were all there, but they were too obvious to be noticed. It almost seemed that the camera was recording events even before they were happening, as it was experiencing an atmosphere of spectral realities, of hyper-real, self-referential events, of simulacra which, as Jean Baudrillard pointed out, are about absent originals and non-existent truths beyond themselves: 'The simulacrum is never that which conceals the truth – it is the truth which conceals that there is none. The simulacrum is true.'[16] The un-reality of truth became Nikolaides' main theme in his relentless and unforgiving exploration of the reality of fantasies.

In other films of the same period, from Nikos Grammatikos' *The King/O Vasilias* (2002) to Dimitris Koutsiabasakos' *The Guardian's Son/O Yios tou Filaka* (2006), one can also detect an escape from the great and glorified urban centres, especially Athens, to the great unknown and somehow hostile reality of rural Greece. In the age of classical cinema of the 1950s and 1960s, films presented a comic image or a caricature of the villager who moved to the big city to enjoy the comforts of modern life. The man of the village spoke in dialect that brought hilarity from the urbanites, while the girl was a naive virgin who could not resist the advances of a man in a suit in a big car. Despite their frivolity, they stood as living reminders of the essential and authentic Greek origins, unspoiled by the cunning of modernity and the urban hermeneutics of suspicion. But now, disenchantment with the urban reality, indeed with modernity and post-modernity, sent the characters back to the their parents' or grandparents' homes, where they unearthed the reasons for their departure: the memory of the civil war, an extra-marital affair, an illegal child, a murderous affair, a public disgracing for sexual promiscuity or the shaming of a homosexual son. The secrets are out and cannot help the recovering drug addict (*The King*) or the hopeful youth (*The Guardian's Son*) regain the paradise they hoped to find when they unlocked the door of the old ancestral home.

In the first decade of the twenty-first century, Greek cinema, even more than literature, which was predominantly driven by market demands for bestsellers with simple plotting and facile symbolism, depicted a deterritorialised, depersonalised and

depsychologised nihilistic continuum dominating public discourse about being and identity. With very few exceptions, in the work of the two grand masters of the 1970s, Angelopoulos and Voulgaris, a cinema of nostalgia for lost collectivities and a certain feeling of *communitas* were spectacularly absent. Angelopoulos' two films of the period were mournful dirges, elegies to a lost world of common ideals and shared existential adventures. In a period of generalised cynicism, even such past tragedies became symbols of hope and intimations of renewal. Voulgaris' revisiting of the past in his *Brides/Nifes* (2004) and *Deep Soul/Psihi Vathia* (2009) invests the disastrous past with empathy and compassion. Migrant women were sent as brides to the unknown through a painful journey of self-oblivion but there was hope that some of them would make it and realise their potential. In *Deep Soul* even the catastrophic Civil War becomes the symbol of the common destiny awaiting both Left and Right ideologues: in the end they are both destroyed. The feeling that communitarian sociability is a project for renewal permeates Voulgaris' high melodrama – a storyline he explored further in his 2013 *Little England/Mikra Anglia*, an imposing monument of artificiality, visual intensity and artistic self-consciousness.

## The cinema of transgression

> Bourgeois society is ruled by equivalence. It makes dissimilar things comparable by reducing them to abstract quantities.
> Max Horkheimer and Theodor Adorno[17]

Against this background, the so-called Weird Wave of Greek cinema emerged. The term is rather misleading: it would probably be better to call it the Cinema of Transgression, as all codes of representation, narrative strategies and signs of communication are problematised and become themselves the ultimate ends of the filmic experience. The real break came with Yorgos Lanthimos' *Kineta* (2005), when a new kind of representation was articulated, or struggled to be articulated. Lanthimos directed some of the funniest commercials of contemporary Greek television, and co-directed a hilarious comedy with Lakis Lazopoulos, *My Best Friend/O kaliteros Filos mou* (2001). His video clips of songs by famous pop stars are also worth mentioning, as they explain the allure of the fast jump cuts we see in his films. But *Kineta* gave a completely new orientation to his cinematography and paved the way for other directors to cut the umbilical cord to the grand masters of the past and instead parody and ridicule their style. His work demarcates a new patricide: through a hallucinogenic non-linear narrative, made by an

Figure 7.1: Yorgos Lanthimos, *Kineta* (2005). The lost geometry of grand narratives.

awkward movement of the camera, consciously artificial acting and deliberate gaps in the story, Lanthimos re-created a state of mind looking at the immense silence of lost collectivities through the discontinuities and the disruptions of current imploding experience.

In *Kineta* the visual field itself is dismantled relentlessly: the spectators are exposed to the holes and the gaps of dominant representations. The outer disunity is homologous to an inner chaos: the form relates to the internal structure of their being, and thus their visuality is constructed out of incongruous fragments and unrelated iconographies, replete, however, with cinematic recollections. The spectator is unable to make sense of such indeterminate collages of references and images. The great taboo of classical cinema, the solidity of reference to a given reality, is totally discarded: the film is about images colliding with other images, or indeed the memory of images with the memory of other images, and the director connects them as free-flowing signifiers through an intertextual game of frustrated identifications. Their connection is arbitrary and therefore unnecessitated: this is the most creative element in the visual language of Lanthimos.

In the film, realism clashes with hyper-realism in a conflict that manages to dismantle all the codes of filmic narrative we had seen in recent Greek cinema after Cacoyannis. Lanthimos was aware that he was taking a new approach to the cinematic experience: his implicit subtext in many scenes was Angelopoulos' *Reconstruction*, the film that inaugurated the New Greek Cinema movement in the

1970s. The brawls between a man and woman were not simple re-enactments of what happened; they are also narrated by a clinical voice that sounds as if it is reading a forensic report. The crime exists both in reality and in language, as action and verbalisation. (See Figure 7.1.) It was a total and transcendental crime, not a mere personal incident; it was also a cinematic event, indicating that Angelopoulos' filmic hegemony, which had assassinated previous film production, was now itself assassinated. The crime replicates itself through a series of cruel but necessary stylistic patricides.

In a strange way, *Kineta* is probably the most interesting film by Lanthimos to this day. Theodoris Koutsogiannopoulos observed that:

> at first level, one can accuse the film for the absence of plot and the non-existence of normal characters. However, having in mind the Asian and the Independent American Cinema, Lanthimos constructs something totally his own and is interested in atmosphere and situations as they result from stylistic conventions. Characters which are nameless and with fluid personality, like wallpaper in the old-fashioned hotel and the deserted landscape, spring out of nothing and impersonate roles with the persistence of a hypnotised individual who obeys internalised commands. Lanthimos insists on his image by repeating it constantly: he imposes it as an addiction in order to make it into pattern.[18]

Lanthimos himself said that in his film 'all elements are realistic yet the end result does not seem realistic', although 'at the moment you film reality it is transformed into something else'.[19] Maria Katsounakis described it as:

> [a] film which oscillates between artistic extremism and narrative indeterminacy. A hand-made film without decorations. Without make-up, with natural light, and with spaces and people without any ornamentation … a narrative experiment reflecting on its own birth.[20]

Without pity, the camera decentres the dominant fantasies of a whole generation, indeed of a whole political order, by depicting the destructive entropy of all petit bourgeois certainties. This film was the first of a cinema of transgression that was gradually developing during this period of artificial affluence. It was primarily a visual transgression that frustrated all expectations about what cinema should do: still parallel to the practices of the Danish cinematic movement Dogma 95 but also beyond them, as it also involved language in the project of shocking viewers and delegitimising its use in the understanding of reality. With this film, the

factuality of events gave way to the facticity of their interpretation: the technologies of representation simply imploded. Lanthimos relativised the visual languages that both representationalism and presentationalism had invented in order to depict the fluidities and the ambiguities in the world of post-modern subjects, an era of diminished expectations and minimal hopes.

In this sense, Lanthimos posited a question that had seemed forgotten or overlooked during the previous 20 years: the question of cinematic form as a specific encoding of reality. The violence, meaninglessness and nothingness were not simply conditions out there but modes of representation and modalities of being within us: they are fragmented only because the viewers' mind is also fragmented. In order to visually represent the 'nihilistic continuum' of the context, Lanthimos did not fall into the easy sensationalisation offered by a gripping story or the political dramas of Hollywood realism. On the contrary, he revisited the potential of formal representation and redesigned, as it were, the limits of form, by privileging plot over story, gesture over drama and silence over dialogue. The film tried to separate its spectators from its story: the camera of Thimios Bakatakis moved erratically, avoided action, cropped out bodies and looked elsewhere, as if it was the reluctant bystander to a series of accidents loosely connected to each other. Lanthimos employed a number of acting techniques – Brechtian and post-Brechtian – to force his viewers to de-internalise all the hegemonic discourses that had shaped their outlook and defined their expectations of movies. His melange of techniques also presented other possibilities of perception and interpretation. The film ends abruptly, with an eerie expectation that a catharsis might be given – but it is not. The end credits give some kind of solution to the drama.

With this film Lanthimos re-radicalised *mise-en-scène* in a post-Godardian manner and ascribed new political significance to the anti-aesthetics of a visual culture that could not be legitimised by the dominant discourses of power. Antonioni's touch, as well as that of Robert Bresson's final films, especially *L'Argent* (1983), can be felt in the film. The link with the past is maintained through the sentimental songs of the 1960s and 1970s, which are heard against the background of loneliness or the explicit exploitation of sex workers. The implied tragic tension is diffused and spread everywhere: the film is not destined to offer a substitute for this tragedy but to indicate that we are all involved in committing acts of cruelty and dehumanisation. The vulgarity of the petite bourgeoisie is seen through the obsession of a policeman with expensive cars: they represent the ultimate triumph of his banality over the lavish crudeness of his office. One could claim that this film closed the cycle of optical experiments which had started

with Angelopoulos in 1970, and began a new and transgressive approach to film narrative – conscious of its limitations but totally unafraid to take new risks and frame new territories.

His real cinematic explosion, however, came with his next film, *Dogtooth/Kinodontas* (2009). The film gained wide international recognition with its bizarre dialogue, unnatural setting and self-conscious acting. However, it is less radical and less subtle than *Kineta*; its success can be attributed to its self-referentiality and the absence of any cultural markers, despite some critics claiming that it was an ingenious and depoliticised remake of the Mexican filmmaker Arturo Ripstein's *The Castle of Purity* (1973). Yet despite its similarities, especially in depicting 'the father's desperate attempt to stem the tide of the crisis and maintain his dominance regardless of the changing ideological times',[21] Lanthimos' film is a post-political message, a cry of despair from the children against the ubiquitous oppression, extended now to the natural universe as well as to the central apparatus of personality building, language itself. Lanthimos' most recent film, *Alps/Alpeis* (2012), continues the same quirky decentring of narrative, plot and *mise-en-scène*, but it is so self-conscious that the film presents itself as an image of its own images. Lanthimos says that the film 'in its essence is not about death and loss … but about the people who accept the role of the deceased [and] make a pact with the family and enter their life'.[22] Yet the dead person cannot be replaced and history is repeated as a farce again, because the idea that history can be suspended or changed is one of the follies and the delusions of a culture without self-reflection. Consequently, one can see his films as elaborate farces, because of their deliberate absurdity, improbable plots and stylised presentations. All this is somehow closer to theatre than to cinema.

Lanthimos' style is further elaborated by his associate, Athina Rachel Tsangari, whose first film, *Attenberg* (2012), drew considerable international attention. Finally, in Alexandros Avranas' *Miss Violence* (2013) the nightmare narrative takes the whole transgressive cinema movement in a new direction, closer to a new kind of realism, exploring not the open space of an urban reality but the domestic confined *topos* of the petit-bourgeois sacrosanctum, the family home. Guy Lodge observed that:

> Avranas' film employs an irony-free meter that certainly distinguishes his work from that of Lanthimos or Athina Rachel Tsangari, and lends the film's most explicitly severe sequences of domestic and sexual abuse a kind of cumulative numbing power. Any intended social allegory may be less apparent to audiences than if the proceedings tilted into outright absurdism.[23]

Static camera, slow movement, minimal montage and editing make this film a particular expression of realism as it is focused around the unreality and the artificiality of a semiotic world dissociated from its pragmatic references. This confronting and unfriendly style also found an interesting revision with Ektoras Lygizos' *Boy Eating the Bird's Food/To Agori troei ta Fagito toy Pouliou* (2013), a film that, through the festival circuit, gained considerable international recognition. The style of representation is framed by extreme anti-naturalism and Bressonian focusing on 'insignificant details'.[24] An admirer of Bresson's minimalistic style, Lygizos states that 'cinema interests me only as construction. I use pure fragments from reality but then strip them bare in order to develop something more than their pragmatic significance'.[25] Lygizos uses the aesthetics of transgressive cinema to take a new direction towards self-conscious constructivism without, however, losing the urgency of a political statement; a hungry man at the centre of modern affluence, maniacally performed by Yannis Papadopoulos, is a 'metaphor about how we can feed our soul', as Lygizos points out.[26]

Other films, such as Yorgos Gikapeppas' *The City of Children/I Poli ton Paidion* (2011) and Argyris Papadimitropoulos and Jan Vogel's *Wasted Youth* (2011) explore new representations formed during the years of trouble after 2007. The new generation becomes the main focus of the camera: as the family structure correlates to both the social structure and to the realities of the young, the films are veritable psychiatric diagnoses. The atmosphere of psychopathology that has formed mental realities and infused visual representations is depicted through the aesthetics of excess and hyperbole. Social malaise is inflated so that it looks like a condition of being: the ontology of disconnected asynchronicities becomes the central underpinning principle of such visual investigations. No felt temporality links the parallel lives of people without a sense of orientation. Living in an eternal now, they torment themselves with dreams of future projects which they are unable to conceive; their frustrated desires and unresolved Oedipal conflicts are depicted as altered states of being, when humans define themselves in conditions of heteronomy and subalternity.

In a scene in *Wasted Youth* when the young couple try to engage in amorous embrace, the girl says: 'We must wait, we have all the time ahead of us.' 'No,' replies the young boy. 'There is no time left. Twenty-twelve is the year of our death. There is no time. A planet falls on the earth and destroys everything.' Unfortunately, such an apocalyptic end is not given to any of them. Only a bullet from a frustrated, frightened and anxious policeman, whose existence is equally absurd and lost, brings an end to the life of people without qualities. The ontology of alienation is

the central framing quality of being in history. Their 'meaningless' meta-language is the greatest proof of their heteronomy: they borrow their expressions from television news and reality shows. They have no feelings to express because they have lost the ability to be creative with language: they cannot individuate anything. The heteronomous subjects turn against each other. They mirror their own facelessness and thus turn against all those who reflect the absurdity they experience.

The slow passage of time in these new films has nothing to do with the elongated psychological temporality we see in the movies of Bresson, Antonioni, Angelopoulos or Tarkovksy. The camera follows action – and, particularly, the naked or semi-naked body – with cold detachment and painful frigidity. Each scene is more like a moving snapshot, closer to a video clip, enveloped by loud music and minimalistic *mise-en-scène*. Despite a very strong sense of place, one can immediately see that they depict a mediated sense of being: people now see their own reality through their television sets, computers or iPhones. This reframed reality is the refraction of another refraction: what we see on screen is the displaced double image whose verisimilitude we cannot judge. Contemporary filmmakers try to compile a new visual language to represent this most ominous and sinister reality; it is given by a very common metaphor in the political parlance of the day, based on a cryptic film by Ingmar Bergman. They want to depict what comes out of a serpent's egg: the horror of banality and the dread of evil nothingness. With these films, the Greek cultural imaginary enters the twenty-first century as a novice in nihilism.

The director who more than any other expresses this disturbing frisson of nihilism is Costas Zapas. Beyond Nikolaides' graceful corporeality, Giannaris' homosexual salvific grace and Lanthimos' prophetic irrationalism, Zapas stands against family, nationality, society and identity, not cryptically or metaphorically but with violence, intolerance and brutality. In a neo-Freudian way, he juxtaposes culture with the chaos of instincts as manipulated by the neoliberal state, giving birth to the inner fascist beast, which devours the ability of humans to relate. His films come out of an atmosphere analogous to the one that produced Derek Jarman's *The Last of England* (1987): they show a landscape of devastation, blasphemy and betrayal. As the destruction of the social fabric of England by the neoliberal policies of Margaret Thatcher created a state of exemption, a siege mentality that suffocated the cultural imaginary and forced it to depict its own excremental filth and cannibalistic voraciousness, the same state confronts contemporary Greek cultural imaginary in Zapas' films. The delegitimisation of power has imposed a state of prolonged anomie and lawlessness, not simply in terms of external patterns of

interaction but also as internal modes of being. His films express a visceral denunciation of contemporary Greek reality.

Zapas was born in 1969 in Athens and grew up during a period of high hopes and great disenchantment. His maturity coincided with the demise of all political projects caused by the rise and fall of the Socialist Party. During the same period he experienced a society without a positive image of itself, as the political reality was always dominated by corruption, inertia and introspection. His first film was *Uncut Family* (2004), as the first part of the 'Family Trilogy', followed by *The Last Porn Film* (2006) and *Minor Freedoms/Mikres Eleutheries* (2008). In 2011, he released his provocative *The Rebellion of Red Maria/I Antarsia tis Kokinis Marias*, a film that expresses the 'times we live [in], times in which psychoses prevail', as is mentioned in the brief note on the films by the director. Talking about this film Zapas stated:

> We live in a time of instincts as culture never prevailed ... The Greeks have never been able to face the truth about themselves. We are a servile nation, a nation which looks only very low. And looking low means that you don't move forward. We are a closed society, not an international country.[27]

Zapas' films are about the demise of a whole cultural worldview. They are about the demise of his 'beloved' Greece, as it relives a new trauma and thus resuscitates many old ones. The director struggles to save what can be saved from his old feelings of love and dedication. In an interview with Spanish newspaper *O Globo* he announced the making of his new film *Frankenstein; or the Odyssey of Death*. He said:

> Greece is today the Frankenstein of Europe. My country has been submitted to all kinds of economic experiments. What happens today with them, it has already happened in many countries of Latin America in the recent past; but what is rare, however, is that an economic disaster of such magnitude has happened at the heart of Western civilisation. The new leaders of Europe bite the hand that fed them intellectually. They violate the moral law. And as ancient tragedy has taught us, the violation of moral laws leads to tragedy. You cannot restructure a nation without offering a salvation; the result will only be a catastrophe. And from the ruins a monster will rise. Remembering Mary Shelley, who is more monstrous: the creature or the people who created it?[28]

The 'Family Trilogy' is a violent response to Angelopoulos' incomplete trilogy of time. Despite his high modernism, Angelopoulos was, deep down, a romantic

and an idealist: he thought that human beings are good or that they can have a dream of goodness, despite their own choices and their own collective history, which was chaos and disorder. Zapas and his generation have no such illusions: they experience a tragic universe without catharsis. The evil of history resides in their very existence: their own soul is evil and therefore their own polis is the abode of evil. Instead of depicting the traumas of the past, Zapas' films plunge into the belly of the beast, into the institution that caused the most severe and permanent destruction to the mind and the sensibility of its society. The power of the state does not appear as an invisible institution and mechanism of collective control: it is at the ultimate space of intimacy and affection, the family home. The family is the enemy of the community, of culture, of individuality. Not the external enemy, the alien other, but the internal other, the dominator, the overlord, the master. (See Figure 7.2.) In his *The Last Porn Movie*, the parents both manipulate their child; their horrible psychological rape of the child becomes an allegory of the structure and the function of power in the country. Family is also the focus of the second film, *Uncut Family*, in which the theme of incest reverses the civilising process of the taboo and throws the human soul back to its primitive brutality.

The third film in the trilogy, *Minor Freedoms*, is probably the most accomplished and the most harrowing of all. The father kills the mother and forces both his daughter and son into prostitution; they both try to fight back but the last word belongs to the king; the order of the father prevails. Zapas stated:

> *Minor Freedoms* is different from the previous films because the earlier works were a mixture of symbolism and realism; *Minor Freedoms* is 'pure realism'. It represents my total turn towards realism ... It is a film about Greece and the holy trinity that has imprisoned this place for so long, and continues to imprison it – motherland-religion-family.[29]

Zapas turns to 'pure realism' as the only mode to present the existential anomie and personal delegitimisation that permeate the creative imaginary in our time (and not only in his native land). In the first film of the trilogy one of the characters says: 'Anyone with a camera can shoot a porn film. We only need to invent a story.' In *Minor Freedoms* the tragedy imposed by a master-father on his own offspring is framed by an Aristotelian understanding of storyline, minimal editing and nonexistent montage, as the plot unfolds in utter simplicity and architectonic austerity. Stylistically, it is almost *cinema vérité*, a running commentary on the hidden truths of contemporary Greek reality.

# Realism in Greek Cinema

Figure 7.2: Costas Zappas, *Uncut Family* (2004). The triangulation of lost connections.

In a sense this film is a miniature version of Angelopoulos' *The Travelling Players*, minus the political drama and the transtemporal scale: the political element lies in the depiction of the master/slave dialectic that permeates Greek society – and generally the neoliberal order of things. For Zapas, 'the artist's task is to make visible the invisible and transform everyday reality into an epic'. In the small scale of his minimalistic film, Zapas addresses the dialectic that has invisibly dominated the formation of all relations in Greek society without ever talking about it directly. The master/slave dialectic has imposed its own classifications in the cultural imaginary of the society, but in moments of crisis, as Alexandre Kojève has so succinctly analysed, the fear of not being recognised, which has created such oppressive relationships, is lost and the slaves understand the social conditioning of their enslavement. So the slave 'can change and he actually changes, thanks to his work'.[30] By changing, the slave confronts his or her own interiority, the ideas, discourses and practices that have formed his or her existence – but the work of the slave is to be a good slave, to conform to his or her position.

Thus the rebellion is not simply against the state and its apparatuses but against the last myth of its oppressive mechanisms, the fixed and essential self, the national

236

psyche, the ethnos and all the essentialised icons of the nation. It is only then that the film acquires its tragic foundations, since the enemy is not simply the master outside, but the self that internalised its own enslavement. In that sense his films are extremely political manifestos, exposing the meltdown of society and its strategies of social control. In a strange way, this family trilogy continues Angelopoulos' *The Hunters'* brutal demystification of power, but now it doesn't blame the Americans or the British, and doesn't have any optimistic hopes about the Communist revolution. Now the enemy is the self, the father, the mother, the basis of social existence, the tragic institution of family; but the family is also religion, nationhood and politics. Zapas' cinema of transgression confronts head-on all such comforting grand narratives and exposes their consequences. His 'pure realism' is indeed the most interesting development in representing reality, 'stripping naked a society in decomposition [and] exploding all its prejudices', as is mentioned in the section of the Thessaloniki Film festival dedicated to his work in 2011.

Most Greek films produced today are either independent (Zapas works with Lars von Trier's Zentropa) or international productions. This gives them the incredible privilege of proceeding with their radical critique of state power and the structures that traumatised the body politic without ever offering the opportunity to experience mourning and proceed with rituals of catharsis. Most of the films consciously denounce popular success, which by definition would undermine their transgressive aesthetics, and insist on remaining successful in 'niche markets', letting the audience search for them mostly in festivals. In the past, official Greek censorship imposed strict limitations on what could be presented on screen and continuously suppressed the representation of recent historical experience; after the 1980s, the state bureaucracy imposed the self-justifying fantasy of left-wing martyrdom, managing to dehistoricise reality and thus manipulate cultural memory.

Today cinema roams free, borderless and fearless, able to confront the idols of the tribe, the addictions of a consumer society and the pretensions of a complacent middle class. In a sense, it brings marginalised discourses back to life through new underground cinematic forms. However, the experimentation is now happening in the writing of the script and the acting, instead of in the technological innovations of the camera. Instead of being a weird wave, or the new current, it is probably a pure cinema of transgression, as it is based on totally independent means and dissociates itself from any state support or connection with mainstream studios and their distribution networks.

As the Greek state – the ultimate big brother and the transcendental father – has faltered and lost all its legitimacy, so Greek cinema liberates itself from the false

hopes with which left-wing ideology has infected it for so long. Contemporary films boldly expose the symbolic universe of state domination. It is no longer disguised by the sweet tyranny of grand narratives or the heroic mythology of the left-wing ideologues. The whole imploded structure of the state lies naked in front of the viewers – without the opium of the past or the perverse sublimating rituals of religion. In a strangely prescient text written in the Greek Diaspora in 1978 by the political philosopher Nikos Poulantzas, a number of questions were posited that are, paradoxically, pertinent to the current crisis as well:

> It is known that economic crises ... do not necessarily bring about a crisis of the state. If so, does this crisis occur in all capitalist states and with equal sharpness? What role does it play in the reorganisation of state machinery? What is the exact nature of crisis? Is it a crisis leading to the disruption and weakening of the state, or one giving rise to a further crisis foreshadowing the strengthening and modernisation of the state? Do the weakening and replacement of the present state constitute two alternatives, or are they rather a dual contradictory tendency characteristic of the state today?[31]

Giannaris, Koutras, Lanthimos, Tsangari and Zapas dismantle the aesthetics of an official culture that has been addicted to the virtual realities of the spectacular through mental manipulation and bad faith, and they portray a society in search of new anti-mythologies about itself. From the ontology of the master/slave, they move towards an unsettling understanding of historical experience based on the moral choices that individuals dare to make or not make in their life. They depict a culture of historical decline in a society without democracy, so they explore the internalised fascism that the simulacra and the spectacles of contemporary hyper-medialised reality have manufactured in order to maximise the monopolistic power of the invisible oligarchic elites in the era of late corporate capitalism. They don't pretend to be outside such reality: on the contrary, they express its central codes of self-representation and debunk them from within. The subjectivity of their characters is expressed through their very *unfreedom* as the politicised rebellious citizen of the 1970s has now become either a follower or a tyrannical master. They depict a cultural paradigm in implosion and in conflict with itself. It will take time, of course, for this demythologising imagery to become palatable to modern spectators. At the moment, their films are mostly screened across the international festival circuit as Greek audiences prefer the safety of Hollywood blockbusters or the reassurance of banal Greek comedies. It remains to be seen what will emerge after the process of creative destruction is completed.

In a sense these directors' realism, which is so awkward, destabilising and surreal, serves as a reminder of how Georg Lukacs understood filmmaking: 'If film as a work of art succeeds in making people reflect seriously about a past or present situation and confront it with their own situation, then its goals have been achieved.'[32] In the post-modern society of useless comforts and substitute pleasures, Lukacs' 'seriously' means uncomfortably: he means to take audiences out of their comfort zone and confront them with their own failures and not with their subliminal or idealised selves. Their films develop a cinematic space between what Angelopoulos called 'memory and non-memory'[33] in which the screen becomes the contested opening for conflicting ontologies and episte-mologies, between remembering and forgetting, being and nothingness. They are all searching of a form, a new *mise-en-scène* that will epitomise the state of existential anomie dominating their realities. As all institutions have imploded and all forms of ideological power have been delegitimised, the morphoplastic imaginary becomes active again and searches for the potentialities of new formal schematisations.

On the other hand, a strong sense of commitment and social engagement permeates the films of these otherwise disenchanted filmmakers. The negativity of their images constitutes a profound positive testimony about the function of cinema in contemporary societies, especially in conditions of prolonged crisis when the certainties of the past have to be radically problematised and the aspi-rations for the future have to be reimagined. Their realism is both therapeutic and lethal; it confirms R. G. Collingwood's conclusion that: 'Art is the com-munity's medicine for the worst disease of the mind, the corruption of con-sciousness.'[34] Through the unnerving images of Lanthimos, Koutras, Zapas and Tsangari, a new awareness of the cinematic emerges which confronts viewers with the reality of subjection and unfreedom as the ontological ground of their own consciousness.

# Optimistic Epilogue

[Back then] if you worked, you had; if you didn't work, there were no ways to receive funding from any ministry, the Film Centre, or the European Union. No sponsors existed. Only us, the cinema screen and the world.

Aliki Vouyiouklaki[1]

During the 1980s, Greek cinema, after decades of being ignored by the Greek state, was offered freedom, money and iconic status, only to be transformed into a bureaucratic exercise in ideological and stylistic conformity. The state promoted grand narratives about the Civil War and political melodramas about the persecution of left-wing martyrs and socialist saints. Soon, the audience withdrew from such an extravaganza of sentimentalism and stayed at home watching the American and Brazilian soap operas which dominated Greek television.

After 1989–91, history returned with a vengeance: the collapse of the so-called 'existing socialism' destroyed the totalising homogeneity of Greek cultural production and questioned the domination of left-wing ideological preconceptions. The unifying spatio-temporal metaphors employed to visualise social experience vanished: the Others were inside the gates and contributed to the self-Othering of all those who claimed to be sovereigns over their own domain. After almost 1 million immigrants flooded the country and changed its demography, such subversive self-fragmentation forced Greek cinema to abandon its introspective and insular smugness. It was then that Greek audiences realised that misery can be real, and not a decorative motif in their imaginary museum of glamorous antiquities or mournful memories.

The moral failure soon became a failure of the imagination: the period of affluence that followed between 1993 and 2009 occluded, indeed suspended, any modern and self-reflexive subjectivity. Unable to cope with the

# Optimistic Epilogue

challenges of history, Greek cinema regressed to the communitarian innocence of self-indulgent comedies or the flattering reassurance of patriotic melodramas. The actual drama of historical experience was transformed through the blockbusters of the period, such as *Brides*, *Touch of Spice* and *El Greco*, into a high school performance of self-mythologisation. The borrowed affluence neutralised all codes of meaningfulness: images became the façade for a museum of ghosts and phantasms, as the disjunction between reality and its image increased.

And in 2009 the global crisis struck. In less than a year, the Greek state lost its authority, or what was left of it. The condition of living in a society without any form of moral, intellectual or political authority, has been explored by a number of recent Greek films. The common background in all of them is the state and its institutions as the internal enemy, the ultimate negative alien within a society that had totally lost its ability to trust or believe in anything. The 'Weird Wave' or the Cinema of Transgression is not the product of the economic meltdown: on the contrary, it refracted the panicked reaction to the absurd conspicuous consumption, the reckless consumerism and the systemic abuse of power that were taking place before and after 2004. Yorgos Lanthimos' *Kineta* (2005) is the landmark film, and deserves a second viewing today.

During the crisis of the last six years (to 2015), Greek cinematographers have shown enviable resilience and tireless inventiveness; austerity of means, starkness of dialogue, unembellished settings, all created a form of anti-aesthetics purifying cinematic form of all superfluous and artificial illusionism. Although they never presented a manifesto, like the Dogma 95, they stopped posturing as the victims of history and detached themselves from the self-congratulatory melancholia of the past. They succeeded in securing international funding to make new films and promote their cultural imaginary worldwide. Young cinematographers used the economic collapse as an opportunity to explore the deep social implosion that has engulfed all levels of culture – especially the level of symbols, representations and cultural iconographies. The collapse of a particular social order led to the debunking of its hegemonic cultural mythology while technological advances democratised the medium making accessible to everyone. Some films stand out as landmarks of the structural and psychic violence experienced by the population as well as of a life totally mediated by commodities.

In Panos Koutras' *Strella* (2009) the main protagonist is a transvestite who parodies the name of the most significant film in Greek cinema, *Stella*, and with it the tradition established around charismatic individuals such as its protagonist, Melina Mercouri, and its director, Michael Cacoyannis. For Koutras, the real

**241**

hero is someone hybrid, in between masculinity and femininity: Strella, a boy who wants to be a woman, who talks about men using feminine articles and sees women as the real pillars of society. Gender dynamics have become the key to unlocking the radicalism of visual imagination: the new Zorba is another ageing transvestite, the legendary Betty, the person who knows how to ridicule the past – and bawdy jokes is the most we get out of its lost glories.

Koutras' *Strella* puts an end to the self-indulgence of the Zorba tradition, its patriarchal narcissism and phallocentric egomania. Now Strella commits the ultimate abomination: she has sex with her own father. 'I was carried away,' she says. 'I didn't mean to ... It happened.' But the rugged, criminal and condemned father himself is not pure; he comes out of prison with his masculinity traumatised, indeed sacrificed, to the delusions of the political and social order that created him. The film ends happily: Athens celebrates the new family 'model'; father and son have found their lovers among the newly arrived immigrants from Russia and live happily ever after. The Acropolis is lit in jubilation as fireworks proclaim the death of the past. Real masculinity emerges through its feminisation. With his recent film *Xenia* (2014) Koutras has moved in a new direction, reinscribing identity politics into the traditional genre of melodrama: his reinvention of popular culture through his 'queerness' challenged the existential and political axes of contemporary individualsim and presented identity not simply as performance but as ethical disposition towards the self and the other.

In 2009, another Young Turk, Yorgos Lanthimos, released his confronting family saga *Dogtooth*, taking on the institution of the family itself. The film was nominated for an Oscar and has caused considerable anxiety and bewilderment in its viewers. It is the traditional 'family saga', about the ways in which the parents keep their children immune to the outside world by imprisoning them in the safety of a luxury home, by giving different meaning to common words and by reinventing the order of things for them. Nothing is what it seems; a vast army of pseudo-events and personalised delusions has turned the world upside down. The 'black' is 'red' and the 'red' is a train; linguistic signs have lost all referential function. When we say 'freedom', we mean 'plasma television'; when we talk about democracy we mean holidays, and when we say 'love', we refer to fish and chips. This is the world that the grand politicians of the recent past have created for the new generation. The film is a bold exposé *ad extremis* of such implosion of meaning, of the complete and utter mystification of common sense, of the ultimate obscuring of all self-evident truths that were consolidated in the political paradigm of the last one hundred years.

# Optimistic Epilogue

Finally, the film that has shown the most provocative boldness and euphoric unconventionality was made by a female director, Athina Rachel Tsangari. *Attenberg* (2010) is a bizarre tale of feminine empowerment, as two girls relearn the meaning of things by exploring each other and by saying goodbye to the dominant mentality of the previous social order, with its 'bourgeois arrogance' and its 'petit-bourgeois paroxysm', as the dying father in the film says. The two girls learn the world anew: they discover walking, thinking, singing, kissing, making love, exploring empty houses and deserted industrial villages. There is a peculiar exhilaration in this film; relics from an idyllic past pop up from time to time, like the nostalgic French song by Françoise Hardy, *Tous les Garçons et les Filles*, that make everything quirky in a liberating and redeeming way: singing songs of hope in the era of nihilism is an act of provocation as well as a farewell hymn.

No more philosophical statements about life, love, memory, history and God; no more dilemmas about identity, belonging, nationality and other similar catastrophes. What *Attenberg* presents is the extreme naturalism, almost primitivism, of human emotions, the acuity of their experience, the need to be contemporary and feel at home within your own skin. Grand ideologies about classical ruins and temples of worship become superfluous; we have our own contemporary ruins, our own industrial rubbish bins, and we experience the political limbo in which meanings and feelings are all suspended, leaving behind the 'toxic waste of modernism', as one character says.

*Attenberg* ceremoniously assassinates Greek neoclassicism by presenting psychologies of capricious eccentricity. It depicts the 'permanent challenge' to ideological fantasies that actual people represent. It questions the intellectual foundations of Greek society, its institutional legitimacy and mental obsessions. Yet by presenting its negation, Tsangari at the same time shows the liberating potential of the Greek imaginary; only self-confident traditions can deny themselves and thus renew their critical ability. Tsangari shows the imaginative capital and the sublimating force of such counter-tradition – she brings visual language to the edges of its grammatical cohesion; it remains to be seen where she will go from there. Her recent film *Chevalier* (2015) seems that have totally broken all boundaries between Greek and global cinemas: it is an anthropological study of male antagonism, subverting stereotypes about masculinity and exposing the illusory, specular nature of phallic power. The movie is not disturbing or weird; it is the reality around it that is frightening and 'weird' in its dislocation and disarticulation. By employing anti-illusionist techniques, Tsangari shows that there should be no illusions about the reality her camera is exploring, a reality of asymmetric relations between signs and meanings.

In his own way, Lanthimos, too, took his work one step further. With his rather problematic *Alps* (2011) and recently with the internationally acclaimed *The Lobster* (2015) he started moving beyond language, definitely beyond the Greek language, to the realm of transcultural, deterritorialised visual narratives about dystopian mental and social realities. His later film effectively fuses narrative and atmosphere, linked by a Beckettian script and a method of acting that reinvents performance through self-conscious theatricality. In a world abandoned by all projects of renewal, even human relations become infernal machines of self-entrapment: the absence of the political leads to the tyranny of the personal. Roy Andersson's *A Pigeon Sat on a Branch Reflecting on Existence* (2014) and *The Lobster* both redefine the cinematic experience as performance and storytelling, indicating a transition to a new cinema of gestures. With his last film, in which a new sense of narrative regains centrality, Lanthimos transcends the confines of any 'national cinema' and joins the ranks of prominent directors such as Wong Kar-Wai, Ang Lee, Park Chan-Wook, Paolo Sorrentino, Gulliermo del Toro, Roy Andersson, Alejandro González Iñárritu, even Lars von Trier, contributing to the establishment of global cinema and abolishing all notions about local cinema or cultural specificity. Lanthimos is the first truly transcultural director – the inventor of 'notional cinema', framing signs and images that articulate universalist claims about cinematic visuality and operating within a global paradigm of production, casting, distribution and reception.

Contemporary Greek filmmakers reinvent their cinematic language by 'unimagining' its historical trajectory. They reconfigure the representations and the images they grew up with through bold experiments about alternative yet parallel realities within a world of shared experiences; they discover the innate ambiguities within the pluriverse of everyday uncertainties, beyond the totalising fantasies of the old master narratives. They fuse Cacoyannis' morphoplastic plasticity, Koundouros' semiotic hermeticism, Dalianidis' inverted cryptoeroticism and Angelopoulos' chromatic conceptualism with experimental filmmakers' ambivalence towards their own medium: after the 1970s, today is the first time we witness a self-reflexive cinematic conscience in action. They are bringing the Greek cultural imaginary to modernity and postmodernity by infusing its inherited formal schemata with new signifiers and their unpredicted variations.

By 'unimagining' the dominant visual language they explore the expressive artificiality of cinematic representation and the illusory character of the society of the spectacle. By taking risks with form and experimenting with the narrative, they illustrate the existential decentredness of contemporary experience. By using theatricality, self-conscious acting and artificial *mise-en-scène*, they emphasise the

# Optimistic Epilogue

absence of any unifying mythopoeic statements. Their language of transgression confronts viewers with what is familiar and friendly but decontextualised and out of place: they dis-member the beloved cinematic past in order to imagine the future. Their dystopian visions are realistic depictions of the dominant atmosphere of disillusion and frustration that has taken over the social imaginary of Europe after the failure of all projects of renewal. They also depict the rage against all false prophets of modernity, the charismatic ideologues and the opportunism that destroyed the political expectations of all post-1970s generations.

Such semantic bewilderment puzzles contemporary audiences and confuses their expectations of the cinematic experience. The grandchildren of Michael Cacoyannis turn his legacy against itself. It remains to be seen if it can transcend its own limitations and escape the prospect of manneristic repetitiveness. Together with the Independent American Cinema, the Danish Dogma 95, and the Romanian New Wave, the New Greek Cinema of Transgression is probably the most interesting experiment in filmmaking at the moment. It is still 'Greek' because it has discarded all attempts to talk about its Greekness. Its identity is more complex than what could be attributed to its national origins. Ultimately, these filmmakers do have an identity, but it is an ongoing project, reformable and reimaginable. We don't know where they might go – and that's liberating and optimistic. As Cacoyannis said:

> Cinema has no motherland since it is a recent art; and it is not the *form* of the film that betrays its nationality. On the contrary, it is the intervention of its director, I believe, and more than that the perspective of the director that colours the film more than any national perspective.[2]

In this book I have explored the work of several directors and its consequences for the development of a global art in a local context over a period of sixty years. The visual fields they created are inexhaustible and new cinematic idioms have been constantly created in the country, even during periods of most severe crisis. Finally, these films are creating a new social imaginary, framing the ability of a society to critically reflect on its own political and anthropological deficits.

# Notes

## Introduction

1 Hayden White, *The Content of the Form, Narrative Discourse and Historical Representation* (Baltimore and London: The John Hopkins University Press, 1987), p. XI.

## Chapter 1: Realisms and the Question of Form in Greek Cinema

1 Christian Metz, *Film Language, A Semiotics of the Cinema*, trans. Michael Taylor (Chicago: The University of Chicago Press, 1991), p. 3.

2 Vassilis Rafailides, *Film-Constructionism* (Athens: Aigokeros Publications, 1984) p. 75.

3 Vassilis Rafailides, *12 Lessons on Cinema: A Method for Reading Films* (Athens: Aigokeros Publications, 1996) p. 126.

4 Ibid., p. 132.

5 André Bazin, *What is Cinema?*, vol. I (Berkeley and Los Angeles, CA: University of California Press, 1967), p. 21.

6 Fredric Jameson, *The Antinomies of Realism* (London and New York: Verso Books, 2013), p. 11.

7 Shohini Chaudhuri, *Contemporary World Cinema: Europe, The Middle East, East Asia and South Asia* (Edinburgh: Edinburgh University Press, 2005), p. 15.

8 Edward Lucie-Smith, *American Realism* (London: Thames & Hudson, 1994), p. 13.

9 Eleftheria Thanouli, *Post-Classical Cinema: An International Poetics of Film Narration* (London and New York: Wallflower Press, 2009), p. 71.

10 David Bordwell and Kristin Thomson, *Film Art: An Introduction*, 9th edn (New York: McGraw-Hill, 2010), p. 173.

11 Brendan Prendeville, *Realism in 20th Century Painting* (London: Thames & Hudson, 2000), p. 12.

12 John Gibbs, *Mise-en-Scène, Film Style and Interpretation* (London and New York: Wallflower, 2002), p. 100.

13 Theo Angelopoulos, *Interviews*, ed. Dan Fainaru (Jackson, MS and London: University Press of Mississippi, 2001), p. 131.

14 Noël Burch, *Theory of Film Practice*, trans. Helen R. Lane (Princeton, NJ: Princeton University Press, 1969), p. 141.

15 Donald Richie, *A Hundred Years of Japanese Film*, revised and updated (New York: Kodansha USA, 2012), pp. 11–12.

16 Theo Angelopoulos, *Interviews*, ed. Dan Fainaru (Jackson, MS and London: University Press of Mississippi, 2001), p. 5.

17 Pavel Florensky, *Beyond Vision, Essays on the Perception of Art*, compiled and edited by Nicoletta Misler, trans. Wendy Salmon (London: Reaktion Books, 2002), p. 180.

Notes to pages 10–20

18 Ibid., p. 181.

19 Bordwell and Thompson, *Film Art*, p. 43.

20 Christopher Phillips, 'Introduction', in Matthew Teitelbaum (ed.), *Montage and Modern Life 1919–1942* (Cambridge, MA: MIT Press, 1992), p. 22.

21 Michael Witt, *Jean-Luc Godard, Cinema Historian* (Bloomington and Indianapolis, IN: Indiana University Press, 2013), p. 15.

22 Mark Cousins, *The Story of Film* (Edinburgh: Pavilion, 2011), p. 488.

23 Yannis Tombros, 'The Question of Greek Cinema' (1945), in Yannis Soldatos, *History of Greek Cinema*, vol. 4, *Documents 1900–1970* (Athens: Aigokeros Publications, 2004), p. 157.

24 Vrasidas Karalis, *A History of Greek Cinema* (New York and London: Continuum, 2012).

25 Roland Barthes, *The Rustle of Language*, trans. Richard Howard (Berkeley, CA: University of California Press, 1986), p. 140.

26 Soldatos, *History of Greek Cinema*, vol. 4, *Documents (1900–1970)*.

27 Aylaia Mitropoulou, *Greek Cinema*, 2nd edn (Athens: Papazisis Publications, 2006), p. 201.

28 Lydia Papadimitriou, 'Greek film studies today: in search of identity', *Kampos: Cambridge Papers in Modern Greek* 17 (2009), pp. 49–78, 74.

29 Maria Stassinopoulou, 'Definitely maybe: possible narratives of the history of Greek cinema', in Lydia Papadimitriou and Yannis Tzioumakis (eds), *Greek Cinema, Texts, Histories, Identities* (Bristol and Chicago, IL: Intellect, 2012), pp. 129–43, 132.

30 Dina Iordanova, *Cinema of Flames, Balkan Film, Culture and the Media* (London: Palgrave Macmillan, 2009), p. 8.

31 Peter Bondanella, *A History of Italian Cinema* (New York and London: Continuum, 2009), p. 2.

32 Stanley Cavell, *Contesting Tears, The Hollywood Melodrama of the Unknown Woman* (Chicago, IL: University of Chicago Press, 1996), p. 40.

33 Susan Hayward, *Cinema Studies, The Key Concepts*, 3rd edn (London and New York: Routledge, 2006), p. 334.

34 Lucien Goldmann, *Towards a Sociology of the Novel*, trans. Alan Sheridan (London: Tavistock, 1975), p. 159.

35 Lúcia Nagib, *World Cinema and the Ethics of Realism* (New York: Continuum, 2011), p. 8.

36 Ibid., p. 12.

37 Bazin, *What is Cinema?*, p. 15.

38 David Bordwell, 'Contemporary film studies and the vicissitudes of Grand Theory', in David Bordwell and Noel Carroll (eds), *Post-Theory: Reconstructing Film Studies* (Madison, WI: University of Wisconsin Press, 1996), pp. 1–36, 27.

39 Kristin Thompson, *Breaking the Glass Armor, Neoformalist Film Analysis* (Princeton, NJ: Princeton University Press, 1988), p. 21.

40 Karalis, *A History of Greek Cinema*, p. 291.

41 Dimitris Charitos (ed.), *Gregoris Gregoriou* (Athens: Aigokeros Publications, 1996), p. 15.

42 Michel Foucault, *The Archaeology of Knowledge*, trans. A. M. Sheridan Smith (New York: Pantheon Books, 1972), p. 37.

43 The list and its variations between 1986 and 2006 can be found on the official website of the Pan-Hellenic Union of Film Critics at http://www.pekk.gr/index.php/awards/oi-kalyteres-ellinikes-tainies (accessed 12 August 2013).

## Notes to pages 21–31

44 Stratos E. Constantinidis, 'What did you do in the war, Thanassis?', in Dina Iordanova (ed.), *The Cinema of The Balkans* (London and New York: Wallflower Press, 2006), p. 93.

45 Mark Cousins, *The Story of Film* (London: Pavilion, 2004), p. 376.

46 David Parkinson, *History of Film* (London: Thames & Hudson, 2012), p. 240.

47 Vachel Lindsay, *The Art of the Moving Picture* [1915] (New York: The Modern Library, 2000), p. 30.

48 Martin Jay, 'Scopic regimes of modernity', in Hal Foster (ed.), *Vision and Visuality* (New York: New Press, 1999), pp. 3–23, p. 20.

49 Bazin, *What is Cinema?*, pp. 14–15.

50 Konstantinos Blathras, *Lights/Sound/Let's Go: Ten Directors Talk* (Athens: Maistros Publications, 2003), p. 30.

51 Reinhart Koselleck, *The Practice of Conceptual History, Timing History, Spacing Concepts*, trans. Todd Samuel Presner and others (Stanford, CA: Stanford University Press, 2002), p. 83.

52 Maria Tumarkin, *Traumascapes, The Power and Fate of Places Transformed by Tragedy* (Melbourne: Melbourne University Press, 2005), p. 13.

53 Jeffrey C. Alexander, *Trauma: A Social Theory* (Cambridge: Polity Press, 2012), p. 6.

54 Thomas Elsaesser, *German Cinema: Terror and Trauma, Cultural Memory since 1945* (New York and London: Routledge, 2014), p. 7.

55 Karalis, *A History of Greek Cinema*, p. 39.

56 Vamik D. Volkan and Norman Itzkowitz, 'Modern Greek and Turkish identities and the psychodynamics of Greek–Turkish relations', in Antonius C. G. M. Robben and Marcelo M. Suarez-Orozco, *Cultures under Siege: Collective Violence and Trauma* (Cambridge: Cambridge University Press, 2000), pp. 227–47, 245.

57 Ibid., p. 244.

58 Pierre Nora, 'General introduction: between memory and history', in Lawrence D. Kritzman (ed.), *Realms of Memory*, vol. 1: *The Construction of the French Past*, trans. Arthur Goldhammer (New York: Columbia University Press, 1996), pp. 1–20, 19.

59 Sigmund Freud, 'Mourning and melancholia' [1915], in James Strachey and Anna Freud (eds), *The Standard Edition of the Complete Psychological Works of Sigmund Freud*, vol. 14: *On the History of the Psycho-Analytic Movement*, trans. James Strachey (London: Vintage, 2001), pp. 243–58, p. 255.

60 Barthes, *The Rustle of Language*, p. 137.

61 Ibid., p. 140.

62 Rudolf Arnheim, *Visual Thinking* (Berkeley and Los Angeles, CA: University of California Press, 1969), p. 315.

63 Vrasidas Karalis, 'Religion and Greek Cinema', *Filmicon*, posted on 28 December 2014. Available at http://filmiconjournal.com/blog/post/35/religion_and_greek_cinema (accessed 12 July 2015).

64 Siegfried Kracauer, *Theory of Film: The Redemption of Physical Reality* (Princeton, NJ: Princeton University Press, 1997), pp. 296.

65 Bazin, 'What is Cinema?', p. 15.

66 Peter Wollen, *Signs and Meaning in the Cinema* (Bloomington, IN: Indiana University Press, 1972), p. 165.

67 Hal Foster (ed.), *Vision and Visuality* (Seattle, WA: Bay Press, 1988), p. IX.

# Notes to pages 32–57

68 Jason Triantafyllides, *George Tzavellas, International filmmaker*, trans. Jason Triantafyllides (Athens: Andy's Publishers, 2014), p. 20.

69 Gregoris Gregoriou, *Memories in White and Black*, vol. 1 (Athens: Aigokeros Publications, 1988), p. 116.

70 John Berger, *Ways of Seeing* (London: Penguin Books, 1978), p. 33.

71 Lucie-Smith, *American Realism*, p. 9.

72 Gerald Mast, *The Comic Mind: Comedy and the Movies*, 2nd edn (Chicago, IL and London: University of Chicago Press, 1979), p. 21.

73 Yannis Soldatos, *A Man for All Weather; On Thanassis Vengos* (Athens: Aigokeros Publications, 2000), p. 216.

74 Robert Bresson, *Notes on the Cinematographer*, trans. Jonathan Griffin (Copenhagen: Greek Integer, 1977), p. 18.

75 Bruce Isaacs, *The Orientation of Future Cinema: Technology, Aesthetics, Spectacle* (London and New York: Bloomsbury, 2013), p. 243.

76 Lucia Nagib and Anne Jerslev, *Impure Cinema: Intermedial and Intercultural Approaches to Film* (London: I.B.Tauris, 2014), pp. xviii–xxiii.

77 James Elkins, *The Object Stares Back: On the Nature of Seeing* (San Diego, CA: A Harvest Book, 1996), p. 12.

78 Kracauer, *Theory of Film*, p. 32.

79 Costas Sfikas, 'Nothings can replace the suggestiveness created by silence', A conversation with Frida Liappa and Gina Konidou, in Yannis Soldatos (ed.), *Costas Sfikas* (Athens: Aigokeros Publications, 2004), p. 65.

80 Steve Rose, 'Attenberg, Dogtooth and the weird wave of Greek Cinema', *The Guardian*, 27 August 2011. Available at http://www.theguardian.com/film/2011/aug/27/attenberg-dogtooth-greece-cinema (accessed, 12 September 2013)

81 Donald Richie, *Ozu*, (Berkeley, CA: University of California Press, 1977), p. 188.

82 Rafailides, *Film Constructionism*, p. 124.

83 Colin MacCabe, *Godard: Images, Sounds, Politics* (London: British Film Institute, 1980), p. 108.

84 Bela Balazs, *Theory of the Film, Character and Growth of a New Art*, trans. Edith Bone (New York: Dover Publications, 1970), p. 62.

85 Ibid., p. 14.

86 Ibid., p. 15.

87 Kracauer, *Theory of Film*, pp. 302–3.

88 Laura Mulvey, *Visual and Other Pleasures*, 2nd edn (London, Palgrave MacMillan, 2009), pp. 14–18.

89 Berger, *Ways of Seeing*, p. 10

90 Gilles Deleuze, *Bergsonism*, trans. Hugh Tomlinson and Barbara Habberjam (New York: Zone Books, 1991).

91 Maurice Merleau-Ponty, 'Eye and mind', *The Merleau-Ponty Aesthetics Reader: Philosophy and Painting*, ed. Galen A. Johnson, trans. Michael B. Smith (Evanston, IL: Northwestern University Press, 1993), pp. 121–50, 136.

92 Sergei Eisenstein, *The Eisenstein Reader*, ed. Richard Taylor, trans. Richard Taylor and William Powell (London: British Film Institute 1998), p. 64.

Notes to pages 57–73

93 Maya Deren, 'An anagram of ideas on art, form and film', in Bill Nicolls (ed.), *Maya Deren and the American Avant-Garde* (Berkeley, CA: University of California Press, 2001), p. 33.

94 Cornelius Castoriadis, *World in Fragments*, ed. and trans. David Ames Curtis (Stanford, CA: Stanford University Press, 1997), p. 32.

# Chapter 2: The Construction and Deconstruction of Cinematic Realism in Michael Cacoyannis' Films

1 Christos Siafkos, *Michael Cacoyannis, On Close-up* (Athens: Psihogios, 2009), p. 232.

2 Gregoris Gregoriou, *Recollections in Black and White*, vol. 2 (Athens: Aigokeros, 1996), p. 9.

3 Christos Siafkos, *Michael Cacoyannis*, p. 283.

4 André Bazin, *What is Cinema?* vol. 1 (Berkeley and Los Angeles CA: University of California Press, 1967), p. 112.

5 John Grierson, *On Documentary*, ed. and with an Introduction by Forsyth Hardy (London: Faber & Faber, 1979), p. 70.

6 Siegfried Kracauer, *Theory of Film: The Redemption of Physical Reality* (Princeton, NJ: Princeton University Press, 1997), p. 245.

7 Michael Cacoyannis, *That is to Say* (Athens: Kastaniotis, 1990), p. 48.

8 Ibid.

9 Siafkos, *Michael Cacoyannis*, p. 103.

10 Cacoyannis, *That is to Say*, p. 49.

11 Ibid.

12 Pauline Kael, *Kiss Kiss, Bang Bang: Film Writings 1965–1967* (London: Arena, 1970), p. 160.

13 Siafkos, *Michael Cacoyannis*, p. 234.

14 Michel Foucault, *The Foucault Reader*, ed. Paul Rabinow (New York: Pantheon Books, 1974), p. 74.

15 David Thomson, *'Have You Seen ...?'* (London: Penguin Books, 2008), p. 829.

16 Winner of the Nobel Prize in Literature, 1963.

17 Cacoyannis, *That is to Say*, p. 21.

18 Jean-Paul Sartre, *On Theatre*, trans. Frank Jellinek (London: Quartet Books, 1976), pp. 310–11.

19 Cacoyannis, *That is to Say*, p. 49

20 Vladimir Propp, *Morphology of the Folk-tale*, trans. Lawrence Scott, 2nd edn (Austin, TX: Texas University Press, 1968), p. 34.

21 Walter Lassaly, *Itinerant Cameraman* (London: John Murray, 1987), p. 36.

22 Vion Papamichalis, 'Greek film production', in Soldatos, *History of Greek Cinema*, p. 232.

23 Siafkos, *Michael Cacoyannis*, p. 243.

24 Vrasidas Karalis, *A History of Greek Cinema* (New York and London: Continuum, 2012), p. 66.

## Notes to pages 73–85

25  Peter Cowie, *Revolution!: The Explosion of World Cinema in the 60s* (London: Faber & Faber, 2004), p. 21.

26  Ninos Fennec-Michelidis, *100 Years of Greek Cinema* (Athens: Patriarcheas Publications, 1997), p. 23.

27  Peter Cowie, *Eighty Years of Cinema* (London: The Tantivy Press, 1977), p. 87.

28  Gerasimos Stavrou, 'Avgi', 1954. Available at http://www.mcf.gr/downloads/01avgi1954.jpg (accessed 22 September 2013).

29  Eleni Vlahou, '*Windfall in Athens*', *I Kathimerini*, 13 January 1954, in Yannis Soldatos, *History of Greek Cinema*, vol. 4: *Documents (1900–1970)* (Athens: Aigokeros, 2004), pp. 250–1.

30  Pauline Kael, *5001 Nights at the Movies* (New York: Henry Holt & Company, 1982), p. 1819.

31  Karalis, *A History of Greek Cinema*, p. 68.

32  Dimitris Eleftheriotis, *Popular Cinemas of Europe: Studies of Texts, Contexts and Frameworks* (New York/London: Continuum, 2001), p. 158.

33  Siafkos, *Michael Cacoyannis*, p. 321

34  Dan Georgakas, '*Stella*', in Dina Iordanova (ed.), *The Cinema of the Balkans* (London and New York: Wallflower, 2006), pp. 20–1.

35  Achilleas Hadjikyriacou, 'Cacoyannis's *Stella*: representation and reception of a patriarchal anomaly', in Lydia Papadimitriou and Yannis Tzioumakis (eds), *Greek Cinema: Texts, Histories, Identities* (Bristol and Chicago, IL: Intellect, 2012), pp. 87–202, 198.

36  Vrasidas Karalis, 'From the archives of oblivion: the first female Greek director Maria Plyta (1915–2006)', *Modern Greek Studies, Australia and New Zealand* 16–17/A (2013–4), pp. 45–67, 60.

37  Lindsay Anderson, *Never Apologise: The Collected Writings*, ed. Paul Ryan (London: Plexus, 2004), p. 574.

38  Vrasidas Karalis, 'Traumatised Masculinity and Male Stardom in Greek Cinema', in Andrea Bandhauer and Michelle Royer (eds), *Stars in World Cinema: Screen Icons and Star Systems Across Cultures* (London/New York: I.B.Tauris, 2015), pp. 190.

39  Siafkos, *Michael Cacoyannis*, p. 83.

40  Judith Butler, *Gender Trouble: Feminism and the Subversion of Identity* (London: Routledge, 1990), p. 135.

41  Kael, *5001 Nights at the Movies*, p. 597.

42  Donald Spoto, *The Art of Alfred Hitchcock* (New York: Anchor Books, 1992), p. 249.

43  Bosley Crowther, 'Girl in Black: Film by Cacoyannis of Greece Opens in Paris,' *The New York Times*, 17 September 1957, http://www.nytimes.com/movie/review?res=9C0 1E1D61130E23BBC4F52DFBF66838C649EDE (accessed 12 October 2014).

44  Bazin, *What is Cinema I*, p. 38.

45  Anderson, *Never Apologise*, p. 368.

46  Lassally, *Itinerant Cameraman*, p. 59.

47  Kosmas Politis, *Eroica* (Athens: Ermis Publications, 1987, 1st edn 1937).

48  Aristotle, *Poetics*, ed. and trans. Stephen Halliwell (Cambridge, MA: Harvard University Press, 1999), pp. 46–7.

# Notes to pages 85–96

49 Thomas Schatz, *Hollywood Genres, Formulas, Filmmaking and the Studio System* (New York: Random House, 1981), p. 31.

50 Ibid.

51 David Bordwell, *The Way Hollywood Tells It: Story and Style in Modern Movies* (Berkeley, CA: University of California Press, 2006), p. 189.

52 Grierson, *On Documentary*, p. 83.

53 Cacoyannis, *That Is to Say*, p. 44.

54 Anastasia Bakogianni, 'All is well that ends tragically: filming Greek tragedy in modern Greece', *Bulletin of the Institute of Classical Studies* 51/1 (2008), pp. 119–67, 163.

55 Kael, *5001 Nights at the Movies*, p. 452.

56 Karalis, *A History of Greek Cinema*, p. 99.

57 Michael Cacoyannis, '*Electra*', in Soldatos, *History of Greek Cinema*, vol. 4, p. 483.

58 Siafkos, *Michael Cacoyannis*, p. 125.

59 Anastasia Bakogianni, *Electra, Ancient and Modern, Aspects of the Reception of the Tragic Heroine* (London: Institute for Classical Studies, 2011), p. 193.

60 Siafkos, *Michael Cacoyannis*, p. 18.

61 Ibid., p. 15.

62 Ibid., p. 276.

63 Peter Donaldson, 'Olivier, Hamlet and Freud', *Cinema Journal* 26/4 (Summer 1987), pp. 22–48, p. 44.

64 Ibid.

65 Pauline Kael, *The Age of Movies: Selected Writings of Pauline Kael*, ed. Sanford Schwartz (New York: Library of America, 2011), p. 289.

66 Roger Ebert, 'The Trojan Women Review' in http://www.rogerebert.com/reviews/the-trojan-women-1972 (accessed 20 September 2013).

67 Vassilis Rafailidis, *Film Dictionary*, vol. 3: *Greek Cinema* (Athens: Aigokeros, 2003), p. 43.

68 Ibid., p. 44.

69 David Thomson, *The New Biographical Dictionary of Film* (New York: Alfred A. Knopf, 2010), p. 141.

70 Soldatos, *History of Greek Cinema*, vol. 4, p. 483.

71 Peter Bondanella, *The Films of Roberto Rossellini* (Cambridge: Cambridge University Press, 1993), pp. 126–7.

72 John Grierson, 'The Documentary Producer', *Cinema Quarterly*, 2.1 (Autumn 1933), p. 8.

73 Cacoyannis, *That is to Say*, p. 92.

74 Ibid.

75 Ibid., p. 48.

76 Ian Aitken, *Realist Film Theory and Cinema: The Nineteenth-century Lukacsian and Intuitionist Realist Traditions* (Manchester and New York: Manchester University Press, 2006), p. 202.

77 Yannis Tsarouchis, 'We saw Shakespeare for the first time', *Eleftheorypia*, 5 September 1979. Available at http://www.mcf.gr/downloads/18review00002.jpg (accessed 25 September 2013).

Notes to pages 96–107

78 Maria Katsounaki, 'A seductive Cherry Orchard', *Kathimerini*, 28 January 2000.

79 Cacoyannis, *That is to Say*, p. 49.

# Chapter 3: Nikos Koundouros and the Cinema of Cruel Realism

1 Yannis Soldatos, *Corporeal Odysseys in the Work of Nikos Koundouros* (Athens, Aigokeros Publications, 2007), p. 288.

2 Marios Plorites, 'Review of *Magic City*', *Eleutheria*, 12 January 1955, in Yannis Soldatos, *History of Greek Cinema*, vol. 4: *Documents 1900–1970* (Athens: Aigokeros, 2004), p. 254.

3 Siegfried Kracauer, *Theory of Film: The Redemption of Physical Reality* (Princeton, NJ: Princeton University Press, 1997), p. 39.

4 Sergei Eisenstein, *The Eisenstein Reader*, ed. Richard Taylor, trans. Richard Taylor and William Powell (London: British Film Institute, 1998), p. 62.

5 Nikos Koundouros, *Stop Carré* (Athens: Ergo Publications, 2009), p. 207.

6 Plorites, 'Review of *Magic City*', p. 266.

7 Kostas Stamatiou, 'Avgi', 19 August 1956, in Yannis Soldatos, *History of Greek Cinema*, vol. 4: *Documents 1900–1970* (Athens: Aigokeros, 2004) p. 267.

8 Antonia Voutsadaki, *Nikos Koundouros's The Ogre of Athens: A Political Cinema* (Athens: Aigokeros, 2006), pp. 115–16.

9 Aylaia Mitropoulou, *Greek Cinema*, 2nd edn (Athens: Papazisis Publications, 2006), p. 188.

10 Michel Foucault, *The Foucault Reader*, ed. Paul Rabinow (New York: Pantheon Books, 1984), p. 61.

11 Jonathan Franzen, *Freedom, A Novel* (London: Fourth Estate, 2010), pp. 104–5.

12 Peter Bradshaw, 'Franzen's *Freedom* revives legend of *The Dragon*', 12 October 2011. Available at http://www.theguardian.com/film/filmblog/2011/oct/12/jonathan-franzen-freedom-the-dragon (accessed 12 December 2013).

13 Peter Cowie, *John Ford and the American West* (New York: Harry Abrams Inc., 2004), p. 211.

14 Soldatos, *Corporeal Odysseys*, pp. 78–9.

15 Antonis Moshovakis, 'Review of *The Illegals*', in Soldatos, *History of Greek Cinema*, vol. 4, p. 312.

16 Soldatos, *Corporeal Odysseys*, p. 88.

17 Mikhail Bakhtin, *The Dialogic Imagination: Four Essays*, ed. Michael Holquist, trans. Caryl Emerson and Michael Holquist (Austin, TX: University of Texas Press, 1981), p. 84.

18 Ibid., pp. 84–5.

19 Soldatos, *Corporeal Odysseys*, p. 99.

20 Peter Cowie, *Ingmar Bergman: A Critical Biography* (London: Secker & Warburg, 1982), p. 317.

21 Soldatos, *History of Greek Cinema*, vol. 4: *Documents 1900–1970*, p. 498.

## Notes to pages 107–124

22 Roland Barthes, *The Degree Zero of Writing*, trans. Annette Lavers and Colin Smith (London: Jonathan Cape 1967), p. 94.

23 Soldatos, *Corporeal Odysseys*, p. 125.

24 Ibid., p. 162.

25 Ibid., p. 165.

26 Ibid., p. 181.

27 Ibid., p. 185.

28 Ibid., p. 200.

29 Walter Benjamin, 'Theses on the Philosophy of History', *Illuminations: Essays and Reflections*, ed. Hannah Arendt (New York: Schocken Books, 1968), pp. 257–8.

30 Lefteris Xanthopoulos, *The Four Seasons of Nikos Koundouros* (Athens: Gabriilidis Publications, 2014), p. 63.

31 Koundouros in Soldatos, *Corporeal Odysseys*, p. 228.

32 Ibid., p. 232.

33 Vassilis Rafailides, *Film Dictionary*, vol. 3 (Athens: Aigokeros Publications, 2003) p. 209.

34 Nikos Koundouros, interviewed by Yannis Zoumboulakis, *Vema*, 16 March 2013. Available at http://www.tovima.gr/culture/article/?aid=502977 (accessed 20 November 2013).

35 Theodoris Koutsoyiannopoulos, 'Only one star for Koundouros's movie', available at http://www.lifo.gr/mag/cinema/2186 (accessed 20 November 2013).

36 Nikos Koundouros, *Stop Carré*, p. 308

37 Pier Paolo Pasolini, *Heretical Empiricism*, trans. Ben Lawton and Louise K. Barnett (Washington, DC: New Academia Publishing, LLC, 2005), p. xxviii.

38 Thanasis Dritas in conversation with Nikos Koundouros. Available at https://ritsmas. wordpress.com/2013/07/07 (accessed 12 December 2014).

39 John Keats, *The Complete Poetical Works and Letters* (Cambridge: Cambridge University Press, 1985), p. 277.

40 Charles Baudelaire, *Selected Writings on Art and Literature*, ed. Robert Baldick and Betty Radice, trans. P.E. Charvet (London: Penguin Books, 1972), p. 26.

41 Koundouros, *Stop Carré*, p. 10

42 Geoffrey Wall, *Flaubert: A Life* (London: Faber & Faber, 2001), p. 204.

43 Nikos Koundouros, interviewed by Yannis Zoumboulakis, *Vema*, 16 March 2013.

44 André Bazin, *The Cinema of Cruelty: From Buñuel to Hitchcock* (New York: Seaver Books, 1982), p. 56.

45 Antonin Artaud, *The Theatre and its Double* (London: Calder Publications, 1970), p. 65.

46 Viktor Shklovsky, *Literature and Cinematography*, trans. Irina Masinovsky (Champaign and London: Dalkey Archive Press, 2008), p. 30.

47 Siegfried Kracauer, 'Remarks on the actor', in *Movie Acting. The Film Reader*, ed. Pamela Robertson Wojcik (New York and London: Routledge Palgrave, 2004), p. 19.

48 William Vaughan, *Romanticism and Art* (London: Thames & Hudson, 2003), p. 263.

49 Vassilis Rafailides, *Film Dictionary*, vol. 3: *Greek Cinema* (Athens: Aigokeros, 2003), p. 209.

50 Nikos Koundouros, *I Dreamed that I Died* (Athens: Ikaros Publications, 2009).

Notes to pages 124–135

51 Sergei Eisenstein, *Immoral Memoirs* [1946] (Boston, MA: Houghton Mifflin, 1984).
52 Ingmar Bergman, *The Magic Lantern* (Chicago, IL: University of Chicago Press, 1987).
53 Koundouros, *I Dreamed that I Died*, p. 83.
54 Ibid., p. 82.
55 Ibid., p. 148.
56 Ibid., p. 158.
57 Ibid., p. 158.
58 Peter Bondanella, *A History of Italian Cinema* (New York and London: Continuum, 2009), p. 232.
59 Soldatos, *Corporeal Odysseys*, p. 65.
60 Fabrizio M. Ferrari, *Ernesto de Martino: On Religion* (London: Equinox Publishing, 2012), p. 93.
61 Xanthopoulos, *The Four Seasons of Nikos Koundouros*, p. 85.
62 Albert Camus, *The Myth of Sisyphus*, trans. Justin O' Brien (London: Penguin Books, 2000), p. 11.
63 Gilles Deleuze, *Cinema 2: The Time-Image*, trans. Hugh Tomlinson and Robert Galeta (London: Continuum, 2005), p. 260.
64 Ibid., p. 266.
65 Soldatos, *Corporeal Odysseys*, p. 277.
66 Vrasidas Karalis, *A History of Greek Cinema* (New York/London: Contiuum, 2013) p. 232.
67 André Bazin, *Orson Welles, A Critical View* (Los Angeles CA: Acrobat Books, 1991), p. 80.
68 Soldatos, *Corporeal Odysseys*, p. 285.

# Chapter 4: Yannis Dalianidis and the Cryptonymies of Visuality

1 Yannis Dalianidis, *Cinema, Faces and I* (Athens: Kastaniotis, 2005), p. 274.
2 Constantine Kyriakos, *Difference and Eroticism* (Athens: Aigokeros, 2001), p. 27.
3 Lydia Papadimitriou, *The Greek Film Musical: A Critical and Cultural History* (Jefferson, NC and London: McFarland, 2006), p. 62.
4 Tom Cohen, *Hitchcock's Cryptonymies*, vol. 1: *Secret Agents* (Minneapolis, MN: University of Minnesota Press, 2005), p. xi.
5 Ibid., p. 9.
6 David Magarshack, *Stanislavsky: A Life* (London: Faber & Faber, 1950, 2nd edn 1986), p. 67.
7 Julia Kristeva, *Powers of Horror: An Essay on Subjection* (New York: Columbia University Press, 1982), pp. 2–10.
8 Michael Rosen, *On Voluntary Servitude, False Consciousness and the Theory of Ideology* (London: Polity Press, 1996), pp. 258–75.
9 Raoul Vaneigem, *The Revolution of Everyday Life*, trans. Donald Nicholson-Smith (London: Rebel Press, 1983), p. 132.
10 Dalianidis, *Cinema, Faces and I*, p. 49.

Notes to pages 136–158

11 Yannis Dalianidis, *Talks to Jason Triantafillidi* (Athens: Andy's Publishers, 2014), p. 68.

12 Yannis Dalianidis, 'His last interview with his friend Hristos Parides', *Lifo*, 20 October 2010. Available at http://www.lifo.gr/mag/features/2346 (accessed 23 June 2013).

13 Ibid.

14 Manos Tsilimidis, *Almost Between Us* (Athens: Kaktos, 2001), p. 101.

15 William James, *The Will to Believe and Other Essays in Popular Philosophy* (New York: Dover Publications, 1987), p. 90.

16 Dalianidis, *Cinema, Faces and I*, p. 100.

17 Ibid., p. 178.

18 Ibid., p. 142.

19 Sergei Eisenstein, *The Eisenstein Reader*, ed. Richard Taylor, trans. Richard Taylor and William Powell (London: BFI Publishing, 1998), p. 119.

20 Tsilimidis, *Almost Between Us*, p. 105.

21 Ibid., p. 94.

22 Dalianidis, 'His last interview with his friend Hristos Parides'.

23 François Truffaut, *Hitchcock* (London: Paladin/Grafton Books, 1984), p. 503.

24 Tsilimidis, *Almost Between Us*, p. 101.

25 Jacques Lacan, *Ecrits*, trans. Bruce Fink (New York and London; W.W. Norton & Co., 2006), p. 524.

26 Judith Butler, *Gender Trouble: Feminism and the Subversion of Identity* (London: Routledge, 1990), p. 141.

27 Laura Mulvey, *Visual and Other Pleasures*, 2nd edn (London: Palgrave Macmillan, 2009), p. 26.

28 Laura Mulvey, *Fetishism and Curiosity, Cinema and the Mind's Eye* (London: Palgrave Macmillan, 2013), p. vii.

29 Jean Laplanche and Jean-Bertrand Pontalis, *The Language of Psychoanalysis*, trans. Donald Nicholson-Smith (New York: Norton, 1973), p. 318.

30 Kaja Silverman, *Male Subjectivity at the Margins* (New York and London: Routledge, 1992), p. 388.

# Chapter 5: An Essay on the Ocular Poetics of Theo Angelopoulos

1 Andrew Sarris, *The American Cinema: Directors and Directions, 1929–1968* (New York: Da Capo Press, 1996) p. 17.

2 Andrew Horton, *The Films of Theo Angelopoulos: A Cinema of Contemplation* (Princeton, NJ: Princeton University Press, 1999), p. 8.

3 David Thomson, *'Have You Seen …?'* (London: Penguin Books, 2008), p. 910.

4 Yvette Biro, *Turbulence and Flow in Film: The Rhythmic Design*, trans. Paul Salamon (Bloomington and Indianapolis, IN: Indiana University Press, 2008), p. 9.

5 Yorgos Archimandritis, *Theodoros Angelopoulos with Naked Voice* (Athens: Patakis Publications, 2013), p. 70.

6 J. J. Gibson, 'The myth of passive perception, a reply to Richards', *Philosophy and Phenomenological Research* 37 (December 1976), pp. 234–8, 235.

# Notes to pages 159–175

7   J. J. Gibson, 'On the concept of "formless invariants" in visual perception', *Leonardo* 6/1 (Winter 1973), pp. 43–5, 45.

8   Maurice Merleau-Ponty, *Aesthetics Reader: Philosophy and Painting* (Evanston, IL: Northwestern University Press, 1993), p. 141.

9   Theo Angelopoulos, *Interviews*, ed. Dan Fainaru (Jackson, MS and London: University Press of Mississippi, 2001), p. 65.

10  Stratos Keranidis, 'An Interview with Dimos Theos', in Stratos Keranidis (ed.) *Dimos Theos* (Athens: Aigokeros Publications, 2006), p. 11–12.

11  Angelopoulos, *Interviews*, p. 4.

12  Jean Rouch, *Cine-Ethnography*, ed. and trans. Steven Field (Minneapolis, MN and London: University of Minnesota Press, 2003), p. 269.

13  François Truffaut, *Hitchcock* (London: Paladin/Grafton Books, 1984), p. 261.

14  Ibid., p. 263.

15  Angelopoulos, *Interviews*, p. 72.

16  Kostas Papaioannou, *Byzantine and Russian Painting* (London: Heron Books, 1965), p. 30.

17  Archimandritis, *Theodoros Angelopoulos with Naked Voice*, p. 84.

18  Gilles Deleuze, *Cinema 2: The Time-Image*, trans. Hugh Tomlinson and Robert Galeta (Minneapolis, MN: University of Minnesota Press, 1989), p. 15.

19  Stathis Gourgouris, 'Hypnosis and critique: film music in the Balkans', in Dusan I. Bjelic and Obrad Savic (eds), *Balkan as Metaphor, Between Globalization and Fragmentation* (Cambridge, MA: MIT Press, 2002), pp. 323–50, 335.

20  Vrasidas Karalis, 'The disjunctive aesthetics of myth and history in Theo Angelopoulos' *Ulysses' Gaze'*, *Literature and Aesthetics* 16/2 (December 2006), pp. 252–68, 252.

21  Martin Heidegger, *Being and Time*, trans. Joan Stambaugh (New York: State University of New York Press, 1996), p. 232.

22  Edward Said, *On Late Style* (London: Bloomsbury, 2006), p. 148.

23  T. S. Eliot, *Selected Prose of T. S. Eliot* (London: Faber & Faber, 1975), p. 175.

24  Robert Bresson, *Notes on the Cinematographer*, trans. Jonathan Griffin (Copenhagen: Greek Integer, 1997), p. 17.

25  Angelopoulos, *Interviews*, p. 149.

26  David Bordwell, *Figures Traced in Light* (Berkeley, CA: University of California Press, 2005), p. 25.

27  Theo Angelopoulos, 'I am standing by you', interview with Jane Gabriel, 25 January 2012. Available at http://www.opendemocracy.net/article/a-closed-horizon (accessed 9 September 2013).

28  Dan Fainaru, review of *The Dust of Time*, 27 November 2008. Available at http://www.screendaily.com/reviews/europe/features/the-dust-of-time/4042143.article (accessed 10 September 2013).

29  Malcolm Bowie, *Lacan*, (London: Fontana Press, 1991), p. 31. (emphasis in the original)

30  Michael Rosen, *On Voluntary Servitude: False Consciousness and the Theory of Ideology* (Cambridge: Polity Press, 1996).

31  Eirini Stathi, *Space and Time in Theo Angelopoulos' Cinema* (Athens: Aigokeros Publications, 1999), p. 79.

32  Ibid., p. 84.

Notes to pages 175–192

33 Angelopoulos, *Interviews*, p. 87.

34 Wilhelm Worringer, *Abstraction and Empathy*, trans. Michael Bullock (New York: International University Press, 1953).

35 Interview with Antonis Mposkoitis, 6 March, 2009. Available at http://bosko-hippy-dippy.blogspot.com.au/2009/03/blog-post_06.html (accessed 8 April 2016).

36 Ibid., p. 86.

37 Ibid., p. 88.

38 Bordwell, *Figures Traced in Light*, p. 176.

39 Ibid., p. 173.

40 Dimitris Theodopoulos, *Light in Greek Cinema* (Athens: Aigokeros Publicatios, 2009), p. 178.

41 Vassilis Rafailides, *Journey into Myth through History and into History through Myth: The Cinema of Theo Angelopoulos* (Athens: Aigokeros, 2003), p. 53.

42 Sean Cubbitt, *The Cinema Effect* (Cambridge MA: MIT Press, 2004), p. 363.

43 Truffaut, *Hitchcock*, p. 300.

44 George Seferis, *Complete Poems*, trans. Edmund Keely and Philip Sherrard (London: Anvil Press Poetry, 2009), p. 235.

45 Herbert Marcuse, *One Dimensional Man: Studies in the Ideology of Advanced Industrial Society* (New York: Routledge & Kegan Paul, 1964).

46 Angelopoulos, *Interviews*, p. 147.

47 Archimandritis, *Theodoros Angelopoulos with Naked Voice*, p. 72.

48 Geoff Dyer, *Zona* (New York: Pantheon Books, 2012), pp. 10–11.

49 Friedrich Nietzsche, *The Birth of Tragedy*, trans. Douglas Smith (Oxford: Oxford University Press, 2000), p. 38.

50 Dan Fainaru, 'Review of The Dust of Time', *Screen Daily*, 27 November 2008. Available at http://www.screendaily.com/reviews/europe/features/the-dust-of-time/4042143. article (accessed 25 December 2013).

51 Georg Simmel, *Sociology*, trans., ed. and with an introduction by Kurt H. Wolff (London: The Free Press, 1950), p. 402.

52 Fredric Jameson, *The Ancients and the Postmoderns: On the Historicity of Forms* (London & New York: Verso, 2015), p. 134.

53 Angelopoulos, *Interviews*, p. 147.

54 Michel Fais, 'Short lemon-tree, talking with Theo Angelopoulos', *Protagon*, 26 January 2012. Available at http://www.protagon.gr/?i=protagon.el.article&id=12084 (accessed 12 September 2013).

55 Archimandritis, *Theodoros Angelopoulos with Naked Voice*, p. 86.

# Chapter 6: The Feminine Gaze in Antoinetta Angelidi's Cinema of Imaginative Cathedrals

1 André Bazin, *What is Cinema?*, vol. 1, p. 17.

2 Antoinetta Angelidi, 'Poetic cinema and the mechanism of dream'. Available at http://www.cinemainfo.gr/cinema/theory/articles/poiitikoskinimatografos/index.html (accessed 10 October 2013).

258

# Notes to pages 192–203

3   Gregory J. Markopoulos, *Film as Film: The Collected Writings* (London: The Visible Press, 2014), p. 59.

4   Vrasidas Karalis, *A History of Greek Cinema* (London: Bloomsbury, 2012), p. 143.

5   Vassilis Rafailides, *Film Dictionary*, vol. 3: *Greek Cinema* (Athens: Aigokeros, 2003), p. 29.

6   Savvas Michail, 'A trilogy: notes on the cinema of Costas Sfikas', *CameraStylo OnLine*, 13 May 2011. Available at http://camerastyloonline.wordpress.com/2011/05/13/keimena-s avva-michail-gia-ton-kinimatografo-toukosta-sfika/ (accessed 10 October 2013).

7   Vassilis Mazomenos, 'Review of Angelos Frantzis' film *In the Woods*: assault against the dictatorship of realism', *Eleftherotypia*, 28 September 2010.

8   Vassilis Rafailides, 'Antoinetta Angelidi, *Hours – a Square Film*', *Film Dictionary*, p. 241.

9   Jacques Rancière, *Béla Tarr, The Time After*, trans. Erik Beranek (Minneapolis, MN: Univocal Publishing, 2013), p. 5.

10   Antoinetta Angelidi, Elena Mahaira and Konstantinos Kyriakos, *Writings on Cinema: Interdisciplinary approaches* (Athens: Nefeli Publications, 2005), p. 30.

11   Silvija Jestrovic, 'Theatricality as estrangement of art and life in the Russian avant-garde', *Journal SubStance* 31/2&3 (2002), pp. 45–57, 55.

12   Angelidi, Mahaira and Kyriakos, *Writings on Cinema*, p. 30

13   Christian Metz, *Film Language: A Semiotics of the Cinema*, trans. Michael Taylor (Chicago, IL: University of Chicago Press, 1974), p. 14.

14   Peter Wollen, *Signs and Meaning in the Cinema* (Bloomington, IN: Indiana University Press, 1972), p. 162.

15   Antoinetta Angelidi, 'Self-presentation', in Stella Theodoraki (ed.), *A. Angelidi* (Athens: Aigokeros Publications, 2005), p. 35.

16   Ibid.

17   Antoinetta Angelidi, 'Poetic cinema and the mechanisms of dreaming'. Available at http://www.cinemainfo.gr/cinema/theory/articles/poiitikoskinimatografos/index. html (accessed 12 September 2013).

18   Angelidi, 'Self-presentation', p. 43.

19   Ibid.

20   Antoinetta Angelidi, 'Sewing dreams on a ribbon, a discussion with Yannis Frangoulis', *Greek News Blog*, 12 May 2012. Available at http://greeceactuality.wordpress. com/2012/12/ (accessed 20 September 2013).

21   Ibid.

22   Mary Daly, *Gyn/Ecology: The Metaethics of Radical Feminism* (Boston, MA: Beacon Press, 1978), p. 96.

23   Savvas Michail, *Musica ex Nihilo: Essays on Poetry, Life, Death and Justice* (Athens: Agra Publications, 2013), p. 122.

24   Ibid., p. 128.

25   Whitney Chadwick, *Woman, Art and Society* (London: Thames & Hudson, 1994), p. 97.

26   Daly, *Gyn/Ecology*, p. 111.

27   Maya Deren, 'Amateur versus professional', *Film Culture* 39 (Winter 1965), pp. 45–6.

Notes to pages 204–216

28 Antoinetta Angelidi, 'About cinematic time: Similarities between filmic script and the mechanisms of dreaming', *Vema*, 5 December 2008.

29 Ibid.

30 Plato, *Theaetetus*, 191d–196c, trans. and with an essay by Robin A. H. Waterfield (London: Penguin Books, 2004), pp. 100–1.

31 Antoinetta Angelidi, 'The Pleasure of the Artist', in Stella Theodoraki (ed.), *Antoinetta Angelidi* (Athens: Aigokeros Publications, 2005), p. 94

32 Salvador Dali, *The Secret Life of Salvador Dali* (New York: Dial Press, 1942), p. 42.

33 Sergei Eisenstein, *The Eisenstein Reader*, ed. Richard Taylor, trans. Richard Taylor and William Powell (London: British Film Institute 1998), p. 193.

34 Angelidi, Mahaira and Kyriacos, *Writings on Cinema*, p. 177.

35 John Gage, *Color in Art* (World of Art) (London: Thames & Hudson, 2006), p. 195.

36 Derek Jarman, *Chroma, A Book of Colour – June 93* (London: Vintage, 1994), p. 145.

37 Karalis, *A History of Greek Cinema*, p. 188.

38 Germaine Greer, *The Obstacle Race: The Fortunes of Women Painters and their Work* (London: Secker & Warburg, 1979), p. 207.

39 Maria Katsounaki, 'Review of *The Hours*', *Kathimerini*, 19 January 1996.

40 Sebastian Smee, *Lucian Freud, 1922–2011: Beholding the Animal* (Cologne: Taschen, 2012), p. 34.

41 Maria Katsounaki, 'Experimentation is not a privilege of youth: Interview with A. Angelidi', in Theodoraki (ed.), *Antoinetta Angelidi*, p. 121.

42 Vassilis Mazomenos, 'Review of Angelidi's *Thief*', *Anti Magazine*, 16 November 2001.

43 Daly, *Gyn/Ecology*, p. 71.

44 Hannah Arendt, *The Human Condition* (Chicago, IL and London: University of Chicago Press, 1958), p. 177.

45 Antoinetta Angelidi, ibid.

46 Scott MacDonald, *Avant-Garde Film: Motion Studies* (Cambridge: Cambridge University Press, 1993), pp. 11–12.

47 Angelidi, Mahaira and Kyriacos, *Writings on Cinema*, p. 31.

48 Erwin Panofsky, *Three Essays on Style*, ed. Irving Lavin (Cambridge MA: MIT Press, 1997), p. 119.

# Chapter 7: Greek Cinema in the Age of the Spectacle

1 Guy Debord, *Comments on the Society of the Spectacle*, trans. Malcolm Imri (London: Verso, 1990), p. 20.

2 Dimitris Plantzos, 'Archaeology and Hellenic identity, 1896–2004, the frustrated vision', in Dimitris Damaskos and Dimitris Plantzos (eds), *A Singular Antiquity: Archaeology and Hellenic Identity in Twentieth Century Greece* (Athens: Benaki Museum, 2008), pp. 10–30, 11.

3 Debord, *Comments on the Society of the Spectacle*, pp. 11–12.

4 Guy Debord, *The Society of the Spectacle*, trans. Donald Nicholson-Smith (New York: Zone Books, 1995), p. 45.

## Notes to pages 216–231

5 Ibid., p. 12.

6 Dina Iordanova, 'Rise of the fringe: global cinema's long tail', in Dina Iordanova, David Martin-Jones and Belen Vidal (eds), *Cinema at the Periphery* (Detroit, MI: Wayne State University Press, 2010), pp. 23–45, 25.

7 Panos Koutras, 'Interview', *Kathimerini*, 12 December 2009.

8 Ibid.

9 Steve Rose, '*Attenberg, Dogtooth* and the Weird Wave of Greek cinema', *The Guardian*, 27 August 2011. Available at http://www.theguardian.com/film/2011/aug/27/attenberg-dogtooth-greece-cinema (accessed 9 June 2013).

10 Constantinos Giannaris, *thinkfree*, 9 November 2011. Available at http://www.thinkfree.gr/ (accessed June 10, 2014).

11 Carl Gustav Jung, *Memories, Dream, Reflections* (New York: Pantheon Books, 1961). p. 193.

12 Constantinos Giannaris, 'I don't do politics; I make films', *In.Gr*, 11 November 2011. Available at http://news.in.gr/culture/article/?aid=1231137147 (accessed 10 June 2014).

13 Ibid.

14 Alexis Diamantopoulos, 'Director's Note on the Film', November 2006, Available at http://www.livemovies.gr/movies/galazio-forema (accessed 11 June 2014).

15 Alexis Dermetzoylou, 'The extra-filmic event', July 2006, Available at http://www.nikolaidis.eexi.gr/zeroyears/kritikes.htm (accessed 12 October 2014).

16 Jean Baudrillard, *Selected Writings*, ed. Mark Poster (Cambridge: Polity, 1988), p. 38.

17 Max Horkheimer and Theodor Adorno, *Dialectic of Enlightenment*, trans. Edmund Jephcott (Stanford, CA: Stanford University Press, 2002), p. 4.

18 Theodoris Koutsogiannopoulos, '*Kinetta*', *Lifo*, 18 April 2007. Available at http://www.lifo.gr/mag/cinema/25 (accessed 20 Januray 2015).

19 Yorgos Lanthimos, 'The unembellished film of Yorgos Lanthimos', *Kathimerini*, 4 September 2005. Available at http://www.kathimerini.gr/227352/article/politismos/arxeio-politismoy/h-aftiasidwth-tainia-toy-g-lan8imoy (accessed 29 January 2015).

20 Maria Katsounaki, 'From Sfikas to Lanthimos', *Kathimerini*, 26 May 2009. Available at http://www.kathimerini.gr/714681/opinion/epikairothta/arxeio-monimes-sthles/apo-ton-sfhka-ston-lan8imo (accessed 27 January 2015).

21 Charles Ramírez Berg, *Cinema of Solitude, A Critical Study of Mexican Film, 1967–1983* (Austin, TX: University of Texas Press, 1992), p. 161.

22 Vena Yeoryakopoulou, 'Yorgos Lanthimos: Our choices are mostly instinctive', *Cinephilia*, 8 October 2011. Available at http://www.cinephilia.gr/index.php/keimena/pressclips/212-lanthimos (accessed 20 January 2015).

23 Guy Lodge, 'Avranas' *Miss Violence*', *Variety*, 2 September 2013. Available at http://variety.com/2013/film/reviews/miss-violence-review-venice-1200595937/ (accessed 27 January 2015).

24 Robert Bresson, *Notes on the Cinematographer*, trans. Jonathan Griffin (Copenhagen: Greek Integer, 1997), p. 21.

25 Yiagos Antiohos, 'Interview with Ektoras Lygizos', *Athenorama*, 20 December 2011.

# Notes to pages 231–245

26 'Ektoras Lygizos: *Boy Eating the Bird's food* was not destined for being a political film but on the way it developed a social meaning', 11 July 2012. Available at http://www.moveitmag.gr/faces/interviews/lygizos_vari#.VCZzu1e_7Ec (accessed 23 January 2015).

27 Varvara Savvides, 'Costas Zapas Talks', 2 November 2011. Available at http://www.elculture.gr/elcblog/article/kostas-zapas-72156 (accessed 22 Januray 2015).

28 Costas Zapas, 'The tragedy of Greece', *Of Tragedy, of Myth*, 5 February 2012. Available at http://www.protothema.gr/culture/cinema/article/175121/kostas-Zapas-h-ellada-th s-tragodias_-ths-krishs-kai-toy-mythoy/ (accessed 10 December 2014).

29 Yorgos Papastamoulos, 'Constantinos Zapas, "The Situation today in Greek Cinema is … very Greek"'. Available at http://www.os3.gr/archive_interviews/gr_interviews_kos-tas_Zapas.htm (accessed 10 December 2014)

30 Alexandre Kojève, '*Introduction to the Reading of Hegel, Lectures on* The Phenomenology of Spirit', trans. James H. Nicholas Jr (Ithaca, NY and London: Cornell University Press, 1960), p. 50.

31 Nikos Poulantzas, *The Poulantzas Reader: Marxism, Law and the State*, ed. James Martin (London and New York: Verso, 2008), p. 411.

32 Tom Levin, 'From dialectical to normative specificity: reading Lukacs on film', *New German Critique* 40 (Winter 1987), pp. 35–61, 58.

33 Angelopoulos, *Interviews*, p. 53.

34 R. G. Collingwood, *The Principles of Art* (London: Oxford University Press, 1958), p. 336.

# Optimistic Epilogue

1 *Aliki Vouyiouklaki talks to Jason Triantafyllides* (Athens: Andy's Publishers, 2014), p. 79.

2 Michael Cacoyannis, 'Interview with James Potts', in Babis Kolonias (ed.), *Michael Cacoyannis* (Athens: Kastaniotis Publications, 1995), p. 104.

# Bibliography

Aitken, Ian, *Realist Film Theory and Cinema: The Nineteenth-century Lukacsian and Intuitionist Realist Traditions* (Manchester and New York: Manchester University Press, 2006).

Alexander, Jeffrey C., *Trauma: A Social Theory* (Cambridge: Polity, 2012).

Anderson, Lindsay, *Never Apologise: The Collected Writings*, ed. Paul Ryan (London: Plexus, 2004).

Angelidi, Antoinetta, 'The game with the uncanny: poetics for the cinema', in Angelidi, Antoinetta, Mahaira, Eleni and Kyriacos, K. (eds), *Writings on Cinema* (Athens: Nefeli Publications, 2005), pp. 11–36.

____, 'Self-presentation', in Theodoraki, Stella (ed.), *A. Angelidi* (Athens: Aigokeros Publications, 2005).

____, 'About cinematic time: similarities between filmic script and the mechanisms of dreaming', *Vema*, 5 December 2008.

____, 'Poetic cinema and the mechanism of dream'. Available at http://www.cine-mainfo.gr/cinema/theory/articles/poiitikoskinimatografos/index.html (accessed 10 October 2013).

Angelopoulos, Theo, *Interviews*, ed. Dan Fainaru (Jackson, MS and London: University Press of Mississippi, 2001).

____, 'I am standing by you', interview with Jane Gabriel, 25 January 2012. Available at http://www.opendemocracy.net/article/a-closed-horizon (accessed 9 September 2013).

Antiohos, Yiagos, 'Interview with Ektoras Lygizos'. Available at http://www.mag24.gr/interview/synenteyksi-ektoras-lygizos-polybrabeymenos-skinothetis (accesses 12 October 2013).

Archimandritis, Yorgos, *Thodoros Angelopoulos with Naked Voice* (Athens: Patakis Publications, 2013).

Arendt, Hannah, *The Human Condition* (Chicago, IL and London: University of Chicago Press, 1958).

Aristotle, *Poetics*, ed. and trans. Stephen Halliwell (Cambridge, MA: Harvard University Press, 1999).

Arnheim, Rudolf, *Visual Thinking* (Berkeley and Los Angeles, CA: University of California Press, 1969).

Artaud, Antonin, *The Theatre and its Double* (London: Calder Publications, 1970).

Bakhtin, Mikhail, *The Dialogic Imagination: Four Essays*, ed. Michael Holquist, trans. Caryl Emerson and Michael Holquist (Austin, TX: University of Texas Press, 1981).

Bakogianni, Anastasia, 'All is well that ends tragically: filming Greek tragedy in modern Greece', *Bulletin of the Institute of Classical Studies* 51/1 (2008), pp. 119–67.

# Bibliography

_____, *Electra, Ancient and Modern, Aspects of the Reception of the Tragic Heroine* (London: Institute for Classical Studies, 2011).

Balazs, Bela, *Theory of the Film, Character and Growth of a New Art*, trans. Edith Bone (New York: Dover Publications, 1970).

Barthes, Roland, *The Degree Zero of Writing*, trans. Annette Lavers and Colin Smith (London: Jonathan Cape 1967).

_____, *The Rustle of Language*, trans. Richard Howard (Berkeley, CA: University of California Press, 1986).

Baudrillard, Jean, *Selected Writings*, ed. Mark Poster (Cambridge: Polity Press, 1988).

Bazin, André, *What is Cinema?*, vols 1 & 2 (Berkeley and Los Angeles, CA: University of California Press, 1967).

_____, *The Cinema of Cruelty: From Buñuel to Hitchcock* (New York: Seaver Books, 1982).

_____, *Orson Welles, A critical View* (Los Angeles, CA: Acrobat Books, 1991).

Benjamin, Walter, *Illuminations: Essays and Reflections*, ed. Hannah Arendt (New York: Schocken Books, 1968).

Berg, Charles Ramírez, *Cinema of Solitude, A Critical Study of Mexican Film, 1967–1983* (Austin, TX: University of Texas Press, 1992).

Berger, John, *Ways of Seeing* (London: Penguin Books, 1978).

Bergman, Ingmar, *The Magic Lantern* (Chicago, IL: University of Chicago Press, 1987).

Biro, Yvette, *Turbulence and Flow in Film: The Rhythmic Design*, trans. Paul Salamon (Bloomington and Indianapolis, IN: Indiana University Press, 2008).

Blathras, Konstantinos, *Lights/Sound/Let's Go: Ten Directors Talk* (Athens: Maistros Publications, 2003).

Bondanella, Peter, *The Films of Roberto Rossellini* (Cambridge: Cambridge University Press, 1993).

_____, *A History of Italian Cinema* (New York and London: Continuum, 2009).

Bordwell, David, 'Contemporary film studies and the vicissitudes of Grand Theory', in Bordwell, David and and Carroll, Noel (eds), *Post-Theory: Reconstructing Film Studies* (Madison, WI: University of Wisconsin Press, 1996), pp. 1–36.

_____, *Figures Traced in Light* (Berkeley, CA: University of California Press, 2005).

_____, *The Way Hollywood Tells It: Story and Style in Modern Movies* (Berkeley, CA: University of California Press, 2006).

Bordwell, David and Thomson, Kristin, *Film Art: An Introduction*, 9th edn (New York: McGraw-Hill, 2010).

Bowie, Malcolm, *Lacan*, (London: Fontana Press, 1991).

Bradshaw, Peter, 'Franzen's *Freedom* revives legend of *The Dragon*', 12 October 2011. Available at http://www.theguardian.com/film/filmblog/2011/oct/12/jonathan-franzen-freedom-the-dragon (accessed 12 December 2013).

Bresson, Robert, *Notes on the Cinematographer*, trans. Jonathan Griffin (Copenhagen: Greek Integer, 1977).

Bursch, Noël, *To the Distant Observer: Form and Meaning in Japanese Cinema* (Berkeley and Los Angeles, CA: University of California Press, 1979).

Burch, Noël, *Theory of Film Practice*, trans. Helen R. Lane (Princeton, NJ: Princeton University Press, 1969).

# Bibliography

Butler, Judith, *Gender Trouble: Feminism and the Subversion of Identity* (London: Routledge, 1990).

Cacoyannis, Michael, *That is to Say* (Athens: Kastaniotis, 1990).

____, 'Interview with James Potts', in Kolonias, Babis (ed.), *Michael Cacoyannis* (Athens: Kastaniotis Publications, 1995).

____, '*Electra*', in Soldatos, Yannos, *History of Greek Cinema*, vol. 4: *Documents (1900–1970)* (Athens: Aigokeros Publications, 2004).

Camus, Albert, *The Myth of Sisyphus*, trans. Justin O' Brien (London: Penguin Books, 2000).

Castoriadis, Cornelius, *World in Fragments*, ed. and trans. David Ames Curtis (Stanford, CA: Stanford University Press, 1997).

Cavell, Stanley, *Contesting Tears, The Hollywood Melodrama of the Unknown Woman* (Chicago, IL: University of Chicago Press, 1996).

Chadwick, Whitney, *Woman, Art and Society* (London: Thames & Hudson, 1994).

Charitos, Dimitris (ed.), *Gregoris Gregoriou* (Athens: Aigokeros Publications, 1996).

Chaudhuri, Shohini, *Contemporary World Cinema: Europe, The Middle East, East Asia and South Asia* (Edinburgh: Edinburgh University Press, 2005).

Cohen, Tom, *Hitchcock's Cryptonymies*, vol. I: *Secret Agents* (Minneapolis, MN: University of Minnesota Press, 2005).

Collingwood, R. G., *The Principles of Art* (London: Oxford University Press, 1958)

Constantinidis, Stratos E., 'What did you do in the war, Thanassis?', in Dina Iordanova (ed.), *The Cinema of The Balkans* (London and New York: Wallflower Press, 2006), pp. 87–96.

Cousins, Mark, *The Story of Film* (London: Pavilion, 2004).

Cowie, Peter, *Eighty Years of Cinema* (London: The Tantivy Press, 1977).

____, *Ingmar Bergman: A Critical biography* (London: Secker & Warburg, 1982).

____, *John Ford and the American West* (New York: Harry Abrams Inc., 2004).

____, *Revolution!: The Explosion of World Cinema in the 60s* (London: Faber & Faber, 2004).

Crowther, Bosley, '*Girl in Black*: Film by Cacoyannis of Greece Opens in Paris', *The New York Times*, 17 September 1957. Available at: http://www.nytimes.com/movie/review?res=90 C01E1D61130E23BBC4F52DFBF66838C649EDE (accessed 12 October 2014).

Dali, Salvador, *The Secret Life of Salvador Dali* (New York: Dial Press, 1942).

Dalianidis, Yannis, *Cinema, Faces and I* (Athens: Kastaniotis Publications, 2005).

____, *Talks to Jason Triantafillidi* (Athens: Andy's Publishers, 2014).

Daly, Mary, *Gyn/Ecology: The Metaethics of Radical Feminism* (Boston, MA: Beacon Press, 1978).

Debord, Guy, *Comments on the Society of the Spectacle*, trans. Malcolm Imrie (London and New York: Verso, 1998).

____, *The Society of the Spectacle*, trans. Donald Nicholson-Smith (New York: Zone Books, 1995).

Deleuze, Gilles, *Bergsonism*, trans. Hugh Tomlinson and Barbara Habberjam (New York: Zone Books, 1991).

____, *Cinema 2: The Time-Image*, trans. Hugh Tomlinson and Robert Galeta (London: Continuum, 2005).

Deren, Maya, 'Amateur versus professional', *Film Culture* 39 (Winter 1965), pp. 45–6.

# Bibliography

_____, 'An anagram of ideas on art, form and film', in Nicolls (ed.), *Maya Deren and the American Avant-Garde*, pp. 267–322.

Dermetzoylou, Alexis, 'The extra-filmic event', July 2006. Available at http://www.nikolaidis.eexi.gr/zeroyears/kritikes.htm (accessed 12 October 2014).

Diamantopoulos, Alexis Director's Note on the Film', November 2006. Available at http://www.livemovies.gr/movies/galazio-forema (accessed 11 June 2014).

Donaldson, Peter, 'Olivier, Hamlet and Freud', *Cinema Journal* 26/4 (Summer 1987), pp. 22–48.

Dyer, Geoff, *Zona* (New York: Pantheon Books, 2012).

Eleftheriotis, Dimitris, *Popular Cinemas of Europe: Studies of Texts, Contexts and Frameworks* (New York and London: Continuum, 2001).

Eliot, T. S., *Selected Prose of T. S. Eliot* (London: Faber & Faber, 1975).

Elkins, James, *The Object Stares Back: On the Nature of Seeing* (San Diego, CA: A Harvest Book, 1996).

Elsaesser, Thomas, *German Cinema: Terror and Trauma, Cultural Memory since 1945* (New York and London: Routledge, 2014).

Eisenstein, Sergei, *Immoral Memoirs* [1946] (Boston, MA: Houghton Mifflin, 1984).

_____, *The Eisenstein Reader*, ed. Richard Taylor, trans. Richard Taylor and William Powell (London: British Film Institute 1998).

'Ektoras Lygizos: *Boy Eating the Bird's Food* was not destined for being a political film but on the way it developed a social meaning', 11 July 2012. Available at http://www.moveitmag.gr/faces/interviews/lygizos_vari#.VCZzu1e_7Ec (accessed 24 October 2013).

Fainaru, Dan, review of *The Dust of Time*, 27 November 2008. Available at http://www.screendaily.com/reviews/europe/features/the-dust-of-time/4042143.article (accessed 10 September 2013).

Ferrari, Fabrizio M., *Ernesto de Martino: On Religion* (London: Equinox Publishing, 2012).

Florensky, Pavel, *Beyond Vision, Essays on the Perception of Art*, compiled and ed. Nicoletta Misler, trans. Wendy Salmon (London: Reaktion Books, 2002).

Foucault, Michel, *The Archaeology of Knowledge*, trans. A. M. Sheridan Smith (New York: Pantheon Books, 1972).

_____, *The Foucault Reader*, ed. Paul Rabinow (New York: Pantheon Books, 1974).

Franzen, Jonathan, *Freedom, A Novel* (London: Fourth Estate, 2010).

Freud, Sigmund, 'Mourning and melancholia' [1915], in Strachey, James and Freud, Anna (eds), *The Standard Edition of the Complete Psychological Works of Sigmund Freud*, vol. 14: *On the History of the Psycho-Analytic Movement*, trans. James Strachey (London: Vintage, 2001), pp. 243–58.

Gage, John, *Color in Art* (World of Art) (London: Thames & Hudson, 2006).

Georgakas, Dan, 'Stella', in Iordanova, Dina (ed.), *The Cinema of the Balkans* (London and New York: Wallflower, 2006), pp. 13–21.

Giannaris, Constantinos, *thinkfree*, 9 November 2011. Available at http://www.thinkfree.gr/pressroom/ (accessed 15 October 2013).

_____, 'I don't do politics, I make films, 11 November 2011. Available at http://news.in.gr/culture/article/?aid=1231137147 (accessed 10 June 2014).

# Bibliography

Gibbs, John, *Mise-en-Scène, Film Style and Interpretation* (London and New York: Wallflower, 2002).

Gibson, J. J., 'On the concept of "formless invariants" in visual perception', *Leonardo* 6/1 (Winter 1973), pp. 43–5.

____, 'The myth of passive perception, a reply to Richards', *Philosophy and Phenomenological Research* 37 (December 1976), pp. 234–8.

Goldmann, Lucien, *Towards a Sociology of the Novel*, trans. Alan Sheridan (London: Tavistock, 1975).

Gourgouris, Stathis, 'Hypnosis and critique: film music in the Balkans', in Bjelic, Duan I. and Savic, Obrad (eds), *Balkan as Metaphor, Between Globalization and Fragmentation* (Cambridge, MA: MIT Press, 2002), pp. 323–50.

Greer, Germaine, *The Obstacle Race: The Fortunes of Women Painters and their Work* (London: Secker & Warburg, 1979).

Gregoriou, Gregoris, *Memories in White and Black*, vol. 1 (Athens: Aigokeros Publications, 1988).

____, *Recollections in Black and White*, vol. 2 (Athens: Aigokeros Publications, 1996).

Grierson, John, *On Documentary*, edited and with an introduction by Forsyth Hardy (London: Faber & Faber, 1979).

Hadjikyriacou, Achilleas, 'Cacoyannis's *Stella*: representation and reception of a patriarchal anomaly', in *Greek Cinema: Texts, Histories, Identities* ed. Lydia Papadimitrius and Yannis Tzioumakis (Bristol and Chicago, IL: Intellect, 2012), pp. 87–202.

Hayward, Susan, *Cinema Studies, The Key Concepts*, 3rd edn (London and New York: Routledge, 2006).

Heidegger, Martin, *Being and Time*, trans. Joan Stambaugh (New York: State University of New York Press, 1996).

Horkheimer, Max and Theodor Adorno, *Dialectic of Enlightenment*, trans. Edmund Jephcott (Stanford, CA: Stanford University Press, 2002).

Horton, Andrew, *The Films of Theo Angelopoulos: A Cinema of Contemplation* (Princeton, NJ: Princeton University Press, 1999).

Iordanova, Dina, *Cinema of Flames: Balkan Film, Culture and the Media* (London: Palgrave Macmillan, 2009).

____, 'Rise of the fringe: global cinema's long tail', in *Cinema at the Periphery*, ed. Dina Iordanova, David Belen and Vidal Belen, (Detroit, MI: Wayne State University Press, 2010), pp. 23–45.

Isaacs, Bruce, *The Orientation of Future Cinema: Technology, Aesthetics, Spectacle* (London and New York: Bloomsbury, 2013).

Jameson, Fredric, *The Antinomies of Realism* (London and New York: Verso Books, 2013).

____, *The Ancients and the Postmoderns: On the Historicity of Forms* (London & New York, Verso, 2015).

Jarman, Derek, *Chroma, A Book of Colour – June 93* (London: Vintage, 1994).

Jay, Martin, 'Scopic regimes of modernity', in *Vision and Visuality* ed. Hal Foster, (New York: New Press, 1999), pp. 3–23.

Jestrovic, Silvija, 'Theatricality as estrangement of art and life in the Russian avant-garde', *Journal SubStance* 31/2&3 (2002), pp. 45–57.

# Bibliography

Jung, Carl Gustav, *Memories, Dream, Reflections* (New York: Pantheon Books, 1961).

Kael, Pauline, *Kiss Kiss, Bang Bang: Film Writings 1965–1967* (London: Arena, 1970).

\_\_\_\_, *5001 Nights at the Movies* (New York: Henry Holt & Company, 1982).

\_\_\_\_, *The Age of Movies: Selected Writings of Pauline Kael*, ed. Sanford Schwartz (New York: Library of America, 2011).

Karalis, Vrasidas, 'The disjunctive aesthetics of myth and history in Theo Angelopoulos' *Ulysses' Gaze*', *Literature and Aesthetics* 16/2 (December 2006), pp. 252–68.

\_\_\_\_, *A History of Greek Cinema* (New York and London: Continuum, 2012).

\_\_\_\_, 'From the archives of Oblivion: the first female Greek director Maria Plyta (1915–2006)', *Modern Greek Studies, Australia and New Zealand* 16–17/A (2013–4), pp. 45–67.

\_\_\_\_, 'Traumatised Masculinity and Male Stardom in Greek Cinema', in *Stars in World Cinema: Screen Icons and Star Systems Across Cultures*, ed. Andrea Bandhauer and Michelle Royer (London and New York: I.B.Tauris, 2015).

\_\_\_\_, 'Religion and Greek Cinema', *Filmicon*, 28 December 2014. Available at http://filmiconjournal.com/blog/post/35/religion_and_greek_cinema (accessed 12 July 2015).

Katsounakis, Maria, 'Review of *The Hours*', *Kathimerini*, 19 January 1996.

\_\_\_\_, 'A seductive Cherry Orchard', *Kathimerini*, 28 January 2000.

\_\_\_\_, 'From Sfikas to Lanthimos', *Kathimerini*, 26 May 2009.

Keats, John, *The Complete Poetical Works and Letters* (Cambridge: Cambridge University Press, 1985).

Keranidis, Stratos, 'An Interview with Dimos Theos', in Keranides, Stratos (ed.) *Dimos Theos* (Athens: Aigokeros Publications, 2006).

Kojève, Alexandre, 'Introduction to the reading of Hegel, lectures on *The Phenomenology of Spirit*', trans. James H. Nicholas Jr (Ithaca, NY and London: Cornell University Press, 1960).

Koselleck, Reinhart, *The Practice of Conceptual History, Timing History, Spacing Concepts*, trans. Todd Samuel Presner and others (Stanford, CA: Stanford University Press, 2002).

Koundouros, Nikos, *I Dreamed that I Died* (Athens: Ikaros Publications, 2009).

\_\_\_\_, *Stop Carré* (Athens: Ergo Publications, 2009).

\_\_\_\_, interviewed by Yannis Zoumboulakis, *Vema*, 16 March 2013. Available at http://www.tovima.gr/culture/article/?aid=502977 (accessed 20 November 2013).

Koutras, Panos, 'Interview', *Kathimerini*, 12 December 2009.

Koutsoyiannopoulos, Theodoris, '*Kinetta*', *Lifo*, 18 April 2007. Available at http://www.lifo.gr/mag/cinema/25 (accessed 18 October 2013).

\_\_\_\_, 'Only one star for Koundouros's movie'. Available at http://www.lifo.gr/mag/cinema/2186 (accessed 20 November 2013).

Kracauer, Siegfried, *Theory of Film: The Redemption of Physical Reality* (Princeton, NJ: Princeton University Press, 1997).

Kristeva, Julia, *Powers of Horror: An Essay on Subjection* (New York: Columbia University Press, 1982).

Kyriakos, Constantine, *Difference and Eroticism* (Athens: Aigokeros Publications, 2001).

Lacan, Jacques, *Écrits*, trans. Bruce Fink (New York and London: W.W. Norton & Co., 2006).

# Bibliography

Laplanche, Jean and Jean-Bertrand Pontalis *The Language of Psychoanalysis*, trans. Donald Nicholson-Smith (New York: Norton, 1973).

Lassally, Walter, *Itinerant Cameraman* (London: John Murray, 1987).

Levin, Tom, 'From dialectical to normative specificity: reading Lukacs on film', *New German Critique* 40 (Winter 1987), pp. 35–61.

Lindsay, Vachel, *The Art of the Moving Picture* [1915] (New York: The Modern Library, 2000).

Lodge, Guy, 'Avranas' *Miss Violence*', *Variety*, 2 September 2013. Available at http://variety.com/2013/film/reviews/miss-violence-review-venice-1200595937/ (accessed 1 November 2013).

Lucie-Smith, Edward, *American Realism* (London: Thames & Hudson, 1994).

MacCabe, Colin, *Godard: Images, Sounds, Politics* (London: British Film Institute, 1980).

MacDonald, Scott, *Avant-Garde Film: Motion Studies* (Cambridge: Cambridge University Press, 1993).

Magarshack, David, *Stanislavsky: A Life* [1950], 2nd edn (London: Faber & Faber, 1986).

Mahaira, Eleni, 'A. Angelidi: painting, the matrix', in *Writings On Cinema: A. Angelidi* ed. Antoinetta Angelidi, Eleni Mahaira and K. Kyriacos, (Athens: Nefeli Publications, 2005), pp. 133–9.

Markopoulos, Gregory J., *Film as Film: The Collected Writings* (London: The Visible Press, 2014).

Mast, Gerald, *The Comic Mind: Comedy and the Movies*, 2nd edn (Chicago, IL and London: University of Chicago Press, 1979).

Mazomenos, Vassilis, 'Review of Angelidi's *Thief*', *Anti Magazine*, 16 November 2001.

_____, 'Review of Angelos Frantzis' film *In the Woods*: assault against the dictatorship of realism', *Eleftherotypia*, 28 September 2010.

Merleau-Ponty, Maurice, *The Merleau-Ponty Aesthetics Reader: Philosophy and Painting*, ed. Galen A. Johnson, trans. Michael B. Smith (Evanston, IL: Northwestern University Press, 1993).

Metz, Christian, *Film Language: A Semiotics of the Cinema*, trans. Michael Taylor (Chicago, IL: University of Chicago Press, 1974).

Michail, Savvas, 'A trilogy: notes on the cinema of Costas Sfikas', *CameraStylo OnLine*, 13 May 2011. Available at http://camerastyloonline.wordpress.com/2011/05/13/keimena-s avva-michail-gia-ton-kinimatografo-toukosta-sfika/ (accessed 10 October 2013).

_____, *Musica ex Nihilo: Essays on Poetry, Life, Death and Justice* (Athens: Agra Publications, 2013).

Michelidis, Ninos-Fennec, *100 Years of Greek Cinema* (Athens: Patriarcheas Publications, 1997).

Mitropoulou, Aglaia, *Greek Cinema*, 2nd edn (Athens: Papazisis Publications, 2006).

Moshovakis, Antonis, 'Review of *The Illegals*', in *History of Greek Cinema*, ed. Yannis Sodatos vol. 4: *Documents 1900–1970* (Athens: Aigokeros Publications, 2004), pp. 310–12.

Mulvey, Laura, 'Visual pleasure and narrative cinema', *Screen* 16/3 (1975), pp. 6–18.

_____, *Visual and Other Pleasures*, 2nd edn (London: Palgrave Macmillan, 2009).

_____, *Fetishism and Curiosity, Cinema and the Mind's Eye* (London: Palgrave Macmillan, 2013).

Nagib, Lúcia, *World Cinema and the Ethics of Realism* (New York: Continuum, 2011).

Nagib, Lúcia and Anne Jerslev, *Impure Cinema: Intermedial and Intercultural Approaches to Film* (London: I.B.Tauris, 2014).

# Bibliography

Nicolls, Bill (ed.), *Maya Deren and the American Avant-Garde* (Berkeley, CA: University of California Press, 2001).

Nora, Pierre, 'General introduction: between memory and history', in *Realms of Memory*, vol. 1: *The Construction of the French Past*, ed. Lawrence D. Kritzman, trans. Arthur Goldhammer (New York: Columbia University Press, 1996), pp. 1–20.

Panofsky, Erwin, *Three Essays on Style*, ed. Irving Lavin (Cambridge MA: MIT Press, 1997).

Papadimitriou, Lydia, *The Greek Film Musical, A Critical and Cultural History* (Jefferson, NC and London: McFarland, 2006).

———, 'Greek film studies today: in search of identity', *Kampos: Cambridge Papers in Modern Greek* 17 (2009), pp. 49–78.

Papamichalis, Vion, 'Greek film production', in *History of Greek Cinema*, ed. Yannis Soldatos vol. 4: *Documents 1900–1970* (Athens: Aigokeros Publications, 2004), pp. 144–5.

Papaioannou, Kostas, *Byzantine and Russian Painting* (London: Heron Books, 1965).

Parkinson, David, *History of Film* (London: Thames & Hudson, 2012).

Pasolini, Pier Paolo, *Heretical Empiricism*, trans. Ben Lawton and Louise K. Barnett (Washington, DC: New Academia Publishing, LLC, 2005).

Phillips, Christopher, 'Introduction', *Montage and Modern Life 1919–1942* ed. Matthew Teitelbaum (Cambridge, MA: MIT Press, 1992).

Plantzos, Dimitris, 'Archaeology and Hellenic identity, 1896–2004, the frustrated vision', in *A Singular Antiquity: Archaeology and Hellenic Identity in Twentieth Century Greece* ed. Dimitris Damaskos and Dimitris Plantzos (Athens: Benaki Museum, 2008), pp. 10–30.

Plato, *Theaetetus*, trans. with an essay by Robin A. H. Waterfield (London: Penguin Books, 1987).

Plorites, Marios, 'Review of *Magic City*', *Eleutheria*, 12 January 1955, in *History of Greek Cinema*, ed. Yannis Soldatos, vol. 4: *Documents 1900–1970* (Athens: Aigokeros Publications, 2004), pp. 254–5.

Politis, Kosmas, *Eroica* [1937] (Athens: Ermis Publications, 1987).

Poulantzas, Nikos, *The Poulantzas Reader: Marxism, Law and the State*, ed. James Martin (London and New York: Verso, 2008).

Prendeville, Brendan, *Realism in 20th Century Painting* (London: Thames & Hudson, 2000).

Propp, Vladimir, *Morphology of the Folk-tale*, trans. Lawrence Scott, 2nd edn (Austin, TX: Texas University Press, 1968).

Rafailides, Vasilis, *Film-Constructionism: A Method for Reading Films* (Athens: Aigokeros Publications, 1984).

———, *12 Lessons on Cinema: A Method for Reading Films* (Athens: Aigokeros Publications, 1996).

———, *Film Dictionary*, vol. 3: *Greek Cinema* (Athens: Aigokeros Publications, 2003).

Rancière, Jacques, *A Hundred Years of Japanese Film*, revised and updated (New York: Kodansha USA, 2012).

———, *Béla Tarr, The Time After*, trans. Erik Beranek (Minneapolis: Univocal Publishing, 2013).

Richie, Donald, *Ozu* (Berkeley, CA: University of California Press, 1977).

Rose, Steve, 'Attenberg, Dogtooth and the Weird Wave of Greek cinema', *The Guardian*, 27 August 2011. Available at http://www.theguardian.com/film/2011/aug/27/attenberg-dogtooth-greece-cinema (accessed 9 September 2013).

# Bibliography

Rosen, Michael, *On Voluntary Servitude: False Consciousness and the Theory of Ideology* (Cambridge: Polity Press, 1996).

Rouch, Jean, *Cine-Ethnography*, ed. and trans. Steven Field (Minneapolis, MN and London: University of Minnesota Press, 2003).

Said, Edward, *On Late Style* (London: Bloomsbury, 2006).

Sarris, Andrew, *The American Cinema: Directors and Directions, 1929–1968* (New York: Da Capo Press, 1996).

Sartre, Jean-Paul, *On Theatre*, trans. Frank Jellinek (London: Quartet Books, 1976).

Savvides, Varvara, 'Costas Zapas talks', 2 November 2011. Available at http://www.elculture.gr/elcblog/article/kostas-zapas-72156 (accessed 2 November 2013).

Schatz, Thomas *Hollywood Genres, Formulas, Filmmaking and the Studio System* (New York: Random House, 1981).

Sfikas, Costas, 'Nothings can replace the suggestiveness created by silence': A conversation with Frida Liappa and Gina Konidou, in, *Costas Sfikas , ed. Yannis Soldatos* (Athens, Aigokeros Publications, 2004).

Shklovsky, Viktor, *Literature and Cinematography*, trans. Irina Masinovsky (Champaign, IL and London: Dalkey Archive Press, 2008).

Siafkos, Christos, *Michael Cacoyannis, On Close-up* (Athens: Psihogios, 2009).

Silverman, Kaja, *Male Subjectivity at the Margins* (New York and London: Routledge, 1992).

Smee, Sebastian, *Lucian Freud, 1922–2011: Beholding the Animal* (Cologne: Taschen, 2012).

Soldatos, Yannis, ed. *History of Greek Cinema*, vol. 1: *1900–1967* (Athens: Aigokeros Publications, 1999).

____, *History of Greek Cinema*, vol. 4: *Documents (1900–1970)* (Athens: Aigokeros Publications, 2004).

____, *Corporeal Odysseys in the Work of Nikos Koundouros* (Athens: Aigokeros Publications, 2007).

Spoto, Donald, *The Art of Alfred Hitchcock* (New York: Anchor Books, 1992).

Stamatiou, Kostas, 'Avgi', 19 August 1956, in *History of Greek Cinema*, ed. Yannis Sodatos, vol. 4: *Documents 1900–1970*, p. 267.

Stanislavsky, Konstantin, *An Actor's Handbook: An Alphabetical Arrangement of Concise Statements on Aspects of Acting*, ed. and trans. Elizabeth Reynolds Hapgood (London: Methuen, 1963).

Stassinopoulou, Maria, 'Definitely maybe: possible narratives of the history of Greek cinema', in *Greek Cinema, Texts, Histories, Identities*, ed. Lydia Papadimitriou and Yannis Tzioumakis (Bristol and Chicago, IL: Intellect, 2012), pp. 129–43.

Stathi, Eirini, *Space and Time in Theo Angelopoulos' Cinema* (Athens: Aigokeros Publications, 1999).

Stavrou, Gerasimos, 'Avgi', 1954. Available at http://www.mcf.gr/downloads/01avgi1954.jpg (accessed 23 November 2013).

Thanouli, Eleftheria, *Post-Classical Cinema: An International Poetics of Film Narration* (London and New York: Wallflower Press, 2009).

Theodopoulos, Dimitris, *Light in Greek Cinema* (Athens: Aigokeros Publications, 2009).

# Bibliography

Thomson, David, *'Have You Seen ...?'* (London: Penguin Books, 2008).

———, *The New Biographical Dictionary of Film* (New York: Alfred A. Knopf, 2010).

Thompson, Kristin, *Breaking the Glass Armor: Neoformalist Film Analysis* (Princeton, NJ: Princeton University Press, 1988).

Tombros, Yannis, 'The Question of Greek Cinema' (1945), in *History of Greek Cinema*, ed. Yannis Soldatos, vol. 4: *Documents 1900–1970*, pp. 157–8.

Triantafyllides, Jason, *Talks with Yannis Dalianidis* (Athens: Andy's Publishers, 2014).

———, *George Tzavellas, International filmmaker* (Athens: Andy's Publishers, 2014).

———, *Aliki Vouyiouklaki Talks to Jason Triantafyllides* (Athens: Andy's Publishers, 2014).

Truffaut, François, *Hitchcock* (London: Paladin/Grafton Books, 1984).

Tsarouchis, Yannis, 'We saw Shakespeare for the first time', *Eleftheorypia*, 5 September 1979. Available at http://www.mcf.gr/downloads/18review00002.jpg (accessed 12 January 2015).

Tsilimidis, Manos, *Almost Between Us* (Athens: Kaktos, 2001).

Tumarkin, Maria, *Traumascapes: The Power and Fate of Places Transformed by Tragedy* (Melbourne: Melbourne University Press, 2005).

Vaneigem, Raoul, *The Revolution of Everyday Life*, trans. Donald Nicholson-Smith (London: Rebel Press, 1983).

Vaughan, William, *Romanticism and Art* (London: Thames & Hudson, 2003).

Vlahou, Eleni, *'Windfall in Athens'*, *I Kathimerini*, 13 January 1954, in *History of Greek Cinema*, ed. Soldatos, vol. 4: *Documents 1900–1970*, pp. 250–1.

Volkan, Vamik D. and Norman Itzkowitz, 'Modern Greek and Turkish identities and the psychodynamics of Greek–Turkish relations', in Antonius C. G. M. Robben, Antonius C.G.M. and Marcelo M. Suarez-Orozco, *Cultures under Siege: Collective Violence and Trauma* (Cambridge: Cambridge University Press, 2000), pp. 227–47.

Voutsadaki, Antonia, *Nikos Koundouros' The Ogre of Athens: A Political Cinema* (Athens: Aigokeros Publications, 2006).

Wall, Geoffrey, *Flaubert: A Life* (London: Faber & Faber, 2001).

White, Hayden, *The Content of the Form, Narrative Discourse and Historical Representation* (Baltimore, MD and London: The John Hopkins University Press, 1987).

Witt, Micheal, *Jean-Luc Godard, Cinema Historian* (Bloomington and Indianapolis, IN: Indiana University Press, 2013).

Wollen, Peter, *Signs and Meaning in the Cinema* (Bloomington, IN: Indiana University Press, 1972).

Worringer, Wilhelm, *Abstraction and Empathy*, trans. Michael Bullock (New York: International University Press, 1953).

Xanthopoulos, Lefteris, *The Four Seasons of Nikos Koundouros* (Athens: Gabriilidis Publications, 2014).

Yeoryakopoulou, Vena, 'Yorgos Lanthimos: Our choices are mostly instinctive', *Cinephilia*. Available at http://www.cinephilia.gr/index.php/keimena/pressclips/212-lanthimos (accessed 21 November 2013).

Zapas, Costas, 'The tragedy of Greece', *Of Tragedy, of Myth*, 5 February 2012. Available at http://www.protothema.gr/culture/cinema/article/175121/kostas-Zapas-h-ellada-ths-tragodias_-ths-krishs-kai-toy-mythoy/ (accessed 25 November 2013).

# Index

*1900* (Italy: 1976), 169, 176
*1922* (1978), 26, 43, 56, 111, 119, 126

Adorno, Theodor, 227, 260
Aeschylus, 172, 176
*Agnes of the Harbour/I Agni tou Limaniou* (1952), 32
Aitken, Ian, 96, 252
Alexander, Jeffrey C., 25, 248
*Alexander the Great/Megalexandros* (1980) 21, 47, 162, 176, 177, 178, 179
Alexandrou, Aris, 120
*Allegory/Allegoria* (1985), 195
Almodóvar, Pedro, 51, 58
*Alps* (2012), 58, 244
Altman, Robert, 218
Anderson, Lindsay, 78, 82, 251
Andersson, Roy, 244
Andritsos, Costas, 18
Angelidi, Antoinetta, 2, 3, 15, 38, 41, 49, 57, 191–214, 258, 259, 260
Angelopoulos, Theo 2, 3, 8, 9, 11, 13, 14, 15, 18, 19, 20, 21, 22, 24, 28, 38, 46, 47, 48, 57, 68, 80, 90, 106, 110, 128, 129, 136, 139, 142, 143, 157–90, 192, 193, 194, 199, 203, 204, 207, 208, 216, 217, 218, 220, 227, 228, 229, 233, 234, 236, 237, 244, 246, 256, 257, 258
*Anna's Engagement/To Proxenio tis Annas* (1972), 143
*Antigone* (1960), 108
Antiohos, Yiagos, 261
Antonioni, Michelangelo, 14, 57, 167, 172, 230, 233
Archimandritis, Yorgos, 158, 256, 257, 258
Arendt, Hannah, 204, 254, 260
Aristophanes, 40

*L'Argent* (France: 1983), 230
Aristotle, 47, 48, 85, 176, 188, 191, 196, 199, 235, 251
Arnheim, Rudolf, 29, 248
Artaud, Antonin, 121, 254
*Astero* (1929), 20, 80, 161
*Attack of the Giant Mousaka, The/I Epithesi tou Gigantiou Mousaka* (1991), 51, 219
*Attenberg* (2010), 58, 231, 243
Arvanitis, Yorgos, 91, 127, 180, 181
Avdeliodis, Dimos, 20
Avranas, Alexandros, 50, 52, 221, 231, 260
*Ayoupa/Bed of Grass* (1957), 40

Bakatakis, Thimios, 230
Bakhtin, Mikhail, 105, 106, 253
Bakogianni, Anastasia, 86, 87, 252
Balazs, Bela, 54, 249
*Barefoot Battalion, The/To Xipolito Tagma* (1953), 20, 34
Barthes, Roland, 11, 107, 247, 248, 254
*Battleship Potemkin* (Soviet Union: 1925), 99
Baudelaire, Charles, 119, 254
Baudrillard, Jean, 260
Bazin, Andre, 6, 15, 22, 30, 52, 54, 61, 82, 99, 121, 128, 158, 191, 246, 247, 248, 249, 250, 251, 254, 255, 258
*Beauty of Athens, The/I Oraia ton Athinon* (1954), 39
*The Beekeeper/O Melissokomos* (1986), 169, 181, 188
*Belle de Jour* (France: 1967), 151
Benjamin, Walter, 113, 254
Berger, John, 37, 57, 249
Bergman, Ingmar 21, 64, 81, 86, 124, 167, 172, 211, 233, 255

# Index

Bergson, Henry, 57

Bertolucci, Bernardo, 47, 167, 168, 169, 176

Biondi, Beniamino, 4

Biro, Yvette, 158, 256

*Bitter Bread/Pikro Psomi* (1951), 20, 33

Bjelic, Dusan, 257

*Black Field/Mauro Livadi* (2009), 225

Blathras, Constantinos, 248

Bondanella, Peter, 247, 252, 255

*Bordello* (1985), 38, 111, 118, 123, 225

Bordwell, David, 8, 15, 85, 169, 179, 180, 246, 247, 252, 257, 258

Borg, Charles Ramirez, 261

Bosch, Hieronymus, 225

Boulmetis, Tassos, 216, 217

Bowie, Malcolm, 257

*Boy Eating the Bird's Food/To Agori troei to Fagito toy Pouliou* (2013), 231

Bradshaw, Peter, 103, 253

Brakhage, Stan, 192, 197

Brandhauer, Andrea, 251

*Breathless* (France: 1960), 163

Brecht, Bertolt, 47, 48, 152, 168, 176, 189, 196, 230

Bresson, Robert, 29, 41, 47, 81, 167, 168, 230, 233, 249, 257, 261

*Brides/Nifes* (2004), 216, 227, 240

*Broken Blossoms* (USA: 1919), 83

Bunuel, Luis, 99, 121, 151

*Burning Heads/To Gala* (2011), 221

Bursh, Noel, 8, 10, 246

Butler, Judith, 79, 154, 155, 251, 256

Byron, Lord, 114, 123, 126

*Byron, or Ballad for a Demon* (1991), 38, 114, 123, 126, 127

Cacoyannis, Michael 1, 2, 3, 4, 7, 10, 11, 14, 15, 17, 20, 21, 22, 23, 24, 25, 31, 34, 36, 37, 38, 42, 54, 55, 56, 59, 60–97, 100, 106, 108, 121, 125, 130, 133, 137, 147, 172, 175, 182, 204, 210, 228, 241, 244, 245, 250, 252, 253, 262

Camus, Albert, 114, 127, 255

canon, Greek cinema, 18–21

Capra, Frank, 133

Carne, Marcel, 31

Carol, Noel, 247

*Castle of Purity, The* (Mexico: 1973), 231

Castoriadis, Cornelius, 58, 250

Cavell, Stanley, 14, 247

Ceylan, Nuri Bilge, 14

Chadwick, Whitney, 259

Chan-Wook, Park 244

Chaplin, Charlie, 101

Charitos, Dimitris, 247

Chaudhuri, Shohini, 7, 246

Chekhov, Anton, 96

*Cherry Orchard, The* (1999), 37, 42, 96

*Chevalier* (2015), 243

*Chien Andalou, Un* (Spain: 1929), 99

*Christmas Tango/To Tango ton Hristougennon* (2011), 221

*Chronicle of a Sunday* (France: 1960), 162

*Citizen Kane* (USA: 1941), 101

*City of Children, The/I Poli ton Paidion* (2011), 221, 232

Clair, René, 74

*Coffee-Reader, The/I Kafetzou* (1955), 40

Cohen, Tom, 131, 255

Collingwood, R. G., 239, 262

colour, 111, 118, 165, 174–5, 177, 206–7

comedy, 39, 41

*Conformist, The* (Italy: 1970), 176

Constantinidis, Stratos E., 248

Coppola, Francis Ford, 176

*Counterfeit Pound, The/ I Kalpiki Lira* (1955), 20, 32, 33, 73

Cousins, Mark, 11, 21, 28, 247, 248

*Cow, The* (Iran: 1969), 13

Cowie, Peter, 73, 251, 253

*Cranes Are Flying, The* (Soviet Union: 1957), 14

*Critique of Separation* (France: 1961), 192

Crowther, Bosley, 80, 251

Cubitt, Sean, 181, 258

Curtiz, Michael 31

# Index

da Vinci, Leonardo 123
Dali, Salvador, 206, 260
Dalianidis, Yannis, 2, 3, 15, 18, 20, 24, 27, 38, 40, 44, 45, 46, 53, 56, 92, 129–156, 172, 244, 255, 256
Daly, Mary, 201, 212, 259
Damaskos, Dimitris, 260
Damianos, Alexis, 20, 143, 160
*Dangerous Ones (A Protest), The/ Oi Epikindinoi (mia Diamartiria)* (1983), 134
Dante, 186, 197
*Daphnes and Chloe* (1931), 20, 192
Dardenne, Brothers, 58
David, Jacques-Luis, 197, 199
Davies, Terence, 48, 168
*Day of August, A/Dekapentaugoustos* (2001), 222
*Day the Fish Came Out, The/I Mera pou ta Psaria Vgikan stin Steria* (1967), 65, 94
*Days of 36/Meres tou 36* (1972), 47, 139, 143, 171, 173, 174, 193, 194
de Martino, Ernesto, 126
de Sica, Vittorio, 64
*Death by Hanging* (Japan: 1968), 174
Debord, Guy, 192, 215, 216, 260
*Decoupage*, 99, 128
*Deep Soul/Psihi Vathia* (2009), 227
defamiliarisation, 197
Degas, Edgar, 31, 32
del Toro, Gulliermo, 244
Deleuze, Gilles, 57, 127, 163, 249, 255, 257
de-montage 160–1, 175
Deren, Maya, 57, 192, 204, 249, 259
Dermentzoylou, Alexis, 226, 260
Diamantopoulos, Yannis, 224, 260
Dimopoulos, Dinos, 18, 24
Dimopoulos, Nikos, 132
*Dirty City/Vromiki Polis* (1965), 18
*Dogtooth/Kinodontas* (2009), 231, 242
*Domenica d'Agosto* (Italy: 1951), 73
Donaldson, Peter, 252
Donen, Stanley, 133, 167
Douzos, Andreas, 155

*Downhill/Katiforos* (1962), 140
*Dr Mabuse* (Germany: 1922), 101
Dreyer, Carl, 48, 81, 168, 194, 211
Dritas, Thanassis, 254
*Dust of Time, The/I Skoni tou Hronou* (2009), 165, 166, 169, 170, 171, 186, 187, 188
Dyer, Geoff, 185, 258
Dvozhenko, Alexander 14

*East of Eden* (USA: 1955), 167
Ebert, Roger, 89, 252
Economides, Yannis, 221, 222
*Egotism/Egoismos* (1964), 141, 145
Eisenstein, Sergei, 14, 21, 47, 57, 99, 124, 145, 194, 195, 207, 244, 253, 255, 256, 260
*Electra* (1962), 21, 27, 42, 55, 64, 65, 68, 69, 71, 81, 86, 89, 92, 106, 108, 147, 204
*Elefterios Venizelos* (1965), 36
Eleftheriotis, Dimitris, 77, 251
Eliot, T. S., 89, 166, 257
Elkins, James, 46, 249
Elsaesser, Thomas, 26, 248
Emmer, Luciano, 73, 74
*Enemy of the People, The/O Ehthros tou Laou* (1972), 136
*Eroica/Our Last Spring* (1959/60), 55, 64, 83, 84
*Eternity and a day/Aioniotita kai Mia Mera* (1997), 48, 165, 166, 179, 185, 190
*Eudokia* (1970), 20, 143
*Eurydice BA 2037/Evridiki BA 2037* (1975), 192
Euripides, 69, 90
*Eve/Eva* (1953), 35, 36, 78
*Expulsion/Diogmos* (1965), 27

Fainaru, Dan, 170, 184, 187, 188, 246, 257, 258
Fais, Michel, 188, 258
Fassbinder, Rainer Werner, 47, 143, 152, 177
*Fear/Fovos* (1966), 20

# Index

Fellini, Federico, 112, 124
Fennec-Michelidis, Nikos, 73, 251
Ferenci, Sandor, 186
Ferrari, Fabricio M., 255
Ferris, Costas, 20, 193
Finos, Filopoimin, 130, 148
*Fire/Fotia* (?) 136
*First Time Godfather/Proti Fora Nonos*
    (2007), 217
Flaubert, Gustave, 63, 120
Florensky, Pavel, 9, 248
Ford, John, 103, 104, 105
Foster, Hal, 248
Foucault, Michel, 19, 67, 92, 102, 247,
    250, 253
*Four Seasons of the Law, The/I Earini*
    *Sinaxis ton Agrafilakon* (1999), 20
*Fox and His Friends* (Germany: 1975), 152
Frangoulis, Yannis, 259
Franzen, Jonathan, 103, 253
Franztis, Angelos, 41
Freud, Lucien, 209
Freud, Sigmund, 27, 49, 144, 248
Friedrich, Caspar David, 185
*From the Edge of the City/Ap' tin Akri tis*
    *Polis* (1997), 51, 222
*From Here to Eternity* (USA: 1953), 75
*Fuck/Blue Movie* (USA: 1968) 108

Gabriel, Jane, 257
Gage, John, 260
Ganz, Bruno, 48
Garcia, Alejandro Valverde, 4
Gardelis, Nikos, 152
Gardelis, Stamatis, 136, 141
Gare du Nord (France: 1964), 162
Gavala, Maria, 195
Gaziadis, Dimitris, 20, 80, 161
Gaziadis, Mihalis, 34
Gentileschi, Artemisia, 194, 202,
    203, 208
Georgakas, Dan, 251
Georgiadis, Vassilis, 18
Georgitsis, Faidon, 141

*Germans Strike Back, The/Oi Germanoi*
    *Xanarhontai* (1948), 19, 20
Giannaris, Constantine, 15, 38, 41, 51, 57,
    222, 223, 224, 225, 233, 239, 260
Gibbs, John 8, 248
Gibson, J. J., 158–9, 256, 257
Gikapeppas, Yorgos, 221, 232
*Girl in Black/Koritsi me ta Mavra* (1956)
    62, 71, 79, 80, 82, 89, 92
*Girls for Kissing/Koritsia yia Filima* (1966),
    146, 155
*Godfather, The* (USA: 1972), 176
Godard, Jean-Luc, 10, 49, 54, 57,
    163, 167, 168, 172, 192, 194, 199,
    208, 247
*Gothic* (UK: 1986), 114
Goya, Francisco, 43, 211
Goldmann, Lucien, 14, 247
Goritsas, Sotiris, 221
Gourgouris, Stathis, 164, 257
Grammaticos, Nikos, 226
Gramsci, Antonio, 67, 125, 177
Greco, El, 48
*Greco, El* (2004), 240
Greenway, Peter, 199
Greer, Germaine, 260
Gregoriou, Gregoris, 10, 18, 20, 27, 33, 34,
    247, 249, 250
Grieg, Edvard, 192
Grierson, John 54, 63, 85, 86
Griffith, D. W., 33, 83, 175, 192, 199
*Guardian's Son, The/O Yios tou Filaka*
    (2006), 226
Guney, Yilmaz, 13

Hadjikyriacou, Achilleas, 77, 251
Hadjikyriakos-Ghika, Nikos, 81
*Hamlet* (UK: 1945), 68
Haneke, Michael 58
Haralambidis, Renos, 224
Hardy, Françoise Madeleine, 243
Hatzidakis, Manos, 63, 78
Hawkes, Howard, 34
Hayward, Susan, 14, 247

# Index

*Heart of the Beast, The/I Kardia tou Ktinous* (2005), 225

Heidegger, Martin, 165, 179, 185, 200, 204, 257

Helmi, Katerina, 141

Hepp, Joseph, 17

Hitchcock, Alfred, 54, 79, 80, 131, 152, 162, 177, 181

Holbein, Hans, 123

*Homeland/Hora Proeleusis* (2010), 221

*Honey and Pig/Loukoumades me Meli* (2005), 217

*Hope* (Turkey: 1970), 13

Horkheimer, Max, 227, 260

Horn, Dimitris, 70, 74

Horton, Andrew, 3, 175, 256

*Hostage/Omiros* (2004), 222

*Hours – A Rectangular Movie, The/Oi Ores – Mia Tetragoni Tainia* (1995), 49, 191, 197, 208, 209, 210

Hudson, Rock, 140

*Hunters, The/Oi Kinigoi* (1977), 47, 90, 169, 171, 176, 177, 178, 189, 193, 194, 237

*I Confess* (USA: 1953), 180

*I Love Karditsa* (2010), 217

*Idées Fixes/Dies Irae/Parallagges sto Idio Thema* (1977), 49, 191, 194, 197, 201, 205

Iliopoulos, Dinos, 118

*In the Woods/Mesa sto Dasos* (2010), 41

Iñárritu, Alejandro González, 244

Iordanova, Dina, 12, 217, 247, 248, 251, 260

*Iphigenia* (1977), 37, 65, 90, 91

Isaacs, Bruce, 41, 246

*Island/Nisos* (2009), 217

*Island of Silence, The/To Nisi tis Siopis* (1959), 36

Itzkowitz, Norman, 26, 27, 246

*Ivan the Terrible Part II* (Soviet Union: 1947, r. 1958) 207

James, Willian 140, 249

Jameson, Fredric, 6, 187, 188, 246, 258

Jancsó, Miklós 21, 167

Jarman, Derek 48, 208, 224, 233, 260

Jay, Martin, 22, 248

Jennings, Humphrey, 63

Jerslev, Anne, 249

Jestrovic, Silvija, 259

*John the Violent/Ioannis o Viaios* (1973), 49, 143, 193

Jung, Carl Gustav, 223, 260

Kael, Pauline, 65, 75, 79, 87, 250, 251, 252

Kafka, Franz, 43, 118

Kalatozov, Mikhail, 14

Kambanellis, Iakovos, 135

Kandinsky, Wassily, 48

Kanellopoulos, Takis, 106, 169

Karaindou, Eleni, 57, 164, 179

Karalis, Vrasidas, 247, 248, 250, 251, 252, 255, 259

Karayianni, Martha, 139

*Karkalou* (1984), 20

Kar-Wai, Wong, 58, 244

Kassovitz, Mathieu, 58, 224

Katritzidakis, Vangelis, 115

Katsadramis, Thodoros, 162

Katsakis, Manos, 120, 132

Katsounaki, Maria, 96, 209, 211, 229

Katsouridis, Dinos, 21

Kavoukidis, Nikos, 114, 115, 144

Kazan, Elias, 132, 167

Kazantzakis, Nikos, 68

Keats, John, 119, 254

Keitel, Harvey, 182

Keranidis, Stratos, 257

*Kierion* (1968), 161

*Kinetta* (2005), 52, 227, 228, 229, 240

*King, The/O Vasilias* (2002), 226

Kluge, Alexander, 177

*Knifer, The/Maherovgaltis* (2010), 221, 223

Kojève, Alexandre, 236, 262

Kolonias, Babis, 262

Konidou, Gina, 249

Kosseleck, Reinhart, 25, 248

# Index

Koundouros, Nikos, 3, 4, 13, 15, 18, 19, 20, 23, 26, 31, 36, 37, 38, 42, 43, 51, 55, 56, 98–128, 130, 133, 153, 160, 161, 203, 206, 207, 225, 244, 253, 254, 255
Kourkoulakou, Lila, 36
Kourkoulos, Nikos, 132, 139, 141
Koutelidakis, Nikos, 221
Koutras, Panos H., 51, 57, 219, 220, 238, 239, 241, 242, 260
Koutsiabasakos, Dimitris, 226
Koutsoyiannopoulos, Thodoris, 115, 254, 260, 261
Kracauer, Siegfried, 29, 50, 55, 63, 99, 122, 248, 249, 250, 253, 259
Kristeva, Julia, 134, 255
Kurosawa, Akira, 163
Kyriakos, Constantine, 255, 259, 260
Kyrou, Adonis, 25

Lacan, Jacques, 153, 171, 256
*Lacrimae Rerum* (1962), 192
Lambeti, Elli, 74, 80, 81
*Land Without Bread* (Spain: 1932) 121
*Landscape in the Mist/Topio stin Omihli* (1988), 106, 139, 170, 181, 183, 188, 208
Lanthimos, Yorgos, 2, 15, 38, 41, 50, 52, 57, 58, 217, 221, 227, 228, 229, 230, 231, 233, 238, 239, 241, 242, 244, 260, 261
Laplanche, Jean 156, 256
Lascari, Zoe, 45, 132, 139, 140, 141, 144, 151, 152, 155
Laskos, Orestis, 20, 192
Lassaly, Walter, 17, 42, 54, 55, 63, 71, 82, 83, 86, 89, 95, 250, 251
*Last of England, The* (UK: 1987), 233
*Last Porn Film, The* (2006), 233, 235
*Last Tango in Paris* (Italy/USA: 1972), 169
*Last Year in Marienband* (1961), 163
*Law 4000/Nomos 4000* (1962), 140
Lazopoulos, Lakis, 227
Lee, Ang, 244
Levin, Tom 262
Liappa, Frida, 49, 249
Liaskou, Chloe, 141

*Life Sentence/Isovia* (1987), 131
Linsday, Vachel, 22, 248
*Lioube/Lioumpe* (2005), 225
*Little England/Mikra Anglia* (2011), 227
*Little Vixen, The/I Mousitsa* (1959), 131
*Loafing and Camouflage: Sirens in the Aegean/Loufa kai Parallagi: Sireines sto Eyaio* (2005), 217
*Lobster, The* (2015), 58, 244
Lodge, Guy, 231, 261
Lucie-Smith, Edward, 7, 246, 249
Lukacs, Georg, 47, 239
Lurhmann, Baz, 58
Lygizos, Ektoras, 221, 232, 261, 262

MacCabe, Colin, 249
McDonald, Scott, 213, 260
*Madalena* (1960), 24
Magarshack, David, 255
*Magic City/Mayiki Polis* (1954), 37, 98, 122, 123
*Magnificent Ambersons, The* (USA: 1942), 105
Mahaira, Eleni, 207, 259, 260
*Malher* (UK: 1974), 109
Malick, Terrence, 168
Mamangakis, Nikos, 114
*Man from London, The* (Hungary: 2005), 193
*Man at Sea/Anthropos stin Thalassa* (2011), 222, 224
*Man Who Knew Too Much, The* (USA: 1955), 80
Manousakis, Costas, 20
Mantegna, Alessandro, 211
Marat, Jean-Paul, 197, 199, 204
Marc, Franz, 176
Marcuse, Herbert, 184, 258
*Maria of Silence/Maria tis Siopis* (1973), 134
Marinakis, Vardis, 225
*Marinos Kontaras* (1948), 32
Marketaki, Tonia, 21, 49, 143, 193
Markopoulos, Gregory J., 192, 197, 259

# Index

Marx, Karl, 173, 194
Mast, Gerald, 40, 249
Mastroianni, Marcello, 181
*Matchbox/Spirtokouto* (2002), 222
*Matter of Dignity, A/To Teleftaio Psema*
 (1958), 63, 73, 81, 83, 89, 93
Maupassant, Guy de, 31, 63
Mazomenos, Vassilis, 41, 195, 211, 259, 260
Mehrujui, Dariush, 13
Mekas, Jonas, 192
melodrama, 14–15
Mercouri, Melina, 74, 241
Merleau-Ponty, Maurice, 159, 160, 249, 257
Metaxas, General Ioannis, 23, 173
*Metropoles/Metropoleis* (1974), 196
Metz, Christian, 5, 195, 197, 246, 259
Michail, Savvas, 195, 202, 259
Mihalopoulos, Panos, 92, 136, 141
*Million, The* (France: 1931), 74
Minelli, Vincente, 133
*Minor Freedoms/Mikres Eleutheries* (2008),
 234, 235
*mise-en-scène*, 8, 9, 10
*Misfits, The* (USA: 1961), 103
*Miss Violence* (2013), 231
Mitropoulou, Aylaia, 101, 247, 253
Mizoguchi Kenji, 21, 174
*Modelo* (1974), 194, 195
*Momma Don't Allow* (UK: 1955), 83
montage, 3, 74–5
Morgenstein, Maia, 166
Moshovakis, Yannis, 108, 115, 253
*Mouchette* (France: 1967), 168
*Mourning Becomes Electra* (USA: 1947), 86
Mulvey, Laura, 56, 155, 249, 256
Munch, Edvard, 43
*Murderess, The/I Fonissa* (1975), 193
*My Best Friend/O Kaliteros Filos mou*
 (2001), 227

Nagib, Lucia, 14, 15, 247, 249
*Naked in the Street/Yimnoi sto Dromo*
 (1969), 135
Nichols, Dudley, 86

Nicolls, Will, 249
Nietzsche, Friedrich 185, 186, 258
Nikolaides, Nikos, 20, 192, 208, 225,
 226, 233
Nora, Pierre, 27, 248
*North of Vortex* (1991), 51
Novalis, 124
*Nuit et Brulliard/Night and Fog* (France:
 1955), 80

*Odd Man Out* (UK: 1947), 103
*Ogre of Athens, The/O Drakos* (1955), 20,
 37, 42, 98, 100, 102, 103, 118, 123, 125
*Olivados, Los* (Spain: 1950), 121
Olivier, Lawrence, 68, 87
*On the Passage of a Few Persons Through
 a Rather Brief Moment in Time* (France:
 1959), 192
*On the Waterfront* (1954), 167
Ophüls, Max, 21
Orfanelli, Alvise, 70
*Orphans of the Storm* (USA: 1921), 83
Oshima, Nagisa, 167, 168, 172, 174
*Other Sea, The/I Alli Thalassa* (2012,
 incomplete), 157
*Outlaw, The* (USA: 1943), 34
*Outlaws, The/Oi Paranomoi* (1959),
 13, 103, 104
Ozu, Yasujiro, 53, 167, 172, 174

Panofsky, Erwin, 213, 260
*Pather Panchali* (India: 1955), 80
Papadimitriou, Lydia, 12, 130, 247,
 251, 255
Papadimitropoulos, Argyris, 232
Papadopoulos, Yannis, 232
Papaioannou, Dimitris, 215
Papaioannou, Kostas, 257
Papakaliatos, Christophoros, 217
Papamichalis, Vion, 72, 250
Papas, Irene, 91
Papastamoulos, Yorgos, 262
Papastathis, Lakis, 28
Papatakis, Nikos, 20

**279**

# Index

Parajanov, Sergei, 199
Parides, Christos, 137, 256
Parkinson, David, 21, 28, 248
Pasolini, Pier-Paolo, 112, 117, 118, 124, 125, 254
*Peach Thief, The* (Bulgaria: 1964), 13
*Peeping Tom, The* (UK: 1960), 152
*Persona* (Sweden: 1966), 211
perspective, 13–14
Phillips, Christopher, 10, 247
*Photograph, The/I Fotografia* (1986), 20
*Photographers, The/Oi Fotografoi* (1998), 38, 115, 123, 127, 225
*Pierrot le Fou* (France: 1965), 208
*Pigeon Sat on a Branch Reflecting on Existence, A* (2014), 244
Plantzos, Dimitris, 215, 260
Plato, 206, 260
Plorites, Marios, 98, 100, 253
Plyta, Maria, 35, 36, 78
*Polaroid* (2000), 41
Politis, Hristos, 141, 151
Politis, Kosmas, 83
Pontalis, Jean-Bertrand, 156, 256
Poulantzas, Nikos, 239, 262
Powell Michael, 81, 133, 152
Preminger, Otto, 133
Prendeville, Brendan, 8, 246
presentational/representational, 9–10
*Price of Love, The/I Timi tis Agapis* (1984), 21
*Prophetic Bird of Paul Klee's Melancholias, The/To Profitiko Pouli ton Thlipseon tou Paul Klee* (1995), 196
Propp, Vladimir, 71, 250
Proust, Marcel, 140
Pudovkin, Vsevolod, 14

Radev, Vulo, 13
Rafailides, Vassilis, 5, 6, 53, 90, 91, 114, 124, 181, 194, 196, 199, 246, 249, 252, 254, 258, 259
*Raised from its Bones/Ap' Ta Kokkala Bgalmeni* (2011), 221

Rancière, Jacques, 196, 259
Rank, Otto, 206
Ray, Satyajit, 80
realism, 3, 5–7, 15, 59, 85, 99, 133
*Rebellion of the Red Maria, The/I Antarsia tis Kokkinis Marias* (2010), 53, 234
*Rebellious Commoner, The/O Epanastatis Popolaros* (1971), 136
*Reconstruction/Anaparastasi* (1970), 13, 20, 46, 47, 80, 136, 142, 161, 162, 167, 172, 173, 204, 225
Reed, Carol, 81, 101, 103
*Région Centrale, La* (1971), 198
Reisz, Karel, 83
*Rembetiko* (1984), 20
Renoir, Jean, 21, 31, 33, 81, 82, 86
Rentzis, Thanassis, 195
Resnais, Alain, 80, 163, 172
Richardson, Tony, 83
Richie, Donald, 9, 246, 249
Ripstein, Arturo, 231
*River, The/To Potami* (1960), 103, 105, 123, 125
Robben, Antonius, C.G., 248
*Robbery in Athens/Listeia stin Athena* (1969), 161
Rocha, Glauber, 47, 172
*Rome, Open City* (Italy: 1945), 93
*Rope* (USA: 1948), 162
*Rorcile* (Italy: 1969), 117
Rose, Steve, 249, 260
Rosen, Michael, 174, 255, 257
Rossellini, Roberto, 29, 64, 86, 93, 167
Rouch, Jean, 162, 172, 257
*Round-Up, The/The Mploko* (1964), 27
Royer, Michelle, 251
Russell, Ken, 109, 114

*Safe Sex* (2000), 217, 218
Said, Edward, 165, 166, 257
Saint-Saëns, Camille, 192
Sakellarios, Alekos, 19, 20
*Salò, or the 120 Days of Sodom* (Italy: 1975), 112, 117

# Index

Sant, Gus van, 58, 224

Sarris, Andrew, 20, 157, 256

Sartre, Jean-Paul, 69, 250

*Satyricon* (Italy: 1969), 112

*Savage Messiah* (UK: 1972), 109

Savic, Obrad, 257

Savvides, Varvara, 262

Schatz, Thomas, 85, 252

schema plus variations, 11

Schubert, Franz, 192

Scorsese, Martin, 208

*Searchers, The* (USA: 1956), 105

Seferis, George, 68, 163, 183, 184, 258

Serdaris, Vangelis, 161

*Serenity/Yalini* (1958), 192

Seurat, Georges, 188

*Seventh Seal, The* (Sweden: 1957), 86

sexuality, 140–2

Shelley, Mary, 234

*Short Cuts* (USA: 1993), 218

Siafkos, Christos, 250, 251, 252

*Silicon Tears, The/To Klama Vyike ap' ton Paradeiso* (2001), 217

Silverman Kaja, 156, 256

Simmel, Georg, 258

Sinanos, Andreas, 181

*Sinners, The/Oi Amartoloi* (1971), 45, 143, 145, 148, 150, 154

Sirk, Douglas, 133

Sfikas, Costas, 51, 194, 195, 196, 249, 261

Shakespeare, William, 96, 252

*Ship to Palestine, The/To Ploio yia tin Palestini* (2011) 115, 116, 123

Shlovsky, Victor, 122, 254

*Sky, The/O Ouranos* (1962) 106

Smaragdis, Yannis, 28, 216

Smee, Sebastian, 260

Snow, Michael, 192, 198

*Society of the Spectacle* (France: 1973), 192

Soldatos, Yannis, 247, 249, 252, 253, 254, 255

Solomos, Dionysios, 186

*Something Sizzling/Kati Na Kaiei* (1964), 24

*Songs of Fire, The/Ta Tragoudia tis Fotias* (1974), 43

Sophocles, 115, 197, 211

Sorrentino, Paolo, 244

Sougias, Yorgos, 221

*Soul Kicking/Psihi sto Stoma* (2005), 222

*Sous Ciel (Ceu Inferior)* (2011), 159

Spoto, Donald, 251

Stamatiou, Kostas, 253

Stanislavski, Konstantin, 132

Stassinopoulou, Maria, 12, 247

state, Greek policy towards cinema, 21–2

Stathi, Eirini, 177, 257

Stavrou, Gerasimos, 74, 251

*Stella* (1955), 2, 20, 62, 68, 75, 77, 79, 82, 89, 92, 93, 241

*Stella Dallas* (USA: 1937), 75

*Stephanie/Stephania* (1966), 20, 141, 143

*Story of Jacob and Joseph, The* (1975), 93

*Story of a Life/Istoria mias Zois* (1965), 27, 138, 141, 144, 145, 154

*Straight Story, The* (2007), 217

*Stratos/To Mikro Psari* (2014), 222

*Strella* (2009), 51, 241, 242

*Strictly Appropriate/Afstiros Katallinon* (2008), 217, 218

*Strike* (Soviet Union: 1925), 196

studio system, 30

Suarez-Oroszo, Marcelo M., 248

*Suspended Step of the Stork, The/To Meteoro Vima tou Pelaryou* (1991), 106, 181, 185, 188, 190

*Sweet Bunch/Glikia Simmoria* (1983), 20

*Sweet Country* (1986), 91

Tallas, Greg C., 20, 34

Tar, Béla, 193

Tarkovsky, Andrey, 14, 29, 167, 199, 207, 233

Tassios, Pavlos, 129, 143

*Taxi Driver* (USA: 1976), 208

*Tears For Electra/Dakria yia tin Elektra* (1966), 141, 142, 144, 146, 147, 148

Teitelbaum, Matthew, 247

**281**

# Index

*Teorema* (Italy: 1968), 117
Thanouli, Eleftheria, 7, 246
Thatcher, Margaret, 233
Theodoraki, Stella, 195, 259, 260
Theodorakis, Mikis, 34, 65, 90
Theodoridis, Costas, 78, 100, 101
Theodoropoulos, Dimitris, 179, 258
Theophilos, Hatzimihail, 163
Theos, Dimos, 161, 195
*Thief or Reality/Kleftis I Pragmatikotita*
(2001), 49, 191, 197, 199, 203, 207, 210
*Third Man, The* (UK: 1949), 101, 103
Thomson, David, 91, 157, 158, 250, 252, 256
Thomson, Kristin, 10, 15, 246, 247
*Those who Spoke with Death/Aftoi pou*
*Milisan me ton Thanato* (1970), 135
Tombros, Yannis, 11, 247
*Topos* (1985), 49, 191, 198, 209, 210
Tornes, Stavros, 20
*Touch of Spice, A/Politiki Kouzina* (2004),
216, 240
trauma, 3, 24–7, 121, 130, 175
*Travelling Players, The/O Thiasos* (1975),
2, 20, 21, 22, 28, 142, 158, 164, 171, 174,
175, 176, 188, 189, 193, 194, 236
*Trial of Joan of Arc, The* (France: 1962), 168
Triers, Lars von, 58, 244
Triantafillidis, Jason, 136
*Trojan Women, The* (1971), 37, 55,
65, 69, 90
*Trouble with Harry, The* (USA: 1955), 177
*True Blue/Galazio Forema* (2005), 224
*True Life/Alithini Zoi* (2004), 219
Truffaut, Francois, 152, 256, 257, 258
Tsangari, Athina Rachel, 2, 4, 5, 41, 50, 52,
57, 221, 231, 238, 239, 243
Tsarouchis, Yannis, 96, 175, 252
Tsilimidis, Manos, 137, 147, 153, 256
Tumarkin, Maria, 248
Tzavellas, Yorgos, 20, 31, 32, 33, 73, 75,
100, 108, 249
Tzioumakis, Yannis, 247, 251
Tzortzoglou, Stratos, 92
Tzoumerkas, Syllas, 221

*Ulysses' Gaze/To Vlemma tou Odyssea*
(1995), 107, 164, 165, 166, 169, 181, 185,
188, 190, 203
*Uncut Family* (2004), 234, 235, 236
*Under the Sign of Virgo/O Asterismos tis*
*Parthenou* (1973) 143, 149, 151, 154
*Up, Down and Sideways/Pano, Kato kai*
*Plagios* (1992), 91

Vakalopoulos, Hristos, 24
Vakousis, Manos, 114
*Vampyr* (Denmark: 1932), 194, 211
Vaneighem, Raul, 255
Varriano, Giovanni, 17, 104, 106
Vasileiadou, Georgia, 39
Vaughan, William, 254
Venezis, Ilias, 111
Vengos, Thanassis, 40, 120, 122
*Vertigo/Iliggos* (1963), 140
Vlahou, Eleni, 74, 251
Vogel, Jan, 232
Volkan, Vamik D., 26, 27, 248
*Vortex or Medusa's Face* (1967) 42, 51, 56,
108, 109
Voulgaridis, Vangelis, 141
Voulgaris, Pantelis, 129, 143, 193, 216, 217,
220, 227
Voutsadaki, Antonia, 100, 253
Voutsas, Costas, 132, 141
Vouyouklaki, Aliki, 24, 131, 150, 240, 262
*Voyage to Cythera/Taxidi sta Kythira*
(1984), 169, 179, 180, 181
*Voyage to Palestine/Ploio yia tin Palestini*
(1967), 38

Wagner, Richard, 189
Wall, Geoffrey, 120
Warhol, Andy, 108, 192
*Wasted Youth* (2011), 232
*Wastrel, The* (1961), 65, 85
*Weeping Meadow, The/To Livadi*
*pou Dakrizei* (2004), 165, 166, 171,
187, 189
'Weird Wave', 52–3, 231, 234
Welles, Orson, 101, 105, 127, 128

**282**

# Index

*What did you do in the War, Thanassi?/Ti Ekanes ston Polemo Thanasi?* (1971), 21
*What If/An* (2012), 217
White, Hayden, 3, 246
White, Patrick, 59
*Windfall in Athens/Kiriakatiko Xipnima* (1954), 23, 61, 69, 72, 73, 75, 76, 92
*Without Identity/Horis Taftotita* (1965), 141
Witt, Michael, 248
Wollen, Peter, 30, 198, 248, 259
*Woman Should be Afraid of the Man, The/I Gini na Foveitai ton Andra* (1965), 33
*Woman's Past, A/To Parelthon mias Yinaikas* (1968), 141
women's cinema, in Greece, 35–6, 196–7
Worringer, Wilhelm, 176, 258
*Wretches Are Still Singing, The/Ta Kourelia Tragoudane Akoma* (1978), 208
Wyler, William, 31

Xanthopoulos, Lefteris, 113, 126, 254, 255
Xarhakos, Stavros, 135
*Xenia* (2014), 51, 242

Yeoryakopolou, Vena, 261
*Yes but No.../Nai men Alla...* (1973), 143
Yiouryou, Laya, 225
*Young Aphrodites/Mikres Afrodites* (1964), 37, 42, 107, 108

Zapas, Costas, 41, 50, 52, 53, 57, 225, 233, 234, 235, 236, 237, 238, 239, 262
*Zero Years, The* (2005), 225, 226
Zhdanov, Andrey, 19
*Zorba the Greek* (1964), 2, 22, 37, 42, 65, 68, 78, 94, 96, 172
Zoumboulakis, Yannis, 254

CPSIA information can be obtained
at www.ICGtesting.com
Printed in the USA
LVHW080744221021
701184LV00015B/783